Abstract Expressionism
and the American Experience:
a Reevaluation

by Irving Sandler

Hard Press Editions, Lenox and
School of Visual Arts, New York

in association with
Hudson Hills Press
Manchester/New York

Abstract Expressionism
and the American Experience:
a Reevaluation

Published by Hard Press Editions, Inc., Lenox, MA
and School of Visual Arts, New York, NY
in association with Hudson Hills Press,
Manchester, VT and New York, NY.

Published as part of the *Mission Critical Series.*
Series editor: Raphael Rubinstein

Chapter Five was originally published in *Art in America*, June/July 2008.

ISBN: 978-1-55595-311-9

Printed in China

Typeset and formatted by Michelle Quigley
Cover design by Jonathan Gams
Managing editor: Anne Bei
Image research: Liz Riviere

Hard Press Editions would like to especially thank
David Rhodes and the School of Visual Arts
for their commitment to this project as
well as to the future of art criticism.

Front Cover:
Willem de Kooning
Pink Angels, 1945
oil and charcoal on canvas
52 x 40 in.
Frederick R Weisman Art Foundation, Los Angeles.

Acknowledgements

I wish to express my gratitude to the many artists, critics, curators and others in the art world who, over the years, have generously provided me with information, ideas and insights in both formal interviews and informal conversations. Among those who generously submitted to interviews, engaged willingly in lengthy discussions and searched hard for answers to specific questions, I single out among older artists John Ferren, Adolph Gottlieb, Philip Guston, Hans Hofmann, Franz Kline, Elaine de Kooning, Willem de Kooning, Landis Lewitin, Barnett Newman, Philip Pavia, Ad Reinhardt, Milton Resnick, Mark Rothko, Ludwig Sander, David Smith, and Esteban Vicente, and among younger artists, Robert Berlind, Grace Hartigan, Al Held, Angelo Ippolito, Alex Katz, Philip Pearlstein, and Sandy Wurmfeld; critics and historians Elizabeth Baker, Robert Goldwater, Thomas B. Hess, Clement Greenberg, Amy Newman, Frank O'Hara, Robert Rosenblum, Harold Rosenberg, Meyer Schapiro, Robert Storr, and Phong Bui; museum directors and curators Richard Armstrong, Alfred Barr, Ann Freedman, Henry Geldzahler, Thomas Messer, Dorothy Miller, William Seitz, and Adam Weinberg; dealers Leo Castelli, Ann Freedman, Ileana Sonnabend, and André Emmerich; collectors Marie and Roy Neuberger, and friends of the artists John Cage, Edwin Denby, Morton Feldman, and Buckminster Fuller.

I am also deeply grateful for those who have helped provide photographs, notably Anita Duquette of the Whitney Museum.

I would also like to thank Brendan Sullivan and Liz Riviere for their help in the preparation of this book and Catherine Sandler for her close editing of the text.

Above all, very special thanks are due to Jonathan Gams of Hard Press Editions for his enthusiastic encouragement and useful criticism, and Raphael Rubinstein, whose close reading of my text and suggestions in shaping it were invaluable.

I am deeply grateful to Krzysztof Ciezkowski of the Tate Library and Mitchell Benson, Chuck Close, Martin Finkelstein, Elliot Newman, and James M. McKiernan for making this work possible.

Finally, I wish to thank my wife Lucy Freeman Sandler for her wholehearted assistance in every stage of this book, and to whom, on the fiftieth anniversary of our marriage, it is lovingly dedicated.

Table of Contents

PREFACE

We now know the terror to expect. Hiroshima showed it to us.… The terror has indeed become as real as life. What we have now is a tragic rather than a terrifying situation. [No] matter how heroic, or innocent, or moral our individual lives may be, this new fate hangs over us.

Barnett Newman (1948)[1]

[The] new painting does have qualities of passion and lyrical desperation, unmasked and uninhibited, not found in other recorded eras; it is not surprising that faced with universal destruction, as we are told, our art should at last speak with unimpeded force and unveiled honesty to a future which may well be non-existent.…

Frank O'Hara (1959)[2]

The Abstract Expressionists began to "break through," as they put it, to their mature styles in 1947, some 60 years ago, and slowly gained worldwide acceptance. In recognition of their achievement, I published a history of the movement in 1970, titled *The Triumph of American Painting*. Having started the book in the middle 1950s, I wrote as a still embattled advocate, from within the avant-garde art world. This survey appeared more than three and a half decades ago. Since then, I have arrived at new conclusions about Abstract Expressionism, and for that reason I have felt compelled to write a new interpretation. But there are other motivations more personal and existential. Reading the histories of younger scholars of Abstract Expressionism, I have often felt alienated. Their analyses seem to have missed critical aspects of the art and its time, both the intentions of the artists and the state of feeling of the 1940s, the decade in which Abstract Expressionism developed. In this book it is my intention to recapture the early years of the movement.

I believe that, in addition to my being an art historian, I am well equipped in other ways to deal with Abstract Expressionism because in significant respects my life has resembled that of the artists. Although I am more than a decade younger than them, having been born in 1925, they and I lived

through the 1930s, 1940s, and 1950s and were exposed to the same social and political situations. We witnessed, among other momentous events, the Great Depression, the Spanish Civil War, World War II, the atomic bombings of Japan, and the revelation of Nazi death camps, Soviet gulags, and wartime Japanese atrocities—in sum, barbarities on a scale new in human history—and the beginnings of the cold war with its threat of nuclear devastation. Our artistic attitudes were profoundly affected by these events.

Moreover, I experienced the natural and manmade environments that informed the abstractions of Jackson Pollock, Clyfford Still, and Willem de Kooning, the three primary innovators of Abstract Expressionism. Like de Kooning, I was an urban person to my core. I was not an immigrant as he was but the son of immigrants, and although I was born in the United States, I did not learn to speak English until I started kindergarten. I spent four boyhood years in Winnipeg, Canada. Although I lived in the city, I came to know the surrounding prairie and to appreciate the open spaces with which Pollock and Still were familiar from their youth. In 1939, my family returned to the United States, and from 1943 to 1946, I served in the United States Marine Corps during World War II. Hence, I experienced World War II America as the artists had, and I vividly recall the *mood* of the 1940s that was embodied in their greatest paintings. As in *The Triumph*, in this present book I will situate Abstract Expressionism in history as well as in art history, but this time I will focus more on the American experience—that is, the history, culture, imagination, beliefs, and geography of the United States as they informed avant-garde American painting.

I maintain, as does the English writer and performer Stephen Fry, that the practice of history requires imagining your own reaction to past events. If you cannot envision yourself, for example, first hearing of the Japanese bombing of Pearl Harbor or of our atomic destruction of Hiroshima, or cheering President Roosevelt and victorious U.S. soldiers, then knowing the facts is not enough. If you cannot feel with our predecessors, "then all you can do is judge them and condemn them or praise them and over-adulate them." Fry concludes, "History is not the story of strangers, aliens from another realm; it is the story of us had we been born a little earlier."[3] To paraphrase George Kennan, history is not only what happened in the past but what it felt like when it happened.

In 1952, while a graduate student in American history at Columbia University, I encountered an Abstract Expressionist painting at the Museum of Modern Art—a black-and-white abstraction— that struck me dumb. The label informed me that the canvas had been painted two years earlier by Franz Kline, a name new to me, and that it was titled *Chief*. What was it in Kline's work that stunned and moved me? The painting did not provide any particular pleasure or delight. Nor did I "understand" it. I responded in another way—with my "gut," as it were. The painting had a sense of urgency that gripped me. I recognized Kline's need to create something deeply felt. Moreover, *Chief* had a disturbing edge, a certain rawness, disorientation, and lack of balance that reflected my predicament

at the time (and, I would later think, that of humankind). Indeed, Kline's abstraction gave rise to a fresh perception of art, my own life, and the larger world. It was at once surprising, familiar, and imposing. And it challenged me to find out more about it and make sense of my experience of it. I soon encountered other Abstract Expressionist paintings, and discovering where the artists gathered, joined them and listened closely to their conversations, many of which I wrote down.

In the face of public ridicule, the Abstract Expressionists felt embattled. At the same time they also were excited, as Robert Goldwater wrote: "The consciousness of being on the frontier, of being ahead rather than behind, of having absolutely no models however immediate or illustrious, of being entirely and completely on one's own—this was a new heady atmosphere."[4] It was indeed stimulating to be within the avant-garde art world. In time, I began to write art criticism and then art history (using my notes from conversations with artists as the essential source material) in the conviction that among the Abstract Expressionists were to be found the most original, vital, and masterly painters in the world.

I have begun with this mini-autobiography for two reasons. First, I am keenly aware that art history is not transparent. It is written by individuals, who bring to it their own personal and psychological perspectives, ethnic identities, social positions, and political and religious persuasions. Notwithstanding claims to objectivity, the historian's idiosyncrasies shape his or her art history. Second, and more importantly, I have sketched in my own background because I believe that my first-hand experiences may enable me to provide insights into Abstract Expressionist painting that are no longer available to later generations.

This book is not a systematic history of Abstract Expressionism as I meant *The Triumph* to be, but an analysis in greater depth of its development during the 1940s, its most consequential period. As in my earlier book, I have tried to retrieve the embryonic period in the development of Abstract Expressionism—before it was assimilated into art history. To delineate this germinal state, I have relied on the stated intentions and ideas of the artists themselves, many of whom I knew. I never met Arshile Gorky or Bradley Walker Tomlin, both of whom had died by the time I fully entered the New York art world, nor did I meet Clyfford Still, who was unapproachable. I knew Jackson Pollock casually, but beginning in the early 1950s I met the other artists, interviewed most, and became friends with a number, among them Willem de Kooning, Franz Kline, Adolph Gottlieb, Philip Guston, Barnett Newman, and Mark Rothko.

Painter Philip Pearlstein once said, "Don't assume that artists are dumb and don't know what they are really doing and that critics know better because they presumably have a fuller grasp of their time and therefore can presume that their primary purpose is to define what artists did." Pearlstein went on to say, "And don't suppose that your emotional and subjective responses to the work

are sufficient or reliable."[5] I agree, and whenever possible I have sought to find out what an artist's goals have been and why he or she has chosen to work in a certain way.

I am aware that my fraternization with artists might be said to have tainted or compromised my objectivity and critical eye. In *Cousin Bette*, Balzac wrote of mediocre artists who charmed people; he labeled them demi-artists. "The world is fond of them.... They seem to be superior to real artists, who are objected to on the grounds of their alleged egoism, bad manners, and rebellion against the rules of society. This is because great men belong to their work."[6] I can certify that in the world of the Abstract Expressionists, the real artists were not eclipsed by the demi-artists. We knew who was who. And personal charm did not count, or at least not for much.

Being mindful of the aspirations and ideas of artists is central to my own art theory, if one can call it that. My thinking has its source in the pre-Existentialist ideas of Miguel de Unamuno, a philosopher-novelist-poet who hated generalizations. He wrote "that when a man affirms his 'I,' his personal consciousness, he affirms man concrete and real ... and in affirming man he affirms consciousness."[7] I share Unamuno's dislike of generalizations, particularly glittering generalization, what art critic Thomas Hess termed "glidge." If I have sought to deal with the aims, visions, and experiences of singular artists as they are expressed in their works, as a concrete individual myself, I have matched my own perception of the works against my understanding of an artist's aspiration.

Consequently, I have found myself at odds with many of the younger art critics, historians, and theoreticians of the last three decades. They have programmatically disregarded the objectives of artists and have dealt with art in abstract terms, as the illustration of any number of theories—neo-Marxist, psychoanalytic, linguistic—in the process reducing art works to fit their preconceptions. I have also found myself in disagreement with formalist art historians who advance the idea that painting should focus exclusively on the medium of painting, its form, and its antecedents in art history.

In my view, it was living artists who experienced historical events and created art. I have not considered their work as the product of abstract constructions—"laws" of history or human behavior, capitalism, or art historical trends—but as the creation of human beings living in their specific time and responding to their personal artistic and social situation as honestly as they could. Reclaiming the sensibility of Abstract Expressionist artists in the 1940s is difficult because periodic changes in the human condition have occurred since then, and with them, changes in attitudes to art. Now, in the new millennium, as I look back on Abstract Expressionism, I have had to remember that it arose in another era. Many values have changed. It meant different things then to be an artist and an American.

My disagreements with art theoreticians and formalists notwithstanding, from the vantage point of more than a half-century of historical distance, I have taken into consideration post-*Triumph*

criticism and new interpretations. I have sought to sift the credible from the misconceived. I have used new documentation unearthed by scholars since 1970 where it is verifiable and can be validated by the paintings themselves. My aim throughout has been to view the past not from the perspective of the present but as it was experienced in its own time, while nonetheless keeping the present in mind.

Although my interpretation is based primarily on analyzing works of art that convey the artists' personal perspectives on life and art, I believe that these perspectives are shaped both by the changing state of art and the social and political situation. In 1936, Meyer Schapiro wrote that historians should not "reduce art to economics or sociology or politics. Art has its own conditions which distinguish it from other activities."[8] However, with these aesthetic conditions alone, historians cannot understand why art changes. The pressure of social issues plays a critical role. Artists react against existing art because old values and ways of seeing no longer seem relevant, and that motivates them to revise their artistic practice. In short, my aim has been to deal with the interaction of the artists' private visions and the artistic, cultural, and social contexts in which they developed.

I have adopted the label Abstract Expressionism in the title of this book only because it is in common use. Indeed, no label can encompass artists as individual as Gottlieb, Guston, de Kooning, Hans Hofmann, Kline, Robert Motherwell, Newman, Pollock, Rothko, and Still. As Gottlieb said, "At no time was there ever any sort of a doctrine or a programme or anything that would make a School."[9] This is borne out by the work itself. For example, Rothko's and Newman's pictures executed after 1947 are abstract but not Expressionist. Abstract Expressionist better describes much of the painting of de Kooning, Guston, Hofmann, Kline, and, with reservations, Pollock, but many of their canvases have recognizable images and thus are not abstract, and Guston's brushwork often appears more Impressionist than Expressionist.

It follows, as Newman commented, that "There was never a movement in the conventional sense of a 'style,' but a collection of individual voices."[10] Or, as art writer E. C. Goossen quipped, "Abstract-Expressionism … might well have been called 'Abstract-Individualism.'"[11] And both Newman and Goossen might have added that the painters, in defense of their aesthetic intentions, were frequently at loggerheads. In sum, the artists valued their own singular viewpoints above all others; each strove to find his unique voice, to create an authentic style of his own. Only a handful succeeded, but they brought about the triumph of Abstract Expressionism.

Individualism came naturally to the Abstract Expressionists because Americans as a people traditionally have prized the self-reliant maverick, free of all authority but the self and thus at liberty to determine his or her self-image and destiny. Indeed, a self-assertive nonconformism has been central to the construction of American identity. At the same time, the affirmation of self, chest-pounding

though it often is, has been fraught with anxious doubt. At the core of American culture is the question, "Who am I?"

Despite the insistence on their individuality, apparent in their independent styles and in their aesthetic differences, the Abstract Expressionists can be grouped together because they were more or less of the same generation and shared a moment in history. Moreover, they self-consciously thought of themselves as the avant-garde, and they were widely perceived as such. Most significantly, they all rejected as outmoded the established styles of their time, namely Regionalism and Social Realism, popular in the economically depressed 1930s; Synthetic Cubism and geometric abstraction, the dominant avant-garde art of the same decade; and near-abstract Surrealism, the advanced style of the early 1940s.

It may be, as Motherwell wrote, "A painter's most difficult and far-reaching decisions revolve around his rejections."[12] Or, as Pollock put it, "You've got to deny, ignore, destroy a hell of a lot to get at the truth."[13] It appears in retrospect that the artists' disavowals constituted the basis of their group consciousness. As John Ferren, an Abstract Expressionist painter, summed it up, "Avant-gardes start by agreeing on a certain set of negatives. Certain artists are drawn together by their dislike of the same things. From these rebellions come a number of positive actions by individuals which are shared and understood by the group."[14] Indeed, the Abstract Expressionists are connected because they established what Motherwell termed "an underground network of awareness of who is painting what, where, and for what reasons, and that this network modified an artist's awareness."[15] Moreover, between 1947 and 1950 all of the first-generation Abstract Expressionists abandoned the comfort of existing styles and began their innovative work.

Finally, the Abstract Expressionists, despite their aesthetic differences, are linked because of their mutual respect and support. In the face of widespread art world and public hostility, they looked to one another to reassure themselves that what they were creating was not beyond the pale of art. They sought out one another and maintained contact to talk out new ideas. They also met socially, formed shifting coteries, and exhibited in the same galleries. In the end, it was the Abstract Expressionists who chose themselves and left others out. Emblematic of this self-selection is the famous photograph that appeared in *Life* magazine in 1951.

On the other hand, the artists so valued their individualism that they refused to join together in any formal organization, or as a group to combat their aesthetic enemies, or to promote themselves until the very end of the 1940s (although critics and dealers earlier had indicated that a new movement had come into being). Indeed, the artists impeded the efforts of critics and dealers to group them and hence promote them.[16] The artists were so averse to any suggestion that they constituted

an "ism" that they could not agree on a name for the meeting place they founded in 1949 and called it simply The Club.

Aware that Abstract Expressionism resists categorization, I nonetheless treat it under the three headings that I used in *The Triumph*: Mythmaking (as Rothko dubbed it), spanning the years 1942 to 1947; and Field Painting and Gesture Painting, both of which began in 1947. On the whole, these terms have been adopted by art historians in discussing Abstract Expressionism. But in this new study I have added a fourth, Biomorphist Painting, which developed concurrently with Mythmaking. I prefer to use these four subdivisions because they are more descriptive of the work itself than the term Abstract Expressionism, although I revert to the latter when appropriate.

The Mythmakers I deal with are Baziotes, Gottlieb, Pollock, Newman, Rothko, and Still; the Biomorphists are Gorky, Hofmann, Motherwell, and de Kooning. Mythmaking and Biomorphism turned out to be critical but transitional phases. In 1947, Still, soon to be joined by Rothko and Newman, carried Mythmaking into Field Painting. That same year, Hofmann and de Kooning converted Biomorphist Painting into Gesture Painting; somewhat later they were joined by Kline and Guston, among others. Not all the work after 1947 falls neatly into the categories of Field Painting and Gesture Painting. Pollock and Motherwell synthesized elements of the two tendencies but remained closer to Field Painting, and although Ad Reinhardt sought to reject Abstract Expressionist in all of its manifestations, his work is a variant of Field Painting. Field Painting and Gesture Painting are the truly innovative and major tendencies in Abstract Expressionism. Understandably, they will be emphasized in this survey.

Unlike my earlier book, this one focuses on the period from 1942 to 1952, the seminal decade of the movement (with a brief chapter on the 1930s to indicate where the artists began), because by 1952 its main tendencies had been established and accepted, at least in the avant-garde art world. The chief emphasis is on the years from 1947 to 1950. My analysis differs from that of other art historians who commonly treat Abstract Expressionism as a single unit or in overly large segments, particularly as it has receded into history. I believe that this distorts its history. Changes year by year are significant and must be taken into account. My study subdivides the period from 1947 to 1950 into two phases. The first extends from roughly 1947—the year that its primary innovators, Pollock, Still, and de Kooning, arrived at their so-called mature styles—to about 1950, when the second phase begins. In the latter phase, a significant transition in style occurs, a shift generally overlooked by art historians. In brief, the change was from anxious and alienated painting expressing what Barnett Newman in 1946 termed "the tragedy of our time"[17] to more positive and expansive painting that evoked the space of either the American prairies or the metropolis.

For *The Triumph,* I interviewed dozens of avant-garde artists in New York. Differences in their recollections notwithstanding, they were in agreement on the central importance of 15 artists: Gorky, Baziotes, Pollock, de Kooning, Hofmann, Still, Rothko, Newman, Gottlieb, Motherwell, Reinhardt, Guston, Kline, Tomlin, and Brooks. Guided by their consensus, I featured this group in *The Triumph.* The list has since been expanded by other scholars, who have added some half-dozen artists, including Lee Krasner, Jack Tworkov, George McNeil, John Ferren, Richard Pousette-Dart, and Esteban Vicente. Recognizing the limitations of my initial selection, I have come to accept the enlarged list as constituting the Abstract Expressionist canon, at least as it stands at present. On the other hand, in another revision of my earlier thinking, I have come to believe that Pollock, Still, and de Kooning have been far more important in the evolution of Field and Gesture Painting than I admitted in *The Triumph.* The reassessment of the primacy of these painters has substantially shaped my present interpretation of both tendencies.

I have also attempted to answer a number of questions. Why did artists whom I have called the Mythmakers and Biomorphists radically alter their painting at the beginning of America's entry into World War II? Why did they come to believe that Cubism and Surrealism, and above all, Cubist-inspired geometric abstraction, the leading avant-garde styles and their rationales, had ceased to be relevant? What aspects of past art did the artists recycle and what were their formal innovations? Why did Pollock, Still, and de Kooning create original and radical nonobjective styles around 1947 and why did their subsequent painting develop as it did?

Finally, I ask, Why did certain Abstract Expressionists achieve recognition when they did, while others did not? Why have only those artists whose painting of the 1940s was marked by anxiety, alienation, darkness, aggression, and ambiguity continued to command attention? Is it because their works most convincingly embodied the mood or mental state or, in Motherwell's words, "reality as felt"?[18] And why did the styles of these painters change around 1950? In the end I ask, Why did Pollock, de Kooning, Still, Rothko, Newman, Kline, Guston, and Hofmann stand out from their fellow Abstract Expressionists? Was it because their paintings, unique in their own ways, felt more authentic and spoke with greater relevance to their historic moment as nothing else in the visual arts did? And why did the work achieve growing art-world and broader public acclaim over the following half century, becoming trans-historical?

1. Barnett Newman, "The New Sense of Fate," in John P. O'Neill, ed., *Barnett Newman: Selected Writings and Interviews* (Berkeley: University of California Press, 1992), p. 169.

2. Frank O'Hara, *Jackson Pollock* (New York: George Braziller, 1959), p. 22.

3. Stephen Fry, "The Future's in the Past," *The Observer* (London), Review, July 9, 2006, p. 9.

4. Robert Goldwater, "Reflections on the New York School," *Quadrum*, No. 8, 1960, p. 26.

5. Philip Pearlstein, conversation with the author, early 1960s.

6. Honoré de Balzac, *Cousin Bette*, translated by Kathleen Raine, introduction by Francine Prose (New York: Modern Library, 2002), p. 214.

7. Miguel de Unamuno, *The Tragic Sense of Life* (New York: Dover, 1954), p. 13. First published in Spanish in 1912 and in English in 1921.

8. Meyer Schapiro, "The Social Bases of Art," *First American Artists Congress*, New York, 1936, p. 31.

9. David Sylvester, "Adolph Gottlieb," *Living Arts 2*, 1963, p. 3.

10. Barnett Newman, interviewed by Neil A. Levine, "The New York School Question," *Art News*, September 1965, p. 40.

11. E. C. Goossen, "Rothko: The Omnibus Image," *Art News*, January 1961, p. 38.

12. Robert Motherwell, "A Tour of the Sublime," *Tiger's Eye*, December 15, 1948, p. 47.

13. B. H. Friedman, *Jackson Pollock: Energy Made Visible* (New York: McGraw-Hill, 1972), p. 229.

14. John Ferren, "Epitaph for an Avant-Garde," *Arts Magazine*, November 1958, p. 24.

15. Irving Sandler, notes on Robert Motherwell's comments at a panel discussion at New York University with Howard Conant, Gerald Oster, and George Segal, circa 1965.

16. When Howard Putzel in 1945 organized a show titled "A Problem for Critics" to designate a group, several artists in it disagreed with him in public and undercut his endeavor. See Michael Leja, "The Formation of an Avant-Garde in New York," *Abstract Expressionism: The Critical Developments* (New York: Harry N. Abrams, 1987), Chapter 1.

17. Barnett Newman, *Introduction, Teresa Zarnover* (New York: Art of This Century Gallery, 1946), n.p.

18. See Robert Motherwell, "The Modern Painter's World," *Dyn*, No. 6, November 1944, quoted in Dore Ashton and Joan Banach, eds., *The Writings of Robert Motherwell* (Berkeley, Calif.: University of California Press, 2007), p. 27.

INTRODUCTION

For one brief moment … nobody understood art.

Morton Feldman[1]

You know, fifty years from now, our painting will be looked upon as great formalist art, but those of us who set out with formalist intentions will be forgotten.

Philip Guston[2]

Embodying the *zeitgeist*

World War II had a shattering effect on Americans. News of the war was unremitting, disseminated by newspapers, magazines, newsreels, radio, photographs, films, and posters, and above all by letters from millions of servicemen, who were represented by blue stars in the windows of their homes, growing numbers of which were changed to gold, indicating a dead husband or son. Only a few of the first-generation Abstract Expressionists served in the armed forces—most were over age—but all were intensely aware of the approximately 16 million Americans who were serving, and the hundreds of thousands who were being killed.

The war, which followed earlier plagues—World War I, Fascism, Nazism, Stalinism, and the Spanish Civil War—defined the twentieth century. Morton Feldman, a composer and friend of avant-garde painters, once wrote, "[William] Byrd without Catholicism, Bach without Protestantism, and Beethoven without the Napoleonic ideal, would be minor figures." So would Jackson Pollock, Willem de Kooning, Clyfford Still, and, with the exception of Hans Hofmann, the other leading Abstract Expressionists without the omnipresent World War II and the subsequent cold war. Feldman concluded, "It is precisely this element of 'propaganda'—precisely this reflection of a *zeitgeist*—that gives the work of these men its myth-like stature."[3]

Whether as Mythmakers, Biomorphists, or Field or Gesture painters, the artists did not illustrate the hot or cold wars. Instead they internalized the political and social situation and asserted that their

painting was essentially a subjective or inward-looking process. What they ended up expressing was the tragic *mood* as they felt it of the decade—*an embodied mood.*[4] The Mythmakers dealt with mythic subjects and the Biomorphists with the human anatomy; however, the artists in both groups, influenced by Expressionism and Surrealism, interpreted these themes according to their personal experience. As Field and especially as Gesture painters, the artists drew more directly on their subjective experiences than they had as Mythmakers or Biomorphists. As de Kooning put it, "The texture of experience is prior to everything else."[5] Robert Motherwell equated "the content of experience" with the "self."[6] In 1946, Clement Greenberg, despite his arch-formalism, acknowledged that "the genuine artist starts from a personal, particular experience."[7]

In tapping subjective experience to arrive at their art, the artists employed improvisation or, as they often put it, "direct painting."[8] Even Barnett Newman, whose painting was less improvisational than that of his fellow artists, insisted, "I am an intuitive painter, a direct painter. I have never worked from sketches, never planned a painting, never 'thought out' a painting.… I work only out of high passion."[9] He chided the public for refusing to "understand how anybody is able to make … a work of art, spontaneously or directly.… The idea that someone can make anything without planning, without making sketches upon sketches from which one renders a finished product, is incomprehensible to them."[10]

In 1946, Motherwell wrote that the avant-garde artist "is constantly placing and displacing, relating and rupturing relationships: his task is to find a complex of qualities whose feeling is just right—veering toward the unknown and chaos, yet ordered and related in order to be apprehended."[11] How did the artists recognize when they arrived at this "complex of qualities"? De Kooning said, "You can't even know when you've found what you're looking for, it's a *feeling* you get when things set into place."[12] Or, as Motherwell put it, the artist relied on the "shock of recognition."[13]

The Mythmakers used improvisation to invent new images that referred to ancient myths and "primitive" art, and the Biomorphists, to re-imagine the human figure and anatomy. As Gesture and Field painters, the artists also began with improvisation but their goals had changed. The Gesture painter employed the process of trial and error to encounter "felt" images that were metaphors for "self." The Field painter used improvisation to create nonobjective signs, symbols, and images that were at once personal and suprapersonal in that they evoked what the artists termed "the Sublime."

Although the Field and Gesture painters relied on improvisation and shared a number of ideas and attitudes, the two groups were dissimilar in certain critical respects. They had conflicting aesthetic and metaphysical outlooks, led different lifestyles, were members of different social coteries, were represented by different galleries (although they exhibited together in group shows), and had different critical champions. The Field painters generally lived uptown in apartments, were members of the

Betty Parsons and Samuel Kootz galleries, and were promoted by Greenberg. Often further linked as *Color*-Field painters, Newman, Mark Rothko, and Still were close friends in the second half of the 1940s and the first half of the 1950s. Gesture painters such as de Kooning and Kline lived in lofts downtown, shared a bohemian way of life, were members of the Charles Egan Gallery, and were backed by Harold Rosenberg and Thomas B. Hess. The downtown artists frequented the Cedar St. Tavern and met at The Club, which they had founded.

The Field and Gesture painters also had different artistic aims. To direct attention to the suprapersonal aspect of their images, the Field painters deemphasized the role of the brush mark, the handmade sign of the artist's idiosyncratic "touch"—Pollock by pouring paint, Still by troweling impasto, Rothko by staining pigment, and Newman by painting unmodulated surfaces. The Field painters did not vary their imagery or ways of picture-making much; however, even when they had arrived at their signature styles, they continued to improvise.

In contrast to the Field painters, the Gesture painters emphasized the improvisational touch or hand of the artist precisely because they wanted to call attention to the artist's individual creative process. In favoring the brush, the Gesture painters exhibited a regard for the grand tradition of Western painting, even as they deflected painting in new directions. Because of this, they were less radical than the Field painters, who suppressed signs of the handmade.

Despite their differences, both the Field and Gesture painters believed that their improvisational painting, if utterly honest, genuinely searching, and based on feeling, would be "authentic" (a term much used by avant-garde painters at the time)—that is, it would yield abstract "self-portraits." John Ferren dramatically summed up the artists' striving: "We faced the canvas with the Self, whatever that was, and we painted. We faced it unarmed, so to speak. The only control was that of truth, intuitively felt. If it wasn't true to our feeling, according to protocol, it had to be rubbed out."[14] Philip Guston also maintained that no matter how improvisation was used, what resulted in the picture was there because the artist felt it had to be there: "Nothing could be gratuitous. Otherwise the abstract picture would be a ridiculous doodle."[15] Thus, Field and Gesture paintings, as Guston viewed them, were ethical rather than aesthetic—that is, formal—acts, based on the artist's desire for "truth" to his experience.

If, in the privacy of their studios, whether as Mythmakers, Biomorphists, or Field or Gesture painters, the artists followed the urgent dictates of their own visions and passions to create their subjective images, these images—at their most profound—evoked the mood of the hot-and-cold-war forties. Relying on their own experience, they could not avoid being influenced by the intellectual climate, culture, social conditions, and politics of their time. The artists filtered the outer world through their subjective experience. In 1949, de Kooning presented a lecture to an audience

composed primarily of avant-garde artists titled "A Desperate View," in which he observed that "all an artist has left to work with is his self-consciousness," but, he added, this self-consciousness has a social dimension: the abstract artist's "subject matter … is *space*. He fills it with an attitude. The attitude never comes from himself alone."[16]

"The Intrasubjectives"

In 1949, inward expression and the individual styles it gave rise to became the theme of the first major group show that featured the new avant-garde. Held at the Kootz Gallery and titled "The Intra-subjectives," it brought together artists as diverse as Arshile Gorky, William Baziotes, Pollock, de Kooning, Rothko, Adolph Gottlieb, Motherwell, and Hofmann. Kootz stressed that the artists "shared a point of view, rather than an identical painting style."[17] They all "made a concerted effort to abandon the tyranny of the object and the sickness of naturalism" and had tried "to enter within consciousness"—that is, to "invent from personal experience [and] create from an inner world rather than an external one." Consequently, each of their pictures would "contain part of the artist's self."

"The Intrasubjectives" show was premised on the idea that painting that expressed or externalized private visions and experiences, if deeply felt, possessed the power to convey significant truths to viewers, who, so Kootz believed, as human beings, shared the same psychological makeup as the artists who made the paintings. The subjective would thus become intrasubjective.

"A picture we no longer wanted to make"

In their reliance on improvisation, whether as Mythmakers, Biomorphists, or Field or Gesture painters, the artists rejected Synthetic Cubism in both its figurative and abstract aspects. Synthetic Cubist inspired nonobjective art had been avant-garde in the 1930s but had come to look so familiar as to appear academic. Above all, the artists dismissed Piet Mondrian's vision as it was embodied in geometric abstraction. It struck them as too rational—that is, too excessively ordered, composed, and fixed, to be relevant in what W. H. Auden labeled "The Age of Anxiety."[18] World War II and its aftermath had rendered untenable Mondrian's idea that humankind was essentially motivated by reason and that society could become utopian. In 1942, Motherwell acknowledged the greatness of Mondrian but questioned his "loss of contact with historical reality; or more concretely, loss of the sense of the most insistent needs (and thus of the most insistent values) of a given time … when men were ravenous for the *human.*… Mondrian failed, with his restricted means, to express enough of the felt quality to deeply interest us."[19] It is for this reason that the new avant-garde, with a few exceptions, favored fluid or ambiguous organic or biomorphic images. Such forms seemed more human than immutable geometry.

De Kooning also admired his compatriot Mondrian, but, with the Neo-Plasticist's vision in mind, he said, "We can no longer work on the basis of ideals in which we no longer believe."[20] Elsewhere, in contrast to Mondrian's emphasis on absolute equilibrium and human and aesthetic perfectibility, de Kooning said "Art never seems to make me peaceful or pure." He added that painting was "a way of living today," and that he was too "nervous" to "sit in style."[21] This led Thomas Hess to observe that de Kooning's paintings were permeated by an "anguished sense of reality."[22] Even Greenberg, in one of his rare references to content, said that de Kooning had introduced "more open forms, now that the closed-form canon … as established by Matisse, Picasso, Mondrian, and Miró seems less and less able to incorporate contemporary feeling."[23] Motherwell claimed that the new American painters were motivated by "a feeling of being ill at ease in the universe.… Nothing as drastic an innovation as [their] abstract art could have come into existence, save as a consequence of a most profound, relentless, unquenchable need. The need is for felt experience—intense, immediate, direct."[24] Motherwell also wrote, "We were trying to revise modern painting … so that painting would represent our sense of reality better."[25]

Ferren succinctly summed up the attitude shared by the avant-garde artists, whether Mythmakers, Biomorphists, or Field or Gesture painters: "Cubism was a body of intellectual precepts concerning reality which showed us how and why to make a picture we no longer wanted to make." He added, "It was a question of finding your own reality … your own experience." Ferren considered Cubists' reliance on rational picture making too contrived, limited, and impoverished to serve as the mainspring of art. As he concluded, "Truth of feeling makes demands beyond the confines of intellect."[26]

Although they rejected the Synthetic Cubist picture, the Mythmakers and Biomorphists retained Cubist composition as a kind of infrastructure. In his Mythmaking phase, Pollock overlaid Cubist structure with impetuous brushwork, and as a Biomorphist de Kooning melted Synthetic Cubism's clearly defined forms so that they flowed into each other. Even as a Gesture painter, he continued to hold on to the vestiges of Cubist design, but not Pollock; when he became a Field painter, he jettisoned Cubism entirely—as did Clyfford Still.

"At the edge of the abyss"

For the painters who became the Mythmakers and Biomorphists and subsequently the Field and Gesture painters, the Great Depression of the 1930s had been painful, but the horrific events of the first half of the 1940s were calamitous. The world at war appeared to be in chaos and the visual arts in crisis. Newman wrote that after the Japanese attack on Pearl Harbor on December 7, 1941, "some of us woke up to find ourselves without hope.… It was that awakening that inspired the aspiration … to start from scratch to paint as if painting never existed before. It was that naked revolutionary

moment that made painters out of us all."[27] Gottlieb agreed, recalling that he and a few other artists "were painting with a feeling of absolute desperation" and "found [ourselves] at the edge of the abyss." Gottlieb went on to say,

> The situation was so bad that I know I felt free to try anything, no matter how absurd it seemed; what was there to lose? Neither Cubism nor Surrealism could absorb someone like myself; we felt like derelicts. The American establishment was obviously lacking in seriousness. There seemed to be an enormous vacuum that needed to be filled, but with what?... That meant that one had to establish one's own values in the face of that huge vacuum.[28]

After America's entry into World War II, Pollock, Rothko, Gottlieb, and Baziotes sought to reinvent painting by creating new images that were in accord with the anxious and despairing feelings that they and people throughout the world were experiencing. They felt that the time called for a tragic art. For inspiration they looked to terror-filled ancient myths and so-called primitive art, which they believed mirrored their own feelings, using painterly improvisation to invent their own personal images. De Kooning, Hofmann, and Motherwell did not engage in Mythmaking, but such was its appeal at the time that they gave a few of their pictures mythic titles. De Kooning named one canvas *Orestes*; Hofmann, *Idolatress*; and Motherwell, in a modern vein, *Pancho Villa*.

By 1947, de Kooning found his biomorphic inventions limited, and Pollock and Still, soon to be joined by Rothko and Newman, came to believe that primitivistic and mythic subjects could not fully convey the anxious and tragic mood that artists felt the need to express, a mood intensified by the cold war with its threat of nuclear devastation.

The looming mushroom cloud became the defining image of the period. The bombs that leveled Hiroshima and Nagasaki in 1945 were only the beginning; bigger and better bombs fusing hydrogen nuclei were being tested. Horrifying images were etched on the public imagination, burnt and mangled bodies or "a flower disintegrating, shriveling into oblivion.... Searing light, blinding heat, total annihilation. Nothingness was possible."[29] So was the end of the world—in a new Holocaust. People built bomb shelters and armed themselves to keep their neighbors out; children were made to crouch under desks at school during bomb drills. This gave rise to what Gottlieb termed "the neurosis which is our reality."[30]

In this climate, Pollock, Still, and de Kooning felt compelled to embody their experiences directly in images that were more immediate than their Mythmaking and Biomorphist improvisations. They were very conscious of the cold war and the bomb's menace, and they internalized and personalized the disheartening situation and expressed its mood.[31] They assumed that the world was experiencing what they were, and that if they dealt authentically with their feelings and concerns, their work would be rooted in reality.[32]

Venturing into the unknown

In 1947, in a dramatic and unprecedented development, Pollock and Still found their way to Field Painting, and de Kooning, to Gesture Painting. In their quest for directness and immediacy, the Field and Gesture painters rejected Synthetic Cubism, geometric abstraction, and existing Surrealist and Expressionist styles. Their divorce from established modern tendencies presented them with formidable difficulties. As Motherwell wrote:

> With *known* criteria, the work of the artist is difficult enough; with no known criteria, with criteria instead in the process of becoming, the creative situation generates an anxiety close to madness; but also a strangely exhilarating and sane sense too, one of being free—free from dogma, from history, from the terrible load of the past; and above all, a sense of nowness, of each moment focused and real, outside the reach of the past and the future.[33]

In a similar vein, Rosenberg wrote that for artists committed to *any* predetermined system, the truth was already in existence outside the artists' own experience, but that painting as "a way of experiencing … means getting along without the guidance of generalities, which is the most difficult thing in the world."[34] Jack Tworkov concluded that "Abstract Expressionism … has no rules, no specific character, attitude, or face.… As such it is non-academic if you realize that … you cannot predict in advance what its look ought to be."[35]

In moving from familiar picture-making into an artistic *terra incognita*, the Field and Gesture painters encountered daunting formal challenges. If the orderly composition of cleanly edged forms in the clear, flat colors of Cubist abstraction were suppressed or jettisoned, then what? Freewheeling brushwork? Open color? The problem was to compose coherent abstract pictures—for the Field painters, using expanses of color, and for the Gesture painters, using improvisational drawing with the brush. Creating an immediate image, one that would make a sudden impact on the viewer, presented the artists with another difficult formal problem. One solution was to create an allover, single or mass image, as in Pollock's linear webs, or Still's, Rothko's, and Newman's expansive color-fields. Another solution was to paint aggressively, as de Kooning and Franz Kline did. Immediacy could also be achieved by greatly increasing the size of the canvas. The "big picture" also facilitated directness, as painters could bring more of themselves physically into the painting—more of the body, the arm rather than just the hand. Immediacy, directness, and large scale became earmarks of the new American painting.

The innovations of the Mythmakers, Biomorphists, and especially the Field and Gesture painters, violated the art world's expectations of what Modernist art was supposed to look like, and their work was generally spurned. It is difficult today, when Abstract Expressionism has long been recognized both at home and abroad, to fathom the hostility it encountered from the art world well into the

1950s. The artists believed passionately in what they were painting but often found it difficult to rebut attacks on their art, because it appeared to be so unprecedented that at first it did not resemble art at all, sometimes even to the artists. Motherwell recalled,

> I hung Baziotes's show with him at Peggy's [Guggenheim's Art of This Century Gallery] in 1944. After it was up and we had stood in silence looking at it for a while, I noticed he had turned white. When he was anxiety-ridden, a white mucus would form around his lips—his throat must have become very dry with emotion. Suddenly, he looked at me and said, "You're the one I trust; if you tell me the show is no good, I'll take it right down and cancel it." At that moment I had no idea whether it was good or not—it seemed so far out; but I reassured him that it was—there was nothing else I could do.... You see, at the opposite side of the coin of the abstract expressionists' ambition and of our not giving a damn, was also not knowing whether our pictures were even pictures, let alone whether they were any good.[36]

Not knowing whether their paintings were of quality indicates that the Abstract Expressionists had no criteria for success or failure. Indeed, the ever-present possibility of failure was very much on their minds. They tried to reach for something beyond what they had already achieved but believed that it would perpetually elude them. The implication was they could never succeed. Van Gogh was their exemplar of failure.[37] At a Club panel, Nicolas Calas criticized Meyer Schapiro's book on van Gogh for focusing on the artist's successes and overlooking his failures. Calas asserted that van Gogh was a bungler, even at suicide. But he added that his unsuccessful striving made him a great artist. In this sense, as Herman Melville wrote, "Failure is the true test of greatness."[38]

Rejection by both the art world and the larger public gave rise to a sense of alienation on the part of the Abstract Expressionists. To defend themselves, they pointed to their ambitious quest for fresh insights into subjective experience and new means to express it. They also attacked their detractors for espousing materialistic and rationalistic values and, more specifically, for supporting stale and outmoded conventional and conformist culture. The avant-garde artists used their estrangement from society to spur further innovation. As Rothko said in 1947, "The unfriendliness of society to his experience is difficult for the artist to accept. Yet the very hostility can act as a lever for true liberation."[39] Indeed, the alienated artists overcame their doubts because, as Jack Tworkov commented, each in his "innermost center has a fierce pride and sure conviction about the values of the authentic artist in the world."[40]

"An ugly beauty"

In their quest for authenticity and in response to the ominous mood of the 1940s, the Abstract Expressionists refused to prettify or "finish" a painting: they accepted crudeness; a number deliberately cultivated a raw look. To the Mythmakers, roughness was associated with archaic myth and

"primitive" art. For the Gesture painters, lack of finish was the result of improvisational or direct painting and was prized. In the name of honesty, let all the scars and blemishes show. The Field painters valued an anti-decorative look because they identified it with the Sublime. Such adjectives as beautiful, tasteful, or elegant were put downs. Tell an avant-garde painter that his work was decorative and you would be shown the studio door. As Thomas Hess wrote, thinking of de Kooning's "scarred and clotted pigment," "The picture was no longer supposed to be Beautiful, but True—an accurate representation or equivalence of the artist's interior sensation and experience. If this meant that a painting had to look vulgar, battered, and clumsy—so much the better."[41] Finishing a painting was looked down upon because it meant that the evidence of the process of search and discovery had been touched up or prettified. At a meeting of some two dozen avant-garde artists at Studio 35 in 1950, Ad Reinhardt asked, "Is there anyone here who considers himself a producer of beautiful objects?"[42] No one did.

The Field and Gesture painters considered roughness a peculiarly American quality. They associated refined and beautiful painting with School of Paris picture making. It was common at the time to compare Kline's American, direct, immediate, and bold brushwork with Pierre Soulages's restrained and nuanced facture, which was considered Kline's School of Paris counterpart.[43] At the meeting at Studio 35, Motherwell said that "young French painters who are supposed to be close to [our] group … in 'finishing' a picture … assume traditional criteria to a much greater degree than we do. They have a real 'finish' in that the picture is … a beautifully made object. We are involved in 'process' and what is a 'finished' object is not so certain." De Kooning agreed: "The point that was brought up was that French artists have some 'touch' in making an object. They have a particular something that makes them look like a 'finished' painting. They have a touch which I am glad not to have."[44]

In 1953, Greenberg summed up his feelings about the Paris–New York polarity. "In Paris they finish and unify the abstract picture in a way that makes it more agreeable to standard taste. [The Abstract Expressionist] vision is tamed in Paris—not, as the French themselves may think, disciplined. The American version is characterized … by a fresher, opener, more immediate surface. [It is] harder to take. Standard taste is offended.… Do I mean that the new American painting is superior on the whole to the French? I do."[45] Or, as Tony Smith asserted, "We were anti-culture because it was suffocating. We judged things not on the basis of tradition but of our experience. If the Europeans considered us barbarous, we said to hell with them. We were going to be what we were, and if it was American, O.K." Smith concluded, "We thought a lot about American-ness."[46]

The idea that there is something peculiarly American about a lack of refinement goes back at least to Ralph Waldo Emerson, who celebrated "the rough and ready style which belongs to a people of sailors, foresters, farmers, and mechanics," which he contrasted to the effeteness and

overrefinement of the English. "Those who have most of this coarse energy—the 'bruisers' … have their own vices but they have the good nature of strength and courage. [They] are usually frank and direct, and above falsehood."[47] A century later, Harold Rosenberg contrasted the new American painter—an unsophisticated "Coonskinner"—playing it by ear with the English painter—a professional "Redcoat"—limited by his artistic expertise.[48]

It is noteworthy that jazz was the preferred music of the Abstract Expressionists. Lee Krasner recalled that Pollock "would get into grooves of listening to his jazz records—not just for days, day and night, [but] day and night for three days running, until you thought you would climb the roof!… Jazz? He thought it was the only other really creative thing happening in this country."[49] At the time, jazz was often denigrated as rough and vulgar—or what Thelonious Monk termed "Ugly Beauty," the title of one of his pieces.[50]

Unfinished-looking painting had a social class aspect. Pollock, de Kooning, Still, Rothko, Gottlieb, Newman, and Baziotes were working class or lower middle class. As avant-garde artists, they were poor, living as bohemians. Coarse facture was a metaphor for their plebeian roots, and a response, perhaps, to living where animals would die, as Kline quipped. The New Yorkers put themselves forward as tough, macho workers, a posture that was in sharp contrast to the stance as artist-aristocrats of the French émigrés in New York. The photograph of Pollock in *Life* magazine with his cigarette dangling from his mouth may have been a pose, but it had a message. It typified the rugged American Westerner—the prototypical small farmer or rancher.

As proletarians and bohemians, the new American painters prized the unpolished look in their canvases because it was the polar opposite of the middle-class spic-and-span kitchens and bathrooms, featured in glossy advertisements in popular magazines, which fueled America's burgeoning consumer culture in the postwar era. Just as the affluent society rejected avant-garde artists, so the artists spurned the glitzy signs of commodity worship. The coarse look of their painting was a defiant denial of Madison Avenue slickness: the paint-smeared dungarees versus the gray flannel suit; the look of the grimy studio against *Better Homes and Gardens*; and, most importantly, the "unfinished" brush work as a signifier of authenticity against the impersonal immaculate surfaces of appliances and packaged goods.

As the American economy and culture became more corporative, the cultivation of the unfinished appearance had another aspect—namely, the rejection of the growing regimentation of life and the alienated work that capitalism required.[51] In opposition to work that entails "a division of labor, a separation between the individual and the final result," art historian Meyer Schapiro maintained that the Abstract Expressionists had prevailed over standardization by creating works that were "more passionately than ever before the occasion of spontaneity or intense feeling, works that

affirmed the individuality or the 'self' of the artist," and that hopefully would inspire their fellow citizens to seek freedom.[52]

"The night of the world"

As if evoking the imagination of disaster, the abstractions of Pollock, Still, Rothko, Newman, and de Kooning from 1947 to roughly 1950 are bleak, oppressive, foreboding, angst-ridden, and alienated. They lack fixity or repose and exhibit signs of discord, harshness, and, at times, violence. Color is disquieting more often than not; formal design is ambiguous and threatens to decompose and disintegrate.[53] Pollock's dripped and poured skeins of paint on canvases such as *Full Fathom Five* (1947) are congested and suffocating; Still's heavily coated areas of pigment are oppressive and turbid, and de Kooning's facture, as in *Excavation* (1950), is raw and aggressive. The colors preferred by the three painters are dark and unappetizing—in a word, anti-decorative. Although their works are abstract, they retain references to the human image. De Kooning reduced his figures to anatomical fragments, Still invented threatening humanoids and after 1947 spread their organic parts over the canvas, and Pollock buried or trapped stick-like figures in his poured webs. In one horizontal canvas, *Number 1, 1948,* Pollock evoked the figure by impressing his own hand onto the surface—the tangible trace of his body. Moreover, Still's and Pollock's canvases from 1947 to 1949 were generally vertical, their verticality suggesting the upright human figure.

Above all, the abstractions of Still, Pollock, and de Kooning are distinguished by the tension between disorder and order. De Kooning's paintings (e.g., *Excavation)* seem to be in perpetual flux. The frayed edges of Still's shapes, as in *Number 6* (1945-1946), serve to destabilize composition. The pulls of order and chaos, disintegration and integration, and control and loss of control are most straightforwardly revealed in Pollock's drip paintings. Greenberg maintained that it was precisely the opposition between disorder and order in his canvases that gave them their particular timeliness. He further claimed that "Pollock's superiority to his contemporaries in this country lies in his ability to create a genuinely violent and extravagant art without losing stylistic control."[54] Oscar Wilde once said that Turner invented sunsets because he made viewers see them in a new way. Similarly, Pollock can be said to have invented chaos.

The chaos in Pollock's painting seems to well up from deep within his psyche, as a kind of upsurge of primal energies, which provides the work with its authenticity. Chaos, however, not only was the result of Pollock's individual psychology but was informed by the turbulent state of the world, which, like his adventitious process, seemed unmanageable and beyond rational control. In Pollock's work, the personal and the social converge. He did seek to organize the seemingly accidental effects yielded by his technique, ordering and making sense of them, as he himself would claim. In response to the accusation that his work was chaotic, Pollock responded, "NO CHAOS DAMN

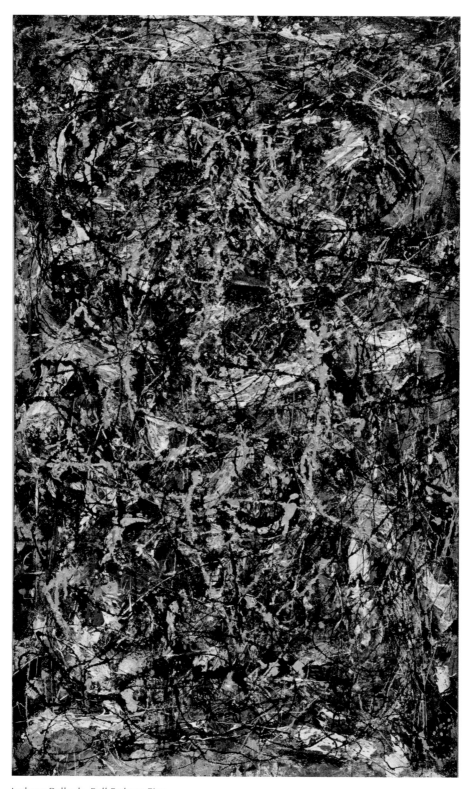

Jackson Pollock, *Full Fathom Five*
1947, oil on canvas with nails, tacks, buttons, key, coins, cigarettes, matches, etc.
50-7/8" x 30-1/8"

IT!" He also insisted, "I CAN control the flow of paint. There is no accident."[55] Frank O'Hara called attention to Pollock's success in wresting pictorial order from his poured pigment; he wrote of his "amazing ability to quicken a line by thinning it, to slow it by flooding, to elaborate the simplest of elements, the line—to change, to reinvigorate, to extend, to build up an embarrassment of riches in the mass of drawing alone."[56] Nonetheless, the poured images are on the verge of breaking down and disintegrating into chaos far more than they coalesce into a structured image.

Like Pollock's Field abstractions of the late 1940s, de Kooning's Gestural paintings reflect the mood of the time not only in their dark colors, flux, and facture but in their mutilated anatomies. Indeed, de Kooning's images evoke the torn flesh remains of aerial bombardments. Yet they preserve traces of humanist man, or as much of him as de Kooning could salvage. Pathetic though this tenuous hold on the human is, it is the source of whatever optimism and sensuous pleasure is to be found in his black-and-white paintings. Novelist William Inge, who saw his first painting by de Kooning in 1950, found in his work

> some recognizable truth that matched the violence and terror and absurdity that I read about in the newspapers those days…. The canvases looked like a battleground upon which some bloody war had been fought, a war of instincts and emotions, fought and won…. They were not paintings *about* life. They were paintings created *out* of life. [They] became beautiful to me because of that element of truth that I mentioned. And truth redeems the most fearsome of objects with the grace of tragedy. Only the false is ugly.[57]

As words, ambiguity and violence, disorder and order, formlessness and form do not sound substantial, but in visual terms they are of great consequence. Indeed, they are keys to my interpretation of Field and Gesture Painting from 1947 to 1950. The issues that engaged the Field and Gesture painters in their studios were essentially posed in the language of painting. As they viewed it, whatever meanings or content the painting conveyed about the artists, art, and the world had to be derived from the color, form, and facture of the works themselves. It is a truism that modern art is modern precisely because it reveals itself primarily through the inherent expressiveness of self-sufficient forms and colors rather than through subject matter. Indeed, a world view can be deduced from pictorial details and nuances.

Disorder, chaos, disintegration, violence, and darkness—the manifestations of a tragic sense—are embodied in the most expressive of Field and Gesture Painting of the late 1940s. This work speaks graphically of the human predicament during the early years of the cold war— "the crisis," as Rosenberg termed it—and perhaps too of the universal human condition. The world at the time seemed to have descended into a chronic state of uncertainty, confusion, and madness—"the night of the world," to borrow a phase from Hegel.[58] The revelation of the Holocaust intensified the awareness of the human capacity for both barbarism and suffering. The bad dream of recent history pervaded

the artists' studios.[59] Thomas Hess recalled that Abstract Expressionism was "founded on despair and glimpses … of hopelessness."[60] In a 1943 letter to the *New York Times*, Rothko wrote that "only that subject matter which is tragic and timeless is valid."[61] Newman agreed: "The basic truth of life … is its sense of tragedy."[62] Elsewhere he said that he wanted his paintings to make "contact [with] the hard, black chaos that is death, or the grayer, softer chaos that is tragedy."[63]

Typical of his verbal style, de Kooning's statements were cryptic. He did not say explicitly that his art was tragic, but a talk he gave in 1951, "What Abstract Art Means to Me," reveals much about the cheerless mood of the time. De Kooning took aim at utopian-minded geometric abstraction. Its advocates, or "theoreticians" as he dubbed them, believed that nonobjective art would release humankind from its wretchedness. They had a longing for "glass and an hysteria for new materials which you can look through." De Kooning said that he faced life's misery, which was exemplified by "an unheated studio with broken windows in the winter."[64] As Motherwell summed it up, "I think that my generation is the most tragic that has ever existed. American painting is really after a sense of the tragic. If [it] is really tragic, then it may be great. If not then it is of no consequence."[65]

Modernist writers, including W. H. Auden, T. S. Eliot, W. B. Yeats, Franz Kafka, and Samuel Beckett, also sought to convey the tragic mood. This dark mood informed not only "high" art and literature but popular culture as well. The movie *The Maltese Falcon*, released in 1941, was an early example of *film noir* (the label coined in 1946 by Nino Frank), a style of movie making whose heyday stretched into the 1950s.[67] The characters in these films move through dark and oppressive spaces towards an unfathomable denoument. In their cheerless intimations of tragedy, noir movies were the mass cultural counterpart of Abstract Expressionist painting.

The compelling evocation of the tragic mood in the work of Pollock, Still, de Kooning, Rothko, and Newman was responsible for their growing recognition. It did take several years for the art world, and much longer for the general public, to appreciate their subjective abstract art, but with a single exception (Hans Hofmann), only tragedians among the Field and Gesture painters have grown in stature. Why these artists and not myriad others working in a similar vein or in entirely different styles? The reason is that during the 1940s, their art, scarred as it was by anxiety and darkness, put its finger on the pulse of the decade. In their struggle to register their subjective experience, the most acclaimed Field and Gesture painters created works that provided compelling insights that illuminated the mood of their time. The artist's personal sense of being as manifest in his painting was of a piece with his historic moment. That is, the mood of the artist's inner world corresponded with that of the outer world and consequently provided compelling insights not only about the artist and his culture and society but also about the human condition.

Greenberg sensed this when he wrote, in 1946, that for art to be "great anywhere and at any time … it is necessary to register what the artist makes of himself and his experience in the world, not merely to record his intentions, foibles, and predilections."[68] It may even be, as Rosenberg once said, that an urgent situation or idea finds the artist, rather than the other way around. Motherwell stated that "each period and place has its own art and esthetic—which are specific applications of a more general set of human values, with emphases and rejections corresponding to the basic needs and desires of a particular place and time."[69] Thus, the strongest Field and Gesture painters created work that was at once personal and social, subjective and intrasubjective, historical and trans-historical. Their painting was both of its moment and transcended it.

European tragedians

So urgent was the tragic sense of life that it was not only the leading American painters who evoked it in the 1940s but also a few exemplary Europeans, notably Alberto Giacometti, Francis Bacon, and Jean Dubuffet. Bacon painted his grotesque *Three Studies for Figures at the Base of a Crucifixion* in 1944. In his first show that year, Dubuffet exhibited his *art brut* figures based on the art of the insane, of children and of so-called primitive peoples. Giacometti began to invent his ravaged figures in 1947, the year that Pollock, Still, and de Kooning painted their innovative abstractions. Some abstract painters in Europe also evoked a tragic mood, foremost of whom were Alfred Wols, Jean Fautrier, and Bram van Velde. But the American avant-garde on the whole recognized Giacometti, Bacon, and Dubuffet as the three most significant Europeans artists of the postwar era, and not the Parisian abstract painters.

Emaciated and staring into nothingness, Giacometti's frontal standing figures look as if they had barely survived the death camps, much as he denied that his sculpture alluded to the Holocaust. He did admit in 1945 that he was fascinated by Jacques Callot's sadistic "small-scale but relentlessly detailed scenes of massacre, torture, and rape."[70] And in 1950 he said, "I am most touched by sculpture where I feel there is contained violence." About his own subjects he said that "the form of a person is … above all a sort of kernel of violence."[71]

Giacometti also wanted to represent the precise sensation of viewing a person in front of him— that is, to reconcile the details of the human figure with its total impression. He wrote that at one point while working from the model, trembling with terror, he "had begun to perceive heads in the emptiness, the space which surrounds them, that is, in between being and nonbeing."[72] And as Jean-Paul Sartre observed, Giacometti's fragile and vulnerable figures were ravaged by space, or simply ravaged.[73] However, Giacometti lamented that he had never succeeded in depicting the figure, even in those sculptures that he allowed to be exhibited. He spoke of them as abandoned works rather

than completed ones. Not surprisingly, in the image he presented in photographs, Giacometti looked as tortured as Pollock did.

In an essay on Giacometti, Sanford Schwartz commented:

> To take him at his word, his art was the embodiment of helplessness and futility. So in some way the artist who maintained that his subjects were perception and rendering—and really the impossibility of rendering—wasn't so different from the artist who was popularly thought to mirror a stricken alienated mankind. That is why the idea of an "existential" Giacometti has never lost its currency.[74]

Francis Bacon's key images of the early 1950s were of isolated popes, based on Velázquez's *Portrait of Pope Innocent X Pamphili*, which he transformed into monstrous, terror-ridden, and depraved screaming figures. His glosses on the Velázquez are among the most nightmarish and ghoulish images in the history of art, as hellish as those in Goya's *Disasters of War*.

In an interview with Bacon, David Sylvester referred to the artist's recurring "interlocking of Crucifixion imagery with that of the butcher shop" and added that this was what made "critics emphasize what they call the element of horror in your work." Sylvester then asked whether the open mouths were "always meant to be a scream." Bacon spoke of his fascination with the screaming nanny in Eisenstein's film *Battleship Potemkin* (1925). He then recalled a book he had bought of "hand-colored plates of diseases of the mouth, beautiful plates of the mouth.... I was obsessed by them." He said, "We are born with a scream.... That was one of my real obsessions. The men I painted were all in extreme situations, and the scream is a transcription of their pain. [We] often also die with a scream. Perhaps the scream is the most direct symbol of the human condition."[75]

Bacon's images were often drawn from illustrations of disasters and death camps in newspapers and magazines. He said, "I have a feeling of mortality all the time." Bacon added, "I was brought to London during the war [World War I]. I was made aware of the possibility of danger even at a very early age. Then I went back to Ireland and was brought up during the Sinn Fein movement. [There] would be snipers. [When] I was 16 or 17, I went to Berlin [which was] very violent." With World War II in mind, Bacon said, "I have been accustomed to always living through forms of violence—which may or may not have an effect upon one, but I think probably does. But this violence of my life, the violence which I have lived amongst is different to the violence in painting. [The] violence of paint [has] nothing to do with the violence of war. It's to do with [the violence] within the image itself which can only be conveyed through paint." Bacon concluded, "I'm just trying to make images as accurately of my nervous system as I can. I don't even know what half of them mean."[76]

Dubuffet's primitivistic figures drawn in crudely painted and scratched lines on and into sludgy impasto are both monstrous and funny. American critic Jack Kroll linked Dubuffet's work to the *zeitgeist* of the 1940s when he wrote that his mordant caricatures "at the confluence of satire, pathos and

tragedy [were] just what was called for."[77] In 1951, Dubuffet delivered a lecture titled "Anticultural Positions" at Chicago's Arts Club, in which he said,

> I have the impression that a complete liquidation of all the ways of thinking, whose sum constituted what has been called humanism, and which has been fundamental for our culture since the renaissance, is now taking place.… I think the increasing knowledge of the thinking of so-called primitive peoples, during the past fifty years, has contributed to the change.… Personally, I believe very much in values of savagery; I mean: instinct, passion, mood, violence, madness.[78]

Samuel Beckett was interested in the visual arts and became friendly with a number of artists. He was closest to the abstract painter Bram van Velde but he numbered Giacometti among his acquaintances. Beckett was taken with the sculptor's image of the isolated figure in a void, as it was the essential subject of his own writing. Beckett also admired Bacon, of whom he said, "He [Bacon] is so disturbing, and so powerful. I don't think I would actually want to live with one of those pictures, but there is no doubt he is one of the most important contemporary artists."[79] Beckett began to express the bleak mood of the postwar years in 1945, and more than any of his contemporaries most fully characterized it in his work of the next four years, notably the trilogy of *Malloy, Malone Dies,* and *The Unnamable.*

Unlike the American Field and Gesture painters, who were primarily non objective, the three European contemporaries were figurative, and therefore more closely bound to the humanist tradition of Western art, despite the fact that they eviscerated the human body. In a sense, they are related to the earlier American Mythmaking and Biomorphism rather than to the radical Field and Gesture Painting.

Identifying with America

Around 1950, Pollock's and Still's Field Painting and de Kooning's Gesture Painting underwent a significant change. Pollock and Still did not alter their facture greatly, but the modifications they made in the image, size, format, and palette significantly transformed the content of their work. Pollock's abstractions continued to be composed of meshed skeins of poured paint, and Still's, of open areas of color troweled onto the canvas with palette knives. They are also allover, seeming to extend beyond the canvas limits—their most innovative feature. But unlike their earlier canvases, which are vertical, dark, and congested, the paintings after 1950 tend to be horizontal and increasingly large. They are also more expansive and lyrical. Whereas the canvases of the late 1940s are dense and crowded, the later paintings are spacious and buoyant.

Around 1950, de Kooning began piecing together the rough, compacted, and complex body fragments of his anatomical abstractions of the late 1940s into recognizable images of women. In 1958,

he summed up the change in Gesture Painting that occurred around 1950: "They called us drippers and paint-slingers. I don't think our pictures look violent *any more*. The big Pollock [*Autumn Rhythm* (1950) at the Metropolitan Museum] seemed very lyrical and calm."[80]

The change in Field and Gesture Painting reflected a shift in America's mood and outlook. With time, the angst that pervaded life in the 1940s dissipated. To be sure, the cold war with its threat of nuclear devastation continued to generate fear, but at the same time, despite the Korean War, there was a growing sense that the worst would not happen. Nonetheless, the threat of Soviet imperialism persisted, and in response to this threat American artists and intellectuals, with a few exceptions, now supported the cause of the democratic West and sought a rapprochement with mainstream American society.

The Field and Gesture painters now sought to be part of American life. Their painting began to express or suggest a more positive attitude to the American experience. The United States was becoming a prosperous consumer society, and living was better than ever before. To be sure, avant-garde artists remained underdogs, but most slowly partook of the burgeoning affluence, and beginning in 1950, they received growing acceptance by the art world and tardily from the public. The proof of their new status was the 1951 group photograph in *Life* of eighteeen artists, labeled the Irascibles, which included most of the leading Field and Gesture painters. Even a few years earlier, such public recognition would have been unthinkable.

How American is it?

Harold Rosenberg once wrote that "people carry their landscapes with them."[81] And these places or spaces, whether actual or remembered, are active forces that shape the visual imagination. The growing identification that Still, Pollock, and de Kooning had with the United States was reflected in the allusions in their abstractions to the American scene or, more to the point in their case, to American space. However, Pollock and Still on the one hand, and de Kooning on the other, had sharply different conceptions of space.

Pollock's and Still's forebears had made the trek to the West, and the two painters had spent most of their boyhood and teenage years on small western farms in landscapes distinguished by their seeming limitlessness. Given their family histories and early experiences of the Great Plains, it seems more than plausible to view their large-scale, horizontal, allover, open, and expansive abstractions as metaphors for prairie space. Still and Pollock had turned against Regionalism as an academic figurative style but not against its concern with the American scene. Rather than representing the American West literally, they internalized its vast space, and in so doing, radically reconceived Regionalism in nonobjective terms. Their Field Painting became a kind of avant-garde successor not

only to Regionalism but also, further back, to nineteenth-century panoramic painting of the American landscape.

In contrast, de Kooning's sense of American space was essentially urban, at least until the late 1950s. He had grown up in Rotterdam and as a young man had emigrated to New York, where he became the city's most compelling visual poet. In his complex and compacted black-and-white abstractions of the late forties, he had evoked the congested space and hectic tempo of the metropolis in perpetual change. In a sense, he situated himself in its flux, recognizing that the flux was as much within himself as in his environment. De Kooning's paintings of women of the early 1950s are equally urban and dynamic but their mood is no longer dark. The figures are now recognizable as women and hence are more human. Although they are fierce, they are also funny. Alluding to billboard pinups, the women evoke the American city, just as the abstract Field paintings of Still and Pollock evoke the prairies. The geographic images of Pollock, Still, and de Kooning, though subjective and imagined, are American. They were viewed in the 1950s as unmistakably Modernist, and, compared to the latest European painting, they seemed brand new. Hence, they attracted growing attention abroad as the new global avant-garde. In short, the Field and Gesture painters created avant-garde styles that were national—but not provincial—and international.

The Field painters and Gesture painters were aware of their debt to European painting but differed in how to acknowledge what they owed—that is, whether to consider their art primarily national or international. In the first half of the twentieth century, New York avant-garde artists had maintained that their art aimed to be global and that national characteristics were inconsequential. Besides, artistic nationalism was identified with Regionalism, which they had rejected. The art historian Meyer Schapiro spoke for the avant-garde artists in 1936 when he attacked nationalism in art. As he wrote, "Distinctions in art [made on the basis of race or nationality] have been a large element in the propaganda for war and fascism and in the pretense of peoples that they are eternally different from and superior to others and are, therefore, justified in oppressing them." Schapiro was particularly dismissive of chauvinist claims that a "great national art can issue only from those who possess Anglo-Saxon blood."[82]

The German occupation of Paris in 1940 reinforced the New York avant-garde's internationalist outlook. Paris was isolated from the free world. A considerable number of its leading artists fled to New York, transforming it into the capital of world art, a situation the local avant-garde quickly recognized. The Federation of Modern Painters and Sculptors, of which Gottlieb was president and Rothko an active member, announced in 1943, "Now that America is recognized as the center where art and artists of all the world meet, it is time for us to accept cultural values on a truly global plane." More than that, it was up to the United States to "nourish … Western creative capacity."[83] In 1944, Pollock acknowledged his debt to the School of Paris, saying that it was important that leading

modern European painters had come to New York because "they bring with them an understanding of the problems of modern art [although] the two painters I admire most, Picasso and Miró, are still abroad."[84]

Despite their internationalist outlook, the New York avant-garde increasingly questioned whether there was an American aspect to their painting and how it might be defined. They abhorred nationalism—and its concomitant bigotry—as a malevolent force that leads a people to hate and wage war abroad, and at home to discriminate against ethnic, racial, and religious minorities. But they did recognize the existence of a national identity, which encompasses a people's positive aware-ness of shared qualities and aspirations and is distinct from nationalism. Although they knew the difference, the artists were unsure how to acknowledge national identity without lapsing into nation-alism.

The artists found it difficult to deal with nationalism because no significant thinker of the stature of Marx, Freud, or Jung, or even Sartre or Camus, had considered the issue in depth. The ideologi-cal interests of the new American painters—and as intellectuals generally—had been heavily influenced by Marxism (particularly in the 1930s), Freudian and Jungian psychology (in the early and middle 1940s), and Existentialism (after 1946). All these theories underestimated the role of nationalism and national consciousness in human affairs, despite the fact that nationalism had been a dominant force in the nineteenth and twentieth centuries.[85] Thomas Hess was one of the few crit-ics who recognized this. But it was only in 1968 that he wrote,

> Nationalism obviously is far more deeply involved with individual identity than modern political scientists and scientific politicians would ever admit.… Perhaps it has a biological basis in the human animal's need for territorial integrity. Perhaps in our age of alienation and fragmented social structures, nationhood supplies an essential cultural root.
>
> In any event, however much we intellectuals may despise a parade or giggle at anthems, they symbolize emotional realities that must be taken into account.[86]

Still, Pollock and Newman on the one hand, and de Kooning on the other, took opposing posi-tions in their thinking about American-ness in relation to their art. Still belligerently asserted his native roots, proclaiming that in his Field paintings he had utterly rejected European art and that his work was grounded exclusively in the American experience.[87] He fulminated that the Armory Show "had dumped on us the … sterile conclusions of Western European decadence."[88] In his opinion, his painting was a new departure in the New World. Pollock and Newman shared Still's attitude but were not as strident as he was.[89]

De Kooning and the Gesture painters in his circle rejected Still's nationalism. Keenly aware of the sources of their painting in European Modernism, even after they had deflected it in new

directions, they were reluctant to make the claim that their works were peculiarly American. Unlike Still, few had had earlier careers as Regionalists. Instead, they were globally minded Modernists who considered themselves the heirs of the grand tradition of Western art, particularly modern French painting. They prized internationalism and denigrated as narrow and provincial any art that made nationalist claims. De Kooning himself was always aware that he was an immigrant and thus was less inclined to assert his American-ness. So were his closest friends, the Russian-born John Graham (né Ivan Dabrowski) and the Armenian-born Arshile Gorky (né Vosdanig Adoian), as well as many of their acquaintances, including the German-born Hans Hofmann, Polish-born Jack Tworkov, and Russian-born Milton Resnick.

De Kooning and his fellow Gesture painters criticized Still for denigrating European painting. However, they recognized that their painting was different from that of their European counterparts. Toward the end of the 1940s, the New Yorkers began to wonder whether this difference might be characterized as American, although what was uppermost in their minds was that it was different from what they conceived of as School of Paris painting—and better.

However it was formulated, the issue of national identity was increasingly discussed in the art world. The American-ness of American art was one of the topics of the symposium on "The State of American Art," organized by Robert Goldwater in 1949 and published in the *Magazine of Art*. The participants were leading art critics and historians. One of the questions Goldwater asked was, "What is being done in the United States today of sufficiently marked character to warrant being called 'American'?" On the whole, the 16 respondents emphasized the international dimension of American art, but they did suggest in answer to Goldwater's question that there was a distinctly national aspect in American art, although none of the participants singled out Abstract Expressionism in this regard.[90] But what is national identity? It is rooted in a people's common geography, language, culture, traditions, laws, customs, symbols, institutions, and historical memories and beliefs—real and imagined. Moreover, national identity is based on a shared commitment or aspiration to certain values. For example, Americans have traditionally prized individualism, self-reliance, freedom, independence, and nonconformity. They have also valued openness, expansiveness, directness, boldness, and energy. In a variety of ways, the Field and Gesture painters embodied these attributes in their painting, which thus may be considered to be American. In 1950, Louis Finkelstein, a younger colleague of the Abstract Expressionists, wrote:

> There is something distinctly American in [the] rejection of all discipline save that of the experience itself. The New World has always meant … the throwing off of old conventions. [A] robust individualism [runs] deep in our artistic tradition. We find it in the philosophy and theory of art of Emerson, the life and writings of Thoreau, in Whitman's affirmation of man as the measure and base of society [and] in Melville's passionate concern for the individual soul.[91]

Hofmann spoke for his fellow artists when, in 1949, he concluded a talk on the topic of "What Is an Artist" by hailing the American Constitution as a great work of art. He closed with the exhortation, "Long live the arts and the artist in a free future."[92]

National identity is founded on selected memories, some of which are invented, that people in the present choose to hold dear. Its function is to help people define their own identities and to situate themselves in the world.[93] To be sure, the United States is distinguished by the diversity of its people, regions, economic classes, and lifestyles, but during the hot-and-cold-war years attention was focused on the commonality of the American experience, not its heterogeneity.

If there is any single historical event that shaped generations of Americans whose families emigrated from Europe, it is the transatlantic passage from the Old World to the New. The myth of the United States as a New World originates in this journey.[94] Indeed, it began with the seventeenth-century pilgrimage to what the Puritans conceived of as a new Jerusalem. The transatlantic voyage echoed the Christian creation myth, but one in which immigrants could beget themselves. For many, the journey ended in the cities on the Atlantic seaboard; for others, it proceeded from the East Coast westward. Whether the immigrants and their descendants settled in cities or on the western plains, the sense of these places shaped their unique and national identity. It is significant that both the prairies and the metropolis, notably New York, are grand themes in American art and literature.

Indeed, of all the indices of national identity, a people's consciousness of place or space is the foremost. Geography has a personal dimension, the need to belong to a place or places: national, regional, and local.[95] Geography no longer counts as it did in the 1940s and 1950s. The United States has ceased to be the land of distinctive regions that it was in the past. The sense of a nation composed of diverse places has been disappearing as homogenization has increased. The ubiquitous shopping malls are more or less the same everywhere; outlets of the same national stores are found in each of them. One would be hard put to tell apart the motel rows on the outskirts of any town or city. Television has standardized American life; regional dialects have been assimilated into one tongue. The Internet and the global economy are furthering the process of homogenization, even creating a class of business nomads.

However, the past three decades have witnessed the remarkable growth of diverse racial and ethnic groups that have asserted their distinctiveness, and this heterogeneity has given rise to a concomitant multiculturalism. Race, class, ethnic, and gender differences weigh more heavily in our thinking than they did in the forties and fifties. Nonetheless, as music and culture critic Stanley Crouch wrote in 1997, "Our culture, what makes us American, is something that has influenced all of us, wherever we are from in the United States. We are all, essentially, variations on a certain set of propositions that make us American."[96] Of course, a nation's identity is not fixed; Americans have

had to invent themselves anew continually. National memory can change over time, and certainly it has done so in the reassessment of the role of Native Americans, African Americans, and women in the history of the United States. But these revisions took place after the forties and the fifties—that is, after the heyday of Field and Gesture Painting.

In his 2003 overview of current American art history, John Davis was ambivalent about whether Abstract Expressionism should be considered primarily as a national art or as an international art. He wrote, "Americanists run the risk of minimizing [Abstract Expressionism's] global sweep … and tying it down with nationalist baggage that prevents it from being seen as a participant in international forums."[97] However, as art historian John McCoubrey has commented, other "American critics have been anxious to place this painting squarely in the center of an international stage. Europeans, on the other hand, have seen in it … the presence of a uniquely American spirit."[98] He cited the English art historian and painter Lawrence Gowing, who remarked about American art in 1958, "Its antecedents are no more than half European; its birth and rebirth are wholly American … filled with the unique American substance, the material poetry of the country, to gain its present force."[99]

As I view it, the roots of Abstract Expressionism in international art have been adequately established by scholars, including myself. Hence, I believe that it will be fruitful in this book to focus more on its relatively neglected national dimension than I did in *The Triumph*, while not, of course, overlooking its global aspects.

1. Morton Feldman, "Give My Regards to Eighth Street," *Art in America*, March-April 1971, p. 99.

2. Philip Guston, to the author, New York, May 9, 1957.

3. B. H. Friedman, ed., *Give My Regards to Eight Street* (Cambridge, Mass.: Exact Change, 2000), p. 17.

4. I owe this formulation to Arthur Danto, who maintains that works of art are "embodied meanings."

5. William C. Seitz, *Abstract Expressionist Painting in America* (Cambridge, Mass, and London, England: Harvard University Press, 1983), p. xviii.

 In an early statement (February 1944), in *Arts and Architecture*, Pollock said that "the source of art is the unconscious." Mark Rothko, in a taped interview conducted by William Wright in 1950, broadcast in 1951 on station WERI, Westerly, RI, quoted in Leja, *Abstract Expressionism*, p. 35, said that his images were "pictorial equivalent[s] for man's new consciousness of his more complex inner self."

6. Robert Motherwell, "The Modern Painter's World," *Dyn,* November 1944, p. 13.

7. Clement Greenberg, "Koestler's New Novel," *Partisan Review*, November/December 1956, p. 580.

8. Most Abstract Expressionists spoke of their reliance on improvisation. For example, Jackson Pollock, in narration for the Namuth film on him, 1951, quoted in Bryan Robertson, *Jackson Pollock* (New York: Harry N. Abrams, 1960), p. 194, said, "I don't work from drawings or color sketches. My painting is direct…. The method of painting is a natural outgrowth of a need. I want to express my feelings rather than illustrate them. Technique is just a means of arriving at a statement."

9. Dorothy Gees Seckler, "Frontiers of Space" (an interview with Barnett Newman), *Art in America*, No. 2, 1962, p. 83.

 In Barnett Newman, "The 14 Stations of the Cross, 1958-1966," *Art News*, May 1966, p. 26, Newman said, "I begin all my paintings—by painting."

10. John P. O'Neill, ed., *Barnett Newman: Selected Writings and Interviews* (New York: Alfred A. Knopf, 1990), pp. 49-51.

 The process of painting was also vital to Newman's fellow Color-Field painter, Mark Rothko. He said in a statement in "A Symposium on How to Combine Architecture, Painting, and Sculpture," *Interiors*, May 1951, p. 104, "A painting is not a picture of an experience, it is an experience."

11. Robert Motherwell, "Beyond the Aesthetic," *Design*, April 1946, p. 14.

12. Gladys Shafran Kashdin, *Abstract-Expressionism: An Analysis of the Movement Based Primarily upon Interviews with Seven Artists*, Doctoral Dissertation, Florida State University, 1965, p. 114.

13. Jack D. Flam, "With Robert Motherwell," *Robert Motherwell* (New York: Abbeville Press, 1983), p. 15.

14. John Ferren, "Epitaph for an Avant-Garde," *Arts*, November 1958, p. 25.

15. Philip Guston, author's handwritten notes of lecture on "The Muse of Painting," at the University of Minnesota, 1954.

16. Willem de Kooning, "A Desperate View," *A Talk Delivered at the Subjects of the Artist School*, 1949, "The Collected Writings of Willem de Kooning" (New York: Hanuman Books, 1988), pp. 11, 13. Also quoted in Edwin Denby, in *The 30's Painting in New York* (New York: Poindexter Gallery, 1957), n.p.

 In a gloss on de Kooning's comment, his friend Harold Rosenberg, in "Parable of American Painting," *Art News*, January 1954, p, 62, agreed that "a starting point in experience is indispensable if the artist is to prevail against the image of Great Painting that slides between him and the canvas he is working on." Rosenberg wrote this in 1954. However, as early as 1947, Rosenberg, in "Introduction to Six American Artists," *Possibilities 1*, Winter 1947/1948, p. 75, recognized that avant-garde art had moved, or had to move, from "a conscious philosophical or social ideal … to what is basically an individual, sensual, psychic and intellectual effort to live actively in the present."

17. Samuel Kootz, Introduction, "The Intrasubjectives," (New York: Kootz Gallery, 1949), n.p. The works in "The Intrasubjectives" were so individual and diverse in appearance that the title (and by implication, any other label) could not encompass them, as Stuart Preston wrote in "Early Exhibitions," *New York Times*, September 18, 1949, sec. 2, p. 12.

18. In their rejection of rigidity and reason, the Field painters and Gesture painters were anticipated by the Surrealists. As André Breton wrote in 1939, in a text reprinted in *Surrealism and Painting*, trans. Simon Taylor (New York: Harper and Row, 1972), p. 151, "[We] condemn as tendentious and reactionary any image in which the painter or poet today offers a stable universe."

19. Robert Motherwell, "Notes on Mondrian and Chirico," *VVV*, June 1942, p. 59.

20. A comment by de Kooning, quoted by Harold Rosenberg. Irving Sandler, *A Sweeper-Up After Artists* (New York: Thames & Hudson, 2003), p. 230.

21. De Kooning, "What Abstract Art Means to Me," *Museum of Modern Art Bulletin*, Vol. 18, No. 3, Spring 1951, p. 7.

22. Thomas B. Hess, *Abstract Painting: Background and American Phase* (New York: Viking Press, 1951), pp. 103, 107.

 Elaine de Kooning, in *The Spirit of Abstract Expressionism: Selected Writing*, Rose Slivka, ed. (New York: George Braziller, 1993), p. 228, wrote of her husband:

 > Bill was very irritated with his facility and he was constantly struggling against it, going against the grain. He didn't like things to come easy. He wanted to have his image evolve out of a sense of *conflict*. In fact, it wasn't so much that he wanted it to come out of a sense of conflict as that he was born with divine discontent. I don't know where the term "divine discontent" came from, but Bill had it. [My italics]

23. Clement Greenberg, "The Present Prospects of American Painting and Sculpture," *Horizon*, October 1947, p. 17.

24. Robert Motherwell, "Symposium: What Abstract Art Means to Me," *Museum of Modern Art Bulletin*, Vol. 18, No. 3, Spring 1951, p. 12.

25. Motherwell, "The Creative Artist and His Audience," *Perspectives USA*, No. 9, August 1954, p. 108. See also Motherwell, "Symposium: What Abstract Art Means to Me," p. 12.

26. Ferren, "Epitaph for an Avant-Garde," pp. 24-26, 68.

27. Barnett Newman, "Jackson Pollock: An Artists' Symposium, Part 1," *Art News*, April 1967, p. 29.

28. Adolph Gottlieb, statement, "Jackson Pollock: An Artists' Symposium, Part 1," *Art News*, April 1967, p. 31.

29. Kim Levin, "Fifties Fallout," *Arts Magazine*, April 1974, p. 30.

30. Adolph Gottlieb, "The Ides of March," *The Tiger's Eye*, No. 2, December 1947, p. 42.

 The idea of social neurosis was very much in the air in the late 1940s. It was addressed in best selling books such as David Riesman's *The Lonely Crowd* (1950) and C. Wright Mill's *White Collar* (1951). Such works alleged that Americans had accepted "false" values and had been lulled into complacency, which exacerbated the neurosis. In 1949, Gershon Legman published a magazine titled *Neurotica*; in an "Editorial Gesture," in Number 5, Autumn 1949, p. 3, he proposed "to describe neurotic society from the inside" because neurotic culture was making neurotics out of the American people.

31. It should go without saying that artists on the whole are extraordinarily intelligent, but it needs to be said again. The popular conception of the artist as inspired idiot is a vulgar myth. Picasso might well have been speaking for the New York modernists when, as quoted in Nadine Gordimer's "Testament of the Word," *The Guardian Review*, June 15, 2002, p. 6, he remarked testily: "What do you think an artist is? An imbecile who has nothing but eyes if he is a painter?... Quite the contrary, he is at the same time a political being,

constantly aware of what goes on in the world, whether it be harrowing, bitter or sweet, and he cannot help being shaped by it."

Isaiah Berlin, in "A Sense of Impending Doom," *TLS*, July 27, 2001, pp. 11-12, could have been writing about the Mythmakers, Biomorphists, Field, and Gesture painters, although it was made prophetically in 1935:

> When one's experience takes place in a society in which social and political issues are so crucial that they color everything, the artist of integrity … will, in his work, reflect the degree to which politics permeate [his or her] experience. In the present case the mood seems to be one of pressing haste: there is no time, the bomb may burst at any moment, or at least looks as if it may.

Berlin went on the say that in a situation of pervasive instability, artists should "tell the truth about their experience of the present, just as it comes,… immediately, before it cools,… and therefore in great haste and incompletely … because the time itself is in a sense unfinished, or at least it looks to them." Berlin's focus was on the artist's experience, as was that of the Mythmakers, Biomorphists, and the Field and Gesture painters.

Moreover, having been reared in the 1930s, subjected to the ever-present political rhetoric of Social Realists and Regionalists and required to rebut it, the Abstract Expressionists could not help thinking about the social significance of their work.

32. See Terry Eagleton, "The World As Artefact," in *The Ideology of the Aesthetic* (Oxford: Basil Blackwood, 1990), p. 125.

33. Robert Motherwell, "Foreword," in William C. Seitz, *Abstract Expressionist Painting in America* (Cambridge, Mass.: Harvard University Press, 1983), p. xii.

34. Harold Rosenberg, introduction to *Marcel Raymond, From Baudelaire to Surrealism* (New York: Wittenborn, Schultz, 1949), n.p.

35. Jack Tworkov, statement in "Is There a New Academy?" *Art News*, September 1959, p. 38.

36. Stephanie Terenzio, ed., *The Collected Writings of Robert Motherwell* (New York: Oxford University Press, 1992), p. 3.

37. De Kooning, remarks made at The Club, paraphrased in typewritten notes given to me by William C. Seitz in preparation for his Ph.D. dissertation submitted in 1955, later published as *Abstract Expressionist Painting in America* (Cambridge, Mass.: Harvard University Press, 1983). De Kooning said that he sympathizes with van Gogh but feels that his art was cowardice. After starting out to do something for the world—to be a reformer, preacher, and a savior of his fellow men, he weakened when faced with the dirt and blackness of the coal mine, he got "cold feet." It is failure and not success that is important for van Gogh. Painting was a substitute for an heroic existence. "A painter is something of a coward." It is the heroic urge—of which painting is an evasion—that, in part, gives the artist feelings of guilt.

38. "Hawthorne and His Mosses," *The Piazza Tales and other Prose Pieces 1839-1860*, in *The Writings of Herman Melville*, Harrison Hayford et al, eds. (Evanston: Northwestern University Press, 1987), p. 248.

39. Mark Rothko, "The Romantics Were Prompted," *Possibilities 1*, Winter 1947-1948, p. 84.

40. Jack Tworkov, "Cahier," *It Is*, No. 4, Autumn 1959, p. 13.

41. Thomas B. Hess, *Willem de Kooning* (New York: Museum of Modern Art, 1968), p. 45.

42. Robert Goodnough, ed., "Artists' Sessions at Studio 35 (1950)," *Modern Artists in America* (New York: Wittenborn Schultz, 1951), p. 18.

43. See Leslie Judd Ahlander, "Franz Kline at the Washington Gallery of Modern Art," *Art International*, 25 October 1962, p. 49.

44. Goodnough, "Artists' Sessions at Studio 35," pp. 12-13.

45. Clement Greenbert, in a symposium titled "Is the French Avant-Garde Overrated?" *Art Digest*, September 15, 1953, pp. 12, 27.

46. Tony Smith, handwritten transcript of a conversation with the author, New Orange, N.J., December 28, 1966.

47. Harold Bloom, "The Sage of Concord," *The Guardian Review* (London), 24 May 2003, pp. 4-5.

48. Harold Rosenberg, "Parable for American Painters," *Art News*, January 1954. A younger critic, Arthur Danto, with Neitzsche's Apollo-Dionysis dialectic in mind, juxtaposed the American wild man to the European rationalist. In a similar vein, Fairfield Porter, in "Class Content in American Abstract Painting," *Art News*, April 1962, p. 27, differentiated American from European art, characterizing the one as "professional" and the other as "non-professional." He wrote,

 > A professional follows a calling which he claims to have a special skill or knowledge…. He is trained, he is expert, and he may be hired…. American painting looks non-professional. But this does not mean that it looks amateurish. The professional and the craftsman show conscious skill in attaining an end; the non-professional shows a love for his materials and his act regardless of ends and regardless of skill. Skill may be acquired by practice; this love comes of itself from practice.

 The antipathy to professionalism recurs repeatedly in the artists' rhetoric and that of their friends. For example, composer Morton Feldman, a close friend of New York School painters, in Morton Feldman, "The Anxiety of Art," *Art in America*, September-October 1973, pp. 88-89, called the artist who achieved originality "an amateur."

 > Your imitators—these are the professionals. It is these imitators who are interested not in what the artist did but the means he used to do it. That is where craft emerges as an absolute, an authoritarian position that divorces itself from the creative impulse of the originator. The imitator is the greatest enemy of originality.

49. Francine du Plessix and Cleve Gray, "Who Was Jackson Pollock?" interview Lee Krasner, *Art in America*, May-June, 1967, p. 51.

50. Margo Jefferson, "On Writers and Writing: Literary Pentimento," *New York Times Book Review*, February 17, 2002, p. 23.

51. In my treatment of the distinction between art-making and common labor, I am indebted to David Craven, *Abstract Expressionism as Cultural Critique* (New York: Cambridge University Press, 1999), Chapter 5.

52. Meyer Schapiro, "Liberating Quality of Avant-Garde Art." *Art News*, Summer 1957, pp. 38, 40.

53. See Michael Leja, *Reframing Abstract Expressionism: Subjectivity and Painting in the 1940s* (New Haven: Yale University Press, 1993), Chapter 5.

54. Clement Greenberg, "Art," *The Nation*, April 13, 1946, p. 445.

55. In 1950 Bruno Alfieri, quoted in Francis V. O'Connor, "Jackson Pollock" (New York: Museum of Modern Art, 1967), pp. 54-55, first characterized Pollock's painting as "chaos." Pollock was provoked to write a letter to *Time* "NO CHAOS DAMN IT!" *Time*, November 20, 1950, p. 71, denouncing this idea. But I believe that Alfieri was on the right track.

 Donald Kuspit also views Pollock's painting as primarily chaotic. From a psychoanalytic point of view, he wrote in "Breaking the Repression Barrier," *Art Journal*, Fall 1988, pp. 229-230, that "American Abstract Expressionism, which relies on units of raw intensity, seems even more disintegrative [than traditional German Expressionism]—to the point of abolishing the reintegrative, making it seem impossible. The best works of Jackson Pollock and Willem de Kooning can be understood to apotheosize disintegration." Nevertheless, they also suggest the "difficulty" of integration, "preventing [them] from becoming mindlessly disintegrative or matter-of-fact nihilistic."

56. Frank O'Hara, *Jackson Pollock* (New York: Braziller, 1959), p. 26.

57. William Inge, "Willem de Kooning" (Beverly Hills, Calif.: Paul Kantor Gallery, 1965), n.p.

58. Terry Eagleton, *Sweet Violence: The Idea of the Tragic* (Oxford: Blackwell, 2003), p. 41.

59. To be sure, much of the art of the past was tragic, expressing anxiety, alienation, and terror, and any perception of the tragic in art is subjective to a degree. Nevertheless, Field Painting and Gesture Painting were different from earlier artistic tendencies because they were primarily subjective.

60. Thomas B. Hess, "Inside Nature," *Art News*, February 1958, p. 63.

61. Adolph Gottlieb and Mark Rothko (in collaboration with Barnett Newman), "Letter to the Editor," *New York Times*, June 13, 1943, sec. 2, p. 9.

62. John P. O'Neill, ed., *Barnett Newman: Selected Writings and Interviews* (Berkeley: University of California Press, 1990), p. 140.

63. Barnett Newman, *Introduction, The Ideographic Picture* (New York: Betty Parsons Gallery, 1947), n.p.

64. De Kooning, "What Abstract Art Means to Me," *Museum of Modern Art Bulletin*, Spring 1951, p. 7. A younger artist, Robert Rauschenberg, in Calvin Tomkins, *The Bride and the Bachelors* (New York: Viking Press, 1968) p. 210, recalled (to his distaste) that as late as the mid-fifties, "The kind of talk you heard then in the art world … was all about suffering and self-expression and the State of Things."

65. Robert Motherwell, conversation with the author, Provincetown, Summer 1957.

66. Auden's "New York Letter," *The Collected Poetry of W. H. Auden* (New York: Random House, 1945), pp. 272-273. This poem was written in January-April 1940 and published in the United States in March 1941.

67. I am indebted to Michael Leja's discussion of the relation of Film Noir to Abstract Expressionism in *Reframing Abstract Expressionism* (New Haven, Conn.: Yale University Press, 1993), pp. 319-323.

68. Clement Greenberg, "Review of the Whitney Annual," *The Nation*, December 28, 1946, reproduced in John O'Brian, ed., *Clement Greenberg: The Collected Essays and Criticism*, Vol. 2 (Chicago: University of Chicago Press, 1986), p. 118.

69. Robert Motherwell, "What Abstract Art Means To Me," *Museum of Modern Art Bulletin*, Vol. 18, No. 3, Spring 1951, pp. 12-13.

70. Laurie Wilson, "Giacometti's Thin Figures: Dead Men Walking," *Art in America*, May 2002, p. 138. Giacometti's article, titled "A Propos de Jacques Callot," appeared in *Labyrinthe*, April 1945.

71. Ibid, p. 139.

72. Mercedes Matter, "Giacometti: In the Vicinity of the Impossible," *Art News*, Summer 1965, p. 53.

73. Jean-Paul Sartre, "Giacometti in Search of Space," *Art News*, September 1955, p. 29.

74. Sanford Schwartz, "The Devil and Giacometti," *New York Review*, January 17, 2002, p. 23.

75. David Sylvester, "The Exhilarated Despair of Francis Bacon," an interview, *Art News*, May 1975, p. 29.

76. Ibid., pp. 26-31.

77. Jack Kroll, "Dubuffet in All His Existential Glory," *Art News*, April 1962, p. 50.

78. Pepe Karmel, "Jean Dubuffet: The Would-Be Barbarian," *Apollo*, October 2002, p. 12.

79. Ann Cremin, "Friend Game," *Art News*, May 1985, pp. 88-89.

80. T.[homas] H.[ess], "de Kooning," an interview, in "Is Today's Artist With or Against the Past," *Art News*, Summer 1958, p. 27.

81. Harold Rosenberg, "Parable of American Painting," *Art News,* January 1954, pp. 61. Rosenberg may have had in mind Gertrude Stein who, in "An American and France," in *What Are Masterpieces* (Los Angeles: Conference Press, 1940), p. 62, quoted in McCourbrey, p. 128, wrote: "After all anybody is as their land and air is.… It is that which makes them and the arts they make and the work they do and the way they eat and the way they drink and the way they learn and everything."

82. Meyer Schapiro, "Race, Nationality and Art," *Art Front*, March 1936, p. 10.

83. Edward Alden Jewell, "End-of-the-Season Melange," *New York Times*, June 6, 1943, sec. 2, p. 9.

84. Jackson Pollock, "Jackson Pollock," *Arts & Architecture*, February 1944, p. 14.

85. Isaiah Berlin, in "Nationalism," *Against the Current: Essays in the History of Ideas* (New York: Viking Press, 1980), pp. 333-355), observed that nationalism led to the overthrow of governments, the redrawing of borders, and the creation of new nations. He also maintained that in the 20th century, the claims of nationalism had been stronger than the claims of class solidarity. However, Marxists insisted that nationalism was a passing aberration, displaying their misunderstanding of social reality.

86. Thomas B. Hess, "Remarks at the Opening of the de Kooning Retrospective at the Stedelijk Museum, Amsterdam, September 19, 1968," in Hess, *De Kooning* (New York: M Knoedler, 1968), n.p.

87. Much as he denied his roots in European art, Still had written a masters paper on Cézanne and was aware of later Modernist developments.

88. Clyfford Still, letter to Gordon M. Smith, Jan. 1, 1959, in *Paintings by Clyfford Still* (Buffalo, N.Y.: Albright-Knox Art Gallery, 1959), n.p.

89. Barnett Newman moved from nationalism to internationalism and back. He had been a fan of Thomas Hart Benton, "'Tom' to all the natives.…" and in 1938 he interviewed Benton and commented that "Watching Benton work, you see the real man, the Benton in love with provincial America, the America of the farm. He paints the American scene like a modern Brueghel."

O'Neill, ed., "What About Isolationist Art?" *Barnett Newman: Selected Writings and Interviews*, p. 16. Then, in 1942, he paired Regionalism's nationalistic rationale with Nazi blood-and-soil myths. "Both are … vicious [employing] false patriotism [and] the appeal to race." Ibid, pp. 24-25. At the end of the 1940s, he seconded Still's nationalistic sentiments, but he was not as strident.

90. Robert Goldwater, ed., "A Symposium: The State of American Art," *Magazine of Art*, March 1949, pp. 82-102. The participants were Walter Abell, Alfred H. Barr, Jr., Jacques Barzun, John I. H. Baur, Holger Cahill, Alfred Frankenstein, Lloyd Goodrich, Clement Greenberg, George Heard Hamilton, Douglas MacAgy, H. W. Janson, Daniel Catton Rich, James Thrall Soby, Lionel Trilling, John Devoluy, and Patrick Heron.

91. Louis Finkelstein, "Marin and DeKooning," *Magazine of Art*, October 1950, p. 206.

92. Hans Hofmann, lecture, July 3, 1949. In Rosalind Browne, "Art World Eyes Forum 49 Program of Abstract Works and Discussions," *Provincetown Advocate*, July 7, 1949.

93. In his essay on national identity and nationalism, Isaiah Berlin, in "Nationalism, Past Neglect and Present Power," in *Against the Current: Essays in the History of Ideas*, ed. Henry Hardy (New York: Viking Press, 1980), pp. 338, commented, "The need to belong to an easily identifiable group has been regarded, at any rate since Aristotle, as a natural requirement on the part of human beings: families, clans, tribes, estates, social orders, classes, religious organizations, political parties, and finally nations and states, were historical forms of the fulfillment of this basic human need."

See also Anthony D. Smith, *National Identity* (London: Penguin Books, 1991), p. 17.

94. See Leo Marx, *The Machine in the Garden* (London: Oxford University Press, 1964).

95. See Lucy R. Lippard, *The Lure of the Local* (New York: The New Press, 1997), pp. 4, 5, 7.

96. Stanley Crouch, in Brian Lamb, *Booknotes* (New York: Times Books, 1997), pp. 180-181.

97. John Davis, "The End of the American Century: Current Scholarship on the Art of the United States," *Art Bulletin*, September 2003, p. 572.

98. John McCoubrey, *American Tradition in Painting* (Philadelphia: University of Pennsylvania Press, 1963), p. 118.

99. Lawrence Gowing, "Paint in America," *The New Statesman*, May 24, 1958, pp. 699-700, quoted in John W. McCoubrey, ed., *American Art 1700-1960* (Englewood Cliffs, N.J.: Prentice Hall, 1965), p. 226.

CHAPTER 1
The Avant-Garde in the 1930s:
Mastering the School of Paris

Rejecting false aesthetics

Most of the Abstract Expressionists were born between 1904 and 1912. Consequently, they were in their late teens and twenties in 1929, when the stock-market crash ushered in the Great Depression. The economic debacle at home, during which tens of millions of Americans were unemployed or dispossessed, was accompanied by economic, social, and political calamities abroad: Hitler's rise to power, the Spanish Civil War, the Moscow Trials, the Nazi-Soviet Nonaggression Pact, and, in 1939, the outbreak of World War II.

Responding to the economic crisis, most artists chose to work in the socially oriented, figurative styles of Regionalism and Social Realism. The Social Realists, among them William Gropper and Hugo Gellert, were motivated by Marxist dogma and depicted what they imagined to be the plight of the exploited masses. Their slogans were "paint proletarian" and "art as a weapon." In 1932, at a convention of the John Reed Clubs, which were Communist-front organizations for writers and artists, a resolution was adopted calling on artists "to abandon decisively the treacherous illusion that art can exist for art's sake or that the artist can remain remote from the historic conflicts in which all men must take sides" and instead to "join with the literary and artistic movement of the working class in forging a new art that will be a weapon in the battle for a new and superior world."[1] The harbinger of that brave new world was Stalinist Russia.

Unlike the Social Realists, the Regionalists, whose leaders were Thomas Hart Benton, Grant Wood, and John Steuart Curry, recoiled from the crushing events of the present and sought to recapture America's agrarian and small-town past in their paintings. As Benton wrote, they were motivated by "democratic idealism.… We symbolized aesthetically what the majority of Americans had in

mind—America itself. Our success was a popular success."[2] The Regionalist rallying cries were "paint American" and "to hell with Europe," a condemnation that had a xenophobic and racist edge, "suggestive of an ugly neo-fascism," as Benton himself later admitted.[3]

Social Realism and Regionalism were opposed ideologically, but both favored conventional figurative styles and public murals. The artists of both camps repeatedly and vociferously condemned Modernist painting. For the Social Realists, it represented bourgeois decadence and ivory-tower escapism; for the Regionalists, it was seen as un-American, the product, as Benton wrote, of the "hot-house atmospheres of an imported and, for our country, functionless aesthetics."[4]

So influential were the Social Realists and the Regionalists, so adept at promoting their causes, that they amassed considerable power in the art world. Even the Museum of Modern Art had to pay attention. In 1938, the museum mounted "Three Centuries of American Art," a show that featured academic figuration. A huge survey at the museum in the following year, titled "Art of Our Time," ignored American Modernists.

In the face of Social Realist and Regionalist hegemony, it was not easy to be avant-garde during the Great Depression. Nonetheless, a few dozen forward-looking artists—among them de Kooning, Gorky, Gottlieb, and Rothko—opted to experiment with Modernist styles imported from Europe.[5] The Modernists rejected "the Benton-Curry-Wood school and the Rivera-derived WPA murals." As John Ferren wrote, "These painters seemed to us inexcusably blind to the pictorial discoveries of the School of Paris and therefore to be painting retrogressively. We also disliked the subservience of art to political propaganda which their art represented." In a more ironic vein, Ferren recalled that at a time when tens of thousands of small farmers were being dispossessed, "The Iowa farms painted by Grant Wood seemed to us … like dream fantasies of the ideal, immaculately clean farm owned by the most prosperous happy farmer. (Maybe Grant Wood was the most Surrealist painter of the period.)"[6]

Newman was equally dismissive of the Regionalists. He ridiculed them for depicting "the good old things … that our good old straight-standing, clean American folks back home can understand," which resulted in a sentimental "picture-postcard art … a cheap, successful, new commercial art." Newman concluded that the Regionalists were "pushing across a false aesthetic that is inhibiting the production of any true art in this country."[7]

The Social Realists were no less backward-looking than the Regionalists; they merely substituted the factory worker for the farmer or small-towner. Marxist-inspired artists produced trite illustrations of the class struggle—for example, endless caricatures of bloated capitalists protected by vicious policemen beating noble strikers and emaciated women and children. These stereotypes were deceitful, "the soapbox speaking instead of the man," as Balcomb Greene, an abstract painter, scoffed.[8] In

the name of truth and authentic feeling, Modernists rejected the dictates of homegrown commissars and turned to "direct sensual experience," which abstract sculptor Ibram Lassaw claimed in 1938 "is more real than … symbols, slogans, worn-out plots, cliches—more real than political-oratorical art."[9]

Moreover, Social Realism proved increasingly irrelevant as President Roosevelt's relief programs aimed at alleviating the economic depression took effect and labor unions grew in power. Regionalism also lost its currency as the nation's attention turned toward events in Europe. Benton wrote, "By the late autumn of 1941 [just before Pearl Harbor], my mind was so much on the international situation that I found it difficult to concentrate on painting. The American scene which had furnished the content and motivations of my work for some twenty years was outweighed by the world one. As I had no pictorial ideas applicable to this new scene, I was almost completely frustrated." He concluded that with the substitution of "a world concern for … specifically American concerns.… I found the bottom knocked out from under us."[10]

The appeal of geometry

The Modernist artists rejected Regionalism and Social Realism as retrograde art. Even a painter of the stature of Edward Hopper, who was neither a Regionalist nor a Social Realist, came in for ridicule. Carl Holty, an artist and spokesman for abstract art, once quipped that Hopper took the commonplace and made it more commonplace than it was in the first commonplace. Yet, if the work of the American vanguard was livelier and of a higher order than that of the Social Realists and Regionalists, it was nonetheless derivative and not as masterful as that being produced in Paris.

Advanced artists in New York recognized that if they were to create new art, they first would have to assimilate current Modernist art. They began a transatlantic dialogue with the work of Picasso, Mondrian, Miró, Matisse, and Kandinsky, among others, all of whom were living in Paris. In their effort to digest the rich heritage of modern painting, the New York avant-garde was exceedingly fortunate in being able to see large numbers of modern masterworks in the great collections of the Museum of Modern Art, the Museum of Nonobjective Painting (now the Solomon R. Guggenheim Museum), the Société Anonyme (now at the Yale University Art Gallery), and Albert Gallatin's Museum of Living Art (now at the Philadelphia Museum of Art). Moreover, the major surveys of Cubism and Surrealism that the Museum of Modern Art mounted under the direction of Alfred H. Barr Jr. in 1936 were also invaluable in exposing the American artists to European Modernism. The Museum of Living Art, which contained a considerable number of avant-garde works and from 1927 to 1942 was installed in the library of New York University, was extra particularly useful to New Yorkers, most of whom lived and worked close by.

American Modernist art of the 1930s was not monolithic. In fact, it encompassed a variety of aesthetic positions that were often at odds with each other. At the cutting edge of the avant-garde were artists who were influenced first by Synthetic Cubism and subsequently by Dutch De Stijl, German Bauhaus, and Russian Constructivism and Suprematism. They generally painted geometric abstractions in which the interrelationships among cleanly edged forms in matte colors yielded cogent pictorial structures. The Modernists adopted geometric abstraction for several reasons: it was rational at a time when rationality was prized, it was the most advanced level to which modern art had progressed, and it was internationalist in outlook. The New Yorkers also admired the masters of geometric abstraction—above all, Mondrian—who were featured in Paris-based Abstraction-Création, Cercle et Carré, and Art Concret group shows. The Americans recognized that their art was not the equal of the Europeans, on the one hand, and on the other, that it was certainly not as provincial as Social Realism and Regionalism.

Cubist-inspired artists, whether semiabstract or nonobjective, were motivated by a will to order and they aspired to create work whose composition was intelligible and coherent, even logical. Their sensibility was exemplified by the geometric abstractions of Burgoyne Diller and Josef Albers, although the two artists were different—Diller focusing on De Stijl principles of design, and Albers, on the interaction of color. Albers summed up his aesthetic in verse, "To design is/ to plan and to organize, to order, to relate and to control./ In short it embraces/ all means opposing disorder and accident."[11]

Geometric abstraction had both aesthetic and social implications. On the one hand, its adherents embraced an art-for-art's-sake aesthetic and sought to "concentrate upon the structural properties of esthetics [so that their works] become things that can be looked at, complete in themselves, and not merely impressionistic counterfeits of nature."[12] On the other hand, geometric artists who were socially minded envisioned their "perfect" designs as the representative art of a future international, collectivist utopia governed by reason.

Abstract artists could even conceive of their work as socially revolutionary. This position was advanced by Leon Trotsky, André Breton, and Diego Rivera in articles in *Partisan Review* in 1937. Compared with their sworn enemies, the Stalinists, Trotsky's followers were a small and relatively powerless group in leftist circles, but they were vocal and included brilliant spokespersons, such as Meyer Schapiro. Moreover, their theories influenced Clement Greenberg and Harold Rosenberg, later the leading critics of Abstract Expressionism, as well as growing numbers of avant-garde artists. In 1938, Trotsky published a letter in *Partisan Review* in which he castigated the repression of the arts by Stalinist apparatchiks who derided Modernist art as "fascist" and dictated that artists paint in retrogressive, academic, and banal Socialist Realist styles. "Art, like science," he asserted "not only does not seek orders, but by its very essence, cannot tolerate them. Artistic creation has its laws—even

Josef Albers, *b and p*
1937, Oil on masonite,
23 7/8 x 23 3/4 inches (60.6 x 60.2 cm).
Solomon R. Guggenheim Museum, New York
Estate of Karl Nierendorf, By purchase 48.1172.264.
© 2008 The Josef and Anni Albers Foundation / Artists Rights Society (ARS), New York

Burgoyne Diller, 1906-1965 *First Theme,* 1938
Oil on canvas, Overall: 30 1/16 x 30 1/16 in. (76.4 x 76.4cm)
Whitney Museum of American Art, New York;
Purchase, with funds from Emily Fisher Landau 85.44
© Estate of Burgoyne Diller / Licensed by VAGA, New York, NY

when it serves a social movement. Truly intellectual creation is incompatible with lies, hypocrisy and the spirit of conformity. Art can become a strong ally of revolution only in so far as it remains faithful to itself."[13]

In the next issue of the journal, Breton and Rivera affirmed Trotsky's statement in a manifesto: "We can say without exaggeration that never has civilization been menaced so severely as today.... Truly art, which is not content to play variations on ready-made models but insists on expressing the inner needs of man and of mankind in its time—true art is unable *not* to be revolutionary, *not* to aspire to a complete and radical reconstitution of society." Breton and Rivera concluded that it was the artist's inalienable right to escape from all restrictions on his imagination and that they stood for "*complete freedom for art*."[14] Trotsky then published another letter in *Partisan Review* praising Breton and Rivera for their stand and reiterating, "The struggle for revolutionary ideas in art must begin once again with the struggle for artistic truth, not in terms of any single school, but in terms of *the immutable faith of the artist in his own inner self.* Without this there is no art. 'You shall not lie!'—this is the formula of salvation."[15]

It is not surprising that during the Great Depression even nonobjective artists justified their art in social terms. Both the aestheticist and social rationales enabled Modernist artists to uphold abstract art in the face of the reigning Social Realist and Regionalist rhetoric.

In 1936, some three dozen artists formed an organization they named the American Abstract Artists (AAA). Through its shows and catalogues, the AAA played an important role in winning recognition for nonobjective art. As Clement Greenberg recalled, "The annual exhibitions of the American Abstract Artists … were the most important occasions of these years as far as advanced art in New York was concerned. To these exhibitions the subsequent sophistication of New York painting owed a great deal."[16]

However, a small but growing number of avant-garde artists had reservations about geometric abstraction. They recognized that its rationalism was no longer credible, neither was its art-for-art's-sake nor its dream of a socialist and utopian future (much as they may have yearned for it). They acclaimed Mondrian as a great artist, responding to his passion and artistry but not to his geometric-abstract style, which had been underpinned by a brave-new-world vision that could have seemed feasible only in the 1920s and early 1930s with the ostensible success of the Soviet experiment. In the middle 1930s, however, Stalinism turned sour, and with the advent of Nazism and worldwide preparations for war, geometric abstraction seemed to many Modernist artists increasingly irrelevant in the face of the irrational forces that were on the ascendent.

It is significant that Pollock, Baziotes, Gottlieb, and Rothko never joined the AAA, and that Gorky and de Kooning walked out of its first meeting in response to dictates that they work in nonobjective

styles. Even in the 1930s, the future Abstract Expressionists recognized that Cubist-inspired nonobjective painting was a dead end. The entry of the United States into World War II dealt a final blow to Synthetic Cubism and geometric abstraction as viable advanced styles in America.

Disasters foretold

The American Abstract Artists was the largest organization of Modernist artists in the United States, but not the only one. In 1935, another group, which included Rothko and Gottlieb, formed The Ten.[17] They would mount nine shows during the next four years. The Ten's central position was, as the critic Herbert Lawrence wrote, "an attempt to combine a social consciousness with [an] abstract, expressionistic heritage, thus saving art from being mere propaganda on the one hand, or mere formalism on the other."[18] With the exception of Ilya Bolotowsky, its members rejected geometric abstraction. As Gottlieb said, "I felt that nonobjective painters [in the AAA] were in a blind alley because they were docile in following Mondrian. Their paintings were well done but not significant or relevant to what I felt."[19] However, like the AAA, The Ten stood opposed to Social Realism and Regionalism. In 1938, the group attacked the Whitney Annual exhibition and staged a counter show, titled "The Whitney Dissenters." Writing in the catalogue, Marcus Rothkowitz (who later shortened his name to Mark Rothko) and Barnard Braddon, with Regionalist painting in mind, ridiculed "the silo [which] is in ascendancy in our Whitney Museums of modern American art." Rothkowitz and Braddon also declared that The Ten were as one "in their consistent opposition to conservatism."[20]

The Ten favored the Expressionists Chaim Soutine, Georges Rouault, and Max Beckmann. The group was sympathetic to Picasso—they invited Karl Knaths, an American Cubist, to show with them twice—but Matisse was "the man," as Rothko said.[21] Above all, he and Gottlieb admired the French painter's major American follower, Milton Avery, and became his close friend. A "solitary figure working against the stream," as Gottlieb commented, Avery depicted the American scene in a Modernist manner.[22] On the one hand, he featured, as Rothko observed, "the beaches and mountains where [he] summered; cows … friends and whatever world strayed through his studio."[23] On the other hand, he converted these subjects into elementary shapes of flat color derived from Matisse. Unlike Matisse's hedonistic painting, however, Avery's surfaces were drier, the mood of his paintings, sober—perhaps in keeping with his New England roots. Avery's young friends thought of him as peculiarly American, an Americanized Matisse, as Gottlieb characterized him.

The Ten were viewed as Modernists because they freely altered their subjects for expressive purposes. A *New York Times* reviewer of 1935 chastised the group for "reasonless distortion" and "needless obscurity." The critic concluded, "The pictures are mostly such as to give anyone with the

slightest academic sympathies apoplexy."[24] A *New York Sun* critic wrote that the artists "dare any theme … in a splashing, dashing, youthful fashion."[25]

Paintings by The Ten displayed signs of social malaise. At the beginning of the Depression, Gottlieb, inspired by T. S. Eliot's "The Waste Land," painted a picture of that title whose figures evoked a dejected mood. Rothko's subjects of the 1930s were frozen and anxiety ridden. His best known canvases of the decade, which represent subway scenes, evoke the descent into an urban netherworld that can be viewed as a metaphoric fall into Hades, forecasting the kind of mythic subject matter that would engage him in the early and middle 1940s.

Herbert Lawrence observed that the paintings of Gottlieb and Yankel Kufeld, another member of The Ten, expressed "futility, abandonment and the insecurity of modern life."[26] As Jacob Kainen, a close friend of The Ten, wrote, Expressionism was "the direction par excellence for social disillusion and individual nihilism." He added that it was "expressive of the violence of our time, of the swift tempo of disaster which threatens to engulf us." He concluded, "We are closer to chaos than we think."[27] The Lawrence article appeared in 1936; Kainen's, in 1937. Kainen's prophecy was fulfilled by the outbreak of World War II. In the early years of the war, Gottlieb and Rothko would invent fresh images for the disaster that Kainen had foretold.

A hodge-podge of styles

Another group of American Modernists included Stuart Davis, John Graham, and Arshile Gorky—who were dubbed "The Three Musketeers"—as well as de Kooning, the sculptor David Smith, and several others. They did not constitute a formal organization, like the AAA or The Ten, but met often in various Greenwich Village restaurants and bars. Although sympathetic toward geometric abstraction and Expressionism, they were not particularly interested in emulating either. Instead they embraced Synthetic Cubist styles, above all Picasso's. Indeed, they idolized Picasso, whom Graham hailed as "... so much greater than any painter of the present or the past times that it is probable he is also the greatest painter of the future."[28]

Much as Gorky and de Kooning admired Picasso, they were also impressed by other European artists—for example, Miró. Furthermore, as de Kooning recalled:

> There was a terrific amount of activity going on in the thirties…. You don't have to like the art to appreciate the excitement. But many of the people were good artists—Graham, Davis, Gorky. But we also respected American scene and Social Realist artists. Gorky and Soyer were good friends. I wasn't a member of the American Abstract Artists, but I was with them. I disagreed with their narrowness, their telling me not to do something. We fooled around with all kinds of things and changed from style to style a lot. It was a great big hodge-podge.[29]

Davis was the best-known artist of this group, but Graham was the more knowledgeable because he visited Paris regularly and was able to follow Modernist developments there. He was also the most provocative intellectually and in 1937 published his ideas on aesthetics in a book titled *System and Dialectics of Art*. In Graham's view, "Revolution is the repudiation of traditional forms outgrown. *Revolution is the change of methods and not of subject matter*." He added that a change of subject matter could not be radical, for "if nothing else, it is too easy."[30]

Graham had been influenced by Freud and Jung. Anticipating the importance of psychoanalytic theory for artists in the 1940s, he stressed that the unconscious was the primary source of art. As he wrote, artists had to "re-establish a lost contact with the unconscious … and to keep and develop this contact in order to bring to the conscious mind the throbbing events of the unconscious mind."[31]

Graham was a well-known connoisseur of so-called primitive art (or "primitive" art, as I will refer to it, as the term now requires quotation marks). He believed that "primitive" artists were in close touch with the unconscious, and so too were certain modern artists. Graham linked the two in a widely read article, "Primitive Art and Picasso" (1937), in which he wrote, "Picasso's painting has the same ease of access to the unconscious as have primitive artists, plus a conscious intelligence."[32] Graham brought "primitive" art to the attention of his acquaintances and pointed out its significance as authentic art. It is also likely that he introduced Gorky to Freud's thinking and Rothko and Gottlieb to Jung's theories, but his impact was strongest on Pollock. Indeed, Pollock was so impressed by Graham's article relating "primitive" art and Picasso that around 1940 he sought Graham out and became a close friend. Graham's influence contributed greatly to Pollock's conviction of the importance of the unconscious in art, to his interest in Native American art, and to his conversion to Modernist art. Above all, under Graham's guidance, Pollock turned to Picasso for inspiration.

Gorky, who was one of the more prominent younger painters in the informal group, painted both figurative and abstract pictures; most were heavily influenced by Picasso, but in many, he mixed Synthetic Cubist design with Surrealist motifs, notably those of Miró. In his fusion of Cubism and Surrealism, Gorky forecast a pivotal development in American avant-garde art of the following decade. De Kooning also experimented with a variety of styles ranging from representation to Cubist-inspired abstraction, but his most significant works were pictures of shabby, isolated, vulnerable, abject men, many of them self-portraits of sorts. Painted between 1938 and 1940, they were the poignant progeny of the Depression. However, de Kooning tended to treat figural components as abstract elements, and to make these forms expressive in their own right, anticipating his own abstractions of the late forties.

Like Graham, Gorky, and de Kooning, Hans Hofmann revered Picasso. In the 1930s, he was the most influential teacher of modern art in the United States. He was unrivaled in imparting the

principles of Cubist drawing and Fauve color. As Greenberg wrote, "You could learn more about Matisse's color from Hofmann than from Matisse himself."[33] Hofmann had lived in Paris from 1904 to 1914, the premier heroic decade of twentieth-century art, and had witnessed—indeed, participated in—the genesis of Cubism and Fauvism. He had known Matisse, Picasso, and Braque and had been particularly friendly with Robert Delaunay, whose formulation of a coloristic Cubism strongly influenced him. No instructor was better equipped than Hofmann to teach students how to make a modern picture. Half of the avant-garde in the 1930s was enrolled in his classes. None of the leading Abstract Expressionists studied with Hofmann, but they had met him, knew of his ideas, and later counted him as one of them.

Hofmann limited himself to teaching until around 1937, when he began to paint seriously. His pictures of the next half-dozen years consisted of semiabstract Provincetown scenes, as well as interiors and figures, rendered in high-keyed Fauve colors and composed in a free Synthetic Cubist manner. This early body of work signaled Hofmann's later distinctive synthesis in abstract painting of Fauvist color and Cubist structure.

Picasso's *Guernica*

In 1939, Picasso was the subject of a comprehensive retrospective at the Museum of Modern Art, accompanied by Alfred Barr's full-length publication *Picasso: Forty Years of His Art*. His portable mural, *Guernica* (1937), was exhibited in New York in 1939 to raise funds for Spanish refugees, and it drew a huge attendance. Because of its grand scale, stark black, gray, and white color, daring mix of Synthetic Cubist design, and social realist subject matter with an allegorical aspect, it made a powerful impression. American artists knew of *Guernica* before 1939, but seeing the original stimulated their interest in the way Picasso handled mythological allusions (to the horse and bull) of a universal nature in a personal manner—that is, redeploying images that appeared in his easel paintings. By incorporating nightmarish motifs into a flat-pattern Cubist composition, he anticipated a critical move by the American avant-garde in the early 1940s, and in situating the mural between public and private art, Picasso forecast the subjective "big pictures" of the Field and Gesture painters.

With the outbreak of World War II, the reputation and influence of *Guernica* grew. Pollock in particular was obsessed by the mural. Dozens of impulsive drawings that he made in the 1940s were variations on its themes, as if Picasso's imagery for a time had inhabited Pollock's unconscious.

Unlike artists who embraced geometric abstraction, those who submitted to the influence of Picasso—notably Gorky, de Kooning, Hofmann, and Pollock—were able to work through his style to find original styles of their own. Picasso showed a way because his painting was inclusive and

Arshile Gorky, *Organization*
1933-1936, oil on canvas
50" x 59-13/16"
National Gallery of Art, Washington, D.C.

open-ended in a manner that geometric abstraction was not. The young New Yorkers may also have been impressed by Picasso's protean genius and may have aspired to be as innovative as he was.

The impact of Surrealism

In the 1930s, despite the influence of Picasso and Miró, nonobjective artists in New York did not have much sympathy for Surrealist painting. They were well versed in it, having seen shows at the Julien Levy Gallery and occasionally at the Pierre Matisse and Curt Valentin and works at the Museum of Modern Art, above all in the museum's survey of Surrealist art in 1936. But most of what they saw, typified by Dali's canvases, struck them as academically figurative, literary and illusionistic. Given their disposition to a rational and constructive art, geometric artists rejected Surrealism because of its obsession with irrational, inward-looking fantasy and its use of chance effects. However, Miró was admired by Modernist artists because his painting was flat and his organic images provided alternatives to the angular geometry that was ubiquitous in 1930s abstraction.

Surrealism did have an influential advocate in Alfred Barr, who, as founding director of the Museum of Modern Art, exerted considerable taste-making power. In 1936, he mounted the two most important shows of his illustrious career: "Cubism and Abstract Art" and "Fantastic Art Dada Surrealism." Occupying all four floors of the museum, "Cubism and Abstract Art" was an impressive survey, but Barr treated its subject as a historic movement that was past its peak. Indeed, he believed that Cubist-inspired abstraction was a dead end and consequently excluded young American followers from his show.

In contrast to his view of the Cubist tradition, Barr believed that Surrealism was open to fresh developments. As he wrote, "The non-geometric forms of Arp and Miró and [Henry] Moore are definitely in the ascendant," beacons to younger artists.[34] Whereas the members of the American Abstract Artists condemned Surrealist painting as backward-looking and lacking in formal values, Barr extolled it for its exploration of human psychology, "symbolic, 'literary' or poetic subject matter [and] its esthetic of the fantastic, enigmatic and anti-rational."[35] It would be Barr who foresaw that Modernist art would become increasingly subjective and draw inspiration from Surrealism, but this did not occur until the wartime 1940s. Gorky would be the American who fulfilled Barr's prophecy most brilliantly by creating an original variant of Surrealist painting.

Although the shows of European Modernism at the Museum of Modern Art, and their catalogues, were vital in the education of American artists, MoMA was half-hearted in showing the local avant-garde. In 1938, the museum organized a show titled "American Art," which traveled to Paris and London before returning to the United States, where it was displayed at the 1939 World's Fair. The exhibition featured Regionalist and Social Realist painting. In 1939, MoMA presented "Art of

Our Time," which included 326 paintings and sculptures, of which only seven were nonobjective (Kandinsky, Mondrian, Antoine Pevsner, Naum Gabo, Jean Arp, Alexaner Calder, and John Ferren). Most of the relatively few Americans included in the show were Regionalists, Social Realists, Surrealists, or older painters such as John Sloan, Charles Burchfield, and Georgia O'Keeffe.[36] The American Abstract Artists were so incensed by the museum's selection that they picketed, carrying signs that read "How Modern Is the Museum of Modern Art?"

Pollock and Still: Frontiersmen

In 1947, Pollock and Clyfford Still would become the major innovators of Field Painting, but well into the 1930s, Modernist ideas—whether Cubist, Surrealist, or Expressionist—played a marginal role in their picture making. Paradoxically, their work was relatively backward-looking until late in the decade. Both artists were Regionalists, heavily influenced by Thomas Hart Benton. In 1930, at the age of 18, Pollock enrolled in Benton's class at the Art Students League in New York City. Pollock, who posed for one of the figures in his teacher's mural at the New School, was, in a manner of speaking, adopted by the Benton family, and Benton remained a lifelong friend and a kind of surrogate father—even after Pollock had embraced abstraction and publicly downplayed Benton's role in his career. Like Benton, Pollock cultivated the image of a Man of the West. One of his classmates at the Art Students League recalled that he "took pride in being a Westerner and looked down then on the East and Europe."[37]

Still was a student at the Art Students League in 1925 but left soon afterward to teach at various schools away from New York. He did not return to the city until 1945 and thus missed the city's Modernist ferment in the two decades he was away. In 1934, he visited the art critic Thomas Craven, Benton's close friend and champion, and commented that in a three-hour conversation, "We found our viewpoints almost too coincident."[38] What he shared with Craven and the Regionalists was, as Benton expressed it, their "revolt against the unhappy effects which the Armory Show had had on American painting. We objected to the new Parisian aesthetics."[39] Still was so impressed with Craven that he quoted his book *Men of Art* (1931) twice in his master's thesis, "Cézanne: A Study in Evaluation" (1935).[40] It is significant, however, that Still had chosen Cézanne as his subject, indicating his interest in modern art.

Benton's intellectual predecessor was the historian Frederick Jackson Turner. In his essay "The Significance of the Frontier in American History" (1893), Turner, disregarding the Native Americans whose tribal lands were in the West, held that "the existence of an area of free land, its continuous recession, and the advance of American settlement westward, explains American development."[41] He maintained that civilization was perpetually born and reborn on the frontier, and in the process a distinctive nation was forged, peopled by a singular breed that valued individualism and freedom,

and established unique democratic institutions to foster them. With Turner's thesis in mind, Benton wrote, "I wanted to show that the people's behavior, their *action* on the opening land, was the primary reality of American life."[42] He called for artists to "let your American environment … be your source of inspiration, American public meaning your purpose, and an art will come which will represent America."[43]

Pollock's and Still's painting of American scenes owed a great deal to Benton and his fellow Regionalists, Wood and Curry, but it was different from theirs. The younger artists' work was more direct and avoided slickness and the finicky detail favored by the older artists. It was also darker in mood, possessing a "penchant for romantic desolation," as art historian David Anfam wrote of Still.[44]

In Pollock's *The Wagon* (before 1938), a Bentonesque scene of pioneers moving west is shrouded in the kind of heavy and brooding atmosphere found in Albert Ryder's painting, which Pollock greatly admired. By temperament, he was attracted to agitated, rhythmic, and sweeping arabesques, whether in Ryder's and Benton's paintings or in the works of artists Benton introduced him to, including Rubens, late Michelangelo, Rembrandt, and particularly El Greco, all of whose pictures the young Pollock copied. His 1930s paintings, such as the freely brushed and allover *Seascape* (c. 1934) and *Flame* (c. 1934-1938) anticipate his later abstractions. Pollock's encounter with Graham's writing and with Graham himself toward the end of the thirties led to his subsequent conversion to Picasso and Modernism and ended his Regionalist period.

Still recalled, "When I was a young man [in the 1930s] I painted many landscapes—especially of the prairie and of men and the machines with which they ripped a meager living from the thin top soil.… Yet always and inevitably with the rising forms of life dominating the horizon." Ascending verticality was critical to Still because it summoned up his boyhood experience in the Canadian West. As he recalled, "For in such a land a man must stand upright, if he would live. Even if he is the only upright form in the world about him. And so was born and became intrinsic this elemental characteristic of my life and work."[45] Still's best-known image of this period, painted in 1934, is a crudely drawn, earth-colored, solitary elongated naked man, perhaps a self-portrait, striding across a vertical picture plane. With his ribs sticking out and his work-worn, oversized hands, this forlorn figure is the ill-fated but indomitable toiler of the barren land, like Still himself in his unhappy early life on a homestead. From 1917 to 1926 and again after 1931, a great drought devastated prairie farming, whose hardships warped Still's future life. Murray Bundy, who taught with Still at Washington State College in Pullman from 1933 to 1942, recalled that his colleague was a "profound pessimist" who tended to find "decadence" in art and society.[46]

Still's striding man and other figures of the 1930s, a number of them "starved anatomies," as Anfam characterizes them, are distorted and rendered in bleak colors and heavy and sluggish

brushwork.[47] Perhaps he had in mind Cézanne's observation that "one of the most unpleasant of sensations is experienced when we observe abnormalities in familiar objects."[48] Anfam wrote that Still plunged the pastoral that marked Regionalist painting into "a dystopia of limbs, blindness, spent matter. The wasted, bony, or petrified spooks are the old Jeffersonian idyll of the yeoman farmer now in extremis."[49]

The cheerless vision in Pollock's and Still's Regionalist paintings not only evokes the hardships of their early lives but refers more broadly to the plight of the tens of thousands of failed farmers dispossessed during the Great Depression. Pollock's and Still's styles would soon change radically, but not the darkness of their visions, which persisted in their canvases of the 1940s.

The influence of the Mexican muralists and Native American art

The Mexican Social-Revolutionary muralists Diego Rivera, David Alfaro Siqueiros, and José Clemente Orozco were widely admired in the New York art world of the 1930s by artists and art professionals of every stripe. Barr, for example, gave Rivera a show at the Museum of Modern Art in 1930-1931 and helped him to get a commission to paint murals at Rockefeller Center. In 1937, Meyer Schapiro asserted that "all the possibilities [of Cubist abstraction] have been explored by Picasso and Mondrian," and that "the revolutionary Mexican paintings [are] the most vital and imposing art produced on this continent in the 20th century."[50] In 1990, Pete Hamill recalled that Franz Kline told him, "When I got back from London [in 1938], everybody around was trying to be Orozco or Siqueiros, except the guys who wanted to be Mondrian. [The Mexicans] had power. They were trying to do something *big*."[51] Even abstract artists were impressed by their painting because of its visual dynamism.

As an adolescent in California, Pollock had seen Orozco's murals at Pomona College and proclaimed him one of the great artists of the twentieth century. After moving to New York in September 1930, Pollock was able to see major works by Orozco, most likely watched him paint murals at the New School in 1930-1931, and met him at least once at the home of Benton.[52] He visited Dartmouth College in New Hampshire, where Orozco had covered the walls of the library with the *Epic of American Civilization* (1932-1934). Pollock also saw Rivera's large exhibition at the Museum of Modern Art, which opened in December 1930. In 1933, he observed Rivera at work on murals in New York for Rockefeller Center (later destroyed, presumably on the orders of the Rockefeller family, because they contained a portrait of Lenin) and the New Workers' School.

Pollock's attraction to the Mexicans is not surprising, as their wall paintings were far more powerful and epic than Benton's tame reworkings of Renaissance conventions. Above all, Pollock was deeply impressed by the way Orozco incorporated the Mexican scene, ancient myths, folk legends,

Christian narratives and historical and contemporary themes into his dramatic canvases and murals. Inspired by the Mexican's subject matter, Pollock depicted scenes of ritual violence that contained Native American totemic and pictographic motifs, and amalgams of animal and human bones and anatomical parts. He was also influenced by Orozco's drawing, with its staccato linear stabs of pen and brush. Moreover, as Robert Storr has written, "Orozco's inner fury matched Pollock's volcanic anxiety."[53] It is important to keep in mind that whereas the Mexican muralists' intention was public—to familiarize the masses with their heritage and incite them to social revolution—Pollock's was private—to present archetypal images culled from his inner world.

Pollock met Siquieros, who visited New York City in 1936 to attend the American Artists' Congress Against War and Fascism. He stayed on and organized an unconventional project called the Experimental Workshop, which Pollock attended. Charles Pollock, Jackson's brother, recalled:

> The workshop was [meant] to bring art to the masses. [Some] of the technical resources employed there are of interest. The violation of accepted craft procedures, certain felicities of accidental effect (the consequence of Duco and the spray gun …) and scale must have stuck in his [Jackson's] mind to be recalled later.[54]

Pollock's subsequent exploitation of accidental effects owed much to the experiments of Siquieros and his students with spray guns and airbrushes loaded with industrial pigments and housepaints, which they applied to large panels often on the floor, the spontaneity that Siquieros encouraged, and perhaps even the pigment-spattered floor of the workshop itself.

Storr has pointed out that the influence of the Mexicans on Pollock has been understated by historians such as William Rubin, who focused on more prestigious progenitors such as Picasso, Matisse, and Miró to bolster Pollock's stature.[55]

Before learning how the Mexican muralists used pre-Columbian and contemporary Indian motifs, Pollock and Still had been fascinated by Native American life, ceremony, and culture. As a boy in the early 1920s, Pollock joined his brothers in excavating Indian mounds and cliff dwellings in the Southwest. His brother Sanford recalled, "In all of our experiences in the West, there was always an Indian somewhere." And cowboys: "Saddles and horses and boots and guns, all this was a very big part of our childhood experience. In Janesville [a town they had lived in], all the old codgers would sit around our stove and talk about the gunfights and rustlers.… It was all over when we got there, but it was just over."[56] From 1933 to 1941, Still taught at Washington State College in Pullman and with Worth D. Griffen, who painted portraits of Indians, organized a summer art colony on the Colville Indian Reservation, near the reservations of the Nespelem and Chehalis Indians. A number of Still's summer classes actually met on their tribal grounds.

In New York, Graham fostered the interest of his artist friends in Native American art. In "Primitive Art and Picasso," he wrote glowingly of "Eskimo and North American Indian Masks with features shifted around or multiplied, and the Tlingit, Kwakiutl, and Haida carvings in ivory and wood of human beings and animals, these all satisfied their particular totemism and exteriorized their prohibitions (taboos) in order to understand them better and consequently to deal with them successfully."[57] Gottlieb, who was a friend of Graham's, spent the year 1937 in Tucson, Arizona. In a letter to a friend in New York he wrote, "From what I gather is going on (aside from Cézanne and Picasso now and then) I wouldn't swap all the shows of a month in N.Y. for a visit to the State Museum here which has a marvelous collection of Indian things."[58]

There was also much indigenous art to be seen in New York City, in the permanent collections of the Museum of the American Indian, the Brooklyn Museum, and the Museum of Natural History. During the 1930s, local museums increasingly featured "primitive" art, particularly its American variants, Native American and Pre-Columbian art. The Museum of Modern Art presented the aboriginal predecessors of Modernist movements in several important shows: "American Sources of Modern Art" (1933), which featured Aztec, Mayan, and Incan art; "African Negro Art" (1935), consisting of almost 600 sculptures and artifacts; "Prehistoric Rock Pictures in Europe and Africa" (1937), on three of the museum's floors; and "Twenty Centuries of Mexican Art" (1940).[59] The cumulative impact of these and subsequent surveys of "primitive" art would profoundly influence avant-garde art in New York in the early and middle 1940s.

1. Gerald M. Monroe, "The '30s: Art, Ideology and the WPA," *Art in America,* November-December 1975, p. 65.

2. Thomas Hart Benton, *An Artist in America,* 1951 edition, quoted in John W. McCoubrey, *American Art 1700-1960: Sources and Documents* (Englewood Cliffs, N.J.: Prentice-Hall, 1965), p. 202.

3. Ibid. See also Sidney Geist, "Prelude: The 1930's," *Arts,* September 1956, p. 53.

4. Benton, *An Artist in America,* in McCoubrey, *American Art 1700-1960,* p. 202.

5. As I use it, the term *Modernist art* is different from *modern art* in that it constitutes the advanced edge of modern art.

6. John Ferren, "Epitaph for an Avant-Garde," *Arts,* November 1958, p. 24.

7. Thomas B. Hess, *Barnett Newman* (New York: Museum of Modern Art, 1971), pp. 35-36.

8. Balcomb Greene, "Expression as Production" (New York: American Abstract Artists, 1938), section XI, n.p.

9. Ibram Lassaw, "On Inventing Our Own Art" (New York: American Abstract Artists, 1938), section VIII, n.p.

10. Benton, *An Artist in America,* p. 202.

11. Josef Albers, *Despite Straight Lines* (New Haven, Conn.: Yale University Press, 1961), p. 75.

12. George L. K. Morris, "Introduction" (New York: American Abstract Artists, 1949), section IV, n.p.

13. Leon Trotsky, "Art and Politics: A Letter to the Editors," *Partisan Review,* August-September 1938, p. 10.

14. André Breton and Diego Rivera, "Manifesto," *Partisan Review,* Fall 1938, pp. 50-51.

15. Leon Trotsky, "Letters: Trotsky to André Breton," *Partisan Review,* Winter 1938, p. 127.

16. Clement Greenberg, "America Takes the Lead 1945-1965," *Art in America,* August-September 1965, p. 108.

17. The original Ten consisted of nine painters, Ben-Zion, Ilya Bolotowsky, Adolph Gottlieb, Louis Harris, Yankel Kufeld, Mark Rothkowitz, Louis Schanker, Joseph Solman, and Nahum Tschacbasov. Other artists invited to show with them were Lee Gatch, John Graham, Earl Kerkam, Karl Knaths, Edgar Levy, and Ralph Rosenborg.

18. Herbert Lawrence, "The Ten," *Art Front,* February 1936, p. 12. Members of the Ten would occasionally give their pictures socially conscious titles. Ben-Zion titled one picture *Lynching* and Ilya Bolotowsky, another canvas, *Sweatshop.*

19. Adolph Gottlieb, notes on a conversation with the author, Provincetown, Mass., August 1957.

20. Bernard Braddon and Marcus Rothkowitz, "The Whitney Dissenters' Manifesto," reprinted in *The Ten: Birth of the American Avant-Garde* (Boston: Mercury Gallery, 1998), inside cover.

21. Mark Rothko, conversation with the author, New York, 1960s.

22. Sanford Hirsch and Mary Davis MacNaughton, "Adolph Gottlieb: A Retrospective" (New York: Hudson Hills, 1981), p. 17.

23. Mark Rothko, "Commemorative Essay," delivered at the New York Society for Ethical Culture, January 7, 1965; reprinted in Adelyn D. Breeskin, "Milton Avery" (Washington: The National Collection of Fine Arts, Smithsonian Institution, 1969), n.p.

24. Unsigned, *New York Times,* December 22, 1935, quoted in Hirsch and MacNaughton, "Adolph Gottlieb: A Retrospective," p. 129.

25. Braddon and Rothkowitz, *The Ten: Birth of the American Avant-Garde,* back cover.

26. Lawrence, "The Ten," p. 12.

27. Jacob Kainen, "Our Expressionists," *Art Front*, February 1937, pp. 14-15.

28. John Graham, *System and Dialectics of Art* (New York: Delphic Studios, 1937), p. 94.

 In 1945, Graham turned against Picasso with the same passion as he once hailed him. He accused him of being a fraud. He also denigrated "primitive" as an underdeveloped stage in human evolution and Cézanne as a bore. Consequently, Graham became irrelevant in the Modernist art world.

29. Irving Sandler, "Conversations with de Kooning," *Art Journal,* Fall 1989, pp. 216-217.

30. John Graham, *System and Dialectics of Art* (New York: Delphie Studios, 1937), p. 97.

31. Ibid, p. 15.

32. John D. Graham, "Primitive Art and Picasso," *Magazine of Art*, April 1937, pp. 237-239.

33. Clement Greenberg, "New York Painting Only Yesterday," *Art News,* Summer 1956, p. 84.

34. Alfred H. Barr Jr., "Cubism and Abstract Art" (New York: The Museum of Modern Art, 1936), p. 200.

35. Alfred H. Barr Jr., "A Brief Guide to the Exhibition of Fantastic Art, Dada, Surrealism" (New York: The Museum of Modern Art, 1937), n.p.

36. See Sanford Hirsch, *Adolph Gottlieb and Art in New York in the 1930s* (New York: Hudson Hills, 1994), pp. 19-20.

37. Whitney Darrow, quoted in B. H. Friedman, *Jackson Pollock: Energy Made Visible* (New York: McGraw-Hill, 1972), p. 25.

38. Clyfford Still, letter to Mrs. Elizabeth Ames, former Executive Director of Yaddo, Yaddo Archives, Saratoga Springs, N.Y. Quoted in Stephen Polcari, *Abstract Expressionism and the Modern Experience* (Cambridge: Cambridge University Press, 1991), p. 91. The titles of a number of Still's pictures in his show at the San Francisco Museum of Art show in 1943 are of American scenes. See Polcari, *Abstract Expressionism,* footnote 22, p. 379.

39. Benton, *An Artist in America,* 1951 edition, quoted in McCoubrey, *American Art 1700-1960,* p. 201.

40. See David A. Anfam, *Clyfford Still,* thesis submitted for the degree of Ph.D., Courtauld Institute of Art, University of London, 1984, footnote 139, p. 270.

41. Frederick Jackson Turner, "The Significance of the Frontier," in R. A. Billington, ed., *Frontier and Section: Selected Essays of Frederick Jackson Turner* (Engelwood Cliffs, N.J.: Prentice Hall, 1961), pp. 38, 62, 37, and 61. Quoted in Polcari, *Abstract Expressionism,* p. 10.

42. Thomas Hart Benton, *An American in Art* (Lawrence: Kansas University Press, 1969), p. 148.

43. Ibid., pp. 155-156.

44. David Anfam, *Clyfford Still: Paintings 1944-1960* (New Haven, Conn.: Yale University Press, 1998), p. 42.

45. Clyfford Still, statement, in *The Hirshhorn Museum and Sculpture Garden,* Ed. Abram Lerner (New York: Harry N. Abrams, 1974), p. 752.

46. Letter from Murray W. Bundy to David Anfam, February 23, 1978, quoted in Anfam, "Clyfford Still's Art: Between the Quick and the Dead" (Washington: Hirshhorn Museum and Sculpture Garden, and New Haven, Conn.: Yale University Press, 2001), p. 21.

47. Anfam, *Clyfford Still,* p. 26.

48. Ibid.

49. Ibid., p. 28. See also Thomas Albright, "The Painted Flame," *Horizon,* November 1979.

50. Meyer Schapiro, review of Diego Rivera and Bertram D. Wolfe, *Portrait of Mexico,* in *Marxist Quarterly,* October-December 1937, pp. 462-66.

51. Pete Hamill, "Beyond the Vital Gesture," *Art & Antiques,* May 1990, p. 114.

52. In 1930-1931, the Metropolitan Museum of Art mounted a major exhibition of "Mexican Arts," which included paintings by Rivera, Orozco, and Siqueiros as well as pre-Columbian artifacts, Indian crafts, votive paintings, and Colonial portraits.

 The Mexican masters were often to be found in New York. Diego Rivera visited in 1931 during his show at the Museum of Modern Art. Siqueiros came in 1932, was deported, and returned in 1934. He established his experimental workshop in 1936. Orozco was in New York from 1927 to 1934. He painted the New School Mural in 1930 and the Dartmouth murals from 1932 to 1934. In 1932, Alma Reed published a book on Orozco's murals in Pomona College in Claremont, California, and in the New School in New York. Orozco was given a show at the Museum of Modern Art in 1940. Siqueiros and Orozco participated in the American Artists' Congress against War and Fascism in 1936.

 Despite his rejection of their politics, Benton admired the national and ethnic references in the work of the Mexicans and the epic treatment of their subjects.

53. Robert Storr, "A Piece of the Action," in Kirk Varnedoe and Pepe Karmel, eds., *Jackson Pollock: New Approaches,* (New York: Museum of Modern Art, 1998), p. 51.

54. Charles Pollock, letter to William Rubin, 1966, in Terence Maloon, "The Art of Charles Pollock: Sweet Reason" (Muncie, Ind.: Ball State University Museum of Art, 2003), p. 13.

55. Robert Storr, "A Piece of the Action," p. 39.

56. Francis V. O'Connor, "The Genesis of Jackson Pollock: 1912-1943," Ph.D. dissertation, Johns Hopkins University, Baltimore, 1965, p. 31. The quote comes from an interview with Kathleen Shorthall of *Life,* November 2, 1959.

57. John D. Graham, "Primitive Art and Picasso," *Magazine of Art,* April 1937, pp. 237-238.

58. Adolph Gottlieb, letter to Paul Bodin, March 3, 1938, Adolph and Esther Gottlieb Foundation. Quoted in Sanford Hirsch, "Adolph Gottlieb and Art in New York in the 1930s," *The Pictographs of Adolph Gottlieb* (New York: Hudson Hills Press, 1994), p. 17.

59. The Museum of Modern Art's interest in Latin American art was fostered by the Rockefeller family, whose Standard Oil Company was heavily invested south of the border. Nelson Rockefeller was the coordinator of Latin-American affairs from 1940 to 1945.

CHAPTER 2

World War II: Mythmaking and Biomorphism

Catching up with Paris

As a result of the activities of New York museums, the American Abstract Artists, The Ten, Hofmann's school, John Graham, Milton Avery, and other charismatic figures, Modernist artists in New York in the 1930s attained a high level of sophistication. They did not turn away from French Modernism but assimilated it. They digested the painting of Mondrian and Kandinsky, arguably even more thoroughly than artists in Paris had. By the end of the decade, Greenberg wrote, "New York had caught up with Paris as Paris had not yet caught up with herself, and a group of relatively obscure American artists already possessed the fullest painting culture of the time."[1] Never before had this occurred in American art.

In 1939, World War II broke out, and in the following year France was defeated. Leading Parisian artists, prominent among them the Surrealists André Breton, Max Ernst, André Masson, Roberto Matta, Kurt Seligmann, and Yves Tanguy, fled to America.[2] As a consequence, New York replaced Paris as the international capital of art.

The war led Barnett Newman to believe that

> painting was dead [in] the sense that [the] world situation was such that the whole enterprise as it was being practiced by myself and by my friends and colleagues seemed to be a dead enterprise.... What it meant was that [we] had to start from scratch.... I felt that there was nothing in painting that was a source that [we] could use, and at the same time ... we had to examine the whole process.
>
> I felt that the issue in those years was: What can a painter do? The problem of the subject became very clear to me as the crucial thing in painting. Not the technique, not the plasticity, not the look, nor the surface: none of these things meant that much.... The old stuff was out.... It was no longer relevant in a moral crisis, which

is hard to explain to those who didn't live through those early years. I suppose I was quite depressed by the whole mess.[3]

In response to the war, particularly when the United States entered the conflict in 1941, Social Realists and Regionalists had their last gasp as "Artists for Victory," putting their art in the service of the war effort with gruesome illustrations of fiendish Japs, savage Nazis, and the like. These academic styles were still being promoted by the Museum of Modern Art, which mounted major shows of realist art well into the 1940s, including "Americans 1943: Realists and Magic Realists" and "Romantic Painting in America" (both in 1943). For their part, Modernist artists, such as Gorky, Baziotes, Motherwell, Rothko, Gottlieb, Pollock, and de Kooning, had earlier rejected backward-looking realist styles. They were undergoing a drastic and irrevocable change of sensibility, which would cause them to move in fresh directions and become the new avant-garde.

The advanced artists supported the Allied cause, but the war's savagery and suffering gave rise to an "imagination of disaster," to borrow a phrase from Henry James, a fearful and anxious state of mind.[4] The mass butchery brought into sharp relief the irrational side of humankind as inherent in its being, a side that had to be addressed in any art that aspired to be relevant. As Robert Motherwell summed it up, the avant-garde of the 1940s was "ill at ease in the universe."[5] Many artists covered up the traumas of the decade with a hopeful gloss in both their art and rhetoric. For example. Byron Browne said, "I do not view the world as a sad place …; therefore, my pictures are not of a pessimistic nature."[6] De Kooning, for one, was not taken in, commenting, "How could you be Apollonian in 1940; you could only be pathetic."[7] Significantly, the painting of the yea-sayers (with the exception of Hans Hofmann) is now neglected or forgotten.

A new way of seeing

Confronted with a world that seemed to have lost its reason, the new avant-garde artists were in a quandary. They faced what they repeatedly referred to as "the crisis." The then-dominant Modernist art, geometric abstraction, looked increasingly irrelevant in this traumatic time. Everything it stood for—rationalism, art-for-art's-sake, a brave new machine age, and the explicit or implicit futuristic vision of man and society as perfectible—ceased to be believable. New, or at least different, moves seemed necessary. But what could artists paint that would express the reality of this anxious time? How could they evoke humankind's condition in a world out of control? They began by asking what was responsible for this tragic state of affairs. Their answer: irrational drives and conflicts whose source was in the depths of the unconscious. Their search would have to be inward, into their *own* irrational selves. There they hoped to find images and symbols that would illuminate the human predicament.

Surrealism showed them the way because it proposed to explore the unconscious and appeared to reflect the surreal world situation. Matta, a charismatic Surrealist who befriended and influenced a number of young New York avant-garde artists, sought to uncover the artist's psychological response to the war in his painting *Years of Fear* (1941)—the title itself is significant. This nightmarish picture, predominantly gray, consists of a variety of stage sets that lurch in different directions on which stands a wraithlike figure about to be overwhelmed by a malevolent storm. Matta said,

> The apocalypse of the war wreaked havoc on the emotional system.… Everything in this painting was psychological: it was a deep wish to measure what can be felt. How to picture the battlefield, not the physical one but the one inside us.… An internal bombardment.[8]

Surrealism, then, assumed an importance for the New York avant-garde that it had lacked in the 1930s. Its aesthetic relevance was heightened by a growing interest in Freud and Jung. Psychoanalysis became the leading set of beliefs in advanced intellectual, cultural, and artistic circles in the early and middle 1940s, supplanting Marxism, which had dominated 1930s thinking. Psychological conjecture about neuroses and archetypes supplanted social discourse about the class struggle. The soapbox was replaced by the analyst's couch.

The Surrealists claimed that the exploration of the unconscious was more fruitful in revealing truths about human nature than the practice of conscious reason. Indeed, they scorned reason and the sense of order associated with it. The Surrealists argued, like the Dadaists before them, that if reason and the science and technology it gave rise to were at the core of Western civilization and if Western civilization had led to the bloodbath of World War I, then reason was the enemy of humankind and an alternative modus operandi had to be found. The Dadaists' strategy had been to systematically subvert Western culture. The Surrealists were less negative. Influenced by Freudian psychoanalysis, they sought to use art to plumb the unconscious for insights into the human condition, which they hoped would enable them to better it.

Like Freud, the Surrealists believed that entry into the unconscious realm of repressed memories and obscure impulses was blocked by conscious censors, which had to be circumvented. In order to do so, Freud devised the technique of free association, in which an analysand would blurt out whatever thoughts in the flow of consciousness came to mind. The Surrealists developed a visual counterpart to this psychoanalytic process—namely, accidental drawing and painting, or, as Breton termed it, "pure psychic automatism," in which artists employed spontaneous doodling to gain access to the hidden recesses of the unconscious, there to encounter images, symbols, and signs that would be externalized in painting.

The Surrealists identified rational picture-making with Cubist-based abstraction, which they denounced as formalist art-for-art's-sake. Critic and poet Nicolas Calas, a spokesman for Surrealism,

maintained that automatism "destructured the structured, [made] of inner conflicts a source of insight [and made art into] a vehicle for conveying messages with an emotional impact. It was not a craft for the crafty."[9] Automatism was especially valued because it yielded biomorphic images that seemed to have originated in the psyche and that referred to viscera and their physical functions. "Human" organic inventions were considered the antithesis of "inhuman" geometric designs.

The theory of automatism as a way into the inner world, which Breton had proposed in 1924, was familiar to the avant-garde in New York. In 1937, John Graham had written about the pivotal role of the unconscious in art-making and how it could be tapped.[10] And artists had been able to view Surrealist works in considerable numbers in New York galleries and at the Museum of Modern art, notably in its survey of Dada and Surrealism in 1936. Moreover, many of the artists had read James Joyce's *Ulysses* and were impressed by his stream-of-consciousness technique. Nonetheless, it was only in the early 1940s that the avant-garde began to rely heavily on "the intuitive prompting of creation, and … the subconscious impulse," as Goldwater recalled.[11]

There were two main approaches to automatism. One, favored by most Surrealists, was exemplified by Salvador Dalí's "hand-painted dream photographs" in which doodling was concealed under an old-masterish veneer. The other was exemplified by André Masson's and Matta's painting, in which spontaneous drawing was exposed in the completed work. Within the Surrealist coterie itself there was a sharp difference of opinion over the role of automatism. Breton claimed that it was the primary Surrealist technique, but that the artists in his circle had exerted growing "control" over it, which meant consciously "finishing" a picture, as Dalí and Yves Tanguy had. Matta, who had joined the Surrealists in 1938 and become an energetic and vocal young adherent, opposed Breton and declared that Dalí's and Tanguy's paintings constituted an academic dead end. He claimed that Surrealism, "which means to show the functioning of the mind," could remain vital only by revealing the evidence of automatism on the surface of the painting.[12] The New York avant-garde of the forties agreed. In 1945, Newman, voicing Rothko's and Gottlieb's views, declared that academic Surrealism was passé. He objected to its "use of old-fashioned perspective, its high realism, its preoccupation with the dream. [It] was narrow and had become sterile."[13]

Challenging Surrealism's old guard, Matta sought to enlist American artists in a campaign on behalf of automatism. From October 1942 through the following winter, he, Motherwell, Baziotes, Gerome Kamrowski, and Peter Busa met several times to explore the possibilities of automatism, but when Matta lost interest in the group, it fell apart. However, growing numbers of artists were persuaded that automatism could provide "a new way of seeing as well as new things to be seen," as Greenberg observed.[14]

The advanced New York painters made use of accidental drawing and painting, but they recognized that reflection and critical appraisal were required to invest a painting with a convincing sense of emotional truth and a cogent pictorial structure. Actually, their painting was more improvisational than spontaneous. As Motherwell said, a painter ought to begin involuntarily by employing automatism with "'no moral or esthetic *a priori* prejudices [and] when the picture finds its own identity and meaning, one suppresses what one doesn't want, adds and interprets as one likes, and 'finishes' the picture according to one's esthetic and ethic." The "last stage of interpretation and self-judgment is conscious."[15] Accordingly, Motherwell said that the term "plastic automatism" rather than "psychic automatism" better described his artistic practice and that of his fellow avant-garde painters.

A concern with "plasticity," which meant formal values, separated the New York avant-garde from the émigrés. The local artists aspired to create high art—that is, art of quality—and this goal informed their picture making. They wanted to emulate the artistry of past masters and like them produce art-for-the-ages. Matta recognized the difference between himself and his American friends when he said, "They were very professional. They knew a great deal! As a matter of fact, they knew even more than we Surrealists knew about art history. Their studios were covered with reproductions of pictures pasted to the walls, while in our case there was not so much reference to these things."[16]

In contrast to the New Yorkers, Breton and his acolytes maintained that the Surrealists' primary purpose was to transform humankind and society. With the exception of Miró and Masson, they looked down on artful painting as a "lamentable expedient." Calas asked, "'What is there worth saying that is worth saying for art's sake?' The Surrealist answer is: NOTHING."[17] Georges Hugnet stressed this point, asserting that Surrealist works "leave no loophole for formal preoccupations.… The absence in their creation of all plastic endeavor must be borne in mind. [Neither] the paintings nor the objects have any intended connection with art."[18] Moreover, the Surrealists ridiculed the masters of Modernism as "pastry cooks" and "men with a profession." Breton put down Matisse as "an old lion, discouraged and discouraging."[19]

Masson, however, disapproved of the anti-aesthetic attitude of his fellow Surrealists. He attributed it to the fact that Surrealism was essentially a literary movement whose leading figures had little understanding of pictorial structure, color, and other formal qualities. Gorky, who had been admitted into the Surrealist circle, agreed with Masson. In a 1947 letter to his sister Vartoosh, he wrote, "Surrealism is an academic art under disguise and anti-aesthetic and suspicious of excellence and largely in opposition to modern art.… To its adherents the tradition of art and its quality means little." He also found the Surrealists' discourse "somewhat flippant, almost playful. Really they are not

as earnest about painting as I should like artists to be…. Art must be serious, no sarcasm, comedy. One does not laugh at a loved one."[20]

The New Yorkers found Surrealist painting, except Miró's, inferior, even that of its more abstract practitioners, Matta and Masson. But the ideas of the Surrealist painters were useful to the Americans because they revealed the possibilities of automatism and improvisation and provided a rationale for it.

Learning how to be heroic

The growing influence of Surrealism was due partly to the presence in New York of leading émigré artists. They possessed a flair for promotion and a knack for generating excitement, becoming a lively force on the local art scene. In 1942, they published the first issue of *VVV*, a Surrealist journal, and organized "Artists in Exile" at the Pierre Matisse Gallery and "First Papers of Surrealism" at the Reid Mansion on Madison Avenue, for which Duchamp crisscrossed the exhibition space with 16 miles of white string, a maze that received widespread publicity and made the émigrés notorious. Moreover, in 1942, Peggy Guggenheim, who was married to Max Ernst, opened the Art of This Century Gallery, a Surrealist environment designed by Frederick Kiesler, which soon became a fashionable venue and a focal point of émigré activities. To top it off, Dalí and Miró were given major shows at the Museum of Modern Art.

Breton accepted a number of New Yorkers into the Surrealist coterie, among them Baziotes, Gorky, David Hare, Motherwell, Busa, Kamrowski, and Isamu Noguchi. But the Europeans tended to patronize the Americans and did not mix much with them, preferring to keep to themselves.[21] Nonetheless, the Art of This Century Gallery, while featuring Surrealist émigrés, also gave one-person shows to Baziotes, Hofmann, Motherwell, Pollock, Pousette-Dart, Rothko, and Still.

Surrealist highjinks irritated the New York avant-garde artists, reared as they had been in the serious polemics of the Depression thirties. The Americans were also put off because much of academic Surrealist art had become sensationalist, readily co-opted by Hollywood and the fashion and advertising industries. Yet the stance of the émigrés set an example for the American avant-garde. As Goldwater wrote, the visitors were

> international in character, "bohemian" in a self-confident, intensive fashion possible (after so many depressing years) to none of the New York artists, living *as if* they had no money worries…. Moreover, as the latest in a long line of romantics, they accepted this situation as a condition of creativity, and made of it a positive virtue…. Artists of considerable reputation, they transmitted a sense of being at (or simply of being) the artistic center…. New York was at the head of the procession, there was nowhere else to look for standards or models.[22]

Meyer Schapiro observed that the American avant-garde learned from the Surrealists-in-exile how to be "heroic."[23] Their presence gave the New Yorkers the confidence to stop imitating imported styles or at least to entertain the idea. Several, such as Rothko, Gottlieb, and Newman, began to think about forging an independent American art—an urge that would grow stronger as the 1940s progressed.

If the local avant-garde artists rejected academic Surrealism, they acknowledged its relevance in the early 1940s. As Newman wrote, "The horror they [the Surrealists] created and the shock they built up were not merely the dreams of crazy men. [They] showed us the horror of war [and] were the "superreal" mirror … of the world of today."[24]

Advanced New York painters quickly found their way to the cutting edge of Surrealism and in a sense moved *beyond* it by using their variants of automatism to arrive at levels of abstraction that the Surrealists would not accept. In 1944, Newman prophesied that the art of the future might be a combination of Surrealism and abstraction.[25] So did Sidney Janis, who, in *Abstract and Surrealist Art in America* (1944)—which he considered the two mainstreams in American art—pointed to their merging. He said that Surrealism and abstraction had often been thought of as antagonistic, but a number of Americans, including Pollock and Hofmann, were joining elements from each.

The year before, Samuel Kootz, in *New Frontiers in American Painting* (1943), with Rothko and Gottlieb among other artists in mind, declared that Expressionism, broadly defined, was more significant than Surrealism in the development of American art. He concluded that one could predict the future of art "if [one] knew the ultimate potential of Abstraction and Expressionism."[26]

In 1945, Robert M. Coates of the *New Yorker* recapitulated and connected the views of Kootz and Janis. He wrote:

> There is a style of painting gaining ground in this country which is neither Abstract nor Surrealist, though it has suggestions of both, while the way the paint is applied—usually in a pretty free-swinging, spattery fashion, with only vague hints of subject matter—is suggestive of the methods of Expressionism. I feel that some new name will have to be coined for it, but for the moment I can't think of any. Jackson Pollock … and William Baziotes are of this school.[27]

The following year, Coates reiterated "that a new school of painting is developing in this country."

> It partakes a little of Surrealism and still more of Expressionism, and … one can make out bits of Hans Arp and Joan Miró floating in it, together with large chunks of Picasso and occasional fragments of such more recondite influences as the ancient Byzantine painters and mosaicists and the African Negro sculptors. It is more emotional than logical in expression. [It] can't escape attention.[28]

"Gorky, the Ingres of the unconscious"

Gorky had long endeavored to assimilate modern European painting. He was able to meet a number of its creators when he was accepted into the Surrealist émigré coterie. In the late 1920s and 1930s, he had unabashedly imitated the works of a succession of artists, beginning with Monet and Cézanne, progressing to Picasso and Miró, and finally to Kandinsky and Matta. This self-education in modern art pointed him toward the creation of an abstract Biomorphism. But Gorky was also using these masters as surrogates in a search for his own artistic identity. Gorky's subject matter was rooted in memories of his Armenian boyhood, an idyllic life terminated by genocide. Between 1915 and 1918, over a half million Armenians, including many of Gorky's relatives, were massacred by the Turks, and a million more went into exile. In 1919, at the age of 17, Gorky himself endured a 150-mile death march, after which his mother died of starvation in his arms.[29] Then in the next year, he and his younger sister made their hazardous way to the United States.

Gorky's biographer Hayden Herrera wrote that the artist "believed that the traumas he had experienced in Armenia had made him 'privy to mankind's evil secrets' and enabled him to feel more intensely than other human beings."[30] As if in response to the crushing events of his formative years, he changed his name from Adoian to Gorky (the bitter one) and Vosdanig to Arshile (Achilles—who waited aggrieved in his tent for some sign that he was recognized and needed).[31]

The death of Gorky's mother was the defining moment of his life, and later, of his art. Not only did he adore her, but he identified her with the cultural and tragic experience of the Armenian people.[32] Beginning in the middle 1920s, allusions to her appear in many drawings and paintings, as though through his art he could snatch her "out of the pile of corpses to place her on a pedestal," as Nouritza Matossian wrote.[33] Two versions of *The Artist and His Mother,* based on an old photograph, which Gorky worked on from roughly 1926 to 1936 show the eight-year-old Gorky standing beside his disembodied mother, who wears her apron like a shroud, her face staring out, recalling the funerary portraits on the lids of Fayyum coffins.

As early as 1929, Gorky's self-education in modern art had progressed to his version of Picasso's and Braque's Synthetic Cubism, into which he incorporated Miróesque organic shapes. Paintings, such as a series titled *Nighttime, Enigma, and Nostalgia* (1931-1932), are early attempts to synthesize Cubist picture making and Surrealist-derived biomorphic invention. For the remainder of the 1930s, he continued to develop this approach in heavily pigmented abstract paintings.

In 1941, Gorky began to rely increasingly on automatism, arguably the first of the American avant-garde artists to do so, employing the technique to "melt down" Cubist composition. Three paintings titled *Garden in Sochi* (1940-1943) chronicle his growing spontaneity. In the first of the series, the imagery is Miróesque but the paint-laden surfaces recall Gorky's 1930s abstractions.[34] A

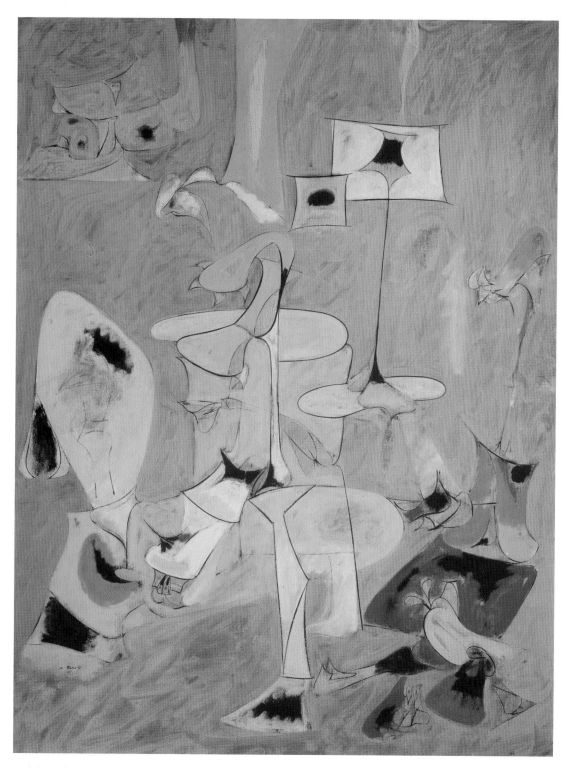

Arshile Gorky 1904-1948
The Betrothal, II, 1947
Oil on canvas, Overall: 50 3/4 x 38 in. (128.9 x 96.5cm)
Framed: 51 3/16 x 39 x 1 15/16 in. (130 x 99.1 x 4.9cm)
Whitney Museum of American Art, New York;
Purchase 50.3
© 2008 Artists Rights Society (ARS), New York

second version is thinly painted, more directly influenced by Miró's paintings. But the third canvas displays the style for which Gorky is best known.[35] Now influenced by Matta's and Kandinsky's improvisation, Gorky detached the drawing in his painting from the color. The linear elements, spontaneously doodled, seem to meander, and the color areas are fluid and spill over the surface. As if possessed by memories and psychic pressures, Gorky improvised abstract amalgams of human, animal, and plant parts, a new order of "hybrid" organisms, as Breton characterized them.[36]

The subject of the *Garden in Sochi* series is the Gorky family's garden in Armenia. The canvases are both lyrical and melancholy, representing, as Gorky said, "our beautiful Armenia which we lost and which I will repossess in my art."[37] Gorky also characterized the painting as his "garden of wish fulfillment." Yet it was dominated by a dead "holy" tree, metaphorically Christ crucified, and by extension, the artist's mother.[38] Each of the *Garden in Sochi* paintings has as its central image a traditional Armenian wooden shoe, like the pair of shoes given to the five-year-old Gorky when his father abandoned his family and emigrated to America.[39]

Of *How My Mother's Embroidered Apron Unfolds in My Life* (1944) Gorky recalled, "My mother told me many stories while I pressed my face in her long apron with my eyes closed. She had a long white apron like the one in her portrait [*The Artist and His Mother*] and another embroidered one. Her stories and her embroidery keep unraveling pictures in my memory as I sit before a blank white canvas."[40] Gorky's abstract painting can be considered a disguise for subjects he found too dreadful to depict literally.[41]

If many of Gorky's images were based on memories of his Armenian boyhood, others were drawn directly from nature. The organic and biomorphic forms and mood of both kinds of painting are related. "While observing grasses, insects and the like, Gorky recalled traumatic and painful episodes in his life, which caused him to transform the natural phenomena."[42]

After 1946—that is, in the last two years of his life—Gorky endured a series of disastrous events. In January 1946, twenty-seven of his paintings were destroyed in a fire in his studio. In March, he was diagnosed with cancer and had a colostomy. In June, he was in an automobile accident that fractured two vertebrae, and, he temporarily lost the use of his painting arm. Then his wife had an affair with Matta. Overwhelmed by his suffering, both physical and psychological, Gorky committed suicide in 1948. His works during the last years, among them *The Limit, Summation,* and *Agony* (all 1947), became increasingly desolate, embodying his growing physical and mental pain.

Gorky was the first American avant-garde painter to recognize that "the vital task was a wedding of abstraction and surrealism," as Adolph Gottlieb observed, and that "out of these opposites something new could emerge."[43] The result was Biomorphist painting. Cubist-inspired design, shaped by feeling, provided an infrastructure for Gorky's fantastic hybrid imagery generated by

Surrealist automatism. He maintained a balance between formal demands, on the one hand, and on the other, the prompting of the unconscious, the pull of memories, and the pressures of his emotions. At the same time, Gorky obsessively refined his improvisational organic imagery by reworking a single theme in a series of pictures, not only for expressive but for formal purposes. Indeed, no matter how spontaneous Gorky's painting seems, his drawing and touch remain virtuoso. He was "the Ingres of the unconscious," as his student and his first biographer Ethel Schwabacher called him.[44]

In relying heavily on automatism, a relatively unexplored direction in Surrealist painting, in letting "unfinished" improvisation stand in the "finished" work, and in approaching abstraction, Gorky was in the vanguard of Surrealist painting—indeed, of international avant-garde painting. He moved from the derivative to the original and from the marginal to the mainstream, becoming the first American to create pictures that no longer looked provincial.

Nonetheless, Gorky's painting stopped short of nonobjectivity, most likely because it was denigrated by orthodox Surrealists as formalist. In his references to sex and in his cultivation of a mood of poetic reverie, his imagery can be characterized as Surrealist. Indeed, Breton claimed him for the movement, the last major painter he championed. By the time of his death in 1948, Gorky's work was no longer avant-garde. Psychoanalytic theory that had given Surrealist painting its cultural prestige was also dated. The painting had become too familiar to be radically new, but it could still be affecting. In Gorky's case, it was pervaded by a pathos unprecedented in American art.

"The realism of our time"

In the early forties, as he had in the thirties, de Kooning continued treating components of figural images as abstract parts in a search for content other than descriptive. Then in 1945, following Gorky's example, he adopted automatism and further dismembered the human body. *Pink Angels* (1945) was seminal. In it, a human figure is transmuted into a large, seemingly seated, pink biomorph that interacts with hacked-up anatomical parts that are overlaid with a web of scrawls. *Pink Angels* was painted in the year that Hiroshima and Nagasaki were destroyed, when the atom bombs, as de Kooning said, "made angels out of everybody."[45] Like Gorky's canvases, it remained in the ambit of Surrealism, but it ushered in de Kooning's radical Biomorphic Abstractions of the late 1940s.

Hofmann's imagery in the 1940s was extremely varied, ranging from vibrant Fauve and Expressionist inspired abstractions to abstractions derived from Synthetic Cubism, including combinations of the two kinds of painting. Central to his body of work in this decade were new Biomorphist abstractions, executed from 1944 to 1947, such as *Ecstacy* and *Gestation* (both 1947). They were composed of flat, ungainly anatomical and organic shapes with machine-like attributes. Hofmann's color

was generally high-keyed, but the palette in these New Biomorphist canvases, their exuberant titles notwithstanding, is often restrained and dissonant.

At the end of 1941, Baziotes, Pollock, Rothko, and Gottlieb began to rely heavily on improvisation. They acknowledged that the source of their practice was Surrealist automatism, but nonetheless found most Surrealist images—melting clocks, armpits, sexual motifs—superficial. Even when nightmarish, these subjects fell short of expressing the dire mood of the time. Painting had to be redefined. In Gottlieb's words:

> A vacuum was created and we had to start from scratch and make something essential to us. We had to take a big jump. What did we have to lose? We agreed to try certain mythic subjects, like Oedipus. We invented our own vocabulary. The important thing was what you wanted to express. What I was trying to express, I guess, was a sense of terror, loneliness, and isolation.[46]

Baziotes, Gottlieb, Pollock, and Rothko found new subjects in ancient myths, notably those of Greco-Roman origin, prompting Rothko to dub them the "Mythmakers."[47] They would join artists who had used myths for centuries to illuminate their lives and times. In short, myths possessed for the Mythmakers intellectual and cultural authority as well as contemporary relevance. As Gottlieb said, ancient myths express "to us something real and existing in ourselves." Their subjective interpretations would embody "the *realism* of our time."[48]

In their thinking, the Mythmakers were influenced by Jung's idea that "Oedipus is still alive for us … that there is an identity of fundamental human conflict which is independent of time and place. What aroused a feeling of horror in the ancient Greeks still remains true. An indissoluble link binds us to the men of antiquity."[49] The Mythmakers were particularly taken by Jung's notion of the collective unconscious as a repository of timeless and universal archetypes that continued to influence human behavior. Jung claimed that visual imagery took precedence over verbal texts in disclosing how the mind functioned. Symbols culled from the collective unconscious could be rendered flat, and hence they lent themselves to a modernist treatment. Consequently, Jung's theories were valued more by the Mythmakers than Freud's conception of dreams, which the Surrealists had been illustrating with academic techniques.[50]

Gottlieb recalled that "a great many writers, more than painters, were absorbed in the idea of myth in relation to art."[51] Both the Mythmakers and the writers, a number of them friends of the artists, found source material and justification for their use of mythic subjects in the writings of Friedrich Nietzsche, James Frazer, Edith Hamilton, and Jane Harrison and in articles in popular magazines. However, information was generally spread by word of mouth, disseminated by artists, such as Graham and Newman, who had studied the texts. Also influential was Joyce's *Ulysses* and T. S. Eliot's *The Wasteland*.[52] In a review of *Ulysses*, Eliot described Joyce's novel in terms that also applied

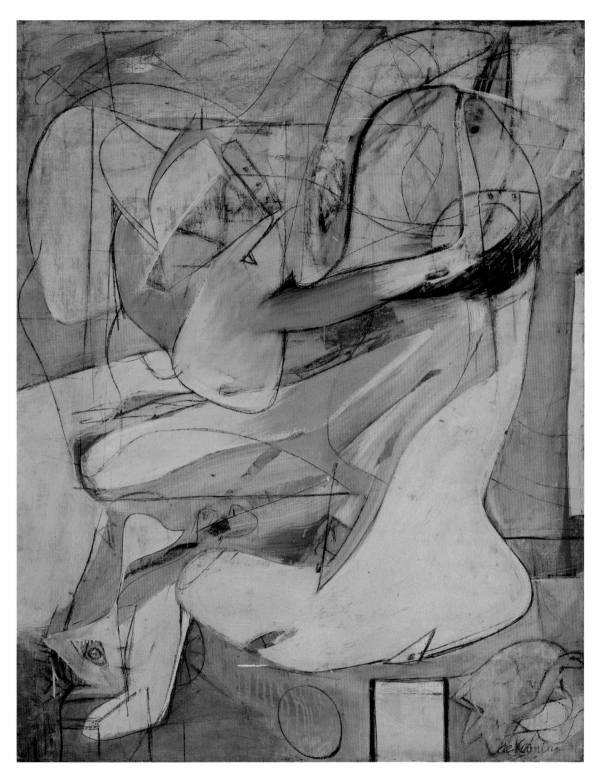

Willem de Kooning, *Pink Angels*
1945, oil and charcoal on canvas
52" x 40"
Frederick R Weisman Art Foundation, Los Angeles
Photo credit: Frederick R Weisman Art Foundation, Los Angeles
© 2008 The Willem de Kooning Foundation / Artists Rights Society (ARS), New York

to the Mythmakers: "In using the [Odyssey] myth, in manipulating a continuous parallel between contemporaneity and antiquity, Mr. Joyce is pursuing a method which others must pursue after him.… It is simply a way [of] giving a shape and a significance of the immense panorama of futility and anarchy which is contemporary history."[53]

The Mythmakers were attracted not only to ancient legends but to aboriginal art. This interest was not new. In the 1930s, Graham had familiarized advanced artists with the art of "primitive races and primitive genius," which he maintained "have readier access to their unconscious mind than so-called civilized people. It should be understood that the unconscious mind is the creative factor and source and storehouse of power and of all knowledge past and future."[54] Graham also claimed that "the art of primitive races is stored with all the individual and collective wisdom of past generations and forms.…" and "is the means and the result of getting in touch with the powers of our unconscious."[55]

Gottlieb and Rothko had anticipated their turn to "primitive" art as early as 1938, when as members of The Ten they questioned the tradition of European art, asserting that they strove to "see objects and events as though for the first time … divorced from the conventions of a thousand years of painting."[56] However, it was only after the shock of Pearl Harbor and the sense of terror it gave rise to that they and other avant-garde artists looked for inspiration to aboriginal art, which seemed to them to embody terror.

The Mythmakers were interested in all of "primitive" art but favored American Indian as well as Pre-Columbian and Eskimo works.[57] This interest was stimulated by shows at the Museum of Modern Art. In 1940, its "Twenty Centuries of Mexican Art," which was subdivided into four sections—Pre-Columbian art, colonial art, folk art, and modern art—revealed how contemporary Mexican painters were using native art and myth to create visually powerful pictures that had up-to-date social relevance.

The following year, the Museum of Modern Art mounted "Indian Art of the United States," the largest and most elaborate show in its history. Eleanor Roosevelt lent her name to the catalogue's foreword, which was actually written by the curator, René d'Harnoncourt. He apologized for the "brutal onslaught of the white invader" on the Indians which "was not merely a violation of intrinsic human rights but was actually destroying values that could never be replaced." D'Harnoncourt then stressed that the thousand objects on all three floors of the museum constituted "part of the artistic and spiritual wealth of this country."[58] Indeed, as Jean Charlot commented in a review of the show, no art could be more American than that of the Indians. They were, he wrote, "the hundred-per-centers of American art beside whom even [the Regionalists] acquire an immigrant flavor."[59]

Max Weber, in a letter to Barr, exclaimed that the distorted masks, totems, and pictographs in the exhibition revealed that "we have *real* Surrealists right here in America."[60]

In the early and middle 1940s, Indian motifs appeared in the pictures of Pollock and Gottlieb. Rothko also painted feathers and other forms that were associated with tribal culture, although he claimed that Indian art did not particularly interest him.[61] It is also noteworthy that Newman curated shows of Pre-Columbian art and Northwest Coast Indian painting in New York galleries, in 1944 and 1946, respectively, and wrote catalogue introductions to them.[62]

During World War II, the indigenous cultures of the Americas took on a new relevance, not only for the Mythmakers but for the American public and its leaders.[63] "Twenty Centuries of Mexican Art" and "Indian Art of the United States" had been heavily subsidized by the federal government for political reasons. In response to the threat of war and fears about America's national security, the Roosevelt administration embarked on a Good Neighbor policy of friendship with Central and South America. The United States' entry into the war in 1941 intensified the need for an internationalist outlook. In fact, Newman had organized the show of Pre-Columbian art partly to promote "inter-American understanding of our common hemispheric heritage."[64]

The Mythmakers were also impressed by the Surrealist émigrés' own interest in aboriginal art, which the latter esteemed because of its fanciful, magical, and erotic qualities and because it appeared to elevate the instinctual over the rational. Breton, Max Ernst, and Wolfgang Paalen, among others, collected these works. Paalen was so intrigued by tribal art that, on leaving German-occupied Paris, he traveled to Alaska and Canada to study Indian culture first hand. Settling in Mexico, he published the magazine *Dyn* (which was available in English in New York), in which he reproduced objects made by the Haida, Bella Bella, Bella Coola, Kwakiutl, and Nootka Indians. In "Amerindian Number" (1944), he wrote that "art can reunite us with our prehistoric past. [This] is the moment to integrate the enormous treasure of Amerindian forms into the consciousness of modern art."[65] Yet, much as the Surrealists valued "primitive" art, they seldom tapped it as a source of images. (An exception was Wifredo Lam.) The Mythmakers, in contrast, did so in the belief that aboriginal art might yield new subjects, forms, and meanings, which would make their imagery more relevant than Surrealist subjects in the war-torn world.

Times of the greatest terror

In 1943, at the low point in the war for the Allies, Gottlieb, Newman, and Rothko began to publicize their artistic intentions. They declared that the contemporary world was essentially as barbaric as past eras during which "primitive" art and ancient myths were created. Human beings, both then and now, were in thrall to apocalyptic external forces, on the one hand, and on the other, to irrational

instinctual impulses. They were powerless to control either and consequently suffered an inescapable feeling of anxiety.[66] Taking a cue from Jung, the artists declared that myths were embedded in humankind's collective unconscious and had always been used by people to contend with the terrors of the unknown. In their view, these age-old stories had had the power to grip and absorb people over the centuries and therefore were trans-historical or perhaps even universal. Consequently, the Mythmakers claimed that ancient myths continued to speak in their day and indeed could help make sense of the world. Rothko said that he discovered in myth

> eternal symbols upon which we must fall back to express basic psychological ideas … symbols of man's primitive fears and motivations, no matter in which land or what time, changing only in detail but never in substance, be they Greek, Aztec, Icelandic or Egyptian. And our modern psychology finds them persisting still in our dreams, our vernacular and our art, for all the changes in the outward conditions of life.[67]

In choosing particular ancient myths as subjects, the artists favored those that featured fearsome and tragic irrational acts of aggression, violence, and cruelty. Speaking for his fellow Mythmakers, Gottlieb imagined that "primitive" art was essentially terror ridden. As he said in a radio broadcast in 1943:

> If we profess kinship to the art of primitive man, it is because the feelings they expressed have a particular pertinence today. In times of violence, personal predilections for niceties of color and form seem irrelevant. All primitive expression reveals the constant awareness of powerful forces, the immediate presence of terror and fear, a recognition of the brutality of the natural world as well as the eternal insecurities of life. That these feelings are being experienced by many people throughout the world today is an unfortunate fact and to us an art that glosses over and evades these feelings is superficial and meaningless. That is why we insist on subject matter, a subject matter that embraces these feelings and permits them to be expressed.[68]

Similarly, Newman wrote in 1946 that he looked for inspiration to archaic culture because aboriginal man's first expression had been "a poetic outcry" of dread.[69] Shortly after the atom bombs were dropped on Japan, he wrote that "we who are living in times of the greatest terror the world has known are in a position to appreciate the acute sensibility primitive man had for it."[70] In 1947, Newman again envisioned the "primitive" artist's mind set:

> To him a shape was a living thing … a carrier of the awesome feeling he felt before the terror of the unknowable. The abstract shape was, therefore, real rather than a formal "abstraction" of a visual fact, with its overtones of an already-known nature. Nor was it a purist illusion with its overload of pseudoscientific truths.… The basis of an aesthetic act is the pure idea that makes contact with the mystery—of life, of man, of the hard, black chaos that is death, or the grayer, softer chaos that is tragedy.[71]

Newman concluded that "spontaneous, and emerging from several points, there had arisen during the war years, a new force in American painting that is the modern counterpart of the primitive art impulse.[72]

Although the Mythmakers felt a bond with "primitive" peoples because of shared feelings of terror and fear, they did not think that they had to reuse aboriginal images, although occasionally they did. On the whole, they employed improvisation to invent personal images, symbols, and signs.

In keeping with their sense of the "primitive"—and as a byproduct of their improvisational technique—the Mythmakers painted roughly. Newman applauded "primitive" art in which "the color is raw, stark, crude. There is little attempt to titillate the eye. [The] primitive artist [is] unconcerned with the decorative nature of shape, of form."[73] Moreover, as Gottlieb, with regard to his own work, remarked, he had "to destroy … the concept of what constituted a good painting at the time.… I felt that it didn't apply to anything I was interested in. I thought the standards were false."[74] Newman agreed that the pictures of the Mythmakers were antithetical to "virtuoso art where men of skill and taste, like skillful violinists, play with color, line, and shape as if they were elements of an instrument."[75] The crudeness of the Mythmakers' painting also distinguished it from the refined facture of the European Surrealists—for example, Dalí—or the well-crafted, neat, matte surfaces of the Cubists.

Pollock as Mythmaker

In 1940, Pollock turned from Regionalism to Modernism. His brother Sanford wrote to another brother, Charles, that Jackson has "finally dropped the Benton nonsense."[76] Pollock later said, "My work with Benton was important as something against which to react very strongly later on."[77] He had been impressed by Graham's 1937 article relating Picasso and "primitive" art and became friendly with him. In 1941, Pollock began to paint mythic pictures. The primary motifs in one such canvas, *Birth* (c. 1941), are grotesque faces appropriated from an illustration of an Eskimo mask at the beginning of Graham's article and rendered with an eye to Picasso's distorted faces. They are arranged vertically as a kind of Indian totem-pole, but they also evoke a goddess-like figure giving birth. It is noteworthy that Graham included this work in a show he curated at the McMillan Gallery in January 1942, marking Pollock's art-world debut.[78]

From the beginning of the forties, Pollock also looked to Surrealism. He said that he was "impressed with [the] concept of the source of art being the unconscious," a response reinforced both by Graham's ideas and by his own Jungian psychotherapy. Pollock adopted automatism but employed it with forceful Expressionist brushwork, which suited his temperament.

Aware that Pollock had been in Jungian analysis and had acquaintances who were steeped in Jungian thinking, art historians have argued about the role of Jungian symbolism in such paintings as *Male and Female* (c. 1942), *Search for a Symbol* (1943), and *Guardians of the Secret* (1943). The controversy centers on whether Pollock's depicted symbols were directly derived from Jung's diagrams. Pollock himself suggested that he was thinking in Jungian terms when he titled a painting *Search for a Symbol*. Some scholars, among them Elizabeth Langhorne, have claimed that Pollock's painting is replete with such symbols. Others, notably William Rubin, rejected interpretations that they believed overemphasized subject matter. Gerome Kamrowski, who, along with Matta and Pollock, experimented with automatism in 1942, recalled that rather than literally transcribing Jungian symbols, Pollock used them on behalf of self-expression.

Michael Leja persuasively negotiates the conflicting Langhorne and Rubin positions. He shows that a number of Pollock's symbols and images are clearly based on illustrations in Jung's texts, and that they offer just what Pollock "would have wanted:... symbolization as the language of the unconscious."[79] At the same time that he specifies Pollock's use of Jungian symbols, Leja identifies motifs—horses, bulls, tortured figures—in dozens of Pollock drawings of 1939-1940 that originated in Orozco's murals, Miró's biomorphic paintings, and, above all, Picasso's *Guernica* and his variations on Matthias Grünewald (published in *Minotaure*, a French Surrealist journal). Leja concludes, "Pollock's principal starting point was the symbolic, politically committed art of Picasso and Orozco [from which he took] the path to conceiving and representing the unconscious."[80] Pollock did not merely illustrate the symbols appropriated from Jung and Picasso but freely revised them, deliberately painting and repainting them.

The allover complex of abstract signs contained in the central rectangle in *Guardians of the Secret*—a key picture in Pollock's development—can be interpreted as Pollock's private metaphor for the unconscious. Resembling a canvas, it anticipates his later drip paintings.[81]

The impulsive abstract signs, scrawled letters, numbers, symbols, and images in Pollock's mythic pictures evoke both Greco-Roman myths and Native American legends. His titles provide general keys to his content, and several suggest mythic rites. *Moon Woman Cuts the Circle* (1943), for example, refers to an Indian tale and incorporates an image of an Indian's head with a feathered bonnet. Others canvases allude to Greco-Roman myths whose themes are bestiality and violence, among them *Pasiphae* (1943), first titled *Moby Dick*. Its subject is the orgiastic coupling of the sun god's daughter and a bull, the offspring of which was the Minotaur.[82] Pollock expressed the bestial actions of the lustful bull (or the killer whale) with savage brushwork. His original name for the canvas is significant. He owned a copy of Melville's novel and named his own dog Ahab.[83] It is noteworthy that in the 1940s, Melville, who had long been neglected, was rehabilitated by literary critics. His bleak vision was viewed as peculiarly American.

In his mythic paintings, such as *Male and Female* and *Guardians of the Secret,* Pollock used a composition of two vertical rectangles framing a horizontal, recalling Picasso's Synthetic Cubist layout, but he overlaid the design of discrete elements with improvisational motifs, open brushwork, and paint squeezed directly from tubes. Pollock's painting was certainly more hectic, abstract, and allover than Picasso's, its turbulent facture in keeping with his mythic and primitivistic themes.

In sum, Pollock used quasi-geometric design to exert control even as he demolished it in a way no Cubist had. He made automatism Expressionist in a way no Surrealist had. In effect, he reworked whatever motifs and compositions he borrowed from Cubism, Surrealism, and "primitive" art and made them his own.

A statement made by Pollock in 1944 is revealing for what it forecast about his development: "I have always been very impressed with the plastic qualities of American Indian art. The Indians have a true painter's approach in their capacity to get hold of appropriate images and in their understanding of what constitutes painterly subject matter. Their color is essentially Western, their vision has the basic universality of all real art." In remarking that the color of American tribal art was Western, Pollock did not specify whether he meant the American West, or Europe, or both. While asserting that Indian art was universal, Pollock also claimed it as his American heritage.[84]

Having called attention to the importance to him of indigenous American art, Pollock went on to ally himself with the most sophisticated international art: "I accept the fact that the important painting of the last hundred years was done in France.... Thus the fact that good European moderns are here is very important." However, he subtly deprecated the Surrealist émigrés, saying, "The two artists I admire most, Picasso and Miró, are still abroad." To those, he should have added Orozco, but he refrained, perhaps because the Mexican was not sufficiently modernist. Pollock concluded that "the idea of an isolated American painting, so popular in this country during the thirties, seems absurd to me."[85] Nevertheless, he admitted that as an American he could create only American art, just as Ryder had, who Pollock claimed was the only American master that interested him. Pollock also remarked on his "feeling" for the West, its "vast horizontality," anticipating the expansive space of his later drip paintings. In his statement, Pollock shrewdly voiced his desire to be considered both a globally minded Modernist and an American (of the prairie variety) painter, aware of both Indian and avant-garde art.

Pollock's unfettered and crude mythic paintings, devoid of urbane artifice and restraint, favorably impressed many avant-garde artists and critics of his own generation, although a significant number of more recent historians were less sympathetic to these works. At the time the mythic paintings were exhibited, Greenberg acclaimed Pollock as the strongest painter of his generation. So did Manny Farber in a long review in the *Nation,* and James Johnson Sweeney in the brochure of his first

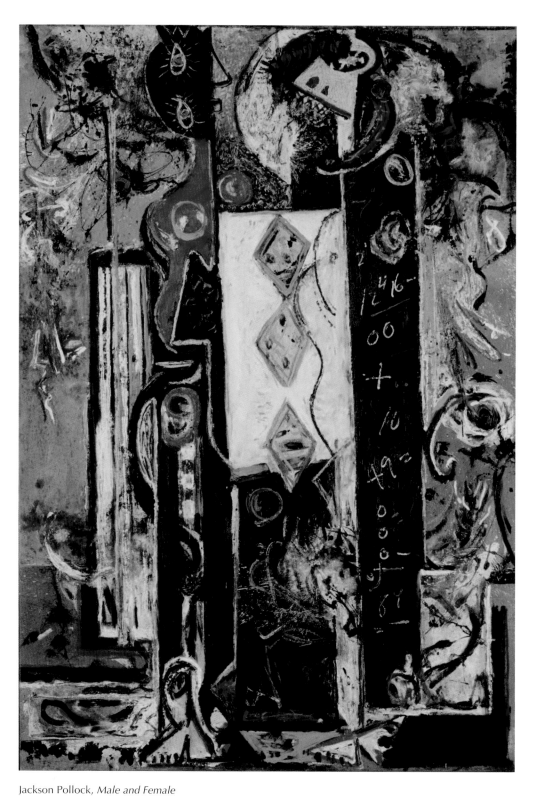

Jackson Pollock, *Male and Female*
1942-1943, oil on canvas
6' 1-1/4" x 4' 15/16"
Philadelphia Museum of Art, Philadelphia
Gift of Mrs. H. Gates Lloyd
Photo credit: The Philadelphia Museum of Art / Art Resource, NY
© 2008 The Pollock-Krasner Foundation / Artists Rights Society (ARS), New York

show in 1943. As Sweeney wrote, "Pollock's talent is volcanic.... Among young painters, [he] offers unusual promise in his exuberance, independence, and native sensibility."[86]

Gottlieb and Oedipus

Shortly after Pearl Harbor, Gottlieb abandoned his Avery-inspired figuration. He was strongly impressed by the imagery of a 12½-by 60-foot facsimile of the Basketmaker pictographs in Barrier Canyon, featured in the Museum of Modern Art's "Indian Art of the United States." Gottlieb then produced a series of his own *Pictographs*. The surface of each painting is divided by an allover, asymmetrical, freely drawn, rectilinear grid, reminiscent of the compositions of Joaquín Torres-Garcia and Mondrian. Gottlieb filled the compartments with flat symbols and signs: schematized fish, birds, and animals; eyes and teeth; eggs and ovals; arrows; and snakelike wiggles that call to mind motifs used by Klee, Picasso, and Miró, on the one hand, and on the other, designs on Indian pottery, blankets, and bark pictures, ancient hieroglyphs, and other archetypal emblems, all of them crudely rendered to give them an archaic look. Gottlieb used a process of free association to arrive at his disparate, disembodied fragments of myth and primitivistic symbols, to relate them to one another, and to situate them in the picture. He meant for the viewer to be as free as he was in linking and interpreting them. He did not intend for these motifs to add up to an explicit narrative but rather to evoke the sense of myth.

The first series of *Pictographs* was titled *Oedipus* (1941). Gottlieb probably chose the Oedipus theme because it had been treated by Freud and because it reflected the savagery and tragedy of the world at war. Gottlieb was stirred by the story of Oedipus' unknowingly slaying his father, marrying his mother, and blinding himself. Gottlieb's Oedipus pictures did include motifs suggestive of the myth, notably eyes. Eyes, in fact, were prominent in art that interested Gottlieb and fed into his own work—Egyptian hieroglyphics, Attic vases, and Northwest Coast, Oceanic, and African tribal art. Eyes coupled with hands also appeared in a number of Gottlieb's pictographs, metaphors most likely for the artist himself.

Rothko: "the spirit of myth"

Rothko turned away from Avery's American scenes in 1942 and began to employ "a free, almost automatic calligraphy," as he said, to interpret Greek legends.[87] His interest in myth was not new. In the late 1930s, Rothko had read Nietzsche's *Birth of Tragedy* and spoke often of its influence on him. In his earlier mythic pictures, Rothko improvised motifs suggestive of fragments of classical Greek sculpture and architecture. The best-known of these works is *The Omen of the Eagle* (1942), whose subject was derived from Aeschylus' tragedy *Agamemnon,* in the *Oresteia* trilogy. In the narrative, two eagles attack a pregnant rabbit and eat her fetus. The incident was the portent of the impending

battle between the Greeks and Trojans that culminated in the sacrifice of the virtuous Iphigenia.[88] Rothko sought not to illustrate "the particular anecdote" but to create an image that evoked the tragic and timeless "Spirit of Myth, which is generic to all myths of all time."[89] In the end, his aim was to express humankind's fears and destructive passions.[90] In later mythic pictures, Rothko enlarged his vocabulary by inventing fantastic hybrids composed of human, animal, bird, fish, insect, plant, protozoa, and other primitive, often aquatic, organisms that seem engaged in cryptic mythic or ritual activities.[91]

Baziotes: horror and humor

Baziotes was inspired by Picasso's retrospective at the Museum of Modern Art in 1939 and recalled, "Well I looked at Picasso until I could smell his armpits and the cigarette smoke on his breath. Finally, in front of one picture—a bone figure on a beach—I got it. I saw that the figure was not his real subject. The plasticity wasn't either—although the plasticity was great. No. Picasso has uncovered a feverishness in himself and is painting it—a feverishness of *death and beauty*." (Italics mine.)[92]

In 1941, Baziotes became friendly with the Surrealist émigrés, in particular Matta, and under their influence he began to improvise organic, mazelike abstractions. Around 1946, he reduced the number and enlarged the size of his shapes and, still improvising, transformed them into monsters. These biomorphic inventions are swollen, ungainly, and inert—unable to move—and are immersed in a watery atmosphere. They are both harrowing and humorous.

Deformity fascinated Baziotes wherever he found it—for example, in the Pre-Columbian sculptures of dwarfs he saw at the Museum of Natural History. They were one source for his misshapen images. He wrote about his painting *Dwarf* (1946):

> The strongest feeling about the picture is that it expresses a quiet horror and overall sensuous feeling....

> The figure is deformed. It appears to have no legs, nor arms. The arms are stumps. As I recollect several years ago, I owned a book of horribly maimed soldiers of the first World War. There was one picture I kept returning to. It was of a soldier who was [severed] at the waist, and whose arms were cut off.... I used to draw him *many times.*

> As I look at the circular form (eye) and jagged lines (teeth) underneath it, I think these forms are inspired from having looked at lizards and prehistoric animals. They have for me a particular fascination of their own, passive and yet so deadly. The eye [was] inspired by the eye of a lizard. The jagged lines [are] the grin of a crocodile which has a mixture of horror and humor.[93]

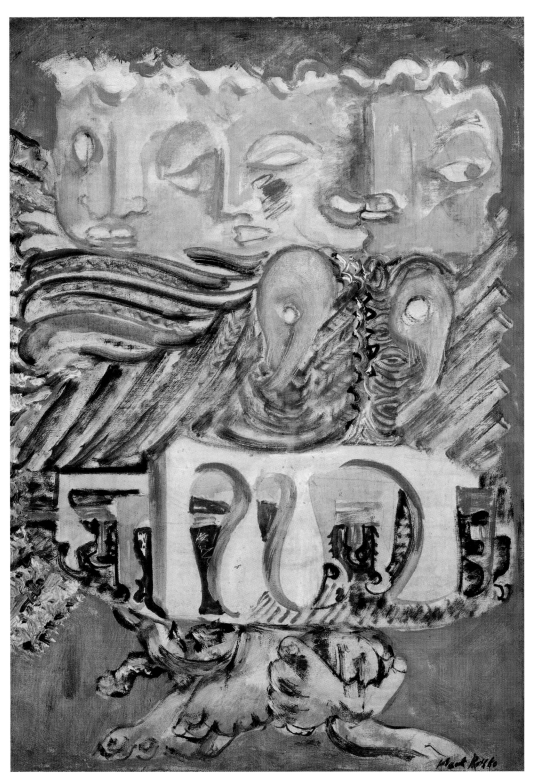

Mark Rothko, *The Omen of the Eagle*
1942, oil and graphite on canvas
25-3/4" x 17-3/4"
National Gallery of Art, Washington, D.C.

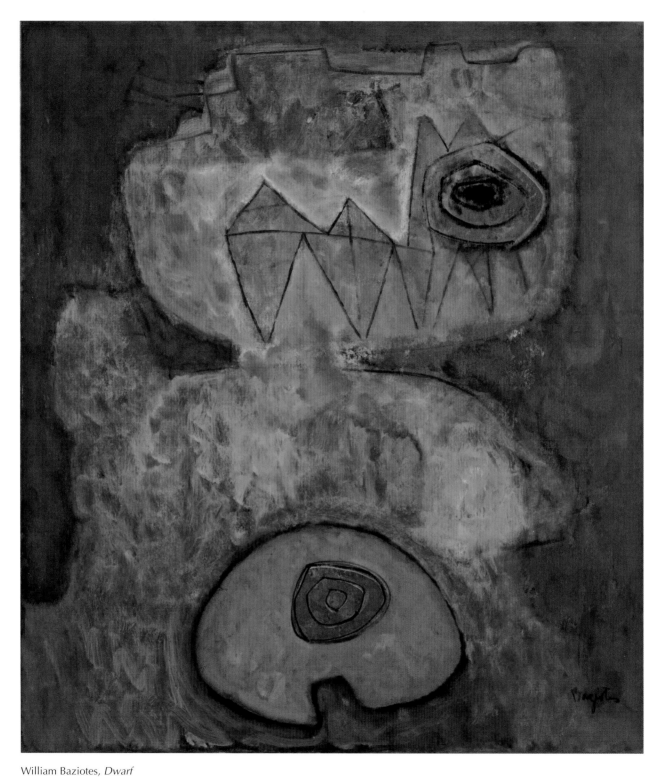

William Baziotes, *Dwarf*
1947, oil on canvas
42" x 36-1/8"
The Museum of Modern Art, New York

Baziotes was portraying a World War I soldier, but most likely he had World War II combatants in mind.

Baziotes' wife, Ethel, reported that the cryptic personage in *Cyclops* (1947) was suggested by a rhinoceros, eyes slung low, at the Bronx zoo. Baziotes thought of the rhinoceros as the living kin of primordial beasts and as a metaphor for the fearsome one-eyed giants of Greek myths, all of them symbolizing primal evil or, as in Baudelaire's words, "man's natural perversity which makes him forever and at once both homicidal murderer and hangman."[94]

Still: "Of the Earth, the Damned, and the Recreated"

Still's friend, Douglas McAgy, recalled, "From roughly 1940 to 1945 [Still's canvases] had occasional figurative elements—a dot for an eye which suggested a head."[95] The mood of the paintings was bleak. A colleague at the Richmond Professional Institute, where Still taught from 1943 to 1945, recalled that he had a "strange dark kind of bitterness which the paintings reflected."[96] Still came to New York in 1945 and had his first one-person show the following year at Peggy Guggenheim's Art of This Century Gallery. The paintings he exhibited are composed of heavy impasto applied with palette knives. The images are dark totemic presences—mouths gaping. In the introduction to the catalogue, Rothko wrote that Still's ominous and awesome abstract figures, which loom in the picture space, are "of the Earth, the Damned and of the Recreated."[97] Still himself gave the pictures mythic titles, among them *Buried Sun* and *Nemesis of Esther*.[98]

Newman: "What are we going to paint?"

During most of the 1940s, Newman was recognized not as an artist but as a writer on avant-garde art and esthetic issues, mainly in support of the Mythmakers, who were his friends.[99] In fact, from 1939 to 1945 he did not paint. He told Thomas Hess that with the world at war he had to rethink the whole problem of painting: "What are we going to paint? Surrealism? Cubism?"[100] After 1945, following the lead of Rothko and Gottlieb, he adopted a Surrealist-inspired biomorphism, which he titled after violent Greek myths: *The Song of Orpheus* and *The Slaying of Osiris*, both of 1945. In the following year, Newman began to reduce his composition, emphasizing simple vertical elements. He titled these abstractions after the Old Testament myth of the origin of the world, as in *The Word I* (1946), and, by extension, a new start in art. For Newman, the point of these works was the rejection of geometric abstractions. To make this intention clear, he titled two pictures, *Euclidian Abyss* (1946-47) and *Death of Euclid* (1947).

More Mythmakers

The idea of mythmaking was so persuasive at the time that vanguard artists who were not counted among the Mythmakers were influenced by them. Hans Hofmann painted *Idolatress* (1944), Willem de Kooning, *Orestes* (1947), and Robert Motherwell, *Pancho Villa, Dead and Alive* (1943), which he said was inspired by the Mexican José Posada's morbid "prints of skeletons and *danse macabre* subject matter.... They depict scenes of violent human emotions often involving suffering, assassination, and death."[101]

Sculptors, among them David Smith, Theodore Roszak, Seymour Lipton, Herbert Ferber, and Isamu Noguchi, who were close to the Mythmakers, also responded to the World War II and cold war mentality by using monstrous subjects. As early as 1939, in *Medals for Dishonor*, Smith took war as his subject. He said that *Medals* "probably grew out of a series of postcards I bought at the British Museum, showing special war medallions the Germans awarded in the First World War, medallions for killing so-and-so many men, for destroying so-and-so many tanks, airplanes, et cetera. [The] idea of 'medals for dishonor' became my position on awards. [Medals] are always about the same. It only depends on where you are born, where the killing is done."[102] In the mid-forties, Smith constructed *Jurassic Bird* (1945) and *Royal Bird* (1948), both based on the skeleton of a birdlike creature in the American Museum of Natural History.[103] Other of Smith's sculptures of the 1940s are violently psychosexual. In *War Landscape* (1947), a winged phallic cannon is a disturbing metaphor for aerial bombardment.[104]

Isamu Noguchi was also tormented by the war and by his relocation to an internment camp for Japanese-Americans. His concerns are revealed in *My Arizona,* a 1943 relief that refers to the battleship that was sunk by the Japanese at Pearl Harbor and to the state where the internment camps were located. Another relief, *This Tortured Earth* (1943), is a landscape that suggests a human body riven with violently gouged orifices, a few vaginal, suggesting both bombing and rape. In Noguchi's words, "*This Tortured Earth* was my concept for a large area to memorialize the tragedy of war. There is injury to the earth itself. The war machine, I thought, would be excellent equipment for sculpture, to bomb it into existence."[105] Noguchi's major piece of the war period, *Kouros* (1944-1945), a 9½ foot-high abstract figure, is composed of biomorphic segments carved from pink Georgia marble. Using the dominant technique of Western sculpture, Noguchi gutted humanist man.[106] When asked about its meaning, Noguchi spoke of "the recognition of his loneliness or tragedy."[107]

Roszak, Ferber, and Lipton invented predatory birds, insects, and animals. Roszak welded *Specter of Kitty Hawk* (1946-1947) and *Raven* (1947). Ferber's *Act of Aggression* (1946) and *Hazardous Encounter* (1947) are composed of threatening bonelike elements. Lipton's *Moby Dick II* (1946) is a voracious open maw; its gaping interior contains a great, phallic tooth-tusk-horn, poised to clamp

down or impale itself in a violent sadomasochistic self-destructive act. The great white whale is transformed into an abstract "symbol of destruction and … evil."[108]

The achievement of the Mythmakers

Art historians—myself included, in earlier writings—have implied that there was a larger social and psychological ambition implicit in the thinking of the Mythmakers. The artists were supposed to have reasoned, as I wrote,

> That if the problem with humankind was humankind itself, they might shed light on human nature—particularly its irrational, violence-prone, savage, and evil side—by investigating "primitive" societies and their culture, informed by psychological theory and with an eye to their own psychic makeup…. Perhaps the art that resulted from this search might even serve to ameliorate the spiritual malaise and alienation that afflicted humankind—and the artists themselves—and offer new hope for regeneration and redemption.[109]

I now think that my hopeful interpretation misstated their intentions.

I also find misleading the idea that the Mythmakers turned to American Indian art not because it embodied terror and fear but because it evoked spirituality and community. Michael Leja has pointed out that there was a paradox in thinking that primitive art could express both states of mind.[110] The Mythmakers recognized the communal aspects of the lives of indigenous people and were sympathetic to them. Newman, for example, wrote of the "healthy, primitive, well-integrated societies of the Northwest [in which] abstract painting was the standard tradition" in order to make a case for abstract art.[111] But almost every other statement Newman made focused on terror.

W. Jackson Rushing, in an article titled "The Birth of Tragedy out of the Spirit of Music" on the impact of the writings of Nietzsche and Jung on Newman, understood that the Mythmakers "shared a tendency to depict ritual violence or inherently violent myths," which he related to "the Dionysian vision … of the 'terrors and horrors of existence.'" But he then stated that the Mythmakers balanced the Dionysian vision with Apollonian order and reason, just as Greek myths had. Rushing declared that Newman, like Nietzsche and Jung, viewed "the world as tragic but redeemable through art."[112] Rushing's thesis reflects the wishful yearnings of historians, myself included at one point, more than it does the outlook of the Mythmakers in the 1940s. In the myth that inspired Newman's painting, *The Song of Orpheus* (c. 1945), the divine musician ends up torn to pieces by the madwomen of Thrace.[113] In a 1947 statement, Newman wrote that "original man, shouting his consonants, did so in yells of awe and anger at his tragic state, at his own self-awareness and at his helplessness before the void." Newman identified himself with this vulnerable "primitive" man who "traced the stick through the mud to make a line," much as Newman himself painted his vertical "zip" down his canvas.[114]

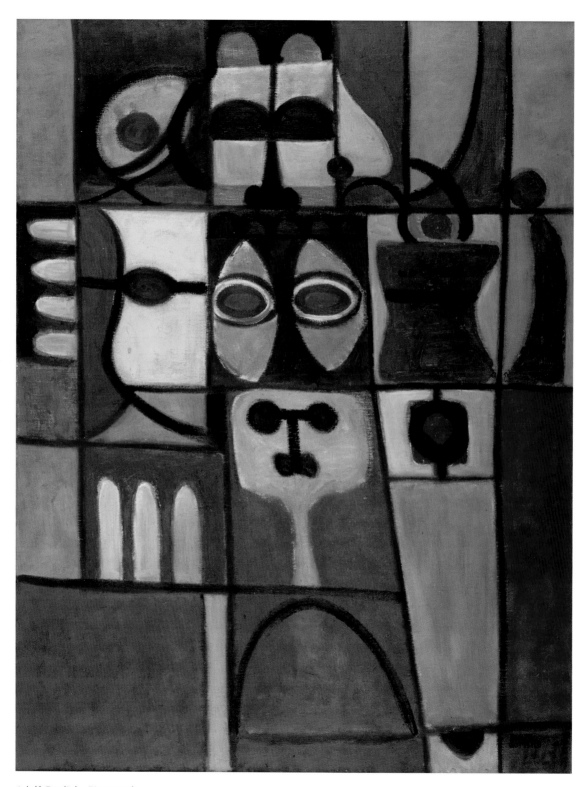

Adolf Gottlieb, *Pictograph*
1942, oil on canvas
48" x 36"
Adolph and Esther Gottlieb Foundation, NY

The atom bomb was the coup de grâce for Newman. In an unpublished article, "The New Sense of Fate," he wrote, "We now know the terror to expect. Hiroshima showed it to us.… The terror has indeed become as real as life. What we have now is a tragic … situation."[115] And where was the source of this inevitable fate to be found? "The self, terrible and constant, is for me the subject of painting."[116] Constant? Did Newman mean that human nature was "unchanging?" So it seems. He viewed humankind as weak and vulnerable, exposed to unfathomable events beyond its control or unforeseen results of its own actions. Occasionally, he suggested the possibility of redemption, but his primary emphasis was on relentless terror and tragedy, a state of mind he tried to embody in his color.[117] However, the Mythmakers did not succumb entirely to total despair. They were, after all, Apollonian enough in their outlook to continue painting.

In 1946, Albert Camus, whose Existentialist novels and essays were much admired by Mythmakers (as well as the Field and Gesture painters), offered a characterization of the last 300 years, "The seventeenth century was the century of mathematics, the eighteenth that of the physical sciences, and the nineteenth that of biology. Our twentieth century is the century of fear."[118] This was very much the pessimistic mood of the United States during the hot-and-cold-war forties, the mood that the Mythmakers sought to embody on their work.

In sum, the Mythmakers rejected the Social Realists' Marxist-influenced depiction of class struggle and the Regionalists' nationalistic accolades of agrarian America as dated, parochial, and banal. They also repudiated Cubist-based abstraction as either art-for-art's-sake and hence lacking in content, or utopian and hence unbelievable. The Mythmakers used improvisation, a Modernist technique, to create new and meaningful mythic and primitivistic near-abstract images that were at once personal, relevant during the 1940s, and universal (or so the artists believed). They recognized that their improvisational approach had its source in Surrealist automatism, but they claimed that their images were different—and more truthful and to the point in expressing the human condition in a terror-ridden time—than the psychological subjects of the Surrealists.

While embracing European Modernism, the Mythmakers distanced themselves from it by referring to Indian and Pre-Columbian art of the Americas, thus introducing an American aspect, but one that clearly differed from the Regionalist conception of "American."[119] On the other hand, because the Mythmakers' work was nearly abstract, it avoided any implication of nationalism. In short, the Mythmakers linked their private and subjective images with momentous calamities of the present, implanting their paintings in history, as urgent responses not only to a brutal war but also to myths, which, as Jung claimed, were timeless, transcending history. In their references to allegedly universal myths, the Mythmakers emphatically opposed the racial myths of the Nazis, and this distinction was of great significance to the artists.[120]

1. Clement Greenberg, "New York Painting Only Yesterday," *Art News,* Summer 1957, p. 85.

2. Matta and Ernst came to the United States in 1939; Dalí, Léger, and Mondrian in 1940; Ernst, Masson, and Breton in 1941; and Duchamp in 1942.

3. John P. O'Neill, ed., *Barnett Newman: Selected Writings and Interviews* (Berkeley: University of California Press, 1992), pp. 302-304. On p. 302, one can read Newman's description of what irrelevant subjects in painting were:

 > There was the kind of painting that was trying to make the world look beautiful.… There was also the kind of painting that was trying to be pure, based on Cubism, where the actual world didn't exist and the so-called paradise of pure forms functioned. It seemed to me that these things were futile enterprises.… On the other hand, you had the folklore artists who were doing the old oaken bucket: Tom Benton and all those old fellows out west. The Surrealists were also kind of beating a dead horse, because they were creating an imaginary world.

4. The "imagination of disaster" antedated World War II, shaping intellectual and cultural discourse as early as World War I. Indeed, the first global war created a rupture in Western civilization. The useless slaughter, the dishonorable peace treaty that followed, and the widespread corruption of postwar society provoked the nihilist mentality of the Dadaists in Europe and New York. In their indignation and despair, they waged war against humanist ideologies and sought to subvert every established convention of Western society and its culture, which they blamed for the wretched war.

 Just as the Dadaists were shaken by the war, so were the Surrealists who followed them. A number had fought in the trenches, Max Ernst on the German side, and on the French, André Masson, who was badly wounded and traumatized in 1917. Other artists and writers who fought were Max Beckmann, Georges Braque, Otto Dix, Paul Eluard, George Grosz, Oskar Kokoschka, and Fernand Léger. Guillaume Apollinaire, Raymond Duchamp-Villon, and Franz Marc were killed. See Martin Ries, "André Masson: Surrealism and His Discontents," *Art Journal,* Winter 2002, pp. 74-85. In large measure, the slaughter of the war was the cause of the irrationality of Surrealist art. For a time, post−World War I malaise was allayed by the Russian Revolution, which seemed to promise a Socialist future. However, utopian dreams dissipated as Communism degenerated into Stalinism, as Nazism and Fascism grew in power, and as the Republicans were defeated in the Spanish Civil War.

5. Robert Motherwell, "Symposium: What Abstract Art Means to Me," *Museum of Modern Art Bulletin,* Spring 1951, p. 12.

 Dore Ashton, who was close to many Abstract Expressionist painters, wrote in "Response to Crisis in American Art," *Art in America,* January-February 1969, p. 29, that "at that crucial point when America was drawn into a global war [they] worked out of a keen awareness of crisis [and] out of their deep sense of malaise."

6. Harry Rand, "Byron Browne: Paintings & Drawings from the 30's, 40's & 50's" (Roslyn, N.Y.: Nassau County Museum of Fine Art, 1987), p. 22.

7. Irving Sandler, "Conversations with de Kooning," *From Avant-Garde to Pluralism: An On-the-Spot History* (Lenox, Mass., Hard Press Editions, 2006), p. 35. The interview took place on June 16, 1959.

8. Elizabeth A. T. Smith and Colette Dartnell, "Matta in America" (Los Angeles: Museum of Contemporary Art, 2002), p. 17.

9. Nicholas Calas, "Surrealist Heritage," *Arts Magazine,* March 1968, p. 28.

10. See John Graham, *System and Dialectics of Art* (New York: Delphic Studios, 1937).

11. Robert Goldwater, "Reflections on the New York School," *Quadrum,* No. 8 (1960), p. 24.

12. Sidney Simon, "Concerning the Beginnings of the New York School: 1939-1943: An Interview with Peter Busa and Matta in December 1966," *Art International,* Summer 1967, p. 17.

13. O'Neill, *Barnett Newman: Selected Writings,* p. 95.

14. Clement Greenberg, "Surrealist Painting," *The Nation,* August 12, 1944, p. 193.

15. Robert Motherwell, "The Significance of Miró," *Art News,* May 1959, pp. 60, 66.

16. Simon, "The Beginnings of the New York School," p. 17.

17. Nicolas Calas, "Surrealism Hits Back," *Arts Magazine,* May 1968, p. 24.

18. Georges Hugnet, "The Exhibitions and Objects of Surrealism, 1936 and 1986," *Arts Magazine,* February 1986, pp. 60, 62-64.

19. William Rubin, "Arshile Gorky, Surrealism, and the New American Painting," *Art International,* February 1963, p. 27.

20. Arshile Gorky, letter to Vartoosh, January 17, 1947, quoted in Michael Fitzgerald, "Arshile Gorky's 'The Limit,'" *Arts Magazine,* March 1980, p. 113.

21. See Jimmy Ernst with Francine du Plessix, "The Artist Speaks: My Father, Max Ernst," *Art in America,* November-December 1968, p. 58. Ernst downplays the influence of the Surrealist émigrés, labeling Motherwell's interpretation "a myth."

22. Robert Goldwater, "Reflections on the New York School," *Quadrum,* No. 8, 1960, p. 24.

23. Martica Sawin, "The Cycloptic Eye, Pataphysics and the Possible: Transformations of Surrealism," in "The Interpretive Link: Abstract Surrealism into Abstract Expressionism (Newport Beach, Calif., Newport Harbor Art Museum, 1986), p. 41.

24. Barnett Newman, "Surrealism and the War," in O'Neill, ed., *Barnett Newman: Selected Writings and Interviews,* p. 95.

25. Barnett Newman, "Sobre el arte moderno: Examen y ratificacion," *La Revista Belga,* November 1944, pp. 18-32, reprinted in "Pre-Columbian Stone Sculpture" (New York: Wakefield Gallery, 1944) n.p.

 In 1945, Mark Rothko wrote in his artist's statement, "A Painting Prophecy—1950" (Washington, D.C.; David Porter Gallery, 1945) n.p., "I quarrel with Surrealist and abstract art only as one quarrels with one's father and mother, recognizing the inevitability and function of my roots, but insisting upon my dissension: I, being both they and an integral completely independent of them."

26. Samuel Kootz, *New Frontiers of American Art* (New York: Hastings House, 1943), p. 60.

 Other artists singled out by Kootz were Abraham Rattner, Max Weber, Paul Burlin, Carl Knaths, Jack Levine, Hyman Bloom, Joseph Solman, and Louis Shanker.

27. Robert M. Coates, "Assorted Moderns," *New Yorker,* December 23, 1944, p. 51.

28. Robert M. Coates, "In the Galleries," *New Yorker,* May 26, 1945, p. 68.

29. Karlen Mooradian, "The Unknown Gorky," *Art News,* September 1967, pp. 52-53.

30. Hayden Herrera, "Gorky's Self-Portraits: The Artist by Himself," *Art in America,* March-April 1976, p. 60. In letters as late as 1947, shortly before his suicide the following year, Gorky brooded over the Armenian genocide, the destruction of Armenian culture, and his urgent need to find images to embody his experience.

31. Julian Levy, *Gorky* (New York: Harry N. Abrams, 1944), p. 18.

32. See Melvin P. Lader, "Arshile Gorky's *The Artist and His Mother:* Further Study in Its Evolution, Sources, and Meaning," *Arts Magazine,* January 1984, p. 98.

33. Richard Dorment, "Genius in Exile," *The New York Review,* March 9, 2000, p. 4.

34. Hayden Herrera, in *Arshile Gorky: His Life and Work* (London: Bloomsbury, 2003), p. 359, writes that what I have considered the first version of *The Garden in Sochi* was the second.

35. See Rubin, "Arshile Gorky, Surrealism, and the New American Painting," p. 29.

36. André Breton, "The Eye Spring Arshile Gorky," "Arshile Gorky" (New York: Julien Levy Gallery, 1945), n.p.

37. Herrera, "Gorky's Self-Portraits," p. 60.

38. Donald Kuspit, "Arshile Gorky in the Thirties," "Arshile Gorky: Paintings and Drawings 1929-1942" (New York: Gagosian Gallery, 1998), p. 8.

39. Gorky's image of a shoe is also reminiscent of Miró's *Still Life with Old Shoe* (1937), which was exhibited at Miró's retrospective at the Museum of Modern Art in 1941.

40. Dorment, "Genius in Exile," p. 6.

41. Gorky's self-concealment may account in part for his name change and teaching of camouflage during World War II. Levy, Gorky's dealer, Foreword, to William Seitz, *Arshile Gorky: Paintings, Drawings, Studies,* (New York, Museum of Modern Art, 1962), p.7, labeled Gorky a "camouflaged man."

42. See Seitz, *Arshile Gorky: Paintings, Drawings, Studies,* p. 21.

43. Adolph Gottlieb, Introduction, "Selected Paintings by the Late Arshile Gorky" (New York: Kootz Gallery, 1950), p. 1.

44. Ethel Schwabacher, Foreword, *Arshile Gorky* (New York: Macmillan, 1957), p. 14.

45. Willem de Kooning, "What Abstract Art Means to Me," Museum of Modern Art Bulletin, Spring 1951, p. 7. Quoted in April Kingsley, *The Turning Point* (New York: Simon and Schuster, 1992) p. 211.

46. Adolph Gottlieb, handwritten notes of a conversation with the author, Provincetown, Mass., August 12, 1957.

47. Mark Rothko, "Clyfford Still" (New York: Art of This Century Gallery, 1946), n.p. In a 1946 letter to Louis Bunce, Pollock wrote favorably about the work of Baziotes, Gorky, Gottlieb, Rothko, and Pousette-Dart. He put down Byron Browne as "slick." Paul J. Karlstrom, "Jackson Pollock and Louis Bunce," *Archives of American Art Journal*, Vol. 24, No. 2, 1984, pp. 26-27.

48. Adolph Gottlieb, "The Ides of Art," *The Tiger's Eye*, No. 2, December 1947, p. 42.

49. Carl G. Jung, "Symbols of Transformation" (originally published as *Psychology of the Unconscious*, 1916) in *Basic Writings of C. G. Jung*, ed., V. S. de Laszlo (New York: Modern Library, 1959), p. 8. Quoted in Mary Davis MacNaughton, "Part II: The Pictographs, 1941-1953," *Adolph Gottlieb: A Retrospective* (New York: Hudson Hills, 1981), p. 36.

50. See Michael Leja, *Reframing Abstract Expressionism: Subjectivity and Painting in the 1940s* (New Haven: Yale University Press, 1993), p. 195.

51. David Sylvester, "Adolph Gottlieb," an interview, *Living Arts*, No. 2, 1963, p. 4.

52. Available to the Mythmakers were anthropological studies on "primitive" societies and culture by Franz Boaz, Lucian Levy-Bruhl, Ruth Benedict, Margaret Mead, Claude Lévi-Strauss, and Alfred Kroeber. A number of the artists perused the anatomical, biological, and botanical material found in D'Arcy Thompson's *On Growth and Form*. In 1938, Robert Goldwater's *Primitivism and Modern Art* was published; it dealt with Gauguin, Brancusi, Derain, Modigliani, and other primitivizers.

Above all, there was Picasso's representation of African sculptures in *Demoiselles d'Avignon*, which went on view at the Modern in 1939. See also Stephen Polcari, *Abstract Expressionism and the Modern Experience* (Cambridge: Cambridge University Press, 1991); Jeffrey Weiss, "Science and Primitivism: A Fearful Symmetry in the Early New York School," *Arts Magazine,* March 1983; and Kirk Varnedoe, "Abstract Expressionism," in *"Primitivism" in 20th Century Art* (New York: Museum of Modern Art, 1984).

53. T. S. Eliot, "Ulysses, Order and Myth," *The Dial*, November 1923, quoted in Dore Ashton, "About Rothko" p. 41.

54. John Graham, "Primitive Art and Picasso," *Magazine of Art,* April 1937, pp. 237-239.

55. Ibid.

56. "Statement," "The Ten: Whitney Dissenters" (New York: Mercury Gallery, 1938), n.p.

57. Pollock was interested primarily in Native American art. However, in 1946 he wrote that a show of "Art of the South Seas" "tops everything [every exhibition] that has come this way in the past four years." Jackson Pollock, "Letter to Louis Bunce," quoted in Paul J. Karlstrom, "Jackson Pollock and Louis Bunce," *Archives of American Art Journal,* Vol. 24, No. 2, 1984, pp. 26-27.

58. Frederick H. Douglas and René D'Harnoncourt, *Indian Art of the United States* (New York: The Museum of Modern Art, 1941), pp. 8-9.

59. Jean Charlot, "All American," *Nation,* February 1941, p. 165.

60. Max Weber to Alfred H. Barr Jr, February 1, 1941, in the records of the Indian Arts and Crafts Board, quoted in W. Jackson Rushing, "Marketing the Affinity of the Primitive and the Modern," in Janet Catherine Berlo, *The Early Years of Native American Art History. The Politics and Scholarship of Collecting* (Seattle: University of Washington Press, 1992), p. 221.

61. A few artists, notably Pousette-Dart, were attracted to Native American art because of its "spirituality."

62. As late as 1949, for a lecture at the Subjects of the Artist School, Newman chose as his topic the monumental prehistoric Indian burial mounds in Ohio.

 The Mythmakers were not the only artists who looked to Indian art, notably that of the Northwest Coast tribes. There was another group that has come to be known as the Indian Space Painters, among them Will Barnet, Robert Barrell, Gertrude Barrer, Peter Busa, Howard Daum, Oscar Collier, Ruth Lewin, Lillian Orloff, Sonia Sekula, Robert Smith, and Steve Wheeler, who used Native American signs and symbols as the subject matter of their art. Their aim was to create a spiritual art that was uniquely American. See Ann Gibson, "Painting Outside the Paradigm," *Arts Magazine,* February 1983, pp. 98-104. Although it has been alleged that these artists were painting pictures inspired by Indian art as early as 1942, they did not exhibit their works until the spring of 1946, at the Gallery Neuf in New York, at which time it was already outworn. A magazine titled *Iconograph* presenting their ideas was published soon after the show. Their work has been compared to that of the Mythmakers, and a major early article on Rothko was included in the first issue of the magazine. However, the comparison is superficial because Indian Space Painting was essentially the illustration of Indian signs reconfigured in Synthetic Cubist composition with an eye to Picasso, Miró, Klee, and Arp. As such it was a derivative and decorative style lacking the automatist approach that gave the art of the Mythmakers its direct, subjective dimension. Wheeler, however, stands out from this group. Moreover, Indian Space Painting tended to view Indian culture positively in its communal aspects. It is noteworthy that at the moment when the Indian Space Painters made their public entry, Pollock and Still, soon to be followed by Rothko, began to find the recognizable elements in their work commonplace and abandon them. The belated recognition of Indian Space Painting seems to me not so much a valid rehabilitation as an attempt by young historians to flesh out a multicultural agenda and by dealers to create a new market.

63. The New Yorkers preferred not to use African motifs, most likely to avoid the issue of race in the United States. See Kirk Varnedoe, "Abstract Expressionism," in *"Primitivism" in 20th Century Art,* Vol. 2, pp. 623-624.

64. Barnett Newman, "Pre-Columbian Stone Sculpture," *La Revista Belga,* August 1944, in O'Neill, ed., *Barnett Newman: Selected Writings,* p. 63.

65. Wolfgang Paalen, Introduction, *Dyn* (Amerindian Number), No. 4-5, Spring 1944, n.p.

 Paalen concluded that the result of primitivizing would be "a universal art [that] will help in the shaping of the new, the indispensable world-consciousness." He was more optimistic than the New Yorkers who, like him, looked to aboriginal art.

66. See Leja, *Reframing Abstract Expressionism,* p. 72.

67. Adolph Gottlieb and Mark Rothko, *The Portrait and the Modern Artist,* mimeographed typescript of a broadcast on "Art in New York," WNYC, New York, October 13, 1943, n.p. The idea that primitive man was essentially fear-ridden was frequently expounded in popular literature but was denied by the leading anthropologists at the time. Anthropologists also disagreed with the idea that there was a generic primitive man. In their interpretation of myths, the Mythmakers projected their own fears back in time onto aboriginal peoples. The Mythmakers did recognize the elan vital, communality, and spirituality of primitive societies, but they tended to minimize these aspects.

68. Gottlieb and Rothko, *The Portrait and the Modern Artist,* n.p.

69. Barnett Newman, "The First Man Was an Artist," *The Tiger's Eye,* October 1947, pp. 59-60.

70. Barnett Newman, "The Art of the South Seas," *Ambros Mundos,* June 1946, p. 70.

71. Barnett Newman, "The Ideographic Picture" (New York: Betty Parson Gallery, 1947), n.p.

72. Barnett Newman, "The Plasmic Image," in O'Neill, ed., *Selected Writings,* p. 144.

 The Mythmakers' motifs tended to be abstract because they were Modernist, but also because much aboriginal imagery was itself abstract. As Barnett Newman, in "The Ideographic Picture" (New York: Betty Parsons Gallery, 1947), n.p., wrote about the paintings of the Northwest Coast Indians, "Here then, among a group of several peoples the dominant aesthetic tradition was abstract. They depicted their mythological gods and totemic monsters in abstract symbols, using organic shapes, without regard to the contours of appearance." Newman also accounted for the abstraction in the Mythmakers' canvases by considering the images "Ideographic—Representing ideas directly and not through the medium of their names; applied specifically to that mode of writing which by means of symbols, figures or hieroglyphics suggests the idea of an object without expressing its name."

73. Ibid.

74. David Sylvester, "Adolph Gottlieb 1960," *Interviews with American Artists* (London: Chatto & Windus, 2001), p. 28.

75. Barnett Newman, "The Plasmic Image," in O'Neill, ed., *Selected Writings.*

76. Francis V. O'Connor, "Jackson Pollock" (New York: The Museum of Modern Art, 1967), p. 24.

77. Jackson Pollock, letter to Louis Bunce, 1946, in Paul K. Karlstrom, "Jackson Pollock and Louis Bunce," *Archives of American Art Journal,* Vol. 24, No. 2, pp. 26-27. Pollock wrote that he admired an "intelligent attack" on Benton, in an article by H. W. Janson. Janson, whose article appeared in *The Magazine of Art,* May 1946, indicted Regionalism for the affinities of its aesthetics to those of the Nazis. Pollock's negative comments were unfair because Pollock in fact owed far more to Benton than it implies.

78. Donald E. Gordon, William Rubin, and other historians consider *Birth* a seminal painting because it was the first to "break through" Picasso. See Donald E. Gordon, "Pollock's 'Bird' or How Jung Did Not Offer Much Help in Mythmaking," *Art in America,* October 1980, p. 44.

79. Leja, *Reframing Abstract Expressionism,* p. 172.

80. Ibid., p. 136.

81. Ibid., p. 129. Leja stresses that Pollock's symbols are based on free association, but only to a degree, as they show "clear evidence of deliberation.… The effect of spontaneity is not necessarily produced by spontaneity."

82. James Johnson Sweeney asked Pollock to change the title of a work from *Moby Dick* to *Pasiphaë.* It is noteworthy that André Masson had given this title to a canvas he painted shortly before Pollock's work.

83. My section on Moby Dick owes a debt to Evan R. Firestone, "Herman Melville's 'Moby Dick' and the Abstract Expressionists," *Arts Magazine,* March 1980, pp. 120-123. He discusses writers who linked Pollock and other artists with Melville. In 1943, Greenberg related the painter's "muddiness of color" to Melville's prose. Brian O'Doherty, a younger critic, coupled Pollock with Ahab. Pollock was not the only Mythmaker

to use Moby Dick as an exemplar of destruction and evil and Ahab as the image of the romantic artist. Other artists of his generation, such as William Baziotes and sculptors Seymour Lipton and Theodore Roszak, viewed Melville as a kindred spirit.

84. See W. Jackson Rushing, "Beauty and Danger: Jackson Pollock in Retrospect," *New Art Examiner,* June 1999, pp. 16-21.

85. Jackson Pollock, "Jackson Pollock" (answers to a questionnaire), *Arts and Architecture,* February 1944, p. 14.

86. Sweeney, "Jackson Pollock" (New York: Art of this Century, 1943), n.p.

 Kirk Varnedoe observed that "since the 1960s a wide consensus, even among Pollock admirers, has held that his figurative work of the early and mid-1940s is (regardless of any interest we may have in its subject matter, Jungian or otherwise) bad painting." For example, John Updike, in "Jackson Whole," *The New York Review,* December 3, 1998, p. 12, called the mythic pictures "ferociously ugly, the cluttered amalgams of a man putting brush to canvas in the wild hopes that a picture will emerge."

87. Mark Rothko, Statement (New York: Art of This Century Gallery, 1945), n.p. In 1969, Rothko inscribed the date 1938 on the back of *Antigone.* The date is questionable. The picture is signed Rothko but the artist did not go by the name "Rothko" until 1940. If Rothko had painted a mythic picture this early, he most certainly would have shown it, even privately, to his close friends Gottlieb and Newman, and they certainly would have commented on it. They did not. The earliest published date of a mythic picture is 1942, ascribed to *The Omen of the Eagle,* reproduced in Sidney Janis, *Abstract and Surrealist Art in America* (New York: Reynal and Hitchcock, 1944), p. 118. Rothko began to paint the mythic pictures in 1942, a fact confirmed by William Seitz and by Bonnie Clearwater, the curator of the Mark Rothko Foundation.

88. I am indebted to Erica Barrish's paper on Rothko's mythic iconography for a seminar I taught at Hunter College in spring 2004.

89. Mark Rothko, "Statement," 1943, in Janis, *Abstract and Surrealist Art in America,* p. 118.

 The very fragmentation of the classical figures could be taken as a sign of cultural dislocation. Rothko may have meant the sacrifice of Iphigenia to symbolize the murder by the Nazis of innocent Jews, news of which was filtering into the United States. Bonnie Clearwater, in *Mark Rothko: Works on Paper* (New York: Hudson Hills, 1984), p. 25, related the mutilation of the figures in the *Omen* and other of Rothko's mythic pictures to the myth of Dionysus, in which the tragic hero was torn apart by the Titans and which signified suffering. Rothko's *The Syrian Bull* (1943), which was reproduced in Adolph Gottlieb and Mark Rothko (in collaboration with Barnett Newman), "Letter to the Editor," *New York Times,* June 13, 1943, sec. 2, p. 9. Rothko's painting refers to the Syrian conquest of Jerusalem, a subject Rothko had illustrated in Louis Browne's history of Israel.

90. See Gottlieb and Rothko, T*he Portrait and the Modern Artist,* n.p.

91. Gottlieb and Rothko (in collaboration with Newman), "Letter to the Editor," sec. 2, p. 9, and Mark Rothko, Statement (1943), in Janis, *Abstract and Surrealist Art in America,* p. 118.

92. Rudi Blesh, *Modern Art USA* (New York: Alfred A. Knopf, 1956), pp. 268-269.

93. William Baziotes, letter to Alfred H. Barr Jr., April 26, 1949, Baziotes File, *Archives of American Art,* New York, quoted in "Mona Hadler: Four Sources of Inspiration," "William Baziotes: A Retrospective Exhibition" (Newport Beach, Calif.: Newport Harbor Art Museum, 1978), p. 85. See also William Baziotes, response to a questionnaire from the Department of Painting and Sculpture, Museum of Modern Art, April 26, 1949, *Archives of American Art,* Smithsonian Institution.

94. Mona Hadler, "William Baziotes: A Contemporary Poet-Painter," *Arts Magazine,* June 1977, p. 105. The quote is from Baudelaire, "Edgar Allan Poe: His Life and Works," *The Painter of Modern Life and Other Essays.* In Donald Paneth, "William Baziotes, A Literary Portrait, (New York, 1952-1961)," *Archives of American Art,* p. 8, Baziotes said in 1952: "We're fascinated by dangerous things. A lizard's eyes. He has a certain

coldness, a certain deadness, the eyes of a madman aren't too far from a lizard's, unknown, unscrupulous, inhuman."

95. Douglas McAgy, in conversation with the author, early 1960s.

96. Theresa Pollak, *An Art School: Some Reminiscences* (Richmond: Virginia Commonwealth University, c. 1969), p. 46. Quoted in David Anfam, "Clyfford Still's Art: Between the Quick and the Dead," "Clyfford Still Paintings 1944-1960" (Washington, D.C.: Hirshhorn Museum and Sculpture Garden, 2001), p. 21.

97. Mark Rothko, in "Clyfford Still" (New York: Art of This Century Gallery, 1946), n.p.

98. Still later claimed that he did so reluctantly at the request of Rothko, but I find his claim is dubious. Still did label an earlier picture, *Totem Fantasy,* which was exhibited in 1939 and again in 1940.

99. As late as 1945, Newman was considered a writer and critic by his friends Gottlieb and Rothko.

100. Thomas B. Hess, "Barnett Newman" (New York: Museum of Modern Art, 1971), pp. 27, 29.

101. Robert Saltonstall Mattison, *Robert Motherwell: The Formative Years* (Ann Arbor, Mich.: UMI Research Press, 1987), p. 94.

102. Katharine Kuh, *The Artist's Voice: Talks with Seventeen Artists* (New York: Harper & Row, 1960), p. 222.

103. Varnedoe, "Abstract Expressionism," in *"Primitivism" in 20th Century Art,* Vol. 2, pp. 652-653.

104. Robert Taplin, "David Smith: Toward Volume," *Art in America,* April 2002, p. 118.

105. Isamu Noguchi, *The Isamu Noguchi Garden Museum* (New York: Harry N. Abrams, 1987), p. 152.

106. See Amy Lyford, "Noguchi, Sculptural Abstraction, and the Politics of Japanese American Internment," *Art Bulletin,* March 2003, pp. 137-151.

107. Katharine Kuh, *The Artist's Voice,* p. 175.

108. Albert Elsen, *Seymour Lipton* (New York: Harry N. Abrams, 1970), p. 28.

109. Irving Sandler, "Abstract Expressionism and the American Experience," in *Pintura estadounidense Expresionismo Abstracto* (Mexico City: Centro cultural arte contemporaneo, 1996), English Supplement, p. 21.

110. Leja, *Reframing Abstract Expressionism,* p. 64.

111. Newman, "The Painting of Tamayo and Gottlieb," in O'Neill, *Selected Writings,* pp. 73, 75.

112. W. Jackson Rushing, "The Impact of Neitzsczhe and Northwest Coast Indian Art on Barnett Newman's Idea of Redemption in the Abstract Sublime," Art Journal, Autumn 1988, pp. 187-188.

113. There was a modicum of hope in one of the myths Newman chose to evoke, at least according to its title, *The Slaying of Osiris* (1945). Osiris was a mythical Egyptian king who was murdered by his evil brother, cut to pieces, and scattered across the country. His wife, Isis, reconstituted his body and he became the ruler of the underworld, the god of the dead.

114. Newman, "The First Man Was an Artist," pp. 59-60.

115. Barnett Newman, "The New Sense of Fate," in O'Neill, ed., *Selected Writings,* p. 169.

116. Harold Rosenberg, *Barnett Newman* (New York: Harry N. Abrams, 1978), p. 21.

117. Newman could occasionally lapse into humanism. In 1946, in "Teresa Zarnower," (New York: Art of This Century Gallery, 1946), n.p., he wrote that she "was sensitive to the tragedy of our times" but recognized that "the defense of human dignity is the ultimate subject matter of art."

118. "The Century of Fear," in Alexanre de Gramont, ed. and transl., *Albert Camus, Between Hell and Reason, Essays from the Resistance Newspaper "Combat," 1944-1947* (Middletown: Wesleyan University Press, 1991), p. 117.

119. Barnett Newman, in "Northwest Coast Indian Painting" (New York: Betty Parsons Gallery, 1946), n.p., wrote that the Mythmakers prized "the many primitive traditions" because they stood apart "as authentic aesthetic accomplishments that flourished without benefit of European history."

120. See Kirk Varnedoe, "Abstract Expressionism," in William Rubin, ed., *"Primitivism" in 20th Century Art*, pp. 651-652.

CHAPTER 3
Field Painting:
From the Terrible Sublime
to the Exalted Sublime

The "imagination of disaster" persisted after the end of World War II. In the year following Hiroshima and Nagasaki, the Baruch Plan for international control of atomic energy failed, and nuclear weapon tests took place on Bikini Atoll. In 1946, the *New Yorker* published an extended article by John Hersey titled "Hiroshima," which described in vivid detail the plight of the city's victims. The essay was widely reported on broadcast in four half-hour television programs on WABC, and published as a book, which became a best seller.[1] Growing numbers of Americans were unsettled by thoughts of nuclear catastrophe and, after the onset of the cold war in 1947, its threat.

Between 1946 and 1947, Pollock and Still, soon to be joined by Rothko and Newman, originated new nonobjective styles. These developed out of a need to embody their sense of terror more directly and immediately than they had in their semiabstract mythic and primitivistic paintings. They found these earlier works, with their Surrealist or Expressionist-related images, symbols and signs too specific, finite, and familiar to convey what they began to term the Sublime, or more specifically, the Terrible Sublime (more of which later). To convey their apprehension and anxiety, Pollock, Still, Rothko, and Newman developed a radical conception of the picture as a nonobjective open field. In Pollock's drip paintings, the field took the form of an allover linear mesh; in Still's, Rothko's, and Newman's abstractions, it became an allover field of color areas. In the light of these innovations, the years they spent as Mythmakers can be viewed as a necessary rite of passage.[2]

The four Field painters found Cubist design wanting. They rejected the relating and balancing of discrete forms contained within the canvas frame whose edges were decisive in determining the design within. Instead, they made their images allover, if not exactly releasing them from the picture

boundaries, then causing them to seem to extend beyond its confines. Cubism's relational composition induces the viewer to experience a picture slowly from part to part to whole. In contrast, the allover image, free of internal restraints, engages the viewer with immediacy—that is, all at once. Cubist picture-making had been central to the Modernist art of the preceding four decades. In discarding it, the Field painters produced the most original formal inventions of the new American painting—and the most difficult for the audience for existing avant-garde art to take in, conditioned as it was to look for relational composition and unable to find any definable design in these holistic abstractions.

Pollock: process and vision

As Pollock developed his mythic paintings, he increasingly pulverized recognizable images, symbols, and signs with impulsive brush marks. Then, in 1947, inhibited by the drag of the brush, he abandoned it. Spreading canvases on the floor and moving around and at times onto them, he poured paint from cans or dripped it from sticks, forming allover webs or networks. Robert Motherwell listed the advantages of working in this manner:

> [One] loses the sense of the horizon line that so often sticks in one's head with a vertical canvas [on the wall]—and the space can be three-dimensionally penetrated without losing the flatness of the floor.... Pollock's famous "drips" could be better controlled [on the floor]; if he had been working vertically, the drips would have become up and down rivulets.... Finally, working on the floor, the automatic drips would not further spread or move, and he could paint ... in layer after layer, and reach a physical complexity that none of his colleagues could.[3]

Pollock's technique allowed him to paint more directly, bringing his entire body into the act of painting. Indeed, he used shoulder, elbow, and arm, as well as wrist and finger, to drip and pour paint. He was thus able to obliterate his earlier semiabstract Picasso-esque imagery and to demolish Synthetic Cubism's order. Or in mythic terms, Pollock can be thought to have cast off Apollonian rationality and permitted Dionysian irrationality and chaos to take over.

Pollock's abstract fields of interlaced skeins of paint lack focal points. The linear elements do not define discrete shapes but traject freely, like traces of energy whose configuration generates even more energy, a continuum of energy so charged that it seems to expand beyond the picture's limits. In 1950, Pollock said, "There was a reviewer a while back who wrote that my pictures didn't have any beginning or any end. He didn't mean it as a compliment, but it was."[4]

Pollock's method of dripping and pouring had its source in Surrealist automatism. He recognized it as the movement's truly radical innovation because it enabled the unconscious to speak freely. But Pollock's use of automatism differed from that favored by the Surrealists. In his *History of*

Surrealist Painting, Marcel Jean, with Pollock in mind, concluded that "it was in the United States during the forties that painters first systematically proposed as pictures—the triumph of pure automatism!… blobs and stains [and the like]. Surrealist painting's departure points had become arrival points, inspiration went no further than 'the means of forcing inspiration,' and the objective methods of Surrealism were reduced to a subjective automatism."[5]

This was objectionable in itself to Jean, but he was also distressed by the nonobjectivity of Pollock's drip painting, which Jean and his Surrealist colleagues branded as anti-human.

One Surrealist painter, André Masson, objected to what he considered his associates' half-hearted attitude toward automatism. He wrote, "The two things that I consider most Surrealist that I've done are automatic drawings and sand paintings. Which interested my comrades not at all, not one bit; whether poet or painter, this wasn't interesting. It's odd." He added that for him, his sand painting was "a truly Surrealist experience, but for the Surrealists it was nothing—what a paradox."[6] But Masson soon gave up the use of extreme automatism; Pollock would take it up.

Art critic Lawrence Alloway indicated how Pollock used automatism differently from the Surrealists, even when they did experiment with its more extreme possibilities:

> Max Ernst defined one of his automatic processes as "reducing to a minimum the part played by … the 'author' of the work." Even Arp's random location of scraps of paper began with the expressive gesture (preparing the paper) which was then impersonalized (by their fall). Chance, used in these ways, intervenes between the artist and his work, separating the act of creation from manual procedures. [The Surrealists] introduced chance into art confidently and cooly. To Pollock, however, who brought chance into the manual act of painting, it was always linked to doubt.[7]

Painter Peter Busa, a friend of Pollock's, concurred, "He went the furthest. He believed in what he was painting, but he had tremendous doubts. His human situation was fragile."[8] Pollock's disquiet resulted from his misgivings over whether his dripping and pouring paint had yielded "art." In fact, his work was often viewed by critics and other art professionals as non-art or even anti-art.

Pollock's process had sources other than Surrealist automatism. He said in 1947 that it was "akin to the method of the Indian sand painters of the West."[9] Hence his picture making was both primitivistic and American. Spattering paint was also a technique that had been practiced at the Experimental Workshop run by David Alfaro Siquieros in New York, which Pollock attended in 1936. As Axel Horn, a student there, reported, "We sprayed through stencils and friskets, embedded wood, metal, sand and paper. We poured [nicrocellulous pigment], dripped it, splattered it, hurled it at the picture surface.… What emerged was an endless variety of accidental effects. Siqueiros soon constructed a theory and system of 'controlled accidents.'"[10] As a Communist, his purpose was to create

a socially revolutionary art intended to communicate to the masses. Pollock turned the technique to his own subjective purposes.

Pollock looked not only to Siqueiros but to José Clemente Orozco. In a drawing of 1947, revealingly titled *War,* an Orozco-like, explosive accumulation of staccato, linear pen and brush strokes in the lower half of the picture blasts a Picassoesque figure in the upper half into oblivion. The erupting image in *War,* which is almost allover, was executed just before the drip paintings and anticipated them.

In sum, Pollock's painting process was derived from three sources: Surrealism, a sophisticated European avant-garde tendency; Native-American "primitive" art; and a technique promoted by Siquieros, a Mexican social revolutionary mural painter. But Pollock deflected what he borrowed in a radically new direction.

Pollock realized that he had adopted automatism to break through the barriers of inhibition, restraint, and discretion, and to release the dammed-up emotions and energies of the psyche. But he also understood that he had to organize the seemingly randomly dripped and poured paint. Consequently, he found himself whipsawed between noncontrol and control, between the unconscious and the conscious, between irrationality and rationality, and between body and mind.[11] Pollock insisted that his images were ordered, "I CAN control the flow of paint. There is no accident."[12] He also denied that he illustrated chaos.[13] Yet Pollock's drip paintings look haphazard to the point of seeming chaotic. And they were often perceived as such, with justification, in my opinion.

In accounting for Pollock's rejection of Picasso's Cubism, his wife, Lee Krasner, said that her husband "admired Picasso and at the same time competed with him [and] wanted to go past him."[14] Art critics and historians have picked up on this idea and have treated Pollock's ambition as a kind of arm-wrestling in which he succeeded in beating the world champ.[15] I disagree with this interpretation. Pollock painted differently because of his inner necessity or vision, not for the sake of outdoing Picasso. In the late forties, his drip painting was innovative, newer, and hence more avant-garde than Picasso's, because Cubism had been around so long that it looked old. But I don't believe Pollock's painting constituted an advance over Picasso. Art is demeaned when it is reduced to an aesthetic contest.

Pollock's drip canvases provided a model for his fellow avant-garde artists. They sought in their own work to emulate what they considered his paintings' relevance, originality, energy, daring, unprecedented freedom, and risk. Pollock was often referred to as a heroic figure and, as de Kooning characterized him, "the icebreaker."[16] However, artists of Pollock's generation rarely used his technique, fearing that if they did they would produce derivative Pollocks. As George McNeil said, "The

poured paintings did not give rise to a bandwagon but to a chain reaction. Jackson helped everyone take a running jump."[17]

Breaking out of the Euclidean prison

Unlike Pollock, who relied primarily on drawing, Still, Rothko, and Newman employed color as their primary pictorial means. To enable it to be expressive in its own right, these Color-Field painters, as they would be labeled, purged pictorial elements that drew attention away from color: complex drawing, composition and gesture, figuration and symbolism, and, above all, the modulation of light and dark values, which dulled color. Put another way, the Color-Field painters wanted to release color from preexisting form and let it form itself. To maximize the visual—and emotional—sensation of color, they applied it in ever-larger expanses that saturate the eye. They also enlarged their pictures, as Greenberg once commented, the idea being that more of a color, say blue, was bluer than less blue.

Around 1946, Still suppressed the mythic abstract personages he had been inventing and turned to nonobjective painting. He retained the upward thrust, which had been a significant attribute of his earlier figurative and mythic images. But he now spread areas of color over the picture surface to create an organic unity between the figure and the ground.[18] Or, as Still put it, he exploded the figure across the canvas.[19] But the images also had a landscape reference. In March 1948, the *Magazine of Art* published a short text stating, "Still feels that his fluid, often flame-like vertical shapes have been influenced by the flatness of the Dakota plains; they are living forms springing from the ground."[20] Although Still dictated this passage, he vehemently denied that his abstractions had any reference to the Western landscape.[21]

Still's paintings are composed of frayed, paint-laden areas of color. Despite the weightiness of the crusty impasto, the color areas, unfixed by their jagged contours, are open and allover. They are not separable shapes against a background but bond with their surrounding areas, functioning as zones in a continuous surface. Color areas that extend to the canvas edges are cut off, as if expanding beyond the picture's limits. Still said (just as Pollock had), "To be stopped by a frame's edge was intolerable; a euclidean prison, it had to be annihilated."[22] Conceiving of painting as a "totally free field," Still found that tyrannical fenced-in pictures with their straight edges and right angles that "merely reiterated the canvas frame."[23] To be free in his art, he sought to annihilate the traps of "grids and geometries" with open and limitless forms.[24] He equated pictorial confinement with geometric abstraction, which he termed "Bauhaus," and he denounced it as totalitarian, the art of a society in which the free individual would not be permitted to exist.

Chronology counts

Meyer Schapiro once said in a lecture, "Chronology counts"—and it does. Consequently, with regard to Field Painting, who did what first is of critical importance. In fact, Pollock and Still were its primary originators and claimed it was both anti-traditional and American. However, Still's innovative role was disputed by Newman in what became a bitter quarrel between these two former friends. Historians have generally avoided taking sides, preferring to emphasize the uniqueness of each artist (and to avoid lawsuits). I cannot skirt the issue, since my interpretation of Color-Field Painting depends on who showed the way and how he justified his development. The stylistic antecedents of the abstractions for which Still is best known are clear in the pictures with recognizable images that he exhibited in 1943. By 1947, his paintings were fully abstract.[25] Rothko and Newman had seen these canvases prior to developing their own individual images.

There is no question about the dates of Rothko's pictures; beginning in 1942, photographs of his work were published. Illustrations in the journal *Possibilities 1* (Winter 1947-1948) indicate that in 1947 he was still painting biomorphic images. Rothko's so-called multiform abstractions of the following year were reproduced in *Tiger's Eye* in 1948 and 1949.[26] Still's influence on them was clear. In her book on Rothko, largely based on her friendship with the artist, Dore Ashton wrote that Rothko visited Still's studio in 1945, and that Still "exercised a powerful attraction for Rothko" and influenced his subsequent work.[27]

By 1947, Still's pictorial innovations were also imprinted on Newman's mind.[28] Newman's first painting in the Color-Field style, a small work titled *Onement 1,* was executed in 1948—according to him. He said that it was "the first painting … where I felt I had moved into an area for myself that was completely me."[29] Newman's color-fields were first exhibited only in 1950, well after the "mature" one-person shows of Still and Rothko.[30]

A number of art world acquaintances of Still, Rothko, and Newman testified to Still's seminal role. The painter Alfonso Ossorio, a friend of his, said simply, "The sparkplug was Still."[31] Theodoros Stamos, a friend of Rothko and Newman (who wrote an essay for the brochure of Stamos's 1947 show), recalled that Still was the first to use simple, big, open forms, adding that Rothko was painting linear, figurative images at the time. "Still opened up the canvas more than … anybody. [He] was a big influence on many, many people. A lot of people will be reluctant to admit it, but I think he was more important than anybody at the time. [His work] was a revelation. They were pictures you walked into and never came out of."[32] Motherwell reported that Still's "show of all the early shows of ours, was the most original. A bolt out of the blue.… Rothko was deeply impressed with Still."[33] Peter Busa, who like Still and Rothko, was represented by the Art of This Century Gallery, said, "In my

book [Still] was the guidepost to Rothko, to Newman's bigness of form, as well as to later developments."[34] Pollock concurred, commenting that "Still makes the rest of us look academic."[35]

The power of Still's painting is conveyed in a recollection by his former student, the art critic Kenneth Sawyer:

> Our first response to these potent, utterly original oils was one of disbelief; then came shock, then admiration. Most of us, veterans of the Second World War, had stern convictions as to the nature of modern painting; it must be Mondrian, Miró or Picasso. What we were confronted with on the walls of the Legion Museum [San Francisco, 1947] was unrelated in the most upsetting fashion. Still's images were organic, his colors and surfaces had nothing in common with what we had come to regard as "good" modern painting. His works were marked by a violence, a rawness, which few of us—though we naturally accepted the violence of the current Europeans—were prepared to recognize as art. It was unnerving to have one's preconceptions so efficiently shorn in a single exhibition. Here was painting that instructed even as it destroyed: The School of Paris had died suddenly for us; something new, something that most of us could not define, had occurred.[36]

In the first extensive analysis of Color-Field Painting, a 1955 essay titled "'American-type' Painting," Greenberg established Still as "perhaps the most original of all painters under fifty-five, if not the best." Greenberg went on to say that Still created a "school" of artists, among them Newman and Rothko, who nonetheless achieved independent styles of their own. Greenberg was an acquaintance of all three artists and was the first prominent critic to acclaim them wholeheartedly.[37]

In recent years, Still's reputation has been eclipsed by Rothko's and, notably, Newman's. Indeed, he has been so neglected that in his book on Abstract Expressionism, *How New York Stole the Idea of Modern Art*, Serge Guilbaut devoted less than two dozen lines to him. Michael Leja, in *Reframing Abstract Expressionism*, did not manage even that pittance. Still himself was largely to blame for his relative neglect. His statements were often pretentious, and arrogant, and occasionally chauvinistic. Moreover, he (and after his death, his wife) allowed his work to be shown and reproduced only rarely and then often to poor advantage by focusing on his post-1960 abstractions, many of which are overblown.[38] This was Still's own doing, because he insisted on having the final say about what was shown and, when he could, about what was written about him.

There have been recent attempts to rehabilitate Still—for example, Michael Kimmelman's 1993 review in the *New York Times*, which observed that despite being one of the most "dislikable men in the history of American art," Still was nonetheless "a painter of significance and originality.... Some of his works are as awe-inspiring as Still intended them to be."[39] Another recent attempt at revival was a large show in 2001 of Still's paintings from 1944 to 1960 at the Hirschhorn Museum, accompanied by a major catalogue with essays by David Anfam, Neal Benezra, and Brooks Adams.[40] The

opening in 2010 of the Clyfford Still Museum adjacent to the Denver Art Museum in Denver, will do even more to cement his reputation.

Rothko and Newman: beyond Biomorphism

Rothko flatly condemned European Renaissance painting as decadent. "We have wiped the slate clean. We start anew. A new land. We've got to forget what the Old Masters did" (but not modern masters, such as Matisse and Bonnard).[41]

In 1947, Rothko expunged calligraphic and biomorphic images, symbols, and signs from his canvases. He began to paint irregular patches of atmospheric color, many roughly rectangular, the vestiges of the horizontal bands in the background of his mythic pictures. Rothko circled back to his own chromatic figurative painting of the 1930s, which had been inspired by Avery and Matisse, but he now seemed intent on expression through color by itself.

Rothko soon found these "multiforms," as the works came to be known, too diffuse and drifting. In 1949, he reduced the diverse areas to a few softly brushed and edged horizontal rectangles of atmospheric, dissonant color, placed, or rather floated symmetrically, one above the other on somewhat more opaque vertical grounds. The uneven "organic" contours of the rectangles and their symmetrical arrangement offset the resemblance to geometric abstraction. All of the components are fused to create uninterrupted fields. The stained and thinly painted translucent films in Rothko's abstractions emit a shadowy aura that seemed to spread outward, as if to envelop the viewer.

In 1948, Newman abandoned his Surrealist-inspired biomorphs and began to cover his canvases with a single, almost flat color punctuated by one or more narrow vertical bands of varying thicknesses and contrasting hues, or zips as he called them. Newman appears to have had in mind Matisse's paintings of the early teens and Avery's simplified American scenes. It is noteworthy that Newman owned Avery's *Man at the Sea,* one of his more pared-down pictures. As color-fields, Newman's abstractions are related to those of Still and Rothko, but their relatively matte surfaces are different from Still's, which are weighed down by their heavy textures, and from Rothko's, which tend to be dissolved by subtle light and dark nuances.

If Matisse and Avery were Newman's "allies," Mondrian was his "foe."[42] Indeed, Newman meant his color-fields to challenge aesthetically and metaphysically Mondrian's palette and relational structure. Unlike Mondrian, who limited his colors to the primaries, black, and white, Newman employed a broad range of colors, chosen for their expressive qualities. Mondrian's bands are vertical and horizontal; they crisscross to form relational structures, segmenting the picture space. Newman began with the module in Mondrian's paintings, the stripe, but used it only as a vertical. Hence his zips, in combination, do not section the painting but emphasize it as an undivided entity, and as such, they

subvert geometric abstraction—hence, the title *Onement* (1948) for his first Field Painting. He said, "If I have made a contribution, it is primarily in my drawing.… Instead of using outlines, instead of making shapes or setting off spaces, my drawing declared … the whole space."[43] Newman's zips act as accents that energize the color-field and prevent it from becoming inert. In this, he took his cues from Matisse's *Red Studio* (1911), in which studio paraphernalia serve the same function as the zips.

Newman's zips are on the edge between discrete forms and integral components of the color-field, neither in front of nor behind it. In works of 1948 to circa 1950, they tend to look more like separable forms. Indeed, in 1950, to stress this role of the zips, Newman made several extremely narrow pictures of single stipes. Varying in height from roughly three to six feet, and from three to six inches wide, they call to mind individual personages. As surrogate figures, Newman's zips relate viewers to their own bodies and provide them with a sense of place in the color-field. Moreover, the uneven and frayed edges of the stripes provide human touches, in a way that Mondrian's precise contours do not. They were in fact influenced by Giacometti's elongated figures ravaged by space. Newman's abstractions waver paradoxically between minimal figuration, Expressionist in feeling, and near geometry with suprahuman connotations. In his larger canvases, the placement of the zips seems unsystematic, particularly when viewed close up (as Newman wanted them to be viewed). Thus, compared with Mondrian's design, which feels rational, Newman's arrangement looks irrational.

"We've changed the nature of painting"

Pollock, Still, Rothko, and Newman recognized that their nonobjective Field Painting was formally innovative. As Pollock said, "The important thing is that Cliff Still … and Rothko and I—we've changed the nature of painting."[44] However, pictorial invention by itself was not their primary aim. Indeed, they objected to formalism and insisted repeatedly that their abstractions issued from an urgent need to create images that were awesome to the extent of being Sublime. The Sublime could be either terrible or exalted. In the cold war of the late 1940s, with its ever-present threat of atomic holocaust, the Field painters sought to suggest the Terrible Sublime. As Hess recalled, "Tragedy, Sublimity, Blackness, Poignancy were very much in the air in the late 1940s and early 1950s."[45]

In 1948, Newman defined the Sublime by contrasting it with the Beautiful and concluded that they were incompatible. "Edmund Burke insisted on a separation.… Even though it is an unsophisticated and primitive one, it is a clear one."[46] As Newman saw it, the Beautiful resides in measurable and hence comprehensible proportions that yield perfect forms. The Sublime is misshapen and ugly, vast, obscure, immeasurable, and unfathomable. The Beautiful is sensuous and pleasurable; the Sublime is confounding, evoking terror—"pain and danger," as Burke wrote. Newman insisted that the Field painters were engaged in a "moral struggle between notions of beauty and the desire for sublimity."

They chose to suggest the Sublime in order to "come closer to the sources of tragic emotion."[47] Newman went on to say that achieving the Beautiful was the goal of classical European art, including its modern variants—above all, Mondrian's Neo-Plasticism, because of its striving for perfection. In contrast, the quest for the Sublime was the aspiration of the American Field painters.

In *Philosophical Enquiry into the Origin of Ideas of the Sublime and the Beautiful* (1757), Burke listed the qualities that summon forth the Sublime: oneness, vastness, boundlessness, darkness, and emptiness. He looked for these attributes in nature; the Field painters sought them in painting. Burke observed that to suggest the Sublime, the imagination should not be checked "at every change [making it] impossible to continue that uninterrupted progression which alone can stamp on bounded objects the character of infinity."[48] Translated into pictorial terms, an allover painting without demarcated forms declares its oneness. The areas in Still's and Rothko's canvases do not contain precise outlines; Still's contours are loosely brushed, and Rothko's, are blurred, rendering the surfaces of their abstractions unbroken and open. Newman's zips do have edges, uneven though they are, but their colors are so adjusted to the color-field that they do not seem to advance or recede, and thus they maintain the uniform picture plane. The linear skeins in Pollock's drip paintings are not perceived as discrete shapes but form an allover mesh that comprises the picture surface (or almost all of it), and the effect is of a continuum of surging energy.

Burke had observed that "sad and fuscous colors, such as black, or brown or deep purple," induce the Terrible Sublime.[49] Still, Rothko, and Newman suffused their canvases (with a few exceptions) with darkness, preferring somber, dissonant, often oppressive colors, and avoided decorative, pleasing and seductive hues. Still said that he "consciously endeavored … to disembarrass color from all conventional familiar associations and responses."[50] In the 1940s, he suppressed "the decorative graces of color" in favor of "scabrous or sodden colors."[51] To further the anti-decorative, Still purged virtuoso touch by using palette knives to trowel congested impasto onto his canvases.

Still identified refinement with European painting and considered it un-American. As his student Ernest Briggs recalled, "To counter preciousness, Still went through a period of deliberate simplification and brutality and painted outsize canvases. He aimed to create a new art of the new world."[52] Jon Schueler, another student, agreed and added that "Still set out to deny everything the Europeans ever did, for example, the sensuousness of paint and color."[53] Rothko and Newman also suppressed attractive facture, Newman by barely modulating the picture surface, and Rothko by blotting scrims.

Burke had also written that the Sublime is called to mind by "greatness of dimension" when "the mind is so entirely filled with its object that it cannot entertain any other."[54] The Field painters often executed wall-size pictures but wanted them exhibited not in public spaces where they would be distanced from viewers but in small rooms. The artists' aim was to place the spectator in an

encompassing environment of color, to literally inundate them with color, to envelop—and aston-ish—them. They wanted to release viewers from their everyday environments and attachments, which prevent the awareness of the Sublime. As Rothko said, "A large picture is an immediate trans-action; it takes you into it."[55] Because of their extensive size, coupled with their allover composition, Field paintings possess an immediacy unprecedented in the history of modern art.

The so-called big picture is often considered a distinctive feature of Abstract Expressionism. As early as 1942 Greenberg urged artists to enlarge their canvases to "burst the confines of the set easel picture."[56] In a letter to the *New York Times* in 1943, Rothko and Gottlieb asserted that their works "must insult anyone who is spiritually attuned to … pictures for over the mantle."[57] In 1947, Pollock applied for a Guggenheim Fellowship in order to paint mural-size easel paintings. In that year, most likely aware that artists were increasing the scale of their pictures, the Museum of Modern Art mounted a show of outsize canvases, the largest of which was Pollock's 8-by 20-foot painting.[58] Still also favored "the big picture," which he considered American in contrast to European. In 1948, Greenberg reiterated, "In this day and age the art of painting increasingly rejects the easel and yearns for the wall."[59] In the late 1940s, however, Field paintings on the whole were rarely very large—that is, not when compared to those in the fifties. But size is relative, and early Field paintings seemed large at the time, which is what the artists intended and how the art-conscious public perceived them. The artists' paintings were not as large as they would have liked, not because they did not want them to be but because they could not afford the canvas and paint.

"Gothic-ness, paranoia and resentment"

Pollock's first drip painting was *Full Fathom Five* (1947), a bleak, frenetic, and congested canvas. Painted and repainted in dense layers, this and other early drip paintings are marked by turmoil and darkness. They continue the mood of preceding mythic canvases such as *Troubled Queen* (c. 1945) with its dark brown tonality and jagged angles. But in the drip paintings, the recognizable images are suppressed, though they still lurk as barely visible stick-like figures, secreted in webs of pigment. There are other figurative references in the early drip paintings: the formats, taller on the vertical than on the horizontal, echo the upright stance of the human figure.

In 1947, Greenberg criticized Pollock's canvases for their "Gothic-ness, paranoia and resentment … violence, exasperation, and stridency." They were the morbid issue of "a sadistic and scatological sensibility."[60] Although Greenberg was Pollock's champion, he was uncomfortable with the negative aspect of his work and felt compelled to comment on it. In 1956, Sam Hunter recalled, "Pollock always saw the painting field as an arena of conflict and strife. [The] configurations were locked in violent conflict."[61] Moreover, in their seeming randomness, the drip paintings could be taken to reflect the unpredictability of world events in the 1940s. Such interpretations were reinforced by

Pollock's departure from traditional techniques that assaulted conventional ideas of what painting was supposed to be. Moreover, the temper of the time led critics to focus on the violence and chaos in his early drip paintings.

Pollock's canvases appeared to have issued from inner urgencies, suggesting that they were representations of "self." Pollock himself said that what his painting "feels like, is just more of me—on and on."[62] Indeed, the sense of the movements of the artist's body is perceived in the curvilinear rhythms of dripped, dribbled, and poured paint. The imprints of Pollock's hand in *Painting, No. 1 1948* are also signs of his presence. Moreover, the incorporation of real objects from the artist's life—cigarettes, paint-tube caps—makes the viewer aware of Pollock's being in the painting. His painting then can be considered bodily performance. In a sense, he incorporated into the Surrealist practice of "psychic automatism" a "physiological automatism." Pollock said that his drip paintings expressed "an inner world … the energy, the motion, and other inner forces."[63] As indexes, that is, as traces of his bodily movements, his physical painting gestures are at one with his subjective processes.

Put another way, Pollock embodied his subjective drives through the direct action of painting. He preferred to work on the floor because, as he said, "I feel nearer, more a part of the painting, since in this way I can walk around it, work from all four sides and literally be in the painting."[64] *Being in* the canvas was a metaphor for the artist's *being* or *inward being*. In short, using a radical technique, Pollock expressed a sense of authentic self, a self that was tormented and unsettled, which also evoked the mood of his time.

Pollock presented his self not only through his own paintings but also through photographs and films that influenced the interpretation of his work. In Hans Namuth's well-known film of 1951, that reflected Pollock's persona of the 1940s, he assumed the role of a macho yet angst-ridden figure. The furrowed-browed Pollock looks as though he is grappling with uncontrollable inner and outer forces of irrationality and chaos. There was a general perception in the art world that his struggle was epic. He was perceived to be, as Leja observes, "both in closer touch with the dark side of the psyche than most of us and courageous enough to face it … at great personal cost," an interpretation reinforced by Pollock's ill-fated death, which was often considered a suicide.[65] As Motherwell wrote, "Pollock was a hero … a modern and international one, as it turned out. Which, given the time and place, is even more heroic."[66] Pollock's friend, Anthony Smith, agreed, "At [Pollock's] funeral, someone said, 'He was just like the rest of us.' Well, it wasn't true. He had more of the hero about him, and everyone knew it."[67]

Pollock's presentation of himself in Namuth's film reveals not only a great deal about Pollock but about the mood of the late 1940s. Indeed, Namuth's film is a telling piece of art criticism.

Still's shocking, flayed, raw-flesh texture

In 1947, Still spread areas of paint, which resembled the biomorphs in his mythic paintings, across the surface of his canvases to create images that call to mind landscape.[68] The mood of the works he made between 1947 and 1950 is forbidding. The heavily textured forms in them are roughly painted, their jagged edges torn as if the shapes had been ripped asunder. They thrust upward like awesome precipices or plunge downward into the depths of dark abysses. Broken with raw cracks, lightning-like shafts, and wound-like tears and slashes, the images also evoke the galvanic crust of the earth erupting. The close-valued tenebrous colors in themselves convey the desolate mood of Still's abstractions. In short, the paintings are stark, dense, and ominous, evoking terror and menace. Thomas Hess characterized Still's canvases as "ugly," adding that their "shocking, flayed, raw-flesh texture makes Dubuffet's attempts at art brut look like haute couture."[69]

Still's canvases reflect something of his wretched boyhood and early manhood on a homestead in western Canada during a period of great drought, when life was desperately difficult for farmers.[70] As his friend Henry Hopkins wrote, Still lived on "wind bitten, hard pan, ice clogged grass lands which would not or could not yield up the crops necessary for survival. Still's father was locked in mortal combat with the forces of nature.… The battle was lost."[71] The hardship of farming on this vast, flat, and empty prairie, in its minatory "awful bigness," finds its expression in the desolate, oppressive, and inchoate dread in Still's late 1940s paintings.

Rothko: "tranquility tinged with terror"

The feeling in Rothko's abstractions was melancholic. It may have been inspired by the tragic events in his life and in the world. As a boy in Dvinsk, Russia (now Latvia), he had lived through the persecution of the Jews and claimed to have witnessed a pogrom. It is doubtful that he had actually experienced the beatings, but it is significant that he often recounted it as an adult.[72] The plight of the Jews under Nazi rule and the revelation of the Holocaust confirmed Rothko's disposition to the tragic. When, in 1959, Werner Haftmann, the director of Documenta, invited Rothko to participate in the exhibition, he refused, saying angrily that as a Jew he would not show his painting in Germany, "a country that had committed so many crimes against Jewry." Haftmann said that Rothko added that if he "could manage to have even a very small chapel of expiation erected in memory of the Jewish victims, he would paint this without any fee—even in Germany, which he hated so much." He then said it need be only a tent.[73]

Rothko thought of his work in dramaturgical terms. His large canvases can be imagined as stage sets for tragic dramas, before which spectators are transformed into real actors, solitary individuals, enacting the events in terms of the own lives. The sense of the tragic remained constant in most of

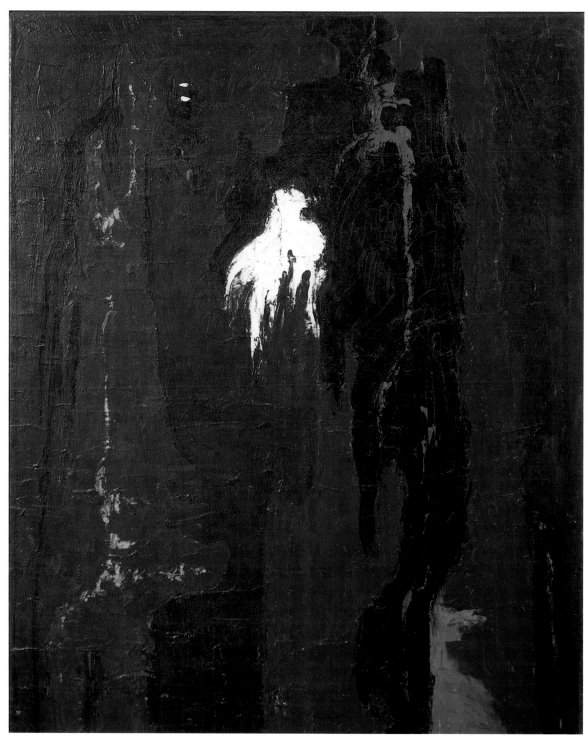

Clyfford Still (1904-1980) *Untitled,* 1945
Oil on canvas, 42 3/8 x 33 5/8 in. (107.63 x 85.41 cm). PH-141.
Whitney Museum of American Art, New York;
Gift of Mr. and Mrs. B. H. Friedman 69.3
© The Clyfford Still Estate

Rothko's paintings throughout the 1950s, except for a series of yellow and orange canvases. The vaporous color areas in many of his abstractions did become somewhat bright and sensuous, but they continued to be dissonant and disquieting, emanating a smothering and oppressive atmosphere, an indefinable ether that dissolves the thickness of this world.[74] Rothko's canvases have been interpreted as quietude at its most Sublime. But their "tranquility [is] tinged with Terror," to borrow a phrase from Burke.[75]

The art critic Charles Harrison wrote, "If anything like an intimation of mortality can be derived from Rothko's paintings—as I believe it can,... it is not in any 'religious' terms, but in terms of [a] sense of 'surrender to the void,' of allowing oneself to be absorbed into the 'interior,' the 'illusory space' of the painting, which is an actual condition of spectatorship, established by the formal characteristics of the painting itself."[76]

Newman's new man

Newman anticipated the zip in an essay of 1947, titled "The First Man Was an Artist." He wrote that aboriginal man "traced [a] stick through the mud to make a line before he learned to throw the stick as a javelin." That mark, aesthetic before it was utilitarian, was "man's first expression ... of awe and anger at his tragic state [and] at his own helplessness before the void."[77] Newman's zip can be taken as a metaphor for the primal and tragic gesture in the mud. It can also be interpreted as a new beginning. The first man to make this line in the mud can be identified with the biblical Adam (also the title of a 1949 picture by Newman), the ancestor of the new man in the New World—metaphorically the pioneer and the immigrant and Newman himself, as a Color-Field painter (along with Still, Rothko, and Pollock)—who was intent on a new beginning in art, unrelated to the styles of the Old World.

In 1948 and 1949, Newman's paintings were dark in mood. *Abraham* (1949), for instance, a black-on-black canvas, "one of Newman's most prized works" according to art historian Yve-Alain Bois, was associated by the artist "with the 'tragic figure of the father' (and much has been made of the fact that, indeed, Abraham was his own father's name)." Bois went on to say,

> Less known is the fact that *Abraham* was a painting born under the condition of utter terror—in an unpublished interview, Newman tells how long it took to overcome his fear of painting the central band black (and indeed, he would return to a black-black juxtaposition only in his prints). Terror, Firstness, Fatherhood: Which biblical name could better evoke simultaneously these three states of being than that of Abraham, the first patriarch, the father of three monotheistic religions, the poor soul, shaking from head to toe at God's request that he kill his own son? Needless to say, Kierkegaard's *Fear and Trembling,* which mainly concerns Abraham's plight, was in Newman's library.[78]

Barnett Newman, *Abraham*
1949, oil on canvas
6' 10-3/4" x 34-1/2"
The Museum of Modern Art, New York

An elegaic vision

Robert Motherwell is not counted among the Field painters but, like them, in his *Elegies to the Spanish Republic,* a series begun in 1949, he embodied a tragic vision. The cental images in the *Elegies* are composed of large, vertical, black planes whose shapes are either rectangular or roughly oval. Looming large in the picture space, they are related to the broad areas in the Color-Field abstractions, but they comprise only one component of Motherwell's pictures. He also incorporated the Synthetic Cubist design of Picasso, the Biomorphism of Miró, the color of Matisse's "black" paintings of the late 1940s, and the brushiness of Gesture Painting. Unlike Still, who repudiated modern European painting, Motherwell embraced it wholeheartedly.

The *Elegies* have tragic political connotations, referring to the Spanish Civil War and World War II, to which the war in Spain was a prologue. As Motherwell wrote, "I was 21 in 1936, and that was the most moving political event of the time."[79] He also wrote, "*The Spanish Elegies* are not 'political,' but my private insistence that a terrible death happened that should not be forgot." Motherwell went on to say that "the pictures are also general metaphors for the contrast between life and death, and their interrelation."[80] Indeed, he wrote that "ivory black … is made from charred bones or horns, carbon black is a result of burnt gas, and the most common whites … are made from lead, and are extremely poisonous on contact with the body."[81] As he saw it, black signified depression and death, and white, the void and evil, like the white whale in Melville's Moby Dick. In short, the stark, funeral friezes in the *Elegies* are symbols of death.[82]

From the Terrible Sublime to the American Sublime

Around 1950, a pronounced stylistic change occurred in Pollock's, Still's, and Newman's abstractions. They tended to became horizontal and brighter in color, more open, more expansive, and larger than the preceding pictures they continued to suggest the Sublime, but the Exalted or American Sublime rather than the Terrible Sublime.[83]

This development reflected a change in the artists' outlook toward the United States. The nation was entering into a period of prosperity. The cold war persisted but, despite the Korean War, it had become an accepted fact of life. Neither the Soviet Union nor the United States had used nuclear bombs, nor did it seem likely that they would, and consequently the sense of crisis abated. Nonetheless, America was faced with the threat of Russian imperialism. Intellectuals and avant-garde artists, many of whom had been on the political left, who had questioned and condemned capitalism, now found virtues in it and supported America's cause in the cold war. They continued to feel alienated by the widespread public hostility to their work, the growing conformity in American life, and the burgeoning mass culture. Nonetheless, they adopted a positive attitude toward the United States.

Pollock's, Still's, and Newman's abstractions after 1950 reflected this outlook. In their horizontality, large scale, and seeming limitlessness they refer to the space of the Great Plains, more directly than Field paintings had in the 1940s.

Pollock: identifying with the land

The depressed mood that had pervaded Pollock's paintings in the late 1940s gave way to a sense of animation in 1950. The darkness and claustrophobic denseness of agitated tangles of paint were replaced by an airy buoyancy evoked by sweeping arm-long skeins of paint that branched into linear flows, as in *Autumn Rhythm* and *One*—his two greatest paintings—and especially *Lavender Mist* (all 1950). In sum, turmoil and stress were supplanted by a quiet lyricism and release.

Pollock's post-1950 canvases also grew bigger, their increased size augmenting the sensation of limitlessness. The big picture allowed Pollock to give freer rein to the movement of his entire body than in his earlier drip paintings, and this in turn enabled him to open up his hitherto congested images and to make them breathe and expand.

Like his earlier vertical drip paintings, Pollock's horizontal abstractions were executed on canvases laid out in the floor, the floor becoming a kind of surrogate earth. Anthony Smith observed, "He identified with the land.… I think that his feeling for the land had something to do with his painting canvases on the floor."[84] Prophetically, as early as 1944, Pollock had spoken of his feeling for the vast horizontality of the prairie that only the Atlantic Ocean resembled.[85] After he moved to Long Island in 1945, he had his studio relocated so that he would have an unobstructed view of the fields and marshes that stretch back to Accabonac Creek.

The surging mesh in Pollock's drip paintings evokes not only American space but nature's flux, its "energy made visible," as he said.[86] A number of titles of 1950s paintings refer to nature—for example, *Autumn Rhythm*. Pollock said, "My concern is with the rhythms of nature … the way the ocean moves.… I work from the inside out, like nature."[87] He did not illustrate nature; instead, denying any distance between himself and nature, he declared, "I am nature."[88] This assertion echoes Emerson's claim that "the currents of the Universal being circulate through me."[89] In short, if Pollock changed "the nature of painting," as he maintained, he also changed the painting of nature.

Pollock's one-time teacher, Benton, had no sympathy for the young artist's abstraction, but he shrewdly sensed its American aspect when he wrote, "What the students have learned, not directly from the master but from areas of study to which he has guided them, is not so easily rejected. I don't think I need press this point."[90] Benton had wanted to "come to something that is in the image of America and the American people of my time."[91] This also appears to have been Pollock's intention.

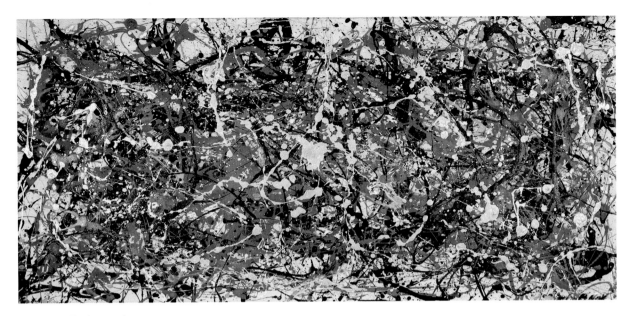

Jackson Pollock, *Number 8*
1949, oil, enamel and aluminum paint on canvas
34-1/8" x 71-1/4"
Collection Neuberger Museum of Art
Purchase College, State University of New York
Gift of Roy R. Neuberger. Photo credit: Jim Frank
© 2008 The Pollock-Krasner Foundation / Artists Rights Society (ARS), New York

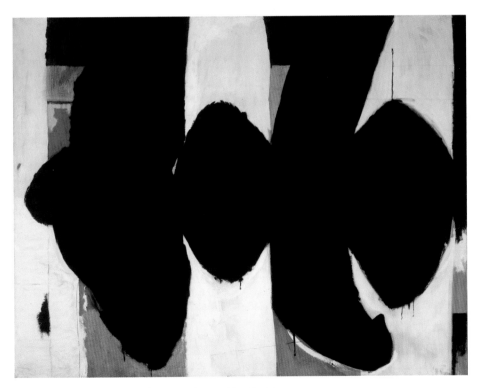

Robert Motherwell, *Elegy to the Spanish Republic No.34*
1953-54, oil on canvas
Overall 80 x 100" (203.2 x 254 cm.)
Albright-Knox Art Gallery, Buffalo, New York
Gift of Seymour H. Knox, Jr., 1957
Art © Dedalus Foundation, Inc. / Licensed by VAGA, New York, NY

Still: the grandeur of the prairie

Like Pollock's drip paintings, Still's color-fields after 1950 are generally horizontal and large-scale. He now wanted, as Jon Schueler said, "to create an enormous space with an enormous emotional impact. And he wanted the space to open out beyond the picture frame."[92] The palette of these canvases is brighter and more resonant, and their facture is looser and less congested, at times even feathery. The images are more open and expansive, particularly because sizeable areas of canvas are left bare, adding a fresh luminosity to the picture.

Just as the mood of Pollock's painting changed from desolation to lyricism, so did Still's. As Hubert Crehan, Still's former student, observed, Still's paintings in the 1940s were of "the Inferno." In the fifties, they were transported

> into a new space which is a kind of Paradise, the open virginal space of the New World—that land and sky which has fired the imagination of rebels for generations as a shelter for a new life, remote from the nightmare of European authoritarian ideological conflict.

> In the paintings of the '50s everything is seen under Western skies or against a limitless plateau…. The paintings become freer from the congenital agitation of the earlier ones and break into a serener motion, simpler forms, clearer, more beautiful color.[93]

As Still himself said grandiloquently of the change in his work, he had made a journey in his painting, "walking straight and alone … until [he] had crossed the darkened and wasted valleys and come at last into clear air and could stand alone on a high and limitless plain." That journey had "a releasing effect," affording "an immense freedom of spirit."[94]

Still denied that his abstractions referred to the Western landscape, despite his occasional statements that suggested they did. He said, for example, "Turner [one of his favorite artists] painted the sea, but the prairie to me is just as grand."[95] In fact, Still's shapes are reminiscent not only of the open fields but of plateaus, mesas, canyons, chasms, fissures, prairie fires, and lightning. In the end, though, as Carter Ratcliff has observed, he sought to evoke "the only subject he considered worthy" —Clyfford Still.[96]

Visionary regionalism

Around 1950, the mood of Newman' paintings also changed—from the sense of the tragic in *Abraham* to the feeling of exaltation in pictures like *Vir Heroicus Sublimis* (1950-1951). The format of the later canvases tends to be horizontal and increasingly large. The vertical bands, or zips, coalesce with the color-field, which seems to extend beyond the picture limits. In a statement handed

out during Newman's second show in 1951, he advised viewers to stand close to his canvases to experience the sense of colors spreading beyond their fields of vision.

Newman was a native New Yorker, but like Still and Pollock, he was attracted by the history and myth of the American West, beginning with its Native American origins. In 1949, he visited the prehistoric Indian mounds in Ohio to view firsthand these vast aboriginal earthworks. They so impressed him that on his return to New York he lectured on the mounds at Studio 35 to an audience of fellow avant-garde artists.

Like Pollock and Still, Newman acknowledged the impact of Western space on his outlook and painting. As he said, "You're not looking at anything [there's not much to see]. But you yourself become very visible."[97] He also remarked, "I have always been aware of space as a space-dome.… I would prefer going to Churchill, Canada, to walk the tundra than to go to Paris.… Anyone standing in front of my paintings must feel the … sensation of complete space [which] should make one feel, I hope, full and alive … in a word, exalted."[98]

To sum up, in their epic abstractions of the 1950s, Pollock, Still, and Newman embodied what Whitman called "that vast Something, stretching out on its own unbounded scale, unconfined," a spot-on description of the American Sublime. They did not illustrate or symbolize the Great Plains but expressed their subjective experiences, memories, and visions of the prairie's illimitable space. In abstracting this essential feature and embodying it in images of extraordinary immediacy, these three artists created a new boundless kind of geography painting.

The topography of the United States has played a seminal role in the history of the nation. So did the belief, central in the thinking of Ralph Waldo Emerson in the nineteenth century and Still in the twentieth, that the vastness and grandeur of the landscape of the New World would give rise to a new culture in the American grain. Americans settlers in the colonial period believed that the country, free from the decadence of European society, would become a second Eden in which human history would begin anew.[99] Its forests would become, as Emerson wrote in 1836, "plantations of God," where "sanctity reigns."[100] As I have observed, the American landscape has often been conflated with the Sublime. Barbara Novak wrote that in the United States, "the idea of the Sublime celebrated by Edmund Burke continued into the nineteenth century, although with some modifications. The Sublime took on more Christian overtones."[101] Novak also wrote that nature became "a repository of national pride [and] a religious alternative."[102] "God in nature and God as nature were virtually interchangeable.… In this, the transcendental philosophy of [Emerson and Henry Thoreau] led the way."[103]

The American wilderness in all of its magnificence continued to be a favorite subject of painting in the nineteeth century. It was also a primary source of imagery for the early Modernist painters

who exhibited in Alfred Stieglitz's gallery, in particular Arthur Dove, John Marin, Georgia O'Keeffe, and Marsden Hartley. For these artists, as Matthew Baigell has pointed out, the "quest was a double one: for personal identification and for American identification. [They] sought to paint with their own voices and they believed that by so doing they would reveal their American voices."[104] The Stieglitz artists sought, in Baigell's words, "to develop an American art based on a sense of place and a desire for the artist to respond as authentically as possible to that place. That is, the artist, in defining himself through his relationship to the landscape … would define himself as an American artist.… Authenticity and Americanism went hand in hand."[105]

This attitude was shared by the Benton, who was admired by Pollock, Still, and Newman early in their careers. Later they rejected him, deciding that it was impossible to represent the drama of the American West "realistically."[106] Instead, they developed a new kind of visionary Regionalist painting that expressed the "sweeping range of the American landscape," which, as Don DeLillo wrote, "can be a goad, a challenge, an affliction, and an inspiration, pretty much in one package."[107]

The lure of the West

Long after moving East, Still recalled, "It was a grand freedom Pollock and I felt in the West … being able to move in any number of miles."[108] After relocating to New York and then to Long Island, the West remained a lure for Pollock. Pollock told Robert Goodnough that in the 1930s, "intermittently he made trips across the country, riding freight trains or driving a Model A Ford, developing a keen awareness of vast landscape and open sky."[109]

When in 1931, following his teacher's advice, Pollock hitchhiked across the United States, he wrote to his brother Charles, "The country begins to get interesting in Kansas—the wheat was just beginning to turn and the farmers were making preparation for harvest."[110]

For Pollock and Still, The West began, in Benton's words, at

> the ninety-eight degree line [where] there is a marked change of country. [The world becomes] immensely bigger. [There] are other prairies in the United States, but the experienced traveler … does not confuse them with the West. [They] lack the character of infinitude which one gets past the ninety-eight degree line.… In the West proper there are no limits. The world goes on indefinitely. The horizon is not seen as the end of a scene. It carries you on beyond itself into farther and farther spaces.… This is the physical effect of the West.[111]

Americans have traditionally viewed the prairies as empty, boundless, featureless, formless, and formidable. The sculptor Isamu Noguchi, a close ally of the Abstract Expressionists, contrasted the Japanese and American views of nature. The Japanese saw nature in its details, "An insect, a leaf, a

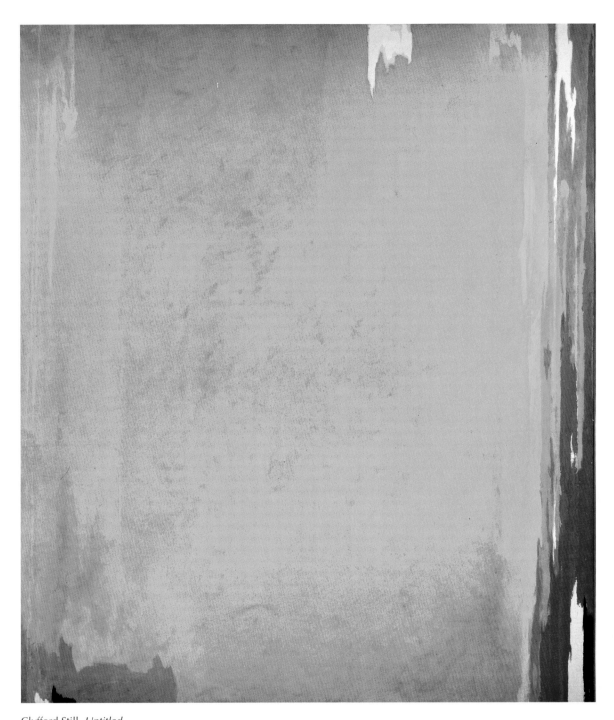

Clyfford Still, *Untitled*
1951, oil on canvas
108″ x 92-1/2″
National Gallery of Art, Washington, D.C.

flower." In America, "Here nature is appreciated for its vastness, its sweep, the panorama of that open Indiana countryside."[112]

In 1785, Congress mandated the surveying of the Northwest Territory. The West was to be divided into a checkerboard grid of six-mile-square units, which were further divided into one-mile-square parcels. This and an Ordinance of 1787 embody Jefferson's belief that democracy would be secured if the land was partitioned into small and equal sections, enabling Americans to own their own farms and be independent and free. Much as the checkerboard grid divided up the West, it also declared its openness. It could be extended endlessly—as opposed to a layout composed of disparate elements that would call attention to its internal design. Pierre Charles L'Enfant, who laid out Washington, D.C., found the Jeffersonian grid plan "tiresome and insipid." His scheme called for monumental buildings with open spaces among them—in the European manner and most un-Jeffersonian.

The Jeffersonian vision gave rise to an agrarian myth in which the exemplary Americans were upstanding, independent, and individualistic small farmers, close to nature, like Still's and Pollock's own fathers. They were the mainstay of democracy. A corollary to this vision was a deep-rooted anti-urbanism. The city represented blight, poverty, avarice, crime, and violence, all of which had been transplanted from the decadent Old World. As Jefferson wrote, "Those who labor in the earth are the chosen people of God." And, "When [people] get piled up upon one another in large cities, as in Europe, they will become as corrupt as in Europe."[113]

As the frontier closed down, cities, influenced by the Jeffersonian vision, began to introduce extensive public parks within their limits, as if to preserve America's geographic heritage. Frederick Law Olmsted, an avid Jeffersonian, designed Central Park in New York City. The park had no central point but many centers. Its four main roads were located beneath the surface of the park so that the land would look continuous and unbounded.[114]

Decentralization is also at the heart of Frank Lloyd Wright's architectural vision. In his book *The Sovereignty of the Individual,* he called for establishment of suburban areas composed of modular, privately owned homes that would be connected to one another by the automobile.[115] Underlying this conception is an egalitarian ideal but one promulgated by a self-acknowledged genius. Wright was Still's architectural counterpart. Both men were born on Western farms and were monomaniacal elitists who sought to create new American democratic works.

The West, imaginary and real

In arriving at their abstract constructs of the Great Plains, Pollock, Still, and Newman were affected by the history of the frontier and its myth. Americans were taught to believe (as I was in

high school) that as settlement moved westward in a succession of frontiers, a new breed of rugged, freedom-loving individuals was born. Having escaped from an oppressive past, Americans had entered into an illustrious future. Indeed, the settling of the West was widely regarded as the Manifest Destiny of the United States.

The belief in the preeminence of the frontier in the nation's history was profoundly indebted to two nineteenth-century luminaries: Frederick Jackson Turner, one of America's most influential historians, and Buffalo Bill Cody, the celebrated impresario of the Wild West show. They did not have to introduce the frontier to Americans—the log cabin had long been a national icon—but they explained its import. Turner and Cody presented two markedly different interpretations of Western colonization.

Turner's lecture "The Significance of the Frontier in American History" (1893) exerted a profound influence on Benton. Turner maintained that waves of pioneers moving into seemingly endless free land accounted for "the evolution of a uniquely democratic, individualistic and progressive American character."[117] The hardships of taming a succession of Western frontiers turned its settlers into enterprising self-made men. Disregarding the fact that the West was populated by Native Americans and others, Turner claimed that his farmers had conquered a wilderness, rooted themselves in the land and extended triumphantly what Jefferson had called "an empire of liberty"—and that they did so in a primarily peaceful fashion.[117]

In contrast to the Turner thesis, Cody, in his Wild West extravaganzas, enacted a violent West in which whites, as innocent and heroic victims, defended themselves against savage Indian aggression. In actuality, the settlers fought the Indians for their land and conquered it. Either way, the story entailed guns, violence, and death.

The opposing narratives of our frontier heritage constructed by Turner and Cody were fundamentally revised by later historians. It was only in 1967, with the publication of William H. Goetzmann's *Exploration and Empire,* that scholarly Western studies began in earnest.[118] As Thomas Flanagan wrote, the historical truth of the West, particularly during the post-Civil War-era,

> is that the railroads, the various Homestead Acts, the greed of prospectors, and the safety of settlers require that the tribes be "pacified," removed from their vast hunting grounds, and herded into reservations. There, they live at the mercy of corrupt agents and cynical politicians, cheated, swindled, and otherwise degraded. Occasionally, they will break out of the reservation. This will be termed "another Indian uprising" and the army will be called into the field.[119]

The truth finally overtook the myth, at least in academic circles, but this occurred two decades after the emergence of Pollock's, Still's, and Newman's Field Painting. In their time, these three artists, like Americans generally, were influenced by the vision of the legendary frontier.

Myths may be unveiled as lies, but they can continue to exert a compelling influence on a people's imagination. Both Turner and Cody recognized that the frontier had ceased to exist physically by the end of the nineteenth century. However, Americans continued to envisage the West as vast, vacant, and unfenced; indeed, its most important attribute was its emptiness. Yet this frontier was supposedly populated by fabled individualists, as historian Patricia Nelson Limerick wrote,

> a colorful and romantic cast of characters—mountain men, cowboys, prospectors, pioneer wives, saloon girls, sheriffs, and outlaws. Tepees, log cabins, and false-front stores were the preferred architecture of the frontier; coonskin caps, cowboy hats, bandannas, buckskin shirts and leggings, moccasins, boots, and an occasional sunbonnet or calico dress constituted frontier fashions; canoes, keelboats, steamboats, saddle horses, covered wagons, and stagecoaches gave Americans the means to conquer the rivers, mountains, deserts, plains, and other wide-open spaces of the frontier; firearms, whether long rifles or six shooters, were everywhere in frequent use. These images are very well understood.[120]

These subjects repeatedly appeared in the visual arts, beginning with the works of George Catlin, Frederic Remington, and Charles Russell. The mythic image of the West and its inhabitants was also the source of innumerable repeated (and repetitive) stories in the popular media. As both a real place and an imaginary realm, the West was deeply implanted in the American consciousness.

"This Americanness"

The "art" that most promoted the frontier myth was the Western movie. From 1942 to 1952 (the heyday of Abstract Expressionism), 228 Westerns were produced by Hollywood. Moreover, Westerns were elevated to "A" film status.[121] The protagonist of the Western was the cowboy who roamed the open prairie under the endless sky, free, independent, and alone. As a kind of latter-day frontiersman, he has been the exemplary American hero, featured not only in movies but in pulp fiction, popular magazines, Wild West shows, frontierland parks, rodeos, and programs on radio and television. Western sagas appealed to the American audience, because they intimated that its spectators were free to invent a new life for themselves.

The myth of the cowboy is personified in the continuing popularity of John Wayne, who has come to be considered the definitive, even archetypal, American.[122] In the role of manly cowboy-sheriff, he was a simple good guy faced with an unequivocal good and evil situation. Then in the 1950s, another type of the movie cowboy appeared, one who, finding himself in ambiguous moral situations, was existentially conflicted, such as the protagonist in *High Noon* (1952). In that film, Gary Cooper as the lawman is deserted by his cowardly townsmen. He can choose to run, as his wife insists he must, but instead he chooses to shoot it out with the bad guys, singlehandedly. He prevails, but then quits in disgust.

In their personas, Pollock, Still, and Newman emulated the independence and freedom of the cowboy. In photographs of Pollock, such as the one in *Life* in 1949, he had himself portrayed dressed as a Westerner, dangling a cigarette from his mouth, or posed beside a battered old Ford. He presented himself in the Cooper rather than in the Wayne model, a tormented hero, macho but anxiety ridden. Pollock's self-presentation as a cowboy may have been play-acting, but it was his way of identifying himself as a man of the West. In his writing, Still called attention to his prairie roots, but he assumed the metaphoric role of solitary prophet in the wilderness.

A number of critics sympathetic to Abstract Expressionism—notably Harold Rosenberg and Thomas Hess—looked askance at Pollock's and Still's self-images. Hess wrote,

> Woven into the tissue of the Jackson Pollock story is one word, repeated endlessly—"America," the New World with its innocence and violence, the go-for-broke Westerner with his hand on a six-shooter and his life on the turn of a card; the innocence of living a life directly through, from the inside out, without masks; the worship of integrity; the idea that there is such a thing as an ultimate honesty, a deepest truth that you can discover inside yourself and hoist it on the picture, sign it, stretch it, hang it in a room.[123]

Hess was being ironic, of course, but his description of Pollock had more than an element of truth.

Twitting Still's stance, de Kooning said, "It's a certain burden, this Americanness. If you come from a small nation, you don't have that.... I feel sometimes an American artist must feel like a baseball player or something—a member of a team writing American history."[124]

He-man machismo was often attributed to Pollock's painting. Greenberg compared it to Dubuffet's, commenting that the work of the American was "rougher and more brutal" than that of the Frenchman. Robert Goodnough talked of Pollock's "violent ways of expression" and Sam Hunter, of his "bursting masculinity." However, this image of Pollock has been exaggerated by critics, who have underplayed his self-doubt.[125]

Luminism, egalitarianism

Like Still and Newman, Rothko lightened the mood of his painting in luminous yellow and orange abstractions that he began in 1949 and which numbered more than 35 by 1957. Unlike his fellow Color-Field painters, Rothko was not interested in the American West or its landscape. Nor did he seem particularly taken with earlier American art. However, his works can be related to the nineteenth-century Luminist painting of Martin J. Heade, Fitz Hugh Lane, and John Kensett, whose theoretical underpinning was to be found in Emerson's Transcendentalism, which strongly influenced

Rothko's thinking. Art historian Robert Rosenblum has eloquently described the connection between Rothko and Luminism:

> [The] abundance and intensity of [the Luminist] visions speak for their importance to a peculiarly American experience. Typically, a Luminist painting confronts us with an empty vista of nature (often a view of sea and sky from the shore's edge) that is more colored light and atmosphere than terrestrial soil; and if there is any movement at all in these lonely contemplations of quietly radiant infinity that seems to expand in imagination even beyond the vast dimensions of the North American continent, it is that of the power of light slowly but inevitably to pulverize all of matter, as if the entire world would eventually be disintegrated by and absorbed in this primal source of energy and life. A surrogate religion is clearly a force here, too. [This] natural American light … can slowly lead us to the supernatural and transcendental thought of Emerson and Thoreau, who also sought a mystic immersion in the powers of nature.

Rosenblum concluded that "with this in mind, Rothko's art can be seen as resurrecting, in an abstract mode, the Luminist tradition."[126]

Still's, Pollock's, Newman's, and Rothko's 1950s Field abstractions can be considered American in other ways. Their nonhierarchical arrangements evoke the egalitarian promise of the United States, which is basic to the nation's idea of itself. Equality is the birthright of every American citizen: as the Declaration of Independence proclaims, "All men are created equal." Greenberg discerned a "democratic" aspect in Field Painting, writing that it "seems to answer something deep-seated in contemporary sensibility. It corresponds perhaps to the feeling that all hierarchical distinctions have been exhausted."[127]

Art critic Carter Ratcliff has coupled Pollock and Walt Whitman as great cultural champions of egalitarianism. "As in Pollock's paintings, so in the sprawl of Whitman's verse, there is energy, an implication of boundlessness, and an intricate weave of incident that never coalesces into a stable hierarchy." At the same time that Pollock's painting and Whitman's verse are metaphors for egalitarianism, Ratcliff points out that they are "animated by a consciousness of self so acute that one can sense it in each twitch of Pollock's arm and every flicker of Whitman's wide-ranging glance."[128] Their assertion of the unique individuality of the creator can be viewed as an elitist antithesis to egalitarianism. Indeed, how to mediate between egalitarianism and individualism has been one of the unresolved issues in American history.

Emersonianism: America's ideology

The affirmation of the individual was central in the thinking of Pollock, Still, Newman, and Rothko. It had its roots in an American libertarian tradition that reaches back to the Nation's

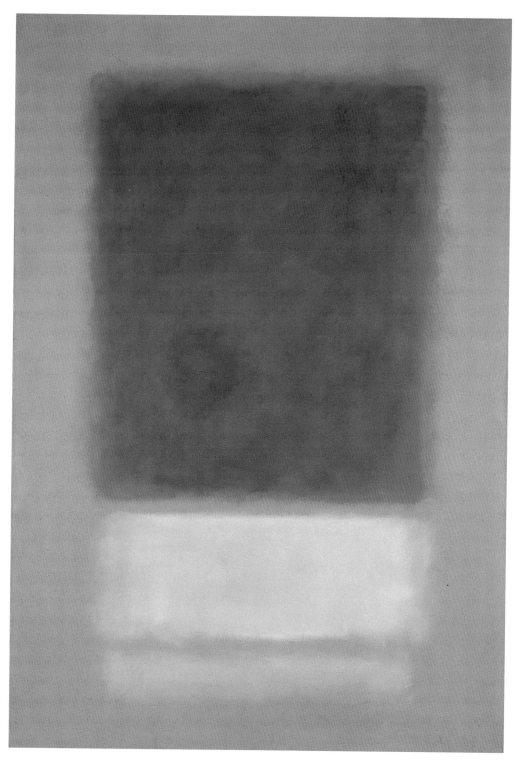

Mark Rothko, *Old Gold Over White*
1956, oil on canvas
68" x 45"
Collection Neuberger Museum of Art
Purchase College, State University of New York
Gift of Roy R. Neuberger.
Photo credit: Jim Frank
© 2008 Kate Rothko Prizel & Christopher Rothko / Artists Rights Society (ARS), New York

colonial beginnings, notably in the dissenting attitude that brought the New England Puritans to these shores.[129] Its exemplar was Emerson, whose thinking was prototypically American. In his view, the representative American was the autonomous, self-reliant nonconformist who rose above all past and present conventions and spoke the truth on the basis of his or her experience. As early as the 1830s, Emerson wrote, "Nothing is at last sacred but the integrity of our own mind.... What I must do is all that concerns me, not what the people think."[130] In 1840, he summed up, "In all my lectures I have taught one doctrine, namely, the infinitude of the private man."[131] This idea has been funda-mental in the American imagination.[132]

Still was the exemplary Emersonian in that he believed, as he said, that the "measure of [an artist's] greatness will be the depth of his insight and his courage in realizing his own vision."[133] Hence he relentlessly extolled his own painting above that of all other artists. Emerson's antipathy to any authority that threatened personal freedom and his glorification of individualism was at the core of the thinking not only of Still but of Pollock, Newman, and Rothko. It led them to spurn estab-lished styles, jettison received ideas and values, and aspire to create original images.

The abstractions of the four Field painters were metaphors both for the self and the Sublime. They cultivated individual styles on the one hand, and on the other, they suppressed autographic touch or hand as signs of the personal, to call attention to the suprapersonal. In a sense, by having it both ways, Pollock, Still, Newman, and Rothko made the self sublime.

In relying on their own experience, Pollock and Still spurned received artistic ideas and values, notably those they identified with Europe.[134] In this, too, they followed Emerson, who rejected Old World traditions and called for a new culture that would be based on life in the New World. As early as 1837, he delivered a speech titled "The American Scholar," one of the most famous of American pronouncements. He declared, "We have listened too long to the courtly muses of Europe." But the "day of dependence ... draws to a close.... We will speak our own minds."[135] Almost a century later, Oliver Wendell Holmes, one of America's foremost Supreme Court Justices, hailed Emerson's address as "our intellectual Declaration of Independence."[136]

In 1871, Whitman endorsed Emerson's prophecy in "Democratic Vistas," an essay as famous as Emerson's "The American Scholar." Whitman envisioned a class of native authors superior to any abroad who would deal with life in the United States. Whitman's own poetry was simultaneously personal and American, manifesting a profound regard for the American experience. In *Song of Myself*, he wrote, "I celebrate myself, and sing myself," and added that his verse was "a nation announcing itself."[137] In exalting himself, Whitman declared that he was eulogizing the United States.[138]

Still believed that his Field painting had fulfilled Emerson's and Whitman's prophecy. More than any of his contemporaries, he projected the public persona of the artist who had broken the constraints of the Old World and was reborn in the New, a pioneer who had invented an unprecedented American art.

"A combination of the *tabula rasa* and Huck Finn"

Emerson's essays so impressed Newman that on his honeymoon in 1936, he visited the writer's New England home, as well as Hawthorne's, and Thoreau's on Walden Pond. In Newman's thinking, Emerson's ideas were reinforced by those of Prince Pierre Kropotkin, the leading exponent of Anarchism, to which his friend Rothko was also sympathetic. In 1968, Newman wrote an introduction to Kropotkin's *Memoirs of a Revolutionary* in which he asserted that the author was "intoxicated with the love of personal freedom." Newman also notes approvingly of Kropotkin, "He saw that all dogmatic systems, no matter how radical, are as much a tyranny as the State, and he took a stand against all establishments." Newman concluded, "Only those are free who are free from the values of the establishment. And that's what anarchism is all about."[139] As opposed to Capitalism and Communism, Anarchism stood for the communal ownership of property and the decentralization of industry. When Newman was asked what his painting "really means in terms of society, in terms of the world, in terms of the situation," he responded, "if my work were properly understood, it would be the end of state capitalism and totalitarianism."[140] What Newman had in mind was that the openness and decentralization of his allover painting was a metaphor for his Anarchist beliefs. As he said, "In terms of its social impact [my painting] does denote the possibility of an open society, of an open world, not of a closed institutional world," a world that would prefigure an egalitarian, future society.[141]

Newman embraced a central idea of Anarchism (as of Emersonianism)—that is, "the autonomy of the Individual."[142] He said that his painting expressed "the feeling of his own totality, of his separateness, of his own individuality."[143] Recalling his experience of the aboriginal earthworks in Ohio, Newman wrote, "Looking at the site you feel, 'Here I am …' and out beyond, there is chaos, nature, rivers, landscapes … but here you get the sense of your own presence … the idea that 'Man is Present.'"[144] In 1950, Newman titled a picture *Here I*. The zip, then, is a surrogate for Man, for Newman himself, and, by extension, for the viewer.

In a white-on-white announcement designed by Newman for his second one-person show in 1951, he characterized his work as a "sort of a combination of the *tabula rasa* and Huck Finn." The *tabula rasa* was the condition of the human mind at birth without any innate ideas, or so it was alleged by the philosopher John Locke. Newman viewed it as a mental realm of uncompromised freedom, possible only in the United States, into which Huck Finn proposed to enter. As Carter Ratcliff

Barnett Newman, *Vir Heroicus Sublimis*
1950-51, oil on canvas
7' 11-3/8" x 17' 9-1/4"
Gift of Mr. and Mrs. Ben Heller
The Museum of Modern Art, New York

commented, "Aunt Sally plans to 'sivilize' Huck and he 'can't stand it.' So he decided to 'light out for the Territory,' the empty, unbounded region of the west, where civilization has not yet begun to erect its confining regulating structures." Ratcliff went on to say that Newman brilliantly conflated "the Lockean model of the mind and Huck Finn's idea of geography. His greater brilliance was to paint images that evoke the habitat of the solitary, primordial American.… Properly read, Newman's art would lead each of us beyond tradition, beyond inhibition to self-renewal in a world of perpetually renewed individualists."[145]

Summing up, Newman wrote that he—and the Field painters—had liberated themselves from "the impediments of memory, association, nostalgia, legend, myth" and instead made "cathedrals … out of ourselves, out of our own feelings."[146]

1. John Hersey, *Hiroshima* (New York: Knopf, 1946).

2. Kirk Varnedoe, "Abstract Expressionism, 'Primitivism' in 20th Century Art" (New York: Museum of Modern Art, 1984), p. 644.

3. Robert Motherwell, in "Jackson Pollock: An Artists' Symposium, Part 1," *Art News,* April 1967, p. 65.

4. "Unframed Space, Interview with Jackson and Lee Pollock," *New Yorker,* August 5, 1950, p. 16.

5. Marcel Jean, *History of Surrealist Painting* (London: Weidenfeld and Nicolson, 1960), p. 347.

6. Deborah Rosenthal, "Interview with André Masson," *Arts,* November 1980, p. 94.

7. Lawrence Alloway, "Notes on Pollock," *Art International,* May 1, 1961, pp. 40-41.

8. Peter Busa, in conversation with the author, New York, May 25, 1966.

9. Jackson Pollock, "My Painting," *Possibilities 1,* Winter 1947-1948, p. 79.

10. Axel Horn, "Jackson Pollock: The Hollow and the Bump," *Carleton Miscellany,* Summer 1966, pp. 85-86, quoted in Laurence P. Hurlburt, "The Siqueiros Experiential Workshop, New York 1936," *Art Journal,* Spring 1976, p. 242. On p. 238, Hurlburt wrote that within weeks of arriving in New York in mid-February, 1936, Siqueiros had organized an "initial nucleus," including Jackson Pollock and his brother, Sande McCoy. When Siqueiros left New York in 1937, the workshop slowly fell apart.

11. Pepe Karmel, in "Allegorical Abstraction," a talk at "A Fine Regard: A Symposium in Honor of Kirk Varnedoe," Institute of Fine Arts, New York University, November 13, 2004, has suggested that Pollock resembled a great dancer or athlete whose body knows what to do almost instinctively, enabling him to make split-second decisions without too much cerebration.

12. See William Wright, excerpts from a taped interview with Jackson Pollock, 1950, *Art in America,* August-September 1965, p. 80.

13. Letter to the Editor, *Time,* December 11, 1950, p. 10.

14. B. H. Friedman, "An Interview with Lee Krasner Pollock," "Jackson Pollock: Black and White" (New York: Marlborough-Gerson Gallery, 1969), p. 7.

15. See Nathan Weinberg, "Pollock and Picasso: The Rivalry and the 'Escape,'" *Arts Magazine,* Summer 1987, pp. 42-48.

16. Willem de Kooning, remarks on a panel in memory of Jackson Pollock at The Club, New York, Summer 1956.

17. George McNeil, in conversation with the author, Provincetown, July 29, 1957.

18. Douglas McAgy, in conversation with the author, New York, 1960s, observed, "By 1946, Still's paintings were essentially abstract. The next year there were single images with rifts of canvas beginning to show through; the color throughout was dark—brownish, dingy, the sizes comparatively small. Beginning in 1948, the canvases got larger and larger. In 1950, the colors began to get bright."

19. Thomas Albright, "The Painted Flame," *Horizon,* November 1979, p. 26.

20. "Clyfford Still," *Magazine of Art,* March 1948, p. 96.

21. Ernest Briggs, in conversation with the author, New York, early 1960s, said that Still told him he did not mean to suggest the prairie but the loneliness of man.

22. Ti-Grace A. Sharpless, "Freedom … Absolute and Infinitely Exhilarating," *Art News,* November 1963, p. 37.

23. Clyfford Still, letter to Mark Rothko, November 10, 1951, in "Clyfford Still" (New York: Metropolitan Museum of Art, 1979), p. 57.

24. Carter Ratcliff, *The Fate of Gesture: Jackson Pollock and Postwar American Art* (New York: Farrar, Straus, Giroux, 1996), pp. 74, 76.

25. Still's paintings with recognizable images were exhibited at the San Francisco Museum of Art in 1946. In 1948, two of his paintings, dated 1947, reproduced in *Tiger's Eye*, December 15, 1948, still contained vestiges of figures. However, several canvases exhibited in 1947 at his show at the Betty Parsons Gallery and the California Palace of the Legion of Honor are fully abstract. The dates of Still's paintings, particularly the later ones, are problematic, because he dated a number from the year he conceived them, not when he actually painted them.

26. Rothko's multiform abstractions were reproduced in *Tiger's Eye*, December 15, 1948, and October 15, 1949.

27. Dore Ashton, *About Rothko* (New York: Da Capo Press, 1996), pp. 93, 95.

 Sam Hunter, in "Letters: Writings on Rothko," *New York Review*, February 17, 1994, p. 40, called Still "an acknowledged role model," and he added,

 > "Still was recognized as an important leader, artistically, [of] Rothko, Barnett Newman and, and for a time, Ad Reinhardt. I think it can be established that all were influenced directly … by Still's uncompromising moral stance, prophetic posturing and cultural extremism. As early as 1946 Rothko wrote an introduction to Still's first New York show … clearly in the spirit of a disciple, referring to the West Coast painter as a leader of a new group of … 'myth-makers.'"

28. Newman alleged that he had painted during the 1930s and had destroyed all of his work of that period. He did not paint from 1939 to 1945. Pictures made circa 1946 were biomorphic abstractions. The first reproductions of works related to his subsequent Color-Field abstractions are dated 1947 and were published the following year in the journal *Tiger's Eye*. One of them, titled *Death of Euclid*, reproduced on March 15, 1948, p. 102, has two vertical stripes, one a reversed L, the other a curve flanked by a sun-moon shape with a halo. Another picture, *Two Edges*, 1948, which was illustrated in *Tiger's Eye*, December 15, 1948, p. 28, contains two vertical plank-like planes. However, late in 1949, *Tiger's Eye* reproduced *The Break*, dated 1948, which is composed of three gesturally painted vertical columns and a sun moon. (The reproduction was most likely dated by Newman because he was listed as an editor of the magazine, although he later claimed to have resigned before the photograph appeared. He later painted the date 1946 onto its surface so that it would precede Still's mature painting.) It appears that Newman was unclear about what direction his painting should take as late as 1948.

29. Barnett Newman, "Interview with Emile de Antonio," in J. P. O'Neill, ed., *Barnett Newman: Selected Writings and Interviews,* (New York), p. 305. The dates of Newman's paintings are suspect, as are Still's, except that Still's were exhibited and reproduced with greater frequency than Newman's. Karen Wilken in "Abstract Expressionism Revisited," *New Criterion*, February 1991, p. 32, wrote that Newman was "reported to have painted after the fact, a series of 'missing-link' pictures to fill a gap of several years in his working life."

 Adolph Gottlieb said to me that Newman began to sketch around 1945 but didn't really paint until 1948. He produced his first one-man show in a year.

30. Prior to Newman's first show in 1950 at the Betty Parsons Gallery, New York, he exhibited work in a Christmas show (1946) and the "Ideographic Picture" (1947, which he curated), both at the Betty Parsons Gallery, and pictures in two other group shows in 1948 and 1949. In 1948, he exhibited one picture at "Abstract and Surrealist Art" at the Art Institute of Chicago.

 I do not mean to imply that Newman was dishonest in claiming that his Color-Field paintings anticipated Still's. I imagine that in painting *Onement 1,* he had an epiphany. As he saw it, his style was so different as to be original—and even the first. If not that, then he claimed that he had the idea of Color-Field Painting prior to seeing Still's paintings, and it was the date of the idea that counted, not the execution. Whatever his justifications, Newman believed that any reference to Still's or Rothko's influence on his development demeaned his original contribution, his absolute vision, and, in the end, his identity as an artist and even as a man. Therefore, Newman felt impelled to declare the autonomy of his painting and defend it passionately.

Contributing to his zeal was the unfavorable art-world reception of his shows in 1950 and 1951, and subsequently Still's rejection of his work and Rothko's critical success, all of which caused Newman to withdraw from showing his work from 1952 to 1958.

Newman often made self-aggrandizing claims for the priority of his work. For example, he insisted that a painting titled *Abraham* (1949) was the first all-black painting and had influenced both Clyfford Still and Ad Reinhardt—an idea accepted by Yve-Alain Bois in "On Two Paintings by Barnett Newman: Abraham," *October,* Spring 2004, pp. 5-27. However, Still painted all-black pictures long before Newman did, although they did not seem black enough for Newman. The notion that Reinhardt would have had to see Newman's black painting to paint his own dark gray ones overlooks the fact that Reinhardt's intentions were diametrically opposed to Newman's and that they evolved from his all-red, all-blue, and all-yellow pictures of the 1950s. Besides, many Abstract Expressionists painted mostly all-black or at least all-gray paintings, including Gorky, de Kooning, Tomlin, Motherwell, and Kline.

31. Alfonso Ossorio, in conversation with the author, New York, April 29, 1968. In a conversation with the Author, New York, May 25, 1966, Peter Busa commented that Still influenced Newman.

32. Theodoros Stamos, interviewed by the author, May 25, 1966.

33. Sidney Simon, "Concerning the Beginnings of the New York School: 1939-1943: An Interview with Robert Motherwell, January 1967," *Art International,* Summer 1967, p. 23.

34. Sidney Simon, "Concerning the Beginnings of the New York School: 1939-1943: An Interview with Peter Busa and Matta, December 1966," *Art International,* Summer 1967, pp. 17-19.

35. Sam Hunter, *Masters of the Fifties* (New York: Marissa del Re Gallery, 1985), n.p.

36. Kenneth Sawyer, "U.S. Painters Today: No. 1—Clyfford Still," *Portfolio and Art News Annual,* No. 2, 1960, pp. 74-87.

37. Clement Greenberg, "'American-type' Painting," *Partisan Review,* Spring 1955, pp. 192-193.

38. Still insisted on packing his 1979 retrospective at the Metropolitan Museum with late overblown paintings and playing down the far more expressive earlier ones. Mrs. Still refused to give T. J. Clark permission to reproduce Still's painting in his *Farewell to an Idea: Episodes from the History of Modernism* (New Haven, Conn.: Yale University Press, 1999).

39. Michael Kimmelman, "Art View: Chilling Isolation, Both on Canvas and Off," *New York Times,* Sunday, January 31, 1993, sec. H, p. 29.

40. James T. Demetrion, ed., *Clyfford Still Paintings 1944-1960* (Washington, D.C.: Hirshhorn Museum and Sculpture Garden, 2001).

41. James E. B. Breslin, *Mark Rothko: A Biography* (Chicago: University of Chicago Press, 1993), p. 283.

42. Barnett Newman not only rejected Mondrian but all of Cubism. In a statement, in "The New American Painting" (New York: Museum of Modern Art, 1959), p. 60, he was still proselytizing against abstract Cubism—long after it was no longer an issue. He wrote, "It is precisely this death image, the grip of geometry, that has to be confronted. In a world of geometry, geometry itself has become our moral crisis." Newman called for a new beginning, but this beginning had occurred a dozen years earlier.

43. Dorothy Gees Seckler, "Frontiers of Space," *Art in America,* Summer 1962, pp. 86-87.

44. Selden Rodman, *Conversations with Artists* (New York: Devin-Adair, 1957), p. 84.

45. Thomas B. Hess, "The Outsider," *Art News,* December 1969, p. 68.

46. Barnett B. Newman, "The Sublime is Now," in "The Ides of Art: Six Opinions on What Is Sublime in Art?" *Tiger's Eye* 6, December 1948, p. 51. Newman wrote, in "The New Sense of Fate," *Selected Writings,* p. 168: "Greece named both form and content; the ideal form—beauty, the ideal content—tragedy." But as he viewed it, these two ideals came into conflict in the visual arts. The Greek vision in European art led to a

"nostalgia over the loss of the elegant column and beautiful profile, in short, the Beautiful. In literature, however, the ancient Greek "writers had to grapple [directly] with the subject matter. That is why we as artists can paradoxically reject the Grecian form—we do not believe any longer in its beauty—while accepting Greek literature, which by its unequivocal preoccupation with tragedy is still the fountainhead of art."

47. Barnett Newman, "The Object and the Image," *Tiger's Eye,* March 1948, p. 111.

48. Burke, *A Philosophical Enquiry,* quoted in Lawrence Alloway, "The American Sublime," p. 15. Like Burke, Kant, in "Critique of Judgment" (1790), I, Book 2, 23, quoted in Rosenblum, "The Abstract Sublime," p. 40, wrote that whereas "the Beautiful in nature is connected with the form of the object, which consists in having boundaries, the Sublime is to be found in a formless object … so far as it, or by occasion of it, boundlessness is represented."

49. Burke, *A Philosophical Enquiry,* II, xiv.

50. J. Benjamin Townsend, "An Interview with Clyfford Still," *Gallery Notes* (Albright-Knox Art Gallery), Vol. 24, No. 2, Summer 1961, p. 13.

51. Thomas Albright, "A Conversation with Clyfford Still," *Art News,* March 1976, p. 35.

52. Ernest Briggs, in conversation with the author, early 1960s.

53. Jon Schueler, in conversation with the author, end of 1959.

54. Lawrence Alloway, "The American Sublime," *Living Arts,* June 1963, p. 15.

55. Mark Rothko, in statement, *Interiors,* May 1951, p. 104, wrote, "However you paint the large picture, you are in it."

56. Clement Greenberg, "Art," *Nation,* May 2, 1942, quoted in John O'Brian, ed., *Clement Greenberg: The Collected Essays and Criticism Volume 1* (Chicago and London: University of Chicago Press, 1986), p. 103. This position may have been influenced by Greenberg's commitment to Marxism, which favored a mural art for the masses.

57. Adolph Gottlieb and Mark Rothko (in collaboration with Barnett Newman), "Letter to the Editor," *New York Times,* June 13, 1943, sec. 2, p. 9.

58. Edward Alden Jewell, in "Unusual Art Show Opens at Museum," *New York Times,* April 2, 1947, p 34, wrote: "Scale constitutes the theme of … this unusual show.… No painting less than six feet in length was considered eligible, and several of the canvases are enormous."

59. Clement Greenberg, "Art," *Nation,* January 24, 1948, p. 107.

60. Clement Greenberg, "The Present Prospects of American Painting and Scupture," *Horizon,* October 1947, p. 26.

61. Sam Hunter, "Introduction," *Jackson Pollock* (New York: Museum of Modern Art, 1956), p. 9.

62. Wright, taped interview with Jackson Pollock, p. 80.

63. Ibid.

64. Jackson Pollock, "My Painting," *Possibilities 1,* Winter 1947-1948, p. 79.

65. Leja, *Reframing Abstract Expressionism,* p. 283.

Artists and art professionals of Pollock's generation often perceived him as an extraordinary individual who defied artistic conventions to be true to himself. It was also believed that Pollock's commitment was so all-consuming that he paid for his art with his life. His painting not only took a terrible toll on his life, but when he could no longer sustain his heroic action, in despair he was cut down by fate or cut himself down. With regard to the growth of his myth, his defeat was his triumph. However, in both the beginning and the

end, it was Pollock's painting that was responsible for its expressive power, not his intentions, rhetoric, personality, role-playing—or myth.

In his role of the tortured (and doomed) artist, Pollock was also related to inarticulate, estranged male characters played in movies at the time by Marlon Brando, James Dean, and Montgomery Clift. Or jazz musician Charlie Parker, who, like Pollock and Dean, died in 1956.

66. Robert Motherwell, "Jackson Pollock: An Artists' Symposium," *Art News,* April 1967, p. 67.

67. Anthony Smith, in Francis du Plessix and Cleve Gray, Interviews, "Who Was Jackson Pollock?" *Art in America,* May-June 1967, p. 54.

68. Kenneth Sawyer, in "Clyfford Still," *Portfolio and Art News Annual,* No. 2, 1960, pp. 74-87, reproduced a double-page photograph of a North Dakota prairie, with Still's approval.

 David Anfam, *Clyfford Still,* PhD dissertation, Courthold Institute of Art, 1984, p. 65, remarked that in his 1943 retrospective Still gave his pictures such titles as *The White Plow, The Yellow Plow, Man with a Sheaf,* and *Green Wheat.*

69. Thomas B. Hess, "The Outsider," *Art News,* December 1969, p. 68. Howard de Vree, in *New York Times,* April 1947, wrote of Still's abstractions that "Grimness, spareness, melancholy are in them." E. C. Goossen , quoted in Patrick McCaughey, "Clyfford Still and the Gothic Imagination," *Artforum,* April 1970, wrote: "Agonized, tortured, foreboding, they are a hieratic vision of hell on high." Or as David Anfam, in "Clyfford Still's Art: Between the Quick and the Dead," in James T. Demetrion, ed., *Clyfford Still Paintings 1944-1960* (New Haven, Conn.: Yale University Press, 2001), p. 38, observed, "Whatever the crusty browns, dead blacks, molten reds, chalky whites, parched ochers, and crepuscular blues convey, it is no easy-going Mediterranean joie de vivre."

70. Herman Cherry, in conversation with the author, New York, February 20, 1958, said that Still lived next to him for four years and invited him only twice into his studio. Both times, he told Cherry about his boyhood, so powerfully had it remained in his memory.

71. Henry Hopkins, "Clyfford Still, 1904-1980," *Art in America,* October 1980, p. 11.

72. Dore Ashton, *About Rothko* (New York: Oxford University Press, 1983), p. 6.

73. Werner Haftman, "Introduction," translated from German into English by Margery Scharer, "Mark Rothko" (Zurich: Kunsthalle Zurich, 1971), p. ix.

74. Irving Sandler, "New York Letter," *Art International,* March 1, 1961, p. 40.

75. Burke, *A Philosophical Enquiry,* quoted in Alloway, "The American Sublime," p. 21.

76. Charles Harrison, "Abstract Expressionism II," *Studio International,* early 1970s, p. 58.

77. Barnett Newman, "The First Man Was an Artist," *Tiger's Eye,* October 1947, pp. 59-60.

78. Yve-Alain Bois, "Here to There and Back," *Artforum,* March 2002, pp. 107-08.

79. Robert Motherwell, a conversation at lunch, Smith College, Northampton, Mass., November 1962. Hand-written notes transcribed by Margaret Paul, January 1963.

80. Ibid.

81. Robert Motherwell, statement, "Black and White: Paintings by European and American Artists" (New York: Kootz Gallery, 1950), n.p.

82. In its expression of tragedy, Motherwell's painting is explicitly symbolic, and hence different from the work of Still, Rothko, or Newman, on the one hand, and on the other, of Pollock or de Kooning, who tended to "encounter" their images in the process of painting.

83. I have adopted the term Lawrence Alloway coined in "The American Sublime," *Living Arts,* June 1963.

84. Anthony Smith, in Francine du Plessix and Cleve Gray, interviews, "Who Was Jackson Pollock?" *Art in America,* May-June 1967, p. 52.

85. Pollock, "Jackson Pollock," *Arts and Architecture,* February 1944, p. 14 (answers to a questionnaire). Lee Krasner [Pollock] recalled, in Barbara Rose, "Pollock's Studio: Interview with Lee Krasner," Barbara Rose, ed., *Pollock Painting* (New York: Agrinde, 1980), n.p., that what Pollock "identified with was about as American as apple pie. His stories about Indians—and he made many trips to the West—were not European in any sense.… He did work with his father, who was a surveyor … so he really had a sense of physical space. In finding this technique of expressing what he expressed, he merged many things out of his American background." See also, Lee Krasner, in Francine du Plessix and Cleve Gray, interviews, "Who Was Jackson Pollock?" *Art in America,* May-June 1967, pp. 48-51.

86. B. H. Friedman, *Jackson Pollock: Energy Made Visible* (New York: McGraw-Hill, 1972), p. 228.

87. Ibid.

88. Bruce Glaser, "Jackson Pollock: An Interview with Lee Krasner," *Arts Magazine,* April 1967, p. 38.

89. Ralph Waldo Emerson, " quoted in Leja, *Reframing Abstract Expressionism,* p. 190.

90. Francis O'Connor, *The Genesis of Jackson Pollock: 1912 to 1943,* PhD Dissertation, Johns Hopkins University, 1965, p. 100.

91. "Thomas Hart Benton: A Descriptive Catalogue" (New York: Associated American Artists, 1939), n.p.

92. Jon Schueler, in handwritten notes of a conversation with the author, end of 1959.

93. Hubert Crehan, "Clyfford Still: Black Angel in Buffalo," *Art News,* December 1959, p. 59.

94. Clyfford Still, letter to Gordon M. Smith, January 1, 1959, in *Paintings by Clyfford Still* (Buffalo, N.Y.: Albright-Knox Art Gallery, 1959), p. 5.

95. Thomas Albright, "The Painted Flame," *Horizon,* November 1979, p. 26. See also Albright, "A Conversation with Clyfford Still," *Art News,* March 1976.

96. Ratcliff, *The Fate of Gesture,* pp. 74, 76.

 The message of another artist of Still's generation, Ansel Adams, is related to that of Still's. The snow-capped mountains in photographs, such as *Heaven's Peak* (1941-1942) are an affirmation of America.

97. Barnett Newman, interviewed by Alan Solomon, quoted in Richard Shiff, "Whiteout … ," Philadelphia Museum catalogue, p. 103.

98. Dorothy Gees Seckler, "Frontiers of Space," interview with Barnett Newman, *Art in America,* No. 2, 1962, p. 80.

99. Matthew Baigell and Allen Kaufman, "Thomas Cole's 'The Oxbow': A Critique of American Civilization," *Arts Magazine,* January 1981, pp. 136-39.

100. Barbara Novak, "Grand Opera and the Small Still Voice," *Art in America,* March-April 1971, p. 64.

101. Barbara Novak, "On Divers Themes from Nature: A Selection of Texts," in Kynaston McShine, ed., "The Natural Paradise: Painting in America 1800-1950" (New York: The Museum of Modern Art, 1976), p. 74.

102. Novak, "Grand Opera," p. 67, and *Nature and Culture* (New York: Oxford University Press, 1980), p. 38.

103. Novak, "On Divers Themes from Nature," p. 70.

104. Matthew Baigell, "American Landscape Painting and National Identity," *Art Criticism,* Vol. 4, No. 1, 1987, p. 29.

105. Baigell, "American Landscape Painting," p. 29.

106. Pollock, "Jackson Pollock," p. 14. Pollock often boasted about his roots in the West; being born in Cody, Wyoming and raised on farms. Still, in Dore Ashton, *The New York School: A Cultural Reckoning* (New York: Viking, 1972), p. 34, recalled times when as a youth his arms were "bloody to the elbow shocking wheat."

As former farm boys, Pollock and Still loved automobiles and tinkering with them, a major agrarian and rural pastime. Alfonso Ossorio, in Francine du Plessix and Cleve Gray, interviews, "Who Was Jackson Pollock?" *Art in America,* May-June 1967, p. 57, wrote, "Aside from painting, machinery was a major passion of Pollock's life. Especially cars.… He was good with all tools. He was very American in that sense—the do-it-yourself logic." For his part, Still owned a Jaguar, which he treasured. He took it apart and put it together several times. He often talked about his regard for things American—hotdogs, boxing, baseball as the national sport—and what it meant to be American. Herman Cherry, in conversation with the Author, the Cedar Street Tavern, New York, February 20, 1958, who had lived next door to Still for a number of years, said, "Still was a fanatic baseball fan and kept baseball gloves in his studio. The painters close to him—Rothko, Newman, Schueler—took up baseball because of him and would play catch in an empty lot."

107. Don DeLillo, "The Power of History," *New York Times Magazine,* September 7, 1997, p. 60.

108. David L. Shirey, "Man of the Arts," *Newsweek,* December 22, 1969, p. 105.

109. Robert Goodnough, "Pollock Paints a Picture," *Art News,* May 1951, p. 38.

110. Francis V. O'Connor, "Jackson Pollock" (New York: Museum of Modern Art, 1967), p. 16.

111. Thomas Hart Benton, *An Artist in America* (New York, 1937), pp. 199-200, quoted in Anfam, *Clyfford Still,* PhD dissertation, p. 262.

112. Katharine Kuh, *The Artist's Voice: Talks with Seventeen Artists* (New York: Harper & Row, 1960), p. 171.

113. Thomas Jefferson, *Notes on the State of Virginia,* quoted in Jacobson, *Place and Belonging in America,* p. 81.

114. See Adam Gopnik, "Olmsted's Trip," *New Yorker,* March 31, 1997, p. 101. Spatial continuity is the chief characteristic of American landscape design. For example, the lawns fronting streets of houses in suburbia evoke an unbroken strip of green, reflecting the open landscape. See Michael J. Lewis, "The American View of Landscape," *New Criterion,* April 2000, pp. 10-11.

115. See Michael J. Lewis, "Ego, Vanity, and Megalomania," *New Criterion,* May 2002, p. 74.

116. Frederick Jackson Turner, "The Significance of the Frontier in American History," *Annual Report of the American Historical Association for the Year 1893* (Washington, D.C.: Government Printing Office, 1984), p. 199.

117. Richard White, "Frederick Jackson Turner and Buffalo Bill," *The Frontier in American Culture* (Berkeley, Calif.: University of California Press, 1994), p. 12.

118. See Larry McMurtry, "The West without Chili," *New York Review of Books,* October 22, 1998, p. 38. Most revisionist historians have attacked Turner's thesis for its ethnocentrism and triumphalism. As Alan Brinkley, in "The Western Historians: Don't Fence Them In," *New York Times Book Review,* September 20, 1992, p. 23, wrote, Turner conceived of the West as "a place of heroism, triumph, and above all progress, a place where Anglo-Americans spread democracy and civilization into untamed lands … where rugged individualism flourished and replenished American democracy." This vision has been reinforced by popular culture: Hollywood movies, TV series, pulp fiction. Moreover, there were Indian and Hispanic societies in the West that were destroyed. On the other hand, the revisionists have been accused of being too negative, overlooking the dreams that drove large numbers of settlers to "Go West," to start anew, and offering no alternative narrative.

119. Thomas Flanagan, "John Ford's West," *New York Review of Books,* December 20, 2001, p. 71.

120. Patricia Nelson Limerick, "The Frontier in the Twentieth Century," in Richard White and Patrica Nelson Limerick, *The Frontier in American Culture* (Berkley, University of California Press, 1994) p. 68.

121. Philip French, "Arts: Decline of the Western," *Times Literary Supplement,* September 18, 1992, p. 18.

By the middle of the fifties, there was a falling off of Western movies. Even so, in 1955, sixty-eight were released, still a considerable number. At this time, television took over from the movies. Toward the end of the decade, there were more than forty series on prime-time television. Among the Western series on prime-time television that dominated the tube from the mid-1950s to the mid-1960s were *Gunsmoke, Wagon Train,* and *Bonanza.* There were also *The Rifleman; Have Gun, Will Travel; Cheyenne; Rawhide;* and *Maverick.* See Ian Frazier, "A Reporter at Large: Great Plains III," *New Yorker,* March 6, 1989, p. 49. Indeed the fifties were the heyday of TV Westerns. For example, in the 1958-1959 season, they accounted for four of the five top shows. Westerns continue to command public attention. Popular films, such as *Dances with Wolves, Young Guns, Legends of the Fall,* and *Wyatt Earp,* were issued in the 1990s. Soon after the destruction of the World Trade Towers, major movie corporations announced the production of new and big-budget Westerns.

122. The cowboy image took on political significance during the cold war, buttressing America's role in the world-wide struggle. Graham Fuller, in "Sending Out a Search Party for the Western," *New York Times,* March 5, 2000, Sec. 2, pp. 13, 16, wrote that the TV or Hollywood Western's "codes were bound up with America's sense of itself as the nation for which no frontier was uncrossable, no enemy was untamable, no mountain too high or forest too dense for conquest." Vietnam dampened that vision. "The jungle terrain—'Indian country' in American soldier's parlance—was an uncrossable frontier, the North Vietnamese Army an unassailable enemy."

123. Thomas B. Hess, "Pollock and the Art of Myth," *Art News,* January 1964, p. 38.

124. Willem de Kooning, "Content Is a Glimpse," *Location,* Vol. 1, No. 1, Spring 1963, quoted in George Scrivani, ed., *The Collected Writings of Willem de Kooning* (New York: Hanuman Books, 1988), pp. 75-76.

Harold Rosenberg, de Kooning's champion, in *Tradition of the New* (New York: Horizon Press, 1959), p. 13, asserted that the Action painter was a prototypical American—that is, a rugged individualist, free of traditional restraints and hence the "heir of the pioneer and the immigrant." Artist Richard Tuttle, in Michael Kimmelman, "Art Review: How Even Pollock's Failures Enhance his Triumphs," *New York Times,* Arts, October 30, 1998, Sec. E, p. 34, described Pollock's poured painting as "archetypically American because [it] appeared to have arisen, as it were, from scratch, out of its own internal energy."

125. Quoted by Jeremy Lewis, Kirk Varnedoe and Pepe Karmel, eds. *Jackson Pollock: New Approaches* (New York: Museum of Modern Art, 1999), p. 70.

126. Robert Rosenblum, "Notes on Rothko and Tradition," *Mark Rothko* (London: Tate Gallery, 1987), pp. 26-27. Dorothy Seiberling's article.

127. Clement Greenberg, "The Crisis of the Easel Painting," *Partisan Review,* April 1984. Reprinted in revised form in John O'Brien, ed., *Clement Greenberg: The Collected Essays and Criticism, Arrogant Purpose 1945-1949, Volume 2* (Chicago and London: University of Chicago Press, 1986), p. 224.

128. Carter Ratcliff, "Jackson Pollock & American Painting's Whitmanesque Episode," *Art in America,* February 1994, pp. 66-67.

129. See Matthew Baigell, "The Emerson Presence in Abstract Expressionism," typescript, *Prospects 15,* 1990.

130. Emerson's quotes come from "Self-Reliance" and "The American Scholar," in Alfred R. Ferguson and Jean Ferguson Carr, eds., *The Essays of Ralph Waldo Emerson* (Cambridge: Harvard University Press, 1979), p. 43, and Stephen E. Wicher, ed., *Selections from Ralph Waldo Emerson* (Boston: Houghton Mifflin, 1957), p. 67, quoted in Matthew Baigell, "American Landscape Painting and National Identity," *Art Criticism,* Vol. 4. No. 1, 1987, p. 38.

131. Leo Marx, "A Visit to Mr. America," *New York Review of Books,* March 12, 1987, p. 36.

132. In his speech upon accepting the Nobel Prize in 1957, Albert Camus (whose Existentialist novels and essays were closely read by the Field painters and Gesture painters), singled out Emerson as his exemplar. He said, "'A man's obedience to his own genius,' Emerson said magnificently, 'is faith in its purist form.'" See Christopher Benfey, "Dangerously Creative," *Times Literary Supplement,* July 25, 2003, p. 4.

Emersonian individualism does have a downside, a self-absorption and self-regard that can lead to a cruel disregard for one's fellow men.

133. Clyfford Still, statement, "15 Americans" (New York: Museum of Modern Art, 1952), p. 22. Still's thinking had its source not only in Emerson's Transcendentalism but also in Longinus' treatise *On the Sublime* of the third century. Longinus situated the Sublime in the character and unique vision of the individual, which was revealed in the surpassing immensity of his or her works.

134. This aspect of Emerson's thinking was echoed in numerous statements by avant-garde artists, an extreme example of which was the claim of David Smith, a close associate of the avant-garde artists, in Max Kozloff, "Walt Whitman and American Art," in Edwin Haviland Miller, ed., *The American Legacy of Walt Whitman* (New York: NYU Press, 1970), p. 38: "I feel no tradition.… I feel my own time. I am disconnected. I belong to no mores—no party—no religion—no school of thought—no institution. I feel raw freedom and my own identity."

135. Ralph Waldo Emerson, "The American Scholar," reprinted in Bernard Smith, ed., *The Democratic Spirit* (New York: Knopf, 1941), pp. 268-69.

136. Smith, "The American Scholar," p. 265.

William Cullen Bryant shared Emerson's attitude. In 1829, he addressed Thomas Cole in a sonnet titled "To an American Painter Departing for Europe" in William Cullen Bryant, "Cole, The Painter, Departing for Europe," quoted in McCoubrey, *American Art 1700-1960,* p. 96: "Thine eyes shall see the light of/ distant skies:/ Yet Cole! thy heart shall bear to/ Europe's strand/ A living image of thy native land." Bryant then informed Cole of the enticements he would encounter in Europe and concluded by enjoining him to "keep that earlier, wilder image bright." Pollock and Still never went to Europe, but their early painting had been illuminated by the light of European modernism. In the end, however, they bore in their hearts only a living image of America.

137. The lines come from Walt Whitman's "Song of Myself" and "By Blue Ontario's Shore." James E. Miller Jr., ed., *Walt Whitman: Complete Poetry and Selected Prose* (Boston: Houghton Mifflin, 1959), pp. 25, 241. Quoted in Baigell, "American Landscape Painting and National Identity," p. 30.

138. See Baigell, "Whitman," pp. 4-5.

139. Barnett Newman, "The True Revolution Is Anarchist!" foreword to *Memoirs of a Revolutionary* by Peter Kropotkin, in Newman, *Selected Writings,* pp. 50-51.

140. Barnett Newman, "Interview with Emile de Antonio," in Newman, *Selected Writings,* pp. 307-308. At the Annalee Newman memorial at the Metropolitan Museum on January 29, 2001, Frank Stella commented to the author that during the Sao Paulo Biennale in 1964, he heard Newman repeat this claim when accosted by a group of Brazilian artists who demanded to know what his abstractions meant.

141. "Interview with Emile de Antonio," in Newman, *Selected Writings,* p. 308.

Robert L. Herbert, in "An Anarchist's Art," *New York Review of Books,* December 20, 2001, p. 24, commented that Newman was the latest in a line of Anarchist artists that extends back to the 1840s, and at that time was exemplified in the writings of Théophile Thoré, the radical critic, and to J. A. Castagnary, one of Courbet's champions. In 1891, the Anarchist painter Paul Signac rejected demands that artists produce propaganda imposed from without and instead pointed out that art would be "more strong and eloquent" when created by "revolutionaries by temperament who, distancing themselves from beaten paths, paint what they see and feel, and often unconsciously give a solid blow of the pickax to the old social edifice."

142. Barnett Newman, "The True Revolution Is Anarchist," p. 45. The phrase is Herzen's.

143. David Sylvester "Concerning Barnett Newman," *The Listener,* August 10, 1972, pp. 169-172.

144. Thomas B. Hess, *Barnett Newman* (New York: Walker & Company, 1969), p. 39.

145. Ratcliff, *The Fate of Gesture,* pp. 81-82. I am also reminded of a line in the movie *Stagecoach* (1939), in which the kind-hearted sheriff and the boozing doctor set the Ringo Kid (John Wayne) and his "fallen" girlfriend free. The doctor says, "Saved from the blessings of civilization."

146. Barnett Newman, "The Sublime is Now," *Tiger's Eye,* December 1948, reprinted in O'Neill, ed. *Barnett Newman: Selected Writings and Interviews.*

Rothko also rejected "memory, history, or geometry," and Still, "outworn myths." See Robert Rosenblum, "The Abstract Sublime," *Art News,* February 1961, and Lawrence Alloway, "The American Sublime," *Living Arts,* June 1963.

CHAPTER 4
Gesture Painting:
Improvisation and Authenticity

The work of de Kooning, Hofmann, Kline, and Guston was labeled Action Painting by Rosenberg, and Painterly Painting by Greenberg. I prefer the term "Gesture Painting" because Rosenberg disregarded the formal aspects of painting and Greenberg focused too exclusively on them.

Because of his improvisational approach, Pollock could be linked to the Gesture painters, but he radically suppressed Synthetic Cubist design to create allover Field Paintings, whereas the Gesture painters related the forms in their canvases and thus carried on an argument with Cubism. Consequently, Pollock was closer to Still, Newman, and Rothko than to de Kooning, Hofmann, Kline, and Guston. Moreover, in contrast to the Gesture painters who applied pigment with brushes, Pollock dripped and poured paint. Even though all the canvases of the Gesture painters, and Pollock, registered the movement of hand and arm, thus revealing the direct process of painting, the difference between dripping and brushing is critical. Pollock's process was an outgrowth of Surrealist automatism, whereas the Gesture painter's practice was an extension of Expressionist facture.

The styles of the Gesture painters were highly individual, but they all made use of the improvisational process more single-mindedly than artists had in the past. As Rosenberg wrote in 1947, in an essay that anticipated his article on Action Painting by five years, avant-garde painters were using direct painting to formulate "as exactly as possible what is emotionally real to them as separate persons." He concluded that each artist "is fatally aware that only what he constructs himself will ever be real to him."[1]

Rosenberg's essay was reprinted the following year in the only issue of *Possibilities 1*, the first magazine to feature the new avant-garde. In the introduction, he and Motherwell, its editors, announced that the publication would speak for artists "who 'practice' in the work their own experience without seeking to transcend it in academic, group or political formulas.… The question of

what will emerge is left open…. As Juan Gris said: you are lost the instant you know what the result will be."[2] It followed that artists would have to employ unpremeditated improvisation to remain open to unforeseen events. Working with no final image in mind and confronted with innumerable choices in painting, artists would be tormented by perpetual doubt. In the end, if they were utterly honest in their practice, they would arrive at "felt" and thus "authentic" images. The centrality of the direct act of painting to the Gesture painters was understood by Renée Arb, prompting her to observe in her review of de Kooning's first show in 1948, "[The] subject seems to be the crucial intensity of the creative process itself, which de Kooning has translated into a new and purely pictorial idiom."[3]

Possibilities 1 published an essay by Richard Huelsenbeck, one of the founders of Dada. A bizarre melange of ideas, the essay includes such statements as "Death ceases to be an escape of the soul from earthly misery and becomes a vomiting, screaming and choking" and "[What] a gigantic humbug the world has made of the spirit."[4] By including the Huelsenbeck essay in their journal, Motherwell and Rosenberg implied that the disastrous social situation that confronted the Dadaists during the bloodbath of World War I and its aftermath was relevant to the situation that faced avant-garde artists during and after the Second World War.

Rosenberg maintained that the avant-garde art featured in *Possibilities* did not illustrate particular political ideas, positions, or events but that it responded to what he termed "the crisis" that had overwhelmed society and culture in the 1940s. The Gesture painters believed that their subjective pictures were the issue of the urgent dictates of their inner reality—that is, their individual visions, dreams, instincts, intuitions, insights, ideas, feelings, hang-ups, and epiphanies—but they recognized that their paintings could not avoid being shaped by the anxious mood of the "crisis." De Kooning's paintings such as *Night Square* (1948), with it fragmented anatomies, "black" color, ambiguous space and rough facture, most completely evoked the tragic atmosphere of the 1940s.

In 1950, Motherwell elaborated on the ideas he and Rosenberg presented in *Possibilities,* "The process of painting then was conceived of as an adventure, without preconceived ideas on the part of persons of intelligence, sensibility and passion. Fidelity to what occurs between oneself and the canvas, no matter how unexpected, becomes central…. It is only by giving oneself up completely to the painting medium that one finds oneself and one's own style."[5] As Kline remarked, "If you meant it enough when you did it, it will mean that much."[6]

In 1952, in an article titled "The American Action Painters," Rosenberg fleshed out his ideas. He wrote,

> At a certain moment the canvas began to appear to one American painter after another as an arena in which to act—rather than a space in which to reproduce, re-design, analyze or "express" an object, actual or imagined. [The final image must come to the artist] as a surprise…. There is no point to an act if you already

know what it contains…. The big moment came when it was decided to paint …
just to PAINT.

Rosenberg went on to say that what gave Action Painting its meaning is "the way the artist organizes his emotional and intellectual energy as if he were in a living situation." Thus, "a painting that is an act is inseparable from the biography of the artist." In the end, the painter "might find reflected the true image of his identity."[7] Rosenberg's point of view was excessively romantic, but in focusing on the Action painters' experience while painting, he gave a plausible account of their intentions.

Rosenberg's formulation of Action Painting influenced art critics and historians. For example, in a doctoral dissertation of 1955, which was based primarily on interviews with Abstract Expressionist artists), William Seitz wrote,

> The spirit in which the extreme Abstract Expressionist painting is begun can be summarized thus: shapes, colors, and lines are placed on the canvas with the least possible premeditation, their initial form and juxtaposition dictated … by unplanned inspirations, by sheer fortuity, or by the inherent nature of the medium. Here is a disorganized but vital complex of raw formal data … which the painter during subsequent phases of the process relates, alters, and organizes on the basis of a mediating set of attitudes and principles which runs through all his works, and even through all his life.[8]

Meyer Schapiro added his gloss on Rosenberg's idea of Action Painting, spelling out what the painting process signified, "The consciousness of the personal and spontaneous … stimulates the artist to invent devices of handling, processing, surfacing, which confer to the utmost degree the aspect of the freely made. Hence the importance of the mark, the stroke, the brush, the drip, the quality of the substance of the paint itself, and the surface of the canvas as a texture and field of operation—all signs of the artist's active presence."

But spontaneity was not all. The forms yielded by instinctive or impulsive activity, as Schapiro continued, are "submitted to critical control by the artist who is alert to the rightness and wrongness of the elements delivered spontaneously, and accepts or rejects them."[9] The "elements of impulse which seem at first so aimless on the canvas are built up into a whole…. The artist today creates an order out of unordered variable elements to a greater degree than the artist of the past."[10] Schapiro then extended the personal into the social, claiming that the spontaneity, freedom, and deep engagement of the Gesture painter were a corrective to American "culture that becomes increasingly organized through industry, economy and the state."[11]

Contributing to the idea of the artist's active presence in Gesture Painting was the conception of the painted mark as the index or impress of the body's movements and, by extension, a signifier of the painter's identity. As Thomas Hess observed, "The sweeping arcs and beats of Pollock's arm

and shoulder are remembered in the enamel on canvas. The muscular energy of his dance informs the colors. The tension between the points of Guston's wrist and the ferrule of his brush condenses in short sweeps of crimson and grey. Kline's arm-length feathered or crushing sweep of black over and beyond the picture exists on the surface of the object."[12]

Motherwell, Rosenberg, and Schapiro believed that the artist's attempt to express his authentic experience had an ethical aspect. As Motherwell said in 1951, "The major decisions in the process of painting are on the ground of truth, not taste."[13] Elsewhere he wrote, "Without ethical conscious-ness, a painter is only a decorator. Without ethical consciousness, the audience is only sensual, one of aesthetes."[14] The artist's process entailed an anxious struggle. As Guston said:

> The canvas is a court where the artist is prosecutor, defendant, jury and judge. Art without a trial disappears at a glance.…
>
> You can't settle out of court. You are faced with what seems like an impossibility— fixing an image which you can tolerate.…
>
> Where do you put a form? It will move all around, bellow out and shrink, and some-times it winds up where it was in the first place. But in the end, it feels different, and it had to make the voyage. I am a moralist and cannot accept what had not been paid for, or a form that has not been lived through.[15]

Precedents of Gesture Painting

The main forerunners of Gesture Painting were Vasily Kandinsky and Chaim Soutine, the dif-ferences in their aesthetic attitudes and styles notwithstanding. In looking to them for inspiration, the Gesture painters emphasized open brushwork, whose source was in Expressionist facture, and rele-gated Synthetic Cubist composition to a secondary position. Gesture painter George McNeil wrote of his disenchantment with "derivative abstract [Cubist] styles from 1920 to about 1945," as opposed to those from 1909 to 1914, which he admired. As he viewed it, Cubism, as early as 1915, had lapsed into contrived and superficial decoration, unable to deal with "the artist's personal expressive state-ment." Acknowledging "Mondrian's magnificence," McNeil added that his work was of no use to contemporary artists who were more excited by "painting that is vivid, real, alive, energized, rich in opulence, perhaps, or dirty with despair, who cares which, but an art through which man has walked, an art with experience and reality pressed into every square inch."

Putting down post-1920 Synthetic Cubism as empty, McNeil concluded that the Gesture painters wanted "to make abstract art a confession, a prayer, a blood-soaked rag, a sum of negatives, a child's glee, anything at all human, anything but cleverness, decoration and self-advertisement."[16] Jack Tworkov, also a Gesture painter, agreed with McNeil, asserting "I really despise later Cubist work—

whether it is Picasso's or anybody else's. [We are] much more interested in … undesigned, unpremeditated approaches to the canvas."[17]

In 1945, Kandinsky was given a retrospective of more than 200 works at the Museum of Non-Objective Painting (now the Solomon R. Guggenheim Museum) in New York. Two translations of his book *Concerning the Spiritual in Art* were published, one in 1946, the other in 1947. Kandinsky's mysticism did not strike a sympathetic chord in the Gesture painters, but his demand that art be based on improvisation dictated by "inner necessity" did. As he said, "The artist is not only justified in using, but it is his duty to use only those forms which fulfill his own need."[18]

Kandinsky's painting—but even more, Soutine's—influenced de Kooning and his close friend Tworkov, who had adjoining studios in downtown Manhattan.[19] Reviewing Soutine's posthumous retrospective at the Museum of Modern Art in 1950, Tworkov, in an article in *Art News,* wrote,

> [Soutine's] passion is not for the picture as a thing, but for the creative process itself. It negates professionalism. Soutine's painting contains the fiercest denial that the picture is an end in itself.… The composition is not a plan, a previous arrangement.… It is rather the unpremeditated form the picture takes as a result of the struggle to express his motive.… The struggle on the part of the artist to capture the sequence of ephemeral experience is not only the heart of Soutine's method, but also expresses his tragic anxiety, his constant brooding over being and not-being, over bloom and decay, over life and death.… It excludes touching up.… It is not a technique but a process. It is most unlike carpentry.[20]

It is not surprising that, in the climate of America at the time, Tworkov should have stressed the struggle, the anxious and tragic aspect of Soutine's painting, rather than formal aspects of his picture making. He had in mind Gesture Painting as much as Soutine's work.

Although the Gesture painters were influenced by Kandinsky and Soutine, they diverged from Kandinsky, who had abandoned his impulsive painting around 1920, and from Soutine, who had always depicted recognizable subjects. They also gave freer rein to improvisation than their predecessors had.

Affinities with jazz and poetry

In their embrace of improvisation, the Gesture painters had much in common with jazz musicians, as well as with Black Mountain and New York School poets. Reacting against canned mass culture and conventional art that struck them as effete, academic, and lacking in contemporary relevance, they forged what scholar David Belgard called "the culture of spontaneity."[21]

Most Gesture painters were fans of jazz.[22] Indeed, jazz improvisation provided models for their practice. Like the musicians, they radically reduced the distance between composition and

performance, extended the expressive range of their mediums, and aspired to find their own "voices." Just as the painters avoided decoration, the jazz musicians spurned facile entertainment, presenting themselves as serious musicians, in the face of widespread denial. Jazz musician Dave Brubeck mirrored the artists' thinking when he wrote, "I aim at the inspired moment; that is, the balance of human emotion, creativity, imagination, and a technical facility equal to the idea of the moment. I believe that the jazz musician's technique should be a study toward the mastery of the inspired moment.… The greatest thrill a jazz musician can know is an inspired execution of an inspired moment of something he has never done before, will never do again, and no one else will ever be able to recreate—not even himself."[23]

In an essay titled "Projective Verse," Black Mountain poet Charles Olson called upon experimental poets to write spontaneously and swiftly, "keep it moving as fast as you can, … USE USE USE the process at all points, in any given poem, always."[24] The New York poets, who described everyday occurrences, agreed. Poet and art critic John Ashbery wrote that the poems of his friend Frank O'Hara (who was an art critic and curator at the Museum of Modern Art) "are all about him and the people who wheel through his consciousness, and they seek no further justification.… Such a program is absolutely new in poetry." Ashbery likened O'Hara to Pollock because both demonstrated "that the act of creation and the finished creation are the same."[25]

De Kooning's "desperate view"

De Kooning, the primary innovator of Gesture Painting, hailed Pollock's artistic radicalism, commenting, "Every so often, a painter has to destroy painting.… Pollock did it. He busted our idea of a picture all to hell. Then there could be new paintings again."[26] However, de Kooning recognized that his brushwork and relational design were different from Pollock's poured technique and field organization. Compared with Pollock, he was "conservative," as he said. So were Gorky and Hofmann. All three artists acknowledged the influence of European "fathers" on their art—in de Kooning's case, both old masters (Rembrandt and Rubens) and modern ones (Picasso, Miró, and Soutine). De Kooning admitted, "I feel myself more in tradition," but he was quick to add that he was "grappling for a way to say something new.… I have this point of reference—my environment— that I have to do something about. But the Metropolitan Museum is also part of my environment.… I change the past."[27] Or, as he said elsewhere, "Picasso and Matisse showed us the way and we filled in with our own personalities." And with new attitudes that de Kooning found contemporary and believable.[28] Thus he purged what in past painting was no longer relevant to him or his time and succeeded in painting pictures that were.

De Kooning admired the old masters. "Titian, he was 90, with arthritis so bad they had to tie on his paint brushes. But he kept on painting Virgins in that luminous light, like he'd just heard about

them. These guys had everything in place, the Virgin and God and the technique, but they kept it up like they were still looking for something. It's very mysterious." Then he added, "I'm not those guys.… They were something else."[29] Indeed, de Kooning stressed that "the main thing is that art is … the way I live."[30] About his existence, he said that "if you are a painter [you] get dirty and pathetic; very miserable.… Maybe this difficulty is personal with me, and maybe it is something that other painters have in common. Perhaps it is also something of today."[31]

In the 1930s and early 1940s, most of de Kooning's images were figurative. Then, in the middle forties, he segmented the figures, producing Biomorphist improvisations. Around 1947, he began to paint a series of primarily black-and-white Gesture paintings in which fragmented anatomies were still more abstract than in his earlier Biomorphist canvases. Nonetheless, in 1950, he said that when he thought of art, he found himself "always thinking of that part which is connected with the Renaissance. It is the vulgarity and fleshy part of it … the stuff people were made of." He also thought of the space the Renaissance painter plotted out, the "large marvelous floor that he worked on." De Kooning went on to say, "It was up to the artist to measure out the exact space for a person to die in or be dead already. The exactness of the space was determined or, rather, inspired by whatever reason the person was dying or being killed for. The space thus measured out on the original plane of the canvas surface became a 'place' somewhere in the floor."[32]

It is significant that of all the subjects in Renaissance art to which de Kooning could have referred, he chose the dying and the dead—signs of a tragic vision.

Much as de Kooning admired the Renaissance, he would not accept the representation of full-blown figures and their ordered surroundings. Paintings, such as *Excavation* (1950) are what Peter Plagens termed "torn-meat abstractions."[33] Indeed, de Kooning's imagery is suggestive of a charnel house. The violence of his ripped-apart anatomies, augmented by the Expressionist roughness of his brushwork, was unprecedented in modern art.

Just as de Kooning dismembered the human figure, he ruptured clear and stable Synthetic Cubist design, disassembling it into ceaselessly shifting and interpenetrating ambiguous forms that are compacted but open. The painted space is disordered, disrupted, and dislocated; it "trembles," which to de Kooning signified "a desperate view" (the title of a lecture that he gave before an audience of fellow artists in 1949).[34] In demolishing the fixed composition of Cubism, de Kooning called into question the possibility of order in contemporary art and by implication in society.[35]

De Kooning said that he was "crazy about Mondrian,"[36] but he recognized that his sensibility was the opposite of that "great merciless artist … who had nothing left over."[37] What appealed to de Kooning was not the absolute equilibrium in Mondrian's nonobjective canvases but the instability manifest in "the optical illusion … where the lines cross they make a little light. Mondrian didn't like

that, but he couldn't prevent [the] flicker."[38] De Kooning acknowledged Mondrian's urge to order but fastened on the one element he couldn't control. As de Kooning summed it up, "a Mondrian keeps changing in front of us."[39]

So do the ambiguous images that de Kooning painted in the restless process of repeated destruction and construction, the signs of which are everywhere in his canvases of the late 1940s. The interpenetrating areas of which they are composed, laboriously painted-in, scraped-out, and repainted, are in perpetual motion, literally slipping in and out of each other. As de Kooning said, "When I'm falling, I'm doing all right. And when I am slipping I say, 'Hey, this is very interesting … As a matter of fact, I'm really slipping most of the time into that glimpse.… I'm like a slipping glimpser."[40] By "glimpse" de Kooning meant the momentary feeling of rightness that caused him to end the ceaseless flow of experience in the painting of a work. Nonetheless, his completed abstractions still seem to be in a transitional state of becoming and never arriving.

The antithesis of de Kooning's tortuous procedure was the pursuit of a style, particularly a "signature" style—that is, an already known style. As he declared, "Style is a fraud." It was a trap that closed off possibilities. According to him, "Art should not have to be in a certain way.… It was a horrible idea of van Doesburg and Mondrian to try to force a style." Elsewhere he said, "The only certainty today is that one must be self-conscious. The idea of order can only come from above. Order, to me, is to be ordered about and that is a limitation."[41] As for himself, he "was too nervous to find out where [he] ought to sit. [He did] not want to 'sit in style.'" De Kooning related his "slipping" to his living situation.[42] "In my life I have very little fixed form."[43] The flux that de Kooning embodied in his painting was within himself but it coincided with a time when the world seemed to have fallen into chaos. Decomposing or melting down both the integral image of man and the classicizing Modernist style—like a metaphorical atom bomb or a death camp oven—de Kooning evoked the anxiety of living in the 1940s. However, when asked by David Sylvester whether he was trying "to make a comment on the age," de Kooning responded, "No. Oh, it maybe turned out that way, and maybe subconsciously when I'm doing it. But I couldn't be that corny."[44] Nonetheless, in expressing reality as he felt it, de Kooning put his finger on the pulse of the time.

"Nature gives me the creeps"

De Kooning's black-and-white canvases include not only anatomical fragments but letters of the alphabet as well. He drew inspiration from the ubiquitous advertisements, billboards, and other signs that clutter our urban environment. The linear elements also have a source in the marks on sidewalks and graffiti on a tenement walls. Poet Edwin Denby recalled walking at night with de Kooning and "his pointing out to me on the pavement the dispersed compositions—spots and cracks and bits of wrappers and reflections of neon lights."[45] De Kooning may have had in mind Leonardo's famous

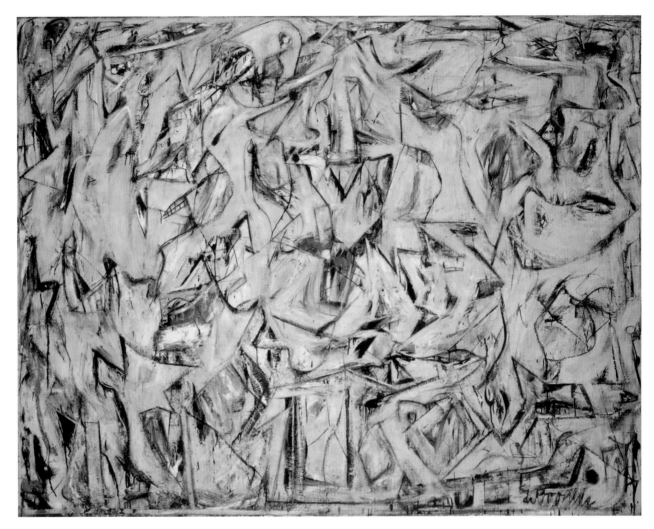

Willem de Kooning, *Excavation*
1950, oil on canvas
81″ x 100-1/4″
The Art Institute of Chicago

comment that irregularities in old walls could inspire new images. Or, less likely, André Breton's belief that the surfaces of things could trigger desire.

De Kooning also evoked the city by pressing newspapers onto wet pigment and pulling them away, leaving the imprint of type and illustrations in the completed picture, as in *Attic* (1949).

His wife Elaine said,

> Bill is a pure city man. He had the city in mind even when he was at Black Mountain College. After all, *Asheville* was painted there. He would say, Nature gives me the creeps. He would quote a jazz musician who said, I'd rather be a lamp-post on a sidewalk in New York than the mayor of any other city. Bill would stop to study words on billboards, the spatial relations of the letters. That was exciting to him.… He would also walk along the waterfront and study the pornographic drawings on the wall. He liked the economy of line and idea—just the sexual organs.[46]

In his response to New York, de Kooning was inspired by the French painter Fernand Léger, with whom he had worked on a Federal Art Project mural in 1936. Painter Mercedes Matter, also an assistant on the project, said that Léger was captivated by the raw energy and vulgarity of New York and industrial America. "He said to avoid streets of good taste. He would go wherever it said 'No Trespassing,' particularly on the docks. In the countryside he loved gas stations not the landscape. A junk heap of scrap cars just filled him with ecstasy."[47]

De Kooning was the consummate New York painter, and his canvases evoke the city's overwhelming complexity, claustrophobic space, frenetic movement, and the uncertainty and anxiety they give rise to.[48] Flux is a metaphor for New York in a state of excavation, perpetually being torn down and built up. Clogged with hectic and raw forms, de Kooning's black-and-white paintings suggest urban squalor, grime, violence, and agitation. When I first saw one in the early 1950s, I recall thinking that it felt like an edgy walk down a traffic-jammed Manhattan street.[49] De Kooning's city is a kind of wilderness, the urban counterpart of Pollock's prairie. It may be, too, that the ambiguity and flux in de Kooning's painting reflected his situation as an immigrant in New York. As a new arrival, he existed in a state of impermanence, dislocation, and transition, like the city itself.

De Kooning retained his regard for the great tradition of European art, perhaps a carryover of his Dutch youth. This prompted him to characterize the Field Painting of Pollock and Still as "American," remarking that it was "made out of John Brown's body—like Frank Lloyd Wright, and you can quote me."[50] Elsewhere he remarked, "They stand all alone in the wilderness—breast bared. This is an American idea."[51] Of course de Kooning had also become an American but in a different way from Still and Pollock. As he said, "It's not so much that I'm an American: I'm a New Yorker."[52]

De Kooning's "public goddesses of droll sex"

In drawings he made around 1950, de Kooning reconstituted the anatomical fragments of his black-and-white abstractions into full-bodied images of women. This led him to paint pictures of imposing women on canvas (1952 to 1954). They are composed of vehement slashes of pigment—painterly drawing—unfixed and unsettled, yet they constitute figures that are centered in the picture, frontal and corporeal, as solid as they are fluid.

Stately and hieratic—like a twentieth-century offspring of the *Venus of Willendorf*—de Kooning's *Women* are nonetheless vulnerable, teetering on fashionable high heels. They are more human than the earlier black-and-white abstractions, and although fierce are also humorous, pointing toward a lightening of mood that paralleled contemporaneous developments in the paintings of Pollock and Still.

With their balloon busts, staring eyes, and bared teeth, the women both continue and challenge the centuries-long tradition of Western figurative painting, including Picasso, Léger, and Soutine. In 1950, at the time of Soutine's retrospective at the Museum of Modern Art, de Kooning said, "I've always been crazy about Soutine … a certain fleshiness in his work."[53] De Kooning also stressed the traditional aspect of the *Women,* remarking that they were related to the idols painted repeatedly through the history of art, the twentieth-century kin of the Sumerian sculptures at the Metropolitan Museum.

The *Women* have been analyzed in diverse ways. They have been viewed as depictions of the artist's mother and of his wife. Elaine de Kooning denied that she was the model, "The ferocious woman he painted didn't come from living with me. It began when he was three years old."[55] The *Women* have struck feminists as mocking representations by a male chauvinist or misogynist. De Kooning denied that he was "a matricide or a woman hater or a masochist."[56] They have also been interpreted as the sisters of Francis Bacon's popes, send-ups of the all-American girl, or, in T. J. Clark's opinion, as examples of American Abstract Expressionist vulgarity. From a formalist perspective, Greenberg saw them as a novel continuation of Cubism.[57]

Like the letter forms in de Kooning's black-and-white abstractions, the *Women* draw on the visual environment of the city and popular culture—one is titled *Marilyn Monroe* (1954). Thomas Hess reported, "The artist has indicated, only half jokingly, that his *Women* are sisters to the giant ladies (girls?) that are pasted on mail trucks and billboards—enormous public goddesses of droll sex and earnest sales-pitches. He has also pointed out that the *Women* are masked by the 'American smile.' In one sketch for *Woman,* her smile was cut out of a 'T-zone' ad for Camels [cigarettes] in *Life Magazine*. De Kooning's *Women* are queens … rulers of a country that names its hurricanes 'Hattie' or 'Connie.'"[58]

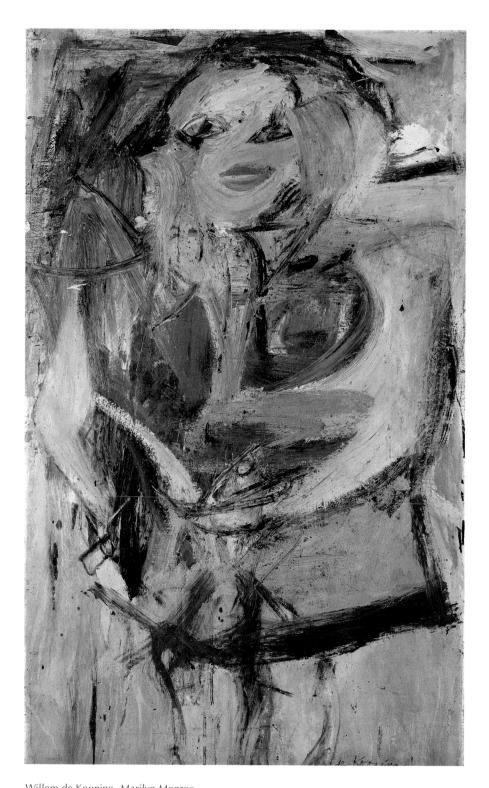

Willem de Kooning, *Marilyn Monroe*
1954, oil on canvas
50" x 30"
Collection Neuberger Museum of Art
Purchase College, State University of New York
Gift of Roy R. Neuberger; Photo credit: Jim Frank
© 2008 The Willem de Kooning Foundation / Artists Rights Society (ARS), New York

De Kooning was the most influential artist in the New York School in the late 1940s and 1950s. His painting appealed to his colleagues because it was inclusive rather than exclusive. It provided them with rich possibilities, both avant-garde and traditional. He demonstrated that painting could be abstract and figurative, and flat and in depth; that it could be composed of Cubist-inspired relational design and of nonrelational fields; that it could refer to past art and react against it. De Kooning arrived at his complex and powerfully expressive images in the act of painting. They embodied his being-in-the-world and such were their painterly qualities that they rivaled the masters of the past that he sought to emulate.

Franz Kline and the industrial sublime

The art world was stunned by the sheer visual power of Franz Kline's black-and-white gestural abstractions when they were first exhibited in 1950. They seemed to have come from nowhere, as his preceding conventional small-scale pictures of American scenes did not signal the dramatic change in his work.

Kline began his career as a Regionalist with a bleak cast of mind, just like Pollock and Still. Disinterested in French modernism, he looked for inspiration to Americans such as Winslow Homer, Thomas Eakins, Albert Pinkham Ryder, James McNeill Whistler, and the Ash Can painters. Kline's earlier subjects were culled from the Pennsylvania coal country in which he grew up, and then, after he moved to New York City in 1938, from urban life as well. In the late forties, he began to experiment with Gesture Painting by converting the contours of his figurative subjects into massive, abstract, black swaths.

The transition into the style for which Kline is best known is evident in two paintings of 1950, whose subject is the dancer Nijinsky (who died that year). One is a portrait based on a photograph, the other an abstraction. The portrait is of Nijinsky in the role of Petrouchka, as Elaine de Kooning wrote, with "the head cocked to one side in a hopeless, disjoined gesture. With the abject, blood-red eyes burning sadly in the pasty white-powered face, this painting fixes the star's private tragedy."[59] Nijinsky, as an ill-fated figure who succumbed to madness, is a surrogate for Kline's wife, a former ballet dancer who had been institutionalized, and in the costume of Petrouchka, the clown who had lost the woman he loved, the image of the artist himself.[60] The second version of Nijinsky, an abstraction composed of the dynamic black-and-white swaths, is also distressing in feeling. Kline's canvas was inspired by his own life, but it also evoked the depressed mood of the 1940s. However, the negative attitude is largely overcome in Kline's subsequent canvases, which tend to be high-spirited, paralleling the work of the other Gesture painters in the 1950s.

Kline was influenced by de Kooning, but his painting process was different. Unlike de Kooning, who would interminably paint, scrape out, and repaint his canvases, Kline would execute numerous quick drawings in ink, gouache, and oil on paper, then choose one and more or less replicate it in oil on large canvases. The improvisational action was primarily in the sketches, but the physicality, the sense of the body in action, is in the painting. Kline said of his abstractions that they "are painting experiences. I don't decide in advance that I'm going to paint a definite experience, but in the act of painting, it becomes a genuine experience for me."[61]

Kline's abstractions celebrate urban and industrial America. He often named his paintings after Pennsylvania coal-country locomotives (but only after the work was completed). Indeed, they seem to refer to the powerful momentum of hurtling engines.[62] His images also call to mind trestles and other industrial structures, as well as partly demolished or partly constructed sections of skyscrapers and bridges. If the Field abstractions of Pollock and Still suggest the prairie Sublime, Kline's energy-packed painterly drawing evokes the industrial/technological Sublime—that is, the sense of awe summoned up by such structures as the Empire State Building or the George Washington Bridge.[63] With Newman in mind, Kline once said, "Hell, half the world wants to be like Thoreau at Walden worrying about the noise of traffic on the way to Boston; the other half use up their lives being part of that noise. I like the second half. Right?"[64]

Philip Guston's Abstract Impressionism

In contrast to Kline's aggressive canvases, the abstractions Philip Guston began to paint in 1950, composed of spare brushmarks in atmospheric fields of white canvas, are unassertive. Despite the airiness and lightness of touch, Guston's pictures exhibit signs of anxiety. The strokes seem tentative and the colors are grayed, signs of his self-doubt. Nonetheless, the canvases from 1951 to 1954 are essentially lyrical. As his friend Ross Feld observed, Guston "reconstituted the maker's pain into the beautiful and the striking."[65]

From the beginning of his career, Guston painted at the edge between the personal and the social. At age 10 in 1923, he discovered the corpse of his father, who had just hanged himself. Making this private trauma political, Guston depicted lynchings by the Ku Klux Klan in the 1930s. Later in the decade, in response to the Spanish Civil War, he portrayed scenes of combat in *Bombardment* and *The Gladiators* (both 1938). *Martial Memory* (1941) is a symbolic picture of boys playing at war, indicating that childhood games are a rehearsal for adult combat. At the time, art historian H. W. Janson wrote, "In the mock seriousness of these boys, Philip Guston has found the true image of this war-torn world, suggesting at once the tinsel glitter of martial trappings and the deep emotional crisis that underlies every human conflict."[66]

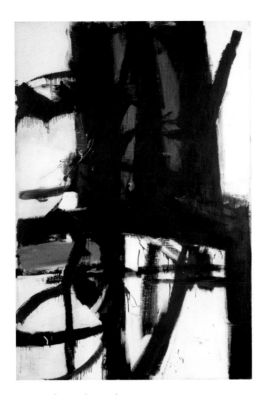

Franz Kline, *The Bridge*
1955, oil on canvas
82" x 54-1/2"
Munson-William-Proctor Arts Institute, Utica
Photo credit: Munson-Williams-Proctor Arts Institute / Art Resource, NY
© 2008 The Franz Kline Estate / Artists Rights Society (ARS), New York

Philip Guston, *White Painting*
1951, oil on canvas
57-7/8" x 61-7/8"
San Francisco Museum of Modern Art, T. B. Walker Foundation Fund
Reprinted with permission from the Estate of Philip Guston

In 1945, in *If This Be Not I,* with an eye to Max Beckmann, Guston pictured a lineup of children standing amid the ruins of war. The children appear again in *Porch No. 2* (1947), but they are distorted and flattened, evoking the cramped and claustrophobic space of death-camp barracks.[67] Guston said that the image was inspired by photographs of Nazi atrocities, but that his intention was to metaphorically evoke genocide, "where the forms and spaces themselves expressed [his] feelings about the holocaust."[68]

The Tormentors (1947-1948) marks Guston's move into abstract painting, even though it contains suggestions of figures—arms that are raised in anguish or surrender and hoods, like those worn by the Ku Klux Klan. This image, painted in brackish reds silhouetted against a black ground, is ominous and menacing. *The Tormenters* gave rise to an impasse in Guston's work. In 1948, he traveled to Italy, where he remained for a year. There he sketched hill towns shimmering in Mediterranean light.

On Guston's return to the United States, his work changed radically, a change that can be traced in three abstractions. The first, titled *Review* (1949-1950), is composed of a dark "sky" and "ground," which contains smoldering gray and red rectangular shapes, the remains of the figures and paraphernalia in earlier pictures. In the next canvas, *Red Painting* (1950), enigmatic black and gray forms are partly dissolved in an allover red field. The mood of *Review* and *Red Painting* is despondent, but in 1951 it gives way to a subdued lyricism. In *White Painting* of that year, the bare canvas becomes the field in which the ghosts of forms composed of discrete brush strokes call to mind Guston's airy drawings of Italian hill towns. It was a new beginning. As Guston remarked, "The desire for direct expression finally became so strong that even the interval to reach back to the palette became too long.... I forced myself to paint the entire work without stepping back to look at it."[69]

Guston's abstractions of the early and middle 1950s struck many of his contemporaries as lyrical, alluding both to nature and Impressionism. He denied these references; nonetheless, his so-called Abstract Impressionism would become a major influence on younger artists in the middle 1950s, rivaling de Kooning's Abstract Expressionism.

Tomlin's elegiac vision

Bradley Walker Tomlin has been relatively neglected by the art world and deserves more recognition. Soon after the United States entered World War II, he began to paint gloomy images—a wreath, the carved figurehead of a ship, the gray wing of a seagull, or a graveyard angel. These were incorporated into Synthetic Cubist compositions whose flat rectangles were partly dissolved in vague atmospheres, as in *To the Sea* (1942) and *Burial* (1943). World War II was very much on Tomlin's mind. He wrote that *To the Sea* "was painted during the period throughout which the toll of sinking

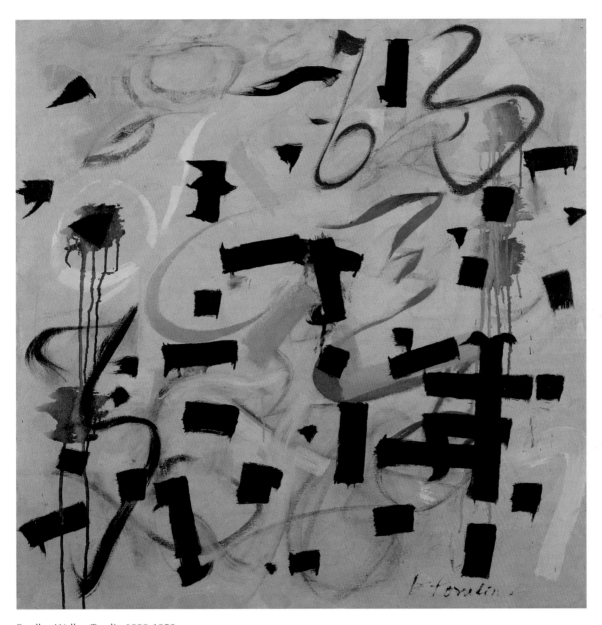

Bradley Walker Tomlin 1899-1953
Number 12 - 1949, 1949
Oil on canvas,
32 x 31 in. (81.28 x 78.74 cm)
Frame 33 1/2 x 32 3/8 in.
Whitney Museum of American Art, New York
Gift of Abby and B. H. Friedman in honor of John I. H. Baur 86.53

of Atlantic shipping had been particularly heavy, and I have endeavored to put down on canvas some of the thoughts which I had at that time."[70]

Around 1946, Tomlin began to suppress figuration and grid-like design and to rely increasingly on painterly gestures. In 1947-48, he painted abstractions composed of whitened brush strokes trailed over dark grounds, as in *Death Cry* (1948). From 1949 to 1952, Tomlin improvised freely brushed, ribbon-like marks in muted colors into more or less allover vertical and horizontal grids, as in *All Souls Night, No. 2*. Pictures painted from 1952 to 1953, the year of his death, consist of large dabs of paint that call to mind a magnified pointillism. Tomlin's work on the whole is distinguished by an austere lyricism with an elegiac aspect.

Hofmann's hedonism

From 1944 to 1947, Hans Hofmann painted mechano-biomorphic images. At the same time, he executed canvases in many other styles, including Gesture Painting. But his works in the latter style did not make as strong an impression on the art world as de Kooning's did. The year 1950 was a critical one in Hofmann's stylistic development. He continued to execute Fauve-inspired abstractions. But unlike his fellow Gesture painters, Hofmann not only retained Synthetic Cubist design but stressed it. This structure functioned to stabilize his impetuous brushwork. But more important, it enabled him to deal more expressly than he had in the past with an issue in painting he had been confronting since his teenage years.

As an adolescent, Hofmann had read and been deeply impressed by philosopher Adolph von Hildebrand's *Problem of Form in the Visual Arts,* first published in 1893. Hildebrand maintained that a third dimension could be derived from images that are assumed to be two dimensional. This was vital to him because he believed that experiencing the third dimension was the highest development of human perception, which made artists who could demonstrate this very special indeed. Hofmann learned from Hildebrand that volume could be created with overlapping flat planes, which turned out to be a method employed by Cézanne, and later, by Picasso and Matisse. In his own painting, Hofmann related material two-dimensional forms so that they suggested a third dimension—that is, a sense of volume or depth—without sacrificing physical flatness, a dimension that was immaterial, which to Hofmann signified spiritual. At the same time, the planes of color were composed part-to-part-to-whole into a unified or organic image. The method used to achieve these ends was what Hofmann termed "push and pull," an improvisational process of pulling forward shapes that recede, poking holes in the picture surface, and pushing back forms that jump out.

Hofmann's painting is marked by an extravagant sensuousness, evoked by his bold and opulent palette and energy-packed surfaces, both flat and painterly. Hofmann said, "Despite the general

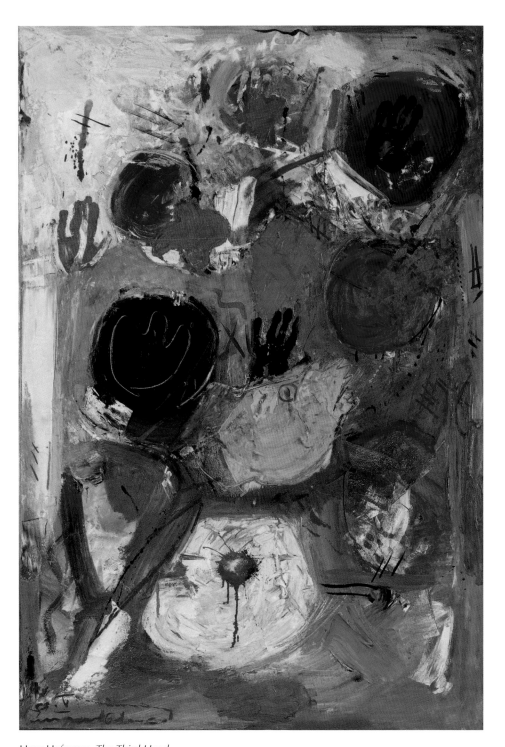

Hans Hofmann, *The Third Hand*
1947, oil on canvas
60-1/8" x 40"
University of California, Berkeley Art Museum and Pacific Film Archive
Gift of Hans Hofmann

pessimistic attitude in the world today, I am nothing but an optimist."[71] Indeed, he was the hedonist par excellence of Gesture Painting.

Hofmann's canvases anticipated the emergence of lyrical Gesture Painting in the 1950s, notably that of Tomlin, Jack Tworkov, Esteban Vicente, James Brooks, and second-generation artists Helen Frankenthaler and Joan Mitchell who entered the New York art world around 1950. By 1955, as Elaine de Kooning observed, "Abstract-Impressionists … outnumber Abstract-Expressionists two to one, but curiously, are seldom mentioned."[72] With the exception of Guston, it did take time for art criticism, still in the throes of existentialist angst and its rhetoric, to catch up with lyrical abstraction.

1. Harold Rosenberg, "Introduction to Six American Artists," *Possibilities 1,* Winter 1947-1948, p. 75. This state-ment originally appeared in "Introduction," "Six American Artists" (Paris: Gallerie Maeght, Spring 1947). The artists exhibited were Baziotes, Bearden, Browne, Gottlieb, Holty, and Motherwell.

 Rosenberg's conception had been anticipated by Miguel Unamuno's *The Tragic Sense of Life* (New York: Dover, 1954), p. 13, a pre-Existentialist book published in 1921 that was widely read in the 1940s and 1950s. Spurning all generalization about human nature, Unamuno wrote that "when a man affirms his 'I,' his per-sonal consciousness, he affirms man, man concrete and real, affirms the true humanism … and in affirming man he affirms consciousness."

2. Robert Motherwell and Harold Rosenberg, "Statement," *Possibilities 1,* Winter 1947-1948, p. 1.

3. Renée Arb, "De Kooning," *Art News,* April 1948, p. 33.

4. Richard Huelsenbeck, "Possibilities: Poe and Dada: A Debate," *Possibilities 1,* Winter 1947-1948, p. 41.

5. Robert Motherwell, "The School of New York" (Beverly Hills, Calif.: Perls Gallery, 1951), n.p.

6. Frank O'Hara, "Franz Kline Talking," *Evergreen Review,* Autumn 1958, p. 63.

7. Harold Rosenberg, "The American Act on Painters," *Art News,* December 1952, pp. 22-23.

8. William C. Seitz, *Abstract Expressionist Painting in America* (Cambridge, Mass.: Harvard University Press, 1983), p. 95.

9. Meyer Schapiro, "The Liberating Quality of Avant-Garde Art," *Art News,* Summer 1957, pp. 38-40.

10. Ibid.

11. Meyer Schapiro, "Recent Abstract Painting," 1957, in *Modern Art: 19th and 20th Centuries* (London: Chatto & Windus, 1978) p. 222.

12. Thomas B. Hess, "Inside Nature," *Art News,* February 1958, p. 60.

13. Motherwell, "School of New York," n.p.

14. Robert Motherwell, "The Painter and the Audience," *Perspectives USA,* No. 9, Fall 1954, quoted in Stephanie Terenzio, ed., *The Collective Writings of Robert Motherwell* (New York: Oxford University Press, 1992), p. 108. Jack Tworkov, in "Jack Tworkov: Paintings, 1928-1982" (Philadelphia: Pennsylvania Academy of Fine Arts, 1987), p. 133, wrote: "Esthetic judgment concerns itself with one question: 'What is true, what is false?'"

15. Philip Guston, Notes for a lecture given at the New York Studio School, New York, May 1965, in "Faith, Hope, and Impossibility," *Art News Annual 1966,* October 1965, quoted in Philip Guston (New York: George Braziller, 1980), p. 42.

 But what prompted the artist to make his decisions? Guston's answer was that you had to "discover how to trust [your] instincts, without knowing how it will turn out. It sounds easy until you try it.… What [other] measure is there." in "Philip Guston Talking," a lecture by Philip Guston at the University of Minnesota in March 1978, Renee McKee, ed., in "Philip Guston" (London: Timothy Taylor Gallery, 2004), pp. 24, 34.

16. George McNeil, "Cubism, Generate and Degenerate," *Art News,* May 1961, pp. 43, 63.

17. In Phyllis Tuchman, "An Interview with Jack Tworkov," *Artforum,* January 1971, p. 68, Tworkov suggested that "Freudian psychology … gave [painters] a kind of reassurance, a trust in automatic activity."

18. Wassily Kandinsky, *Concerning the Spiritual in Art,* trans. M. T. H. Sadler (New York: Dover, 1977), p. 53.

19. Margaret Staats and Lucas Matthiessen, "The Genetics of Art," *Quest 77,* March-April 1977, p. 70. When asked who his major influence was, de Kooning said: "I think I would choose Soutine."

20. Jack Tworkov, "The Wandering Soutine," *Art News,* November 1950, pp. 33, 62. Tworkov also valued Sou-tine's painting because, as he wrote on p. 32, of its

impenetrability to logical analysis … that quality of surface which appears as if it had happened rather than as [being] "made"… [The attributes of Soutine's work] can be summarized as: the way his picture moves toward the edges in centrifugal waves filling it to the brim; his completely impulsive use of pigment as a material, generally thick, slow flowing, viscous, with a sensual attitude toward it … with deep and vibratory color; the absence of any effacing of the tracks bearing the imprint of the energy passing over the surface. The combined effect is of a full, packed, dense picture of enormous seriousness,… lacking all embellishments or any concession to decoration.

21. Many of the ideas in this section are explored in Daniel Belgrad, *The Culture of Spontaneity: Improvisation and the Arts in Postwar America* (Chicago: University of Chicago Press, 1998).

22. In 1946, the Kootz Gallery mounted "Homage to Jazz," which included William Baziotes, Romare Bearden, Adolph Gottlieb, and Robert Motherwell, among others. See Chad Nandeles, "Jackson Pollock and Jazz: Structural Parallels," *Arts Magazine,* October 1981, p. 139. Although jazz was the invention of African-Americans, only two African-American artists—Bearden and Norman Lewis—were associated with Abstract Expressionism.

23. Alfred Frankenstein, "American Art and American Moods," *Art in America,* March-April 1966, p. 78. This section on jazz is in debt to Belgard, *The Culture of Spontaneity,* Chapter 8.

 The kind of jazz most favored by the artists was the Bebop of Charlie Parker, Lester Young, Dizzy Gillespie, Miles Davis, John Coltrane, and Thelonious Monk, which developed at the beginning of World War II and gained national recognition among jazz devotees in the middle 1940s. Dexter Gordon, in Ira Gitler, *Swing to Bop: An Oral History of the Transition of Jazz in the 1940s* (New York: Oxford University Press, 1985), p. 311, quoted in Belgard, *The Culture of Spontaneity,* p. 182, said that bebop emerged because jazz musicians felt the forties were "a time of change." [It] was wartime and people were moving back and forth all over the United States … armies, war jobs, defense jobs. It was a time of great flux … and the music was reflecting this."

 Bebop musicians reacted against big swing bands, in which many of them had played. In the big bands, which had co-opted jazz, performers played prearranged, thoroughly rehearsed scores on a stage removed from the audience. The swing-jazz musicians directed by the band leader performed what the composer had written. Bebop musicians in small combos, jamming in intimate bars and clubs, played improvisational solos while responding to each other's playing in a kind of call-and-response conversation. Their interaction was participatory and democratic. The process was direct and experimental, the result immediate and high-energy. Swing-jazz was meant to be danced to; Bebop, because of its polyrhythmic and polytonal complexity, was meant to be listened to.

 It is noteworthy that around 1950, just as Gesture Painting was becoming more lyrical, Miles Davis and others began to play cool jazz, whose relaxed rhythms were more laid-back than the frenetic tempos of bebop.

24. Charles Olson, "Projective Verse" (1950), reprinted in Donald Allen and Warren Tallman, eds., *The Poetics of the New American Poetry* (New York: Grove Press, 1973), pp. 148-149.

25. John Ashbery, "Writers & Issues: Frank O'Hara's Question," *New York Herald Tribune* (Book Week), September 26, 1966, p. 6.

 In the 1950s, a group of poets, including Frank O'Hara, James Schuyler, John Ashbery, and Barbara Guest, emulated the improvisational process of the Gesture painters. Indeed, they were so taken with avant-garde art that they became art critics. The poets were so identified with the New York School that they came to be labeled the New York School of Poets. Closer to the second generation of the New York School, the poets did not emulate the tragic content of the older Abstract Expressionists but preferred to deal more with their everyday experience.

26. Rudi Blesh, *Modern Art USA* (New York: Knopf, 1956), pp. 253-254.

27. Irving Sandler, "Conversations with de Kooning," *Art Journal,* Fall 1989, p. 216.

28. Ken Wilke, "Willem de Kooning: Portrait of a Modern Master," *Holland Herald,* 17, March 1982, p. 30. Quoted in Marla Prather, "Catalogue," *Willem de Kooning Paintings* (New Haven, Conn.: Yale University Press, 1994), p. 80.

29. Curtis Bill Pepper, "The Indomitable de Kooning," *New York Times Magazine,* November 20, 1983, pp. 45, 47.

30. Harold Rosenberg, "Interview with Willem de Kooning," *Art News,* September 1972, p. 57.

31. William Seitz, *Abstract Expressionist Painting in America,* p. 121.

32. Willem de Kooning, "The Renaissance and Order," *Transformation,* 1951, pp. 85-87.

33. Peter Plagens, Art Dealers Association panel on de Kooning at the Metropolitan Museum, October 15, 1997, handwritten notes.

34. Willem de Kooning, "A Desperate View," talk delivered at "The Subjects of the Artist: A New School," New York, February 18, 1949. First published in Thomas B. Hess, "Willem de Kooning" (New York: The Museum of Modern Art, 1969), pp. 15-16. Robert Storr, in a talk on de Kooning's drawing at the Drawing Center, November 10, 1998, commented on the prevalence of the "fluttering stroke" in de Kooning's drawings, which evoked trembling or shivering flesh.

35. Mark Stevens, "Art: Bravura Brushwork," *New York,* November 28, 1994, p. 78.

36. Harold Rosenberg, interview with de Kooning, in *Art News,* September 1972, p. 56.

37. Willem de Kooning, "What Abstract Art Means to Me," *Museum of Modern Art Bulletin,* Spring 1951, p. 7.

38. Harold Rosenberg, "Interview with de Kooning," p.56.

39. "Artists' Sessions at Studio 35 (1950)," *Modern Artists in America* (New York: Wittenborn Schultz, 1951), p. 20.

40. Sarah Boxer, ed., "Word for Word/Willem de Kooning," *New York Times,* March 23, 1997, sec. 4. p. 7.

41. Willem de Kooning, "A Desperate View," talk delivered at the "Subjects of the Artists: A New School," 1949, quoted in Thomas B. Hess, "Willem de Kooning" (New York: Museum of Modern Art, 1968), pp. 15-16.

42. Willem de Kooning, "What Abstract Art Means to Me," *Museum of Modern Art Bulletin,* Spring 1951, p. 7.

43. Willem de Kooning, interviewed by Bibeb, *Vrij Nederland,* No. 5, October 1968, p. 3.

44. David Sylvester, "Willem de Kooning," *Interviews with American Artists* (London: Chatto & Windus, 2001), p. 51.

45. Edwin Denby, "The 1930s: Painting in New York" (New York: Poindexter Gallery, 1957), n.p. Reprinted in George Scrivani, ed., *Willem de Kooning Collected Writings* (New York: Hanuman Books, 1988), p. 47.

46. Elaine de Kooning, handwritten notes on conversation with the author, New York, May 21, 1958.

47. Mercedes Matter, handwritten notes on conversation with the author, New York, 1960s.

48. Stevens, in "Art: Bravura Brushwork," pp. 78, 80, with *Excavation* in mind, wrote, "The tempo of the city is exactly conveyed. [There] is much stop-start: quick turns, sudden open spaces, glimpses."

49. De Kooning, of course, was not the first American artist to tackle the city as subject. It had been painted by John Marin, Demuth, Stella, Hopper, Sheeler, and Davis, among many others. Marin was quoted in Alfred Frankenstein, "American Art and American Moods," *Art in America,* March-April 1966, p. 77, as saying: "The whole city is alive … I see great forces at work, pushing, pulling, sideways, downwards, upwards, I can hear the sound of their strife and there is great music being played." But no earlier American artist equaled de Kooning in capturing the city's sound. A remark that Max Eastman made in "Max Eastman, Portrait of

a City," *Liberator,* August 1918, p. 22 (article sent to me by Karen Wilken) about Stuart Davis applies equally well to de Kooning. Eastman wrote of Davis's disinclination toward "loveliness of line and color, or of any loveliness at all except that of the strongest individual character. He chooses to have somewhat the character of an alley cat. His art lives among the same squalid and strong-smelling and left-out objects, and it goes its sordid way with the same suave dirty muscular self-adequate gracefulness of power."

50. T.[homas] H.[ess], "de Kooning," (an interview), in "Is Today's Artist With or Against the Past?" *Art News,* Summer 1958, p. 27.

51. Irving Sandler, "Conversations with de Kooning," *Art Journal,* Fall 1989, p. 216. In Sarah Boxer, ed., "Word for Word/Willem de Kooning," *New York Times,* March 23, 1997, Sec. 4, p. 7, de Kooning said: "It's a certain burden, this American-ness. If you come from a small nation, you don't have that. When I went to the Academy and I was drawing from the nude, I was making the drawing, not Holland. I feel sometimes an American artist must feel like a baseball player or something—a member of a team writing American history."

52. Willem de Kooning, "Content Is a Glimpse," *Location 1,* Spring 1963, p. 46.

53. Margaret Staats and Lucas Matthiessen, "The Genetics of Art," *Quest 77,* March-April 1977, p. 40.

54. Willem de Kooning, "Content is a Glimpse," *Location 1,* Spring 1963.

55. Curtis Bill Pepper, "The Indomitable de Kooning," *New York Times Magazine,* November 20, 1983, p. 70.

56. Rosenberg, "Interview with de Kooning," p. 57.

57. See Greenberg, "'American-type' Painting," in *Clement Greenberg: The Collected Essays and Criticism: Affirmations and Refusals 1950-1956,* John O'Brian, ed., (Chicago and London: University of Chicago Press, 1993), p. 222.

58. Thomas B. Hess, *Willem de Kooning* (New York: Braziller, 1959), p. 21.

59. Elaine de Kooning, "Franz Kline: Painter of His Own Life," *Art News,* November 1962, p. 66.

60. Stephen C. Foster, in introduction, "Franz Kline: Art and the Structure of Identity" (Barcelona: Fundacio Antoni Tàpies, 1994), p. 34, wrote that Kline was asked by Ivan Karp whether he was painting himself. He replied, "Who knows, you certainly couldn't be painting someone else, now, could you?"

61. Katharine Kuh, *The Artist's Voice: Talks with Seventeen Artists* (New York: Harper & Row, 1962), p. 152.

62. Elaine de Kooning, "Two Americans in Action: Franz Kline/Mark Rothko," *Art News Annual,* No. 27, Part 2 (Christmas Edition) November 1957, p. 179.

63. I am indebted to Leo Marx, "The Machine in the Garden," 1964, which presents the concept of the "technological sublime." See also David E. Nye, *American Technological Sublime* (Cambridge, Mass.: MIT Press, 1994) and Rosalind Williams, *Notes on the Underground: An Essay on Technology, Society and the Imagination* (Cambridge, Mass.: MIT Press, 2008).

64. Frank O'Hara, "Franz Kline Talking," *Evergreen Review,* Autumn 1958, reprinted in Frank O'Hara, *Standing Still and Walking in New York* (Bolinas, Calif.: Grey Fox Press, 1975), p. 94.

65. Ross Feld, "Guston in Time," *Arts Magazine,* November 1988, p. 41.

66. Horst W. Janson, "Martial Memory by Philip Guston and American Painting Today," *Bulletin of the City Art Museum of St. Louis,* No. 27, December 1942, p. 41.

67. Thomas Albright, "Philip Guston: It's a strange thing to be immersed in the culture of painting," *Art News,* September 1980, p. 114.

68. Dore Ashton, *Yes, But ... A Critical Study of Philip Guston* (New York: Viking Press, 1976), p. 74.

69. H. H. Arnason, "Philip Guston" (New York: Solomon R. Guggenheim Museum, 1962), p. 20.

70. Grace Pagel, *Encyclopaedia Britannica Collection of Contemporary American Art.* See John I.H. Baur, "Bradley Walker Tomlin" (New York: Whitney Museum of American Art, 1957), p. 25.

71. Kuh, *The Artist's Voice,* p. 119.

72. Elaine de Kooning, "Subject: What, How or Who?" *Art News,* April 1955, p. 62.

CHAPTER 5
Abstract Expressionism and the Cold War

A major thesis of Serge Guilbaut's *How New York Stole the Idea of Modern Art* is that the Abstract Expressionists were Cold Warriors. Soon after his book was published in 1983, Guilbaut and I debated this claim at the Whitney Museum. It struck me then as absurd, and I was convinced that it would die of its own accord. It did not. In fact, Guilbaut's allegation has come to be the received wisdom for several generations of art historians.

Even at this late date, Guilbaut's book must be challenged because it is wrongheaded. He misconstrued the historical record and dealt carelessly or cavalierly with facts. He also demeaned the artists he discussed. Examples of his contemptuous assertions are that the Abstract Expressionists were "storm troopers," and that Jackson Pollock was "the perfect commodity" who lent himself to being marketed and "domesticated by the system."[1]

To quote Meyer Schapiro again, "Chronology counts!" And it does. Consequently, I would like the reader to keep in mind three dates. The first is 1947, the year in which Pollock, Still, and de Kooning "broke through" to the singular abstract styles for which they are best known, the year in which the cold war began, and the year the Central Intelligence Agency was founded. The second date is 1952, the year that the Museum of Modern Art mounted its "Fifteen Americans," which included five Abstract Expressionists, and inaugurated its International Program of Exhibitions. And the third is 1958, the year "The New American Painting" was sent to eight European museums by the Museum of Modern Art—the *first major show* of Abstract Expressionist paintings that went abroad.

At the end of World War II, the United States stood preeminent. Its citizens were proud of their victory in World War II and in general were confident about the future of the nation. But optimism was soon undercut by foreboding and anxiety about Communist moves toward world domination. Russia had created captive states in Eastern Europe (1945) and had designs on democratic nations in the West. The fall of China to the Maoists (1949) and the invasion of South Korea by the Communist

North (1950) exacerbated U.S. fears. Moreover, the Soviets had acquired the technology to make the bomb—a shocking and fearful prospect.

During the early years of the cold war there seemed to be only two choices: American democracy or Communist totalitarianism. The growing acceptance of American foreign policy by leftist, hitherto dissident intellectuals prompted many to call for a rapprochement with Middle America. This was the theme of a widely publicized symposium titled "Our Country and Our Culture," published in *Partisan Review* in May-June 1952. The editors and most of the contributing writers and literary critics noted that a large number of intellectuals "now regard America and its institutions in a new way" and "feel closer to their country and its culture." They had come to recognize in American democracy "an intrinsic and positive value … not merely a capitalist myth but a reality which must be defended against Russian totalitarianism." Given these apparent alternatives, there emerged a general consensus among American intellectuals that held that the United States was the global guardian of democratic values that had to be defended.[2]

The Abstract Expressionist artists, on the whole, acquiesced in America's foreign policy, but they found some aspects of the cold war troubling. The widespread fear of Communism generated an atmosphere of cultural repression and suspicion. Communism was linked with modern art by powerful congressmen, federal agencies, and "patriotic" organizations. A number of shows sponsored or subsidized by the government were canceled or censored; paintings and sculptures were often removed merely because they were abstract, and the artists who made them were labeled Reds. Most notable among the modern art opponents in Congress was George Dondero, a Republican from Michigan, who branded modern artists "human termites," "germ-carrying vermin," and "international art thugs," declaring that their art aimed to undermine American society and culture—not an uncommon opinion in the 1940s and 1950s.[3] The Abstract Expressionists realized that their art was new and difficult to understand, but that did not ease the alienation and hurt they felt when their work was censored, or when their own government branded them as subversives. And the Abstract Expressionists would have been equally taken aback by charges that they were Cold Warriors.

The first-wave revisionists

The impetus to examine the art and the art world of the early cold war period from the vantage point of politics and history did not start with Serge Guilbaut. Beginning in 1973, a group of revisionist art historians focused on a question initially posed by Max Kozloff in an article titled "American Painting During the Cold War."[4] He asked, "[What] can be said of American painting since 1945 in the context of American political ideology, national self-images, and even the history of the country?"[5] The date 1973 is significant because Kozloff, and the many critics and art historians who followed him, began to raise this question only during the last stages of the Vietnam War.

They were fiercely critical of the United States' role in the war, and retrospectively of American practices in the cold war. Indeed, during this period, revisionist art historians devoted much of their writing to an analysis of American politics.

The sensibility of the Vietnam generation of historians and critics was radically different from that of the generation that had lived and worked during the 1940s and 1950s. In the earlier decades, a broad spectrum of historians tended to present the United States as the standard-bearer of democracy, freedom, and technological progress. In the 1960s and 1970s, however, as Barry Gewen wrote, scholars found "much to condemn in American history, little or nothing to praise.… American history was a story of cruel domination by the wealthy and privileged."[6]

On the whole, many scholars, as Morris Dickstein observed,

> approach the arts as expressions of social ideology [and] have tried to demonstrate that nearly every cultural phenomenon [of the postwar era], from genre films and literary criticism to abstract art, was somehow a reflex of the cold war, a "hegemonic" expression of the "national security state" and the containment policy toward international Communism.… Such arguments … rarely appealed to factual evidence [and] depend[ed] on tenuous links between politics and culture that are sometimes suggestive but too often arbitrary or reductive.[7]

Kozloff was the first to broach the idea that art since the end of World War II, and Abstract Expressionism in particular, might be dealt with in the context of politics, history, and national character. He noted that "the switching of the art capital of the West from Paris to New York coincided with the recognition that the United States was the most powerful country in the world."[8] This led him to speculate about a possible link between Abstract Expressionism and American society. He concluded that a salient characteristic of both was freedom. The American artists, realizing that they were free to paint as they pleased, in contrast to their Russian counterparts, who were forced to paint in a clichéd, sentimental, backward-looking Socialist Realist style, worked with "a grave sense of mission. Each of their decisions had to be supremely exemplary in the context of a spiritual privilege denied at present to most of their fellow men."[9]

Kozloff went on to say that the painters' sense of mission was intensified by their regard for French Existentialist ideas, especially Sartre's "notion that one is condemned to freedom, that the very necessity to create oneself, to give oneself a distinguishable existence, was a desperate, fateful plight."[10] This made Abstract Expressionist painting relevant, even excruciatingly so. When it was sent abroad, it functioned, according to Kozloff, as "an equivocal yet profound glorifying of American civilization." This was the source of its "allure." But, Kozloff was quick to add judiciously, "We are not so careless as to assume that such an ideal was consciously articulated by artists, or always directly perceived by their audiences."[11]

In a 1974 article titled "Abstract Expressionism, Weapon of the Cold War," art historian Eva Cockcroft praised Kozloff but claimed that he was wrong in maintaining that the links between cultural cold war politics and the new American painting were coincidental.[12] In her opinion, these links were forged by trustees and officers who controlled the Museum of Modern Art. Cockcroft acknowledged in her article that Abstract Expressionist painting succeeded because it was "new, fresh, and creative" and "artistically avant-garde and original," but more important, for her, because it satisfied the "ideological needs of [MOMA's] officers during a period of virulent anti-communism and an intensifying cold war." Consequently, she wrote, the Rockefeller-controlled museum promoted Abstract Expressionism abroad as "the symbol of political freedom."[13]

Cockcroft claimed that Alfred Barr, who had been fired as MOMA's director in 1944 but stayed on at the museum and in 1947 was appointed director of museum collections, was MOMA's leading cold warrior. His chief allies in the artistic campaign against the Russians were Thomas W. Braden and Porter McCray. Braden was executive secretary of the museum from April 1948 to November 1949, he and joined the CIA in 1950. Cockcroft portrayed Braden as the contact man between the CIA and MOMA.

Braden wrote a notorious article in the *Saturday Evening Post* of May 20, 1967, proudly titled "I'm Glad the CIA Is Immoral," which provided revisionist art historians with some major ammunition. According to Braden, the CIA aimed to "Use legitimate, existing organizations; disguise the extent of American interest; protect the integrity of the organization by not requiring it to support every aspect of official American policy.… Was it a good thing to forge such a weapon? In my opinion … it was essential.… For the cold war was … a war fought with ideas instead of bombs.… So long as the Soviet Union attacks deviously, we shall need weapons to fight back."

Braden boasted that by 1953 the CIA "was operating or influencing international organizations in every field where Communist fronts had previously seized ground."[14] He listed a number of such organizations, but not MOMA. (His powers at MOMA were so negligible that he is not even mentioned in Russell Lynes's history of the museum.[15])

The other alleged cold warrior at the Modern, Porter McCray, had served in Nelson Rockefeller's Inter-American Affairs Office, a federal agency, before joining the staff at MOMA in 1947. McCray became director of the museum's newly inaugurated International Program in 1952. Rockefeller and McCray had a history of furthering awareness of American culture abroad, and this would certainly have influenced their activities at MOMA.[16] But did these involve the CIA?

In a wide-ranging 1999 study of the CIA and the cultural cold war, *Who Paid the Piper?* Frances Stonor Saunders claimed that the CIA was behind most American cultural ventures abroad. She asserted that "high-level strategists" in the federal government were eager to show that Abstract

Expressionism was commensurate with America's greatness and freedom. However, she provided little evidence about the activities of these officials. (Their efforts could not have amounted to much, since the United States has always been stingy in its support of art, unlike France, which spent huge sums of money to promote French culture.)

In 1994, Saunders interviewed Waldo Rasmussen, who had been McCray's assistant from 1954 until 1961, at which time he succeeded him. (McCray died in 2000.) Rasmussen told her:

> There was a series of articles relating the Museum of Modern Art's International Program to cultural propaganda; and even suggestions that it was associated with the CIA, and since I worked there through those years I can say, categorically, untrue…. The main emphasis of the International Program was about art—it wasn't about politics, and it wasn't about propaganda. And in fact it was important for an American museum to avoid the suggestion of cultural propaganda, and for that reason it wasn't always advantageous to have connections with American embassies, or American government figures, because that would suggest that the exhibitions were intended as propaganda, and they were not.[17]

In the end, Saunders admits, "There is no prima facie evidence for any formal agreement between the CIA and the Museum of Modern Art." Even so, she goes on to surmise, "The fact is, it [a formal agreement] simply wasn't necessary."[18] But providing supporting facts is necessary.[19]

A less widely known entry in the sequence of 1970s revisionist essays was David and Cecile Shapiro's "Abstract Expressionism: The Politics of Apolitical Painting" (1977), in which the authors advanced a particular aspect of the argument: For Abstract Expressionism to have been a powerful political force, it had to have achieved prominence in the art world.[20] To make their case for its early ascendancy, they listed just about every art book, catalogue, and magazine (no matter how obscure or short-lived) that dealt with Abstract Expressionism, even cursorily, as well as solo and group shows in avant-garde galleries (no matter how unsuccessful) and museums (no matter how insignificant or out of the way). They intended the cumulative piling of data on data to establish Abstract Expressionism's hegemony—indeed, its monopoly of contemporary art—to the detriment of every other style. The Shapiros' thesis does not stand up if one considers how relatively little Abstract Expressionist painting was exhibited at MOMA, the citadel of modern art, in the 1940s and even the 1950s.

A year later, Carol Duncan and Alan Wallach's Neo-Marxist essay, "The Museum of Modern Art as Late Capitalist Ritual: An Iconographic Analysis" (1978), shifted the terms of the argument. They asserted that MOMA *championed* Abstract Expressionism. They likened the museum to the great cathedrals of the past, buildings that "affirm the power and social authority of a patron class" and hence are instruments of "class domination." The layout of the galleries, they claimed, directed the spectators inexorably toward the high altar of Abstract Expressionism.[21] In actuality, when the museum showed the New York School artists at all, it presented Abstract Expressionism as a late stage

of modernism rather than as its triumphant culmination, and as only one of a variety of viable tendencies in contemporary art. Indeed, throughout the 1950s, the Abstract Expressionist artists repeatedly criticized the museum for its lack of support.

Today it seems ironic that in 1957 Marxist art historian Meyer Schapiro, in "The Liberating Quality of Avant-Garde Art," considered the Abstract Expressionists' celebration of freedom and individualism in terms exactly opposite from those of the later Neo-Marxist revisionists. In his view, the artists' exercise of spontaneity and independence contested the conformity and alienated labor required by capitalist society.[22]

Throughout the quarter century preceding the publication of Kozloff's article and those that followed it, it would not have occurred to anyone to connect the new American painting and its supporters with the cold war in any way. Unfortunately, by the 1970s, many Abstract Expressionists, who could have countered the ideas put forth by the revisionists, had already died. Those of us who knew the artists find Guilbaut's claim that they were complicit in the cold war risible. As Lawrence Alloway wrote, "I can just imagine how scathing Barnett Newman [d. 1970] would have been if this [allegation] had surfaced during his lifetime.… He would have deplored anything that suggested he was a defender of imperialism or a lackey of the Rockefellers, or some such thing."[23]

There is no question that when MOMA sent exhibitions that included Abstract Expressionists abroad; it wanted, as Russell Lynes wrote, "to let it be known especially in Europe that America was not the cultural backwater that the Russians … were trying to demonstrate that it was. [Yet the] American State Department's attempts to export our arts for exhibition had been largely aborted by dissident Congressmen … who could not abide any art more sophisticated than a *Saturday Evening Post* cover."[24] The critical questions remain: When did the Modern send exhibitions to Europe, and who was responsible?

One would suppose that if MOMA had been, early on, as well disposed to Abstract Expressionism as Cockcroft claimed, it would have sent a major show like "The New American Painting" to Europe prior to 1958. However, the museum did not. Upon its return from Europe in 1959, "The New American Painting" was exhibited at the Modern, the first time the museum surveyed Abstract Expressionist painting at home, an indication of its relative lack of interest in such work throughout the 1950s. Cockcroft's entire argument collapses in the face of this single fact. The same is true of Duncan and Wallach's contention and that of the Shapiros.

Artists as cold warriors?

In *How New York Stole the Idea of Modern Art,* Serge Guilbaut took a far larger step in characterizing Abstract Expressionism as the art of the cold war. He shifted much of the responsibility from

the Museum of Modern Art to the artists themselves, and claimed that they actually created their pictures on behalf of American foreign policy. Guilbaut wrote, "The avant-garde tailored for itself a coherent, recognizable and salable image that fairly accurately reflected the aims and aspirations of the new liberal America, a powerful force on the international scene."[25] The Abstract Expressionists (notably Clyfford Still and Barnett Newman) did speculate about how their painting might be viewed as American, but they certainly did not "tailor" their art for political ends.

Moreover, Guilbaut muddled the relationships between the creation of art by artists inspired by subjective experiences and needs, the role in their art-making of political tracts and art criticism, the reception of their work by a variety of audiences, and its use by public agencies. Certainly the production of art and its reception are interrelated, as are the needs and desires of artist and viewers, but how art is used by diverse constituencies is often at odds with the artists' intentions. Artists cannot help being influenced by the events of their time, but it is highly questionable that specific political occurrences cited by Guilbaut (for example, the election of Harry Truman and the defeat of Henry Wallace in 1948), or critical writings (for example, an article by Clement Greenberg), affected what Rothko or Pollock painted in their studios.[26] Guilbaut's analysis is flawed by such simplistic correlations.

Underlying Guilbaut's text—not to mention the title of his book—was a pronounced anti-American bias. He treated the Abstract Expressionists as crooks who stole the idea of modern art—from whom? The French! Indeed, as Thomas Lawson pointed out, "There is a large piece of French chauvinism in Guilbaut's argument, an ingrained refusal to believe that anyone, particularly an American, could be as talented an artist as someone from France."[27] Guilbaut also maintained that the Abstract Expressionists were greedy and ambitious. In page after page he claimed that the artists were constantly intent on defining "themselves in the new market."[28] Adept at producing marketable commodities, according to Guilbaut, the painters succeeded—such was their market savvy and skill in political promotion—in demolishing the critical and aesthetic viability of French art and art making.

Guilbaut's attempt to relate Abstract Expressionism to political and social events in America of the 1940s was laudable. And to his credit, he recognized the role of alienation and anxiety at the time, and their influence on the art making of the Abstract Expressionists. However, most of Guilbaut's text is an account not of the artists' response but of the ins and outs of American politics and the diverse attitudes of the political Left. Although he claimed to have based his book on the ideas of the Abstract Expressionists, there is little in Guilbaut's account of what the Abstract Expressionists actually said about politics, aside from Motherwell, who followed left-wing politics and wrote about the subject. Instead, Guilbaut had much to offer about what intellectuals such as Greenberg and Dwight Macdonald published in *Partisan Review* or Macdonald's own journal, *Politics.* In the

process, Guilbaut conferred on these little magazines far greater importance beyond the minuscule world of leftist intellectuals than they actually had.[29]

One of Guilbaut's major claims was that the Abstract Expressionists turned from executing "realistic propaganda pictures in the thirties (whether of revolutionary, liberal, or reactionary inspiration) to painting in a resolutely avant-garde manner in later years."[30] What led them to do so was a "slow process of de-Marxification and later depoliticization of certain groups of left-wing anti-Stalinist intellectuals in New York from 1939 on."[31] Consequently, in his view, the artists stripped their painting of all content or meaning, thus creating an "art of obliteration, an art of erasure."[32] They purged social content and chose to project a private message as a public declaration.[33]

In fact, however, the Abstract Expressionists were not actually politicized (that is, Marxified) enough in the 1930s to paint "realistic propaganda pictures." Guilbaut acknowledged that Gorky did not paint Social Realist or Regionalist pictures.[34] No such simplified sequence applied to de Kooning, who painted a series of abstractions in the 1930s, followed by realistic portraits in the late 1930s and early 1940s, and then abstractions, then the figurative Women, then more abstractions, and so on. Pollock's and Still's earliest subjects were American scenes, but few of their paintings were realistic, and most were too crude and dark in mood to communicate a Regionalist message in the way that pictures by Benton, Curry, and Wood did. In the 1930s, Gottlieb and Rothko painted pictures of American life in a modernist style, but they were more interested in the pictorial ideas of Avery and Matisse and European Expressionism than in social protest. Motherwell never painted realist pictures, and when Baziotes did, it was too early in his career to be of any consequence. Reinhardt began his career as an abstract artist and remained one. Guston, a relative latecomer to Abstract Expressionism, did paint "agit-Prop" pictures early in his career and was acclaimed for them, but he is not mentioned even once in Guilbaut's text. Rather than obliterating figuration—a negative act—the Abstract Expressionists embraced abstraction—a positive act—to emphasize certain ideas and emotions. In doing this, they inscribed their painting into the long tradition of abstract art (most of it European and much of it French), extending it as they diverted it in a new direction. As Robert Goldwater observed, the Abstract Expressionists "were the very conscious heirs of a century of artistic change."[35]

And then there is the chronology problem. Guilbaut maintained that as the cultural counterpart of the Truman Doctrine and the Marshall Plan, Abstract Expressionist painting was established as a recognizable and successful style by 1948. As he viewed it, in 1948 Abstract Expressionism's "victory" was an accomplished fact. Why had it won? "March 1948. A critical moment, for it was then that Greenberg chose to announce that American art was foremost in the world." Guilbaut proclaimed dramatically that "in the war against communism, America now held all the trumps: the atom bomb, a strong economy, a powerful army, and now artistic supremacy, cultural superiority." Thus the

avant-garde introduced painting into "the list of weapons in the cultural arsenal … a weapon that the avant-garde had been working to forge since 1943."[36] A weapon? Since 1943? In fact, 1943 was the year after Pollock began his so-called mythic paintings, and it would be four years before he arrived at his Abstract Expressionist "drip" paintings. Guilbaut's claim is thus implausible.

So is his claim that Greenberg was Abstract Expressionism's "spokesman."[37] In 1949, Robert Goldwater, the editor of the *Magazine of Art,* invited sixteen leading figures in the art world to respond to the question, "Is there an American Art?" These critics, on the whole the most enlightened in America, included Walter Abell, Alfred Barr, Jacques Barzun, John Baur, Holger Cahill, Alfred Frankenstein, Lloyd Goodrich, Clement Greenberg, George Heard Hamilton, Douglas MacAgy, H. W. Janson, Daniel Rich, James Soby, and Lionel Trilling, along with two Europeans, John Devoluy and Patrick Heron, both of them artists as well as critics. For the most part, the participants were sympathetic to abstraction, but in its diverse manifestations. Only MacAgy and Greenberg singled out American Abstract Expressionism as more important than other tendencies.[38] Guilbaut exaggerated Greenberg's stature at the time; for him, Greenberg's advocacy was sufficient to totally eclipse the opinions of the other critics.

An unrecognized avant-garde

Now that Abstract Expressionism is writ large in art history, it is easy to forget how small the art world was in the late forties. In New York, the total number of artist, dealers, collectors, critics, museum personnel, and others in the avant-garde art world was not much more than 100. (Greenberg counted fifty.) The painters were impoverished, neglected, and embattled until well into the 1950s. Greenberg fully recognized this situation. In 1948—and note the date—he described the economic milieu of avant-garde artists as "the shabby studio on the fifth floor of a cold-water, walk-up tenement on Hudson Street; the frantic scrambling for money; the two or three fellow painters who admire your work; the neurosis of alienation that makes you such a difficult person to get along with…. The alienation of Bohemia was only an anticipation in nineteenth-century Paris; it is in New York that is has been completely fulfilled." Greenberg tried to make something positive out of the avant-garde artist's impoverished situation, by claiming that alienation was the "condition under which the true reality of our age is experienced. And the experience of this true reality is indispensable to any ambitious art."[39] The artists themselves recognized that if they wanted to be in the avant-garde, they would have to take vows of poverty. And they did, because as Goldwater wrote, "The consciousness of being on the frontier, of being ahead rather than behind, of having absolutely no models however immediate or illustrious, of being entirely and completely on one's own—this was a new and heady atmosphere."[40]

Whether at home or abroad, Abstract Expressionism was barely recognized as early as 1948.[41] In fact, that year was disastrous for the new American painting and modernist art generally, as I will show. Guilbaut recognized this, but nonetheless wrote, "There is no paradox in speaking of a victory of abstract expressionism as early as 1948, even if the avant-garde was under attack from all sides, from the left, from the right, from the populists, and even from President Truman himself."[42] There certainly is a paradox, but Guilbaut tried to circumvent it by implying that recognition had come from the Museum of Modern Art, whose liberal capitalist leadership was supposed to have assumed the job of exporting Abstract Expressionism when the anti-modernist federal government refused. Guilbaut, along with Cockcroft, failed to see the irony of a private museum having to take on the role of exporting American art on behalf of American foreign policy because the U.S. government itself refused.

However, even within the museum, avant-garde art was being resisted by powerful trustees. In the "Chronicle" of the collection, under the heading "1948," Alfred Barr reported that "some older members of the Committee on the Museum Collections … vigorously questioned the validity of certain acquisitions, including paintings called 'abstract expressionist.' Purchase was difficult."[43] Such was the antipathy to Abstract Expressionism that as late as 1952, in reaction to the acquisition of a Rothko painting, A. Conger Goodyear, a member of the acquisitions committee, resigned (although he remained on the board of trustees).

In 1948, Lincoln Kirstein, Barr's friend, who was curating a show of Elie Nadelman's sculpture at MOMA, published an article titled "The State of Modern Painting" in *Harper's,* attacking "improvisation as a method, deformation as a formula, and painting (which is a serious matter) as an amusement manipulated by interior decorators and high pressure salesmen." One might suppose that Kirstein meant Pollock or Rothko, but in fact he was referring to Léger and Matisse. In his view, Matisse was "a decorator in the French taste, the Boucher of his epoch, whose sources in the miniatures and ceramics of Islam are, inch for inch, his superior."[44] And who was to blame for the sorry state of modern painting? MOMA, because of the permanent collection Barr had assembled and the publications he produced. If someone like Kirstein, who was a member of the Modern's "family," could question the museum's acquisition of works by Matisse, what chance was there for Pollock and his colleagues? This was what Barr, who stopped speaking to Kirstein, was up against.

Francis Henry Taylor, director of the Metropolitan Museum of Art, was particularly abusive. In an oft-quoted article of 1948, he wrote, "Instead of soaring like an eagle through the heavens as did his ancestors and looking down triumphantly upon the world beneath, the contemporary artist has been reduced to the status of a flat-chested pelican, strutting upon the intellectual wastelands and beaches, content to take whatever nourishment he can from his own too meager breast."[45]

In 1948, too, Boston's Institute of Modern Art, which had been founded by New York's Museum of Modern Art, changed its name to the Institute of Contemporary Art, because, as its director, James S. Plaut, asserted, "'modern art' describes a style which … has become both dated and academic" and, moreover, a cult of bewilderment.[46] Plaut was referring to the likes of Picasso, Matisse, Miró, and Mondrian. At the beginning of 1949, the Institute mounted a show titled "Milestones of American Art in Our Century," which featured, according to *Life*, "the main trends in U.S. art of this century which are chiefly rooted in native traditions that are romantic and realistic."[47] Among the contemporary artists were Peter Blume, Jack Levine, Rico Lebrun, Morris Graves, I. Rice Pereira (the only geometric-abstract artist), and Adolph Gottlieb (the only Abstract Expressionist, who at the time was painting pictographs).

Samuel Kootz appears throughout Guilbaut's text as the most business savvy of dealers of Abstract Expressionist painting and a central figure in its establishment. In 1948, he had to close his gallery for a year, as Deirdre Robson, who analyzed the market for the new American painting, reported, "due to financial difficulties caused by [Kootz's] commitments to artists far outweighing the amount made in sales."[48]

Brickbats from Washington

Far from thinking of abstract art as a weapon in America's cultural arsenal, President Harry Truman and many congressmen saw it as just the reverse—a Communist weapon that aimed to subvert the American way of life. Truman ridiculed modern art as the "ham-and-eggs school" and "the vaporings of half-baked lazy people," comments widely reported in the press.[49] In 1949, Congressman Dondero, in a series of speeches on the floor of the House of Representatives, declared, "Modern Art is Communistic because it is distorted and ugly, because it does not glorify our beautiful country … in plain, simple terms that everyone can understand. [It] breeds dissatisfaction. It is therefore opposed to our government, and those who create it and promote it are our enemies."[50]

He also claimed, "Cubism aims to destroy [American standards and traditions] by designed disorder. Futurism aims to destroy by the machine myth…. Dadaism aims to destroy by ridicule. Expressionism aims to destroy by aping the primitive and the insane…. Abstractionism aims to destroy by the creation of brainstorms. Surrealism aims to destroy by the denial of reason."[51]

Last but not the least of the Communist conspirators, according to Dondero, were the Abstract Expressionists. He singled out Motherwell, Pollock, Baziotes, and David Hare as "subversives,"[52] whose "abstractivism [was] a simon pure, Russian Communist product."[53] It is significant that Dondero's influence was greatest between 1946 and 1956.

Attacks by the likes of Dondero led to federal censorship of works that were unconventional or by alleged subversives. This began in 1946 when the State Department organized a show titled "Advancing American Art," which consisted of seventy-nine works of modern art it had purchased for a total of $49,000. Forty works went to Europe and thirty-nine to Latin America. In the middle of a well-received tour, canvases in the show were attacked in Congress as Communistic and made by Communists. In 1947, both sections of the show were abruptly terminated, in Prague and Port-au-Prince. In response to the ensuing controversy, Secretary of State George C. Marshall announced that his department would provide "no more taxpayers' money for modern art."[54] In 1948, the paintings from the ill-fated show were ignominiously auctioned off as war surplus for $5,444. But, significantly, in 1947 the future Abstract Expressionists were so little known that of the seventy-nine artists in the canceled show, only William Baziotes, Adolph Gottlieb, and Robert Motherwell were included. Guilbaut mentioned "Advancing American Art" only twice, for a total of ten lines, and concluded incongruously that despite "disappointments connected with this show"—the disappointments not specified—it "demonstrated that the American government was willing to involve itself with the international art scene."[55]

The United States Information Agency (USIA), which was established as an independent body in 1953 to export American culture, continued the government's censorship of art. As late as 1956, it aborted the tours of two shows it had commissioned because participants or works were politically unacceptable. The first exhibition, titled "Sport in Art," organized by the American Federation of Arts (AFA) with partial funding from *Sports Illustrated,* was to have traveled to seven museums in the United States and to end up in Melbourne, Australia, to coincide with the 1956 Olympic Games. A month later the USIA canceled another show organized by the AFA titled "100 American Artists of the Twentieth Century." The USIA was criticized in the art world so vociferously that the agency decreed that it would sponsor no exhibition that included paintings made after 1917 (the year of the Russian Revolution).[56]

An uphill climb

Guilbaut ended his narrative in 1951, assuming he had made his point. He had not. Within the small circle of the avant-garde there was little concerted effort to present Abstract Expressionism as a movement or tendency, much less a unified style. It was only in 1949 that the first group show, titled "The Intrasubjectives," organized not by the artists but by critic Harold Rosenberg and dealer Samuel Kootz, was mounted in the latter's gallery, which had reopened that year. The *Art Index* does not list a single review. Then in 1951, Robert Motherwell helped arrange "The School of New York" in Los Angeles, and members of The Club (but not in the name of The Club) mounted a more comprehensive survey, titled "The Ninth Street Show," in New York. Again, according to the *Art Index,*

no review. Guilbaut notwithstanding, it was only in the early fifties that the Abstract Expressionists began to be taken seriously outside a small circle. This group of artists was not recognized by the larger American art world or the wider American public until much later, and in Europe, even later.

Indeed, it was not until 1952 that the Museum of Modern Art itself included five Abstract Expressionists (Baziotes, Pollock, Rothko, Still, and Tomlin) in a major show—Dorothy Miller's "15 Americans"—and they were in the minority. And it was only in that year that the museum inaugurated the International Program of Exhibitions, underwritten by the Rockefeller Brothers Fund for five years at $125,000 per annum. To further develop international artistic exchange, MOMA established an International Council in 1953. By 1954, the International Program had organized twenty-seven shows, twenty-two for circulation abroad. Of the shows, most were modest, consisting of prints or photographs,[57] but one was significant: "12 Contemporary American Painters and Sculptors" (1953), of which more later.

Guilbaut's contention that Abstract Expressionist painting achieved recognition by 1948 is not corroborated by the art market. It is true that during the 1940s, some of these painters were given one-person shows in a few adventurous galleries: Hugo Stix's Artists Gallery, Peggy Guggenheim's Art of This Century gallery, and the galleries of Samuel Kootz, Howard Putzel, Betty Parsons, and Charles Egan. However, most of these galleries were small and too poor to publish substantial catalogues or advertise broadly.[58] Betty Parsons, the leading dealer of the Abstract Expressionists, complained that business was slow in the late 1940s.[59] What little art these avant-garde galleries sold was at relatively low prices.[60] Deirdre Robson reported that Pollock rarely got more than $900 for any work he managed to sell from 1947 to 1951. The exceptions were *Number 5*, 1948 ($1,500), and *Number 1*, 1948 ($2,350). The top price paid for a Rothko in the same period was $1,250. At the time, a major School of Paris painting could command up to $15,000.[61]

French art was more expensive than American art because it was far more established and desirable at the time. The Museum of Modern Art was partly responsible for this market advantage. Collectors looked to the museum for guidance and, until the mid-1950s, Barr featured European modernists and presented the development of modern art in a coherent fashion, conveying the idea that the mainstream of modern art and its outstanding practitioners were in Europe. In contrast, even up to the mid-1950s, Barr continued to treat American art as a mixed bag of tendencies, of which Abstract Expressionism was only one. Nor did the museum collect American art in a thoroughgoing manner, maintaining that the Whitney Museum was fulfilling that function. Barr did acquire Abstract Expressionist paintings, among them Gorky's *Agony* (1947) and Pollock's *Number 1*, but as Michael Kimmelman pointed out, judging by Barr's book *Painting and Sculpture in the Museum of Modern Art, 1929-1967,* the museum "acquired as many works by Lucian Freud as by

de Kooning throughout the fifties [and] as many works by Reg Butler as by Baziotes, Kline, Barnett Newman, and Tobey combined."[62]

Collectors were reluctant until well into the fifties to collect the new American painting, even though prices were very low. In 1955, critic and *Art News* editor Thomas Hess complained that "the Americans, even the greatest of them, still are carefully avoided by our big collectors."[63] However, after Pollock's death in 1956 the market for Abstract Expressionist paintings did open up.[64] The catalyst was the sale in 1956, of Pollock's *Autumn Rhythm* to the Metropolitan Museum for $30,000, a shockingly high price at the time.[65] Only then did Abstract Expressionism begin to achieve significant art-market success.[66]

A tale of three cities

If Abstract Expressionist painting was used to advance the U.S. cold war campaign abroad, as Guilbaut claimed, did it succeed? And if so, when? What was its reception in Europe? When was it accepted? When did various leading European art worlds finally recognize that the capital of world art had moved from Paris to New York? Consider three major centers: Paris, Venice, and London, in the years from 1947 to 1959.

It was only in 1958 that the first major survey of Abstract Expressionist painting, "The New American Painting," consisting of eighty-one paintings by seventeen artists, was circulated by MOMA to eight European museums—significantly, at their request. Alfred Barr was motivated to send this survey abroad (with his catalogue introduction), late though it was, in response to the cancellation by the USIA of several shows that contained abstract works. Barr was a dedicated civil libertarian and a leader of the protests against the USIA. His primary aim in organizing "The New American Painting" was to subvert federal censorship of art, a motive that revisionist art historians have not recognized.[67] In 1958, too, MOMA sent "Jackson Pollock: 1912-1956," consisting of thirty-one paintings and twenty-nine drawings, to museums in Paris, Venice, and London, among other venues.

But what was the response to Abstract Expressionist painting in Paris, Venice, and London *before* 1958? The issue is complicated, because the reception differed from country to country. In Paris, the first show of American avant-garde art (the first to be sent to Europe), organized by Kootz with a catalogue introduction by Rosenberg, was exhibited at the Galerie Maeght in 1947. Titled "Introduction à la peinture moderne americaine," it consisted of canvases by Baziotes, Romare Bearden, Byron Browne, Gottlieb, Carl Holty, and Motherwell, all of whom were represented by the Kootz Gallery. The show was a critical and financial debacle. This was the year that Kootz had to close his gallery because of money problems. Guilbaut himself provided a six-page, blow-by-blow account of the critical drubbing the show took from Parisian art writers, detailing their claim that the New

Yorkers had merely aped modern French styles, and badly at that. *Cahiers d'Art* did publish illustrations of each artist's work, leading Guilbaut to conclude that these American painters "could no longer be ignored *in the United States*" (italics mine).[68] However, he offered no evidence that this was true. One would suppose that Greenberg would have commented on the Maeght show or the *Cahiers d'Art* article. But he wrote nothing.

The antagonism toward American avant-garde art was no doubt related to the determination of the Parisian art world to reestablish the preeminence of French painting after World War II.[69] The negative reaction to the Kootz show discouraged the exhibition of avant-garde American art in Paris for the next four years. However, in 1951, an exhibition in Paris, curated by Michel Tapié, made a strong impression on the art world there, according to a letter sent by Georges Mathieu to twenty-five American artists.[70] Tapié coupled the American Abstract Expressionists with French Tachist painters. In his book surveying new work in many countries, *Un art autre* (1952), he linked both avant-gardes as an antidote to the conservative modernist art favored by the French art establishment.

In 1953, MOMA's International Council sponsored "12 Contemporary American Painters and Sculptors" at the Musée National d'Art Moderne in Paris. The show itself was a mixed bag. Contemporary painting was represented by nine artists: Ivan Albright, Stuart Davis, Morris Graves, Edward Hopper, John Kane, John Marin, Ben Shahn, and, of the Abstract Expressionists, only Gorky and Pollock (proof of MOMA's continuing ambivalence regarding American avant-garde painting). Included also were sculptors Alexander Calder, Theodore Roszak, and David Smith. The Parisian critics on both the political left and right generally denigrated the art—paradoxically—as derivative, on the one hand, and on the other as evidence of an American campaign to upstage French art.

During the 1950s, the French art world was inclined to discredit New York–based Abstract Expressionism or divert attention from it. For example, in 1953, Mathieu acknowledged that "since the Second World War, there has existed in the United States, for the first time in the history of American painting, a group of artists whose work, at once completely original and autonomous, permits one to speak of a really American avant garde." Did Mathieu mean Pollock and other New Yorkers, as one would suppose? No. In his view, "Mark Tobey may be considered its greatest innovator" whose "'white writing' of 1942 had started a vast movement concerned with a new understanding of space"[71] (a movement that, in fact, was hardly "vast").

Nonetheless, Parisian interest in Abstract Expressionist painting grew. In 1956, "Fifty Years of Art in the United States," drawn from the collection of MOMA and circulated by the International Council, was mounted at the Musée Nationale d'Art Moderne. Consisting of 108 paintings and twenty-two sculptures by seventy artists, it was a broad survey that included twenty-one paintings by

Gorky, Guston, de Kooning, Motherwell, Pollock, Rothko, Still, and Tobey. The show attracted the largest audience at that museum since World War II.

The Italian art world was somewhat more receptive to Abstract Expressionism than was the French art establishment. In 1948, the American pavilion at the Venice Biennale presented the works of seventy-nine artists, including Baziotes, Gorky, Rothko, and Tomlin. The Greek pavilion featured a selection of 136 works from Peggy Guggenheim's collection, including fourteen by Abstract Expressionists.[72]

At the 1950 Venice Biennale, Alfred M. Frankfurter, the publisher of *Art News* and that year's U.S. Commissioner, presented a retrospective of eighty paintings by John Marin as the main event at the United States Pavilion. Alfred Barr selected six more artists—Gorky, de Kooning, Pollock, Hyman Bloom, Lee Gatch, and Rico Lebrun—each represented with four or five canvases. With the exception of Pollock's works, the latter did not make much of an impression on the Italian critics.

In 1954, the Museum of Modern Art purchased the United States Pavilion from the Grand Central Galleries and became responsible for shows there until 1962. For the 1954 Biennale, commissioner René d'Harnoncourt, MOMA's director, selected fifty works by Ben Shahn, twenty-seven by de Kooning, and one sculpture apiece by Ibram Lassaw, Gaston Lachaise, and David Smith. U.S. Ambassador Clare Booth Luce denounced the selection of "a Communist and [a] foreigner" (although Shahn was not a Communist and de Kooning had been in the United States since 1926). Luce forbade the USIA staff to render any assistance to d'Harnoncourt.[73] In 1956, Daniel Catton Rich of the Art Institute of Chicago was commissioner. He chose forty-six artists with one work each; of the leading Abstract Expressionists, only Kline, de Kooning, and Pollock were included.[74]

Abstract Expressionist painting was exhibited in Britain somewhat later than in France or Italy. A single canvas by Pollock was shown in England in 1953. Three years later, the Tate Gallery organized "Modern Art in the United States," which was also exhibited in Paris. The second-best-attended show at the museum since the end of World War II, its most popular pictures were by Andrew Wyeth and Shahn, but the most controversial were by the Abstract Expressionists. In a review of the show Patrick Heron wrote, "At last we can see for ourselves what it is like to stand in a very large room hung with very large canvases by Jackson Pollock, Willem de Kooning, Mark Rothko, Clyfford Still, Franz Kline, and the others. I think it is true to say that the fame of these painters just managed to precede the arrival of their canvases in London: in other words, the exhibition has come at 'the psychological moment'—the moment when curiosity was keenest.[75]

Heron went on to say, "The idea that this new school of American art has become an international force, capable, even, of exerting an influence in Paris … has been gaining currency."[76] Heron himself had strong reservations about Abstract Expressionist painting, but nonetheless he concluded,

"We will now watch New York as eagerly as Paris for new developments."[77] Jeremy Lewiston later wrote that the critical reception of the contemporary section was not as positive as Heron made it out to be. "Themes of bestiality, violence, and barbarism, recently associated with fascism, were never far from the critics' minds; and in this way Pollock was framed as an enemy of European civilization."[78]

"The New American Painting": a turning point

In 1958, eleven years after the start of the cold war, "The New American Painting" arrived in Europe. Kenneth Rexroth provided a personal account of its European reception in *Art News*. He pointed out that the show provided the first chance for considerable numbers of Europeans to see Abstract Expressionism as a movement. Other surveys, which had included artists as diverse as Grant Wood and Clyfford Still, had been confusing rather than informative. Rexroth dismissed the overseas newspaper reviews as "a parade of busted clichés and demoralized preconceptions." The writers "were under the impression the pictures were painted by Wyatt Earp and Al Capone and Bix Beiderbecke."[79] Rexroth found that "the best tempered and most judicious reviews were in the better English papers." But even in England, "With the exception of a few scholarly art historians … everybody accepted these pictures as either utter novelties, subversive of all tradition whatsoever, or as just amateur provincial imitations of their own painting of years gone by—École de Paris, or Expressionism, or Futurism, depending on the nationality of the critics."[80]

Rexroth was right. "The New American Painting" signaled British acceptance of Abstract Expressionism, as Herbert Read observed.[81] Yet it was visited by only 14,000 spectators, compared with the 250,000 who crowded that year's Royal Academy Summer Show, the star of which was Pietro Annigoni's portrait of Queen Elizabeth.[82] Rexroth went on to say, "The French, as might be expected, were by far the worst.… Most of the [newspaper] criticism was entirely political and had nothing to do with any kind of painting. [The critics] agreed that these Americans, like all other Americans, were dangerous and ignorant barbarians, redskins, in fact."[83]

Rexroth did remark that there were open-minded and judicious critics, notably on the political moderate right and independent left, who "pointed out that although the paintings were truly American, their sources were in the whole European tradition." Rexroth concluded that their opinion represented "the real opinions of the bulk of the educated visitors to the show, Left, Right, and Left Center."[84]

In short, mixed as the response was, the late 1950s saw growing numbers of leading European artists, art critics, museum directors, curators, dealers, collectors, and other establishment figures recognize the new American painting and New York as the center of the avant-garde world. As Jeremy

Lewison wrote, "In the decade and a half since the war, America had been transformed from a target of ridicule to a role model."[85] Still, as Lawrence Alloway commented, "This art was not the way to solicit good cheer among foreign governments.... It was simply too early for that show ["The New American Painting"] to have beneficial political side effects."[86]

In fact, in 1959, the U.S. entry in the art program at the Brussels World's Fair and the "American National Exhibition" in Moscow, where Nikita Khrushchev and Nixon had their "kitchen debate," gave rise to controversy again. The latter contained works by Shahn and Pollock, prompting President Eisenhower to comment that they were not "what America likes," but the show was not canceled.[87] But MOMA did organize a show that America—and the world—liked, namely Edward Steichen's "The Family of Man" (1955). Circulated abroad by the United States Information Service, it was exhibited in eighty-eight venues in thirty-seven countries. The accompanying book sold more than three million copies.[88]

In the end, what did Greenberg, a mainstay of Guilbaut's argument, think about Abstract Expressionism as a weapon in the cold war? He said that it was "a lot of shit—how the State Department supported American art and that it was part of the cold war, and so forth. It was only after American art had made it at home and abroad, principally in Paris, that the State Department said we can now export this stuff. They hadn't dared to before that. The fight had been won."[89]

1. Serge Guilbaut, *How New York Stole the Idea of Modern Art* (Chicago: University of Chicago Press, 1983), pp. 87, 205.

2. "Our Country and Our Culture," *Partisan Review,* May-June 1952, p. 284.

3. Quoted in William Hauptman, "The Suppression of Art in the McCarthy Decade," *Artforum,* October 1973, p. 48.

4. Max Kozloff, "American Painting During the Cold War," *Artforum,* May 1973, p. 43.

5. Kozloff begins his article by referring to my "exhaustive book on Abstract Expressionism … *The Triumph of American Painting* [1970], a title that sums up the self-congratulatory mood of many who participated in its career." Guilbaut also repeatedly attacks my survey. Michael Kimmelman, in "Revisiting the Revisionists: The Modern, Its Critics, and the Cold War," *Studies in Modern Art 4,* New York, Museum of Modern Art, 1994, p. 53, footnote 3, wrote, "The publication of Irving Sandler's *The Triumph of American Painting* … was perhaps the single publishing event that most galvanized the revisionists."

6. Barry Gewen, "Forget the Founding Fathers," *New York Times Book Review,* June 5, 2005, p. 31.

7. Morris Dickstein, *Leopards in the Temple: The Transformation of American Fiction* (Cambridge, Mass.: Harvard University Press, 2002), p. 2.

8. Kozloff, pp. 43-44.

9. Ibid., p. 45.

10. Ibid., p. 47.

11. Ibid., p. 43.

12. Eva Cockcroft, "Abstract Expressionism, Weapon of the Cold War," *Artforum,* June 1974, p. 39.

13. Ibid, p. 41.

14. Thomas W. Braden, "Speaking Out: I'm Glad the CIA Is 'Immoral,'" *Saturday Evening Post,* May 20, 1967, pp. 10-14.

15. Russell Lynes, *Good Old Modern: An Intimate Portrait of the Museum of Modern Art* (New York: Atheneum, 1973).

16. See Helen M. Franc, "The Early Years of the International Program and Council," *Studies in Modern Art 4: The Museum of Modern Art at Mid-Century At Home and Abroad* (New York: Museum of Modern Art, 1994).

17. Frances Stonor Saunders, *Who Paid the Piper? The CIA and the Cultural Cold War* (London: Granta Books, 1999), p. 268.

18. Ibid., p. 264.

19. In an interview of around 2002, I spoke with Rasmussen and we touched on this same question. I asked him whether there was any CIA influence or contribution. His answer: None. Had he ever heard mention of the CIA at the museum? No. Or of Braden? No. Rasmussen added that if the CIA had had any role in MOMA's decisions or financing, he would have known of it. In some cases, the United States Information Agency did play a role, he said, in providing local contacts to facilitate the practical arrangements, transportation and installation of works.

 Further refuting the thesis of CIA promotion of Abstract Expressionism is a recent book on the cultural activities of the CIA by David Caute, titled *The Dancer Defects: The Struggle for Cultural Supremacy During the Cold War* (Oxford: Oxford University Press, 2003).

20. David and Cecile Shapiro, "Abstract Expressionism: The Politics of Apolitical Painting," *Prospects,* No. 3, 1977, pp. 175-214. Reprinted in Francis Frascina, ed., *Pollock and After: The Critical Debate* (London: Routledge, 2000), p. 90.

21. Carol Duncan and Alan Wallach, "The Museum of Modern Art as Late Capitalist Ritual: An Iconographic Analysis," *Marxist Perspectives,* Winter 1978, p. 44.

22. Meyer Schapiro, "The Liberating Quality of Avant-Garde Art," *Art News,* Summer 1957, pp. 36-42.

23. Lawrence Alloway, "Field Notes: An Interview," *Abstract Expressionism: The Critical Developments* (New York: Abrams, in association with Buffalo, Albright-Knox Art Gallery, 1987), p. 130. Newman was a dedicated anarchist who wrote an introduction in 1968 to *Memoirs of a Revolutionary* by Prince Pierre Kropotkin, the leading exponent of Anarchism.

24. Lynes, pp. 384-385.

25. Guilbaut, pp. 200-201.

26. Ibid, p. 184.

27. Thomas Lawson, review of *How New York Stole the Idea of Modern Art, Artforum,* June 1984, p. 83. Rudolph Baranik, "Philistinism in Front of Art and Art History," *Art Criticism,* Vol. 2, No. 3, 1986, footnote 2, p. 45, suggests that Guilbaut's view of Abstract Expressionism was influenced by his being French. Corinne Robins, in "Dumb Artists and Smart Marxists," *American Book Review,* May-June 1984, p. 19, wrote, "Perhaps this book's real value may lie in its giving its American readers a new understanding of just how bitterly European artists and art historians regard the idea of the 'triumph' of abstract expressionism."

28. Guilbaut, p. 90. Guilbaut's book is frequently contradictory. For example, from pages 90 to 95 he wrote about the burgeoning art market after World War II with the implication that the Abstract Expressionists were intent on cashing in. Then he suddenly remarked that "abstract expressionism did not catch [the collecting middle class's] fancy. It rejected abstract expressionism as a joke or, worse still, a subversive threat."

29. On p. 196, Guilbaut wrote that "The first thing to understand is this: the avant-garde artists were attentive to what was being said by the remnants of the left in magazines like *Partisan Review, The Nation,* or Dwight MacDonald's *Politics.*" Guilbaut was interested primarily in what critics and literati, not artists, had to say. In fact, he was more comfortable with writers than with artists. For example, he could have consulted Joseph Solman about Rothko or Gottlieb, as he was their close associate in the 1930s, or asked Balcomb Greene, but he did not. Instead, he assumed that Rothko and Gottlieb were Trotskyists because, having agreed with Schapiro on certain political issues, they were in Schapiro's "circle." He might have asked Schapiro, who was alive, but did not. I did, in 1984. Schapiro scoffed at Guilbaut's assertion that he had a "circle," and that the Abstract Expressionists were Cold Warriors.

30. Ibid., p. 3.

31. Ibid., p. 2.

32. Ibid., p. 197.

33. Ibid., p. 196. Rudolph Baranik, in "Philistinism," pp. 41, 44, raised the crucial question that Guilbaut failed to put forward. Baranik asked, "Can anyone believe that in creating art a mere practical decision [to turn away from propaganda, Social Realist or Regionalist, and I would add Cubist—or Surrealist—inspired abstraction] is enough to give birth to what amounts to a new powerful style? It is mechanistic to believe that disillusionment in Stalinist communism can, quickly, lead to the poetry of Rothko, that Trotskyist theories can result in the black painting of Reinhardt."

34. Guilbaut, p. 20.

35. Robert Goldwater, "Reflections on the New York School," *Quadrum,* No. 8, 1960, p. 29.

36. Guilbaut, pp. 168, 172, 174.

37. Ibid., p. 5.

38. Robert Goldwater, "Reflections on the New York School," *Quadrum,* No. 8, 1960, p. 29.

39. Clement Greenberg, "Art Chronicle: The Situation at the Moment," *Partisan Review,* January 1948, pp. 82-83.

40. Goldwater, p. 26.

41. In 1948, there was a glimmer of a change in attitude toward avant-garde art, or at least attempts to treat it seriously. In October, *Life* magazine published "A *Life* Round Table on Modern Art" with such prominent participants as Greenberg, Schapiro, Francis Henry Taylor, James Thrall Soby, H. W. Janson, and Georges Duthuit. Color reproductions of works by Pollock, de Kooning, Gottlieb, Baziotes, and Stamos were included. Greenberg spoke positively about Pollock's work but others treated it as decorative "wallpaper" or "a pleasant design for a necktie." Life's summation was, "The layman might justifiably conclude that whatever the values of modern art, the precise determination of them is a matter fraught with a great many difficulties. The critics, at any rate, leave us in confusion." In its issue of Aug. 8, 1949, *Life* published an article titled "Jackson Pollock: Is He the Greatest Living Painter in the United States?" It was derogatory but introduced Pollock to a wide public.

42. Guilbaut, p. 4.

43. Alfred H. Barr Jr., "Chronicle of the Collection of Painting and Sculpture," *Painting and Sculpture in the Museum of Modern Art: 1929-1967,* (New York: Museum of Modern Art, 1977), p. 629.

44. Lincoln Kirstein, "The State of Modern Painting," *Harper's Magazine,* October 1948, pp. 47-48.

45. Francis Henry Taylor, "Modern Art and the Dignity of Man," *Atlantic Monthly,* December 1948, pp. 30-31, 36.

46. James S. Plaut, "'Modern Art' and the American Public, a Statement by the Institute of Contemporary Art, formerly The Institute of Modern Art," leaflet, Boston, Feb. 19, 1948, excerpt in *Modern Artist in America 1,* (New York: Wittenborn Schultz, 1951), p. 147.

47. "Revolt in Boston," *Life,* Feb. 21, 1949, p. 84.

48. Deirdre Robson, "The Market for Abstract Expressionism: The Time Lag Between Critical and Commercial Acceptance," *Archives of American Art Journal,* Vol. 25, No. 3, 1985, p. 20.

49. Margaret Lynne Ausfeld, "Circus Girl Arrested: A History of the Advancing American Art Collection, 1946-1948," in *Advancing American Art: Politics and Aesthetics in the State Department Exhibition, 1946-1948,* (Montgomery, Ala.: Montgomery Museum of Fine Arts, 1984), p. 20.

50. Quoted in Emily Genauer, "Still Life with Red Herring," *Harper's Magazine,* September 1949, p. 89.

51. George Dondero, quoted in Francis K. Pohl, *Ben Shahn: New Deal Artist in a Cold War Climate, 1947-1954* (Austin: University of Texas Press, 1989), p. 75.

52. George Dondero, "Modern Art Shackled to Communism," *Congressional Record: 81st Congress, 1st Session,* 1949, Vol. 95, pt. 9, pp. 11584-11585. Reprinted in Herschel B. Chipp, ed., *Theories of Modern Art* (Berkeley: University of California Press, 1956), pp. 496-497.

53. Quoted in Pohl, p. 76.

54. This comment appeared in the *New York Times,* May 6, 1947, quoted in Jane de Hart Mathews, "Art and Politics in Cold War America," *American Historical Review,* October 1976, p. 778.

55. Guilbaut, p. 118. On p. 150, Guilbaut claimed that the "United States indirectly patronized the show at the Maeght Gallery," but offered no proof. He also claimed that "the administration preferred to bypass Congress using such government agencies as the United States Information Service (USIA) to finance private

cultural ventures abroad," without mentioning Congressional influence on the USIA's programs and the agency's censorship of shows.

56. Charlotte Devree, "The U.S. Government Vetoes Living Art," *Art News,* September 1956, p. 34.

57. Franc, p. 118.

58. Deirdre Robson, "The Avant-Garde and the On-Guard: Some Influences on the Potential Market for the First Generation Abstract Expressionists in the 1940s and Early 1950s," *Art Journal,* Fall 1998, p. 217.

59. Robson, "The Market for Abstract Expressionism," p. 20.

60. Guilbaut, on p. 91, wrote that beginning in 1944, there was an "'art boom'.… All sources agree: the art scene was ebullient and the art market was going full steam. The number of art galleries in New York grew from 40 at the beginning of the war to 150 by 1946." Not true. All sources did not agree. As Robson demonstrates, there was no sizable market for Abstract Expressionist paintings until the late 1950s.

61. Robson, in "The Avant-Garde and the On Guard," p. 216, wrote that the early collectors of the new American painting were Eleanor Gates Lloyd, Wright S. Ludington, Sadie A. May, Muriel Kallis Newman, Kenneth McPherson, Roy Neuberger, Alfonso Ossorio, Bernard and Rebecca Reis, Dwight Ripley, and Edward Wales Root. These collectors, a number of whom were painters, were not among the richest Americans and did not have political attachments with government agencies. At least, none of their names appear in Francis Stoner Saunders's *Who Paid the Piper?,* which lists every art-world individual who might have had a connection, no matter how remote, with the CIA.

 I have been able to find only five corporate collections that acquired Abstract Expressionist paintings prior to 1952. They were Abbott Laboratories, Bank of Boston, Citicorp/Citibank NA, Lewis and Roca, and Times Mirror Company. Four had a single Motherwell, one had several Motherwells, and two had a Hofmann in addition to Motherwell. Why Motherwell? Perhaps because he was included in the Museum of Modern Art's "Fourteen Americans" in 1946, or because he seemed more European.

62. Kimmelman, p. 52.

63. Robson, "The Avant-Garde and the On-Guard," p. 20.

64. Ibid., p. 21.

65. Ibid.

66. Ibid., p. 19.

67. Barr was not only a trustee of the American Federation of Arts but a member of the American Civil Liberties Union. He wrote a public letter in which he called upon the American Federation of Arts, the American Council of Learned Societies, and the College Art Association to join in an "outspoken defense of American principles of freedom" against both "the Communists and the fanatical pressure groups working under the banner of anti-communism." See Alfred H. Barr Jr., "Artistic Freedom," *College Art Journal,* Spring 1956, pp. 184-188.

68. Guilbaut, pp. 148-154.

69. My comments are heavily indebted to Michael Plante's doctoral dissertation, "The 'Second Generation' American Expatriate Painters and the Reception of American Art in Paris, 1946-1958," Ph.D. thesis, Brown University, 1992.

70. Georges Mathieu, "Declaration to the Abstract Avant-Garde Painters (A Letter to Twenty-Five American Artists)," typescript, April 1952, n.p. A copy is in the Getty Archives.

71. Mathieu, "Is the American Avant Garde Over-rated?" Oct. 15, 1953, *Art Digest,* pp. 11, 34.

72. The fourteen Abstract Expressionist paintings in the Peggy Guggenheim Collection on display consisted of Baziotes (3), Gorky (1), Motherwell (1), Pollock (6, dating from 1942 to 1946), Pousette-Dart (1), Rothko (1), and Still (1).

73. Franc, p. 123.

74. The other artists identified with the New York School shown in the United States Pavilion in 1956 were Nicholas Carone, Jimmy Ernst, John Hultberg, Norman Lewis, Corrado Marca-Relli, and Hedda Sterne.

 MOMA's Porter McCray was the American commissioner in 1958; he chose Mark Tobey with thirty-six works, Mark Rothko with ten works, David Smith with fourteen works, and Seymour Lipton with nine works.

 In 1960, Adelyn D. Breeskin of the Baltimore Museum of Art chose Philip Guston with thirteen works, Hans Hofmann with thirteen works, Franz Kline with ten works, and Seymour Roszak with fourteen works.

75. Patrick Heron, "The Americans at the Tate Gallery," *Arts,* March 1956, p. 15.

76. Ibid.

77. Ibid, p. 17.

78. Jeremy Lewiston, "Jackson Pollock and the Americanization of Europe," in Kirk Varnedoe and Pepe Karmel, eds., *Jackson Pollock: New Approaches* (New York: Abrams, 1999), p. 208.

79. Kenneth Rexroth, "U.S. Art Across Time and Space: Americans Seen Abroad," *Art News,* Summer, 1959, p. 33.

80. Ibid., p. 52.

81. See Herbert Read and H. Harvard Arnason, "Dialogue on Modern U.S. Painting," *Art News,* May 1960, p. 33. Read wrote, "The real impact [began] with the circulation of the Museum of Modern Art's 'New American Painting' show and the Pollock exhibition."

82. John A. Walker, *Cultural Offensive: America's Impact on British Art Since 1945* (London: Philo Press, 1998), p. 72.

83. Rexroth, "Americans Seen Abroad," p. 52.

84. Ibid.

85. Lewison, p. 214.

86. Alloway, "Field Notes," p. 130.

87. Jane de Hart Mathews, "Art and Politics in Cold War America," *American Historical Review 81,* 1976, p. 779.

88. John Szarkowski, "The Family of Man," *The Museum of Modern Art at Mid-Century: Studies in Modern Art 4* (New York: Museum of Modern Art, 1994), pp. 13, 32.

89. Robert Burstow, "On Art and Politics: A Recent Interview with Clement Greenberg," *Frieze,* September-October 1994, p. 33.

CHAPTER 6

Field Painting and Gesture Painting
and Their Critics

Art history is inevitably influenced by the beliefs and viewpoints of art historians, which themselves are shaped by social, political, and generational circumstances. It follows that as these conditions change, so do the premises of scholars and the way they analyze art and what has been written about it. In my case, participation in the world of Abstract Expressionism led me to focus on the intentions of the painters treated in this study—their singular visions and experiences as they are embodied in their works. I have always identified with artists and have considered myself their advocate. The reader should keep this in mind, as my approach has shaped my evaluations of art critical and historical interpretations of others.

"Mark Rothko is a fraud"

During the 1940s and '50s, art writers—Clement Greenberg and Harold Rosenberg and younger critics like Dore Ashton and myself—who were favorably disposed toward Abstract Expressionism confronted an art world that was hostile on the whole and a general public that was even more so. In response, we saw ourselves as embattled supporters of advanced art. The public, baffled by the new art's nonrepresentation and seeming lack of form, signs of craft, intelligibility, and meaning, vilified it as demented non-or anti-art. Avant-garde art was often considered nihilistic and Communistic by writers in American newspapers and popular magazines and by powerful politicians. Vanguard art's purpose, they claimed, was to subvert the American way of life. In 1949, an influential Michigan Congressman, George Dondero, proclaimed on the floor of the House of Representatives that the Abstract Expressionists were traitors.

Assaults on modern art were to be expected from so-called philistines but not from presumably knowledgeable art world figures such as Francis Henry Taylor, the director of the Metropolitan

Museum of Art, or Lincoln Kirstein, a member of the Museum of Modern Art's "family." In 1948, Taylor published an article titled "Modern Art and the Dignity of Man" in *Atlantic Monthly,* which attracted widespread public attention because of passages such as this: "Instead of soaring like an eagle through the heavens as did his ancestors and looking down upon the world beneath, the contemporary artist has been reduced to the status of a flat-chested pelican, strutting upon the intellectual wastelands and beaches, content to take whatever nourishment he can from his own too meager breast." Taylor went on to say that contemporary art communicated only to snobs, "an intellectual elite—the fashionably initiated." It was unfathomable to the average public, which had rebelled, in Taylor's opinion, with justification.[2]

In 1948 Kirstein, who was curating an Elie Nadelman show at the Museum of Modern Art, wrote an article in *Harper's Magazine* castigating modern art. He identified himself as belonging to "a new opposition [that] is not conservative [but] reactionary," an opposition that "deplores a basic lack of general culture, historical and scientific, on the part of most of our painters, and their lack of stable technical processes and rational craftsmanship."

Moreover, in 1948, Boston's Institute of Modern Art changed its name to the Institute of Contemporary Art. In a statement titled "'Modern Art' and the American Public," the Institute's director, James S. Plaut, denigrated modern art as a "cult of [bewilderment which] rested on the hazardous foundations of obscurity and negation, and utilized a private, often secret, language" and which had withdrawn "from a common meeting-ground with the public."[4]

On the whole, the mass media were hostile. For example, *Time* dubbed Pollock "Jack the Dripper." In 1948, for a moment, *Life,* America's most popular magazine, treated modern art more or less fairly. In response to public interest in controversial issues, *Life* ran a special feature on modern art, a section of which was devoted to "Young American Extremists." The panel of 15 distinguished art historians, critics, museum directors, and curators dealt with the subject seriously but in the main the writers were critical of Abstract Expressionism.[6]

Then, at the beginning of 1949, *Life* showed its true colors. In a review of the exhibition "Milestones of American Art," titled "Revolt in Boston," the magazine reported that the Institute of Contemporary Art, no longer able to "stomach the word 'modern,'" and in opposition to modern art, featured "the main trends in U.S. art of this century, which are chiefly rooted in native traditions that are romantic and realistic."[7] The magazine's sympathies were obviously with the ICA. Also in 1949, *Life* belittled Pollock in an article subtitled "Is He the Greatest Painter in the United States?" (ironically, an article that made him a household name of sorts). But *Life* had no intention of presenting Pollock as a great painter. The article made stabs at explaining his intentions; nevertheless this did not outweigh the ridicule evident in its caption of a photograph of the artist that read,

"Pollock Drools Enamel Paint on Canvas" or another comment, "After days of brooding and doodling, Pollock decides the painting is finished, a deduction few others are equipped to make." There was also a sneering reference to Pollock's champion Greenberg (without mentioning his name) as "a formidably high-brow critic."[8]

Attacks on Abstract Expressionism continued throughout the 1950s and grew increasingly vituperative, perhaps in response to the growing recognition of Abstract Expressionism. Unregenerate humanists suddenly found new voices, although they were of decreasing interest to the avant-garde art world. They condemned Abstract Expressionism as anti-humanist. In 1953, for example, forty-four "realist" artists, including Milton Avery and Edward Hopper, issued a manifesto in the magazine *Reality*. They berated Abstract Expressionism as intent only on form for its own sake and not as "the means to a larger end, which is the depiction of man and his world," based on "a respect and love for the human qualities in painting." The manifesto asserted that "today, mere textural novelty is being presented by a dominant group of museum officials, dealers, and publicity men as the unique manifestation of the artistic intuition." The "realists" pledged to oppose those who had "produced in the whole world of art an atmosphere of irresponsibility, snobbery, and ignorance."[9]

Attacks within the art world also came from geometric abstractionists and their advocates. For example, in 1959 Sibyl Moholy-Nagy railed against "the hermetic chaos of Abstract Expressionism. [Its] bastardized work [is] born from the combined efforts of spiritual nihilism and commercial promotion. The symptoms of a widespread and altogether explicable mental disease are forced on the public by intimidation and promotion.… Mark Rothko [is] a fraud."[10]

The most vicious abuse appeared in the Nation's most prestigious daily newspapers, written by John Canaday of the *New York Times* and Emily Genauer of the *New York Herald Tribune*. Canaday was appointed the *Times*'s chief art critic in 1959 and immediately began a vendetta against Abstract Expressionism. He condemned not only the paintings but the artists as well, labeling them cheats, freaks, charlatans, greedy lackeys, and senseless dupes. Canaday's reviews so incensed the artists and their allies that they sent the *Times* a letter of denunciation signed by forty-nine art-world luminaries including artists Stuart Davis, Gottlieb, Hofmann, de Kooning, Motherwell, Newman, and David Smith; art critics and historians Robert Rosenblum, Meyer Schapiro, and myself; philosopher William Barrett, poet Edwin Denby, and composer John Cage.

The controversy also had its ironies. In the *Times*, Canaday called himself an "embattled critic," the title of a book he later wrote, but his position at the newspaper was enhanced by the mass of letters he received in support.[11] However, Canaday's attack was the last one to command art-world and public attention. By 1961, Abstract Expressionism had become recognized nationally and internationally. It had become the Establishment. The proof of this was the list of distinguished names

attached to the protest letter to the *Times*. Attempts to consider the new American painting as radical had lost credibility.

Formalist criticism and its limitations

During the 1940s, the thinking of Greenberg and Rosenberg, the two leading critics of Abstract Expressionism, was defined by momentous social and political events, notably World War II and the cold war, however, the two critics responded to these conflicts in divergent, even antithetical ways. Rosenberg believed that Abstract Expressionism embodied the mood engendered by these global conflicts, and he tried to characterize it, whereas Greenberg refused to relate the new American painting to its social context and adopted a formalist approach.

Like many other American intellectuals of the 1930s and early 1940s, Greenberg was a Marxist who looked forward to a socialist society. However, he recognized the improbability of a revolution that would usher in a brave new world. Recoiling from the chaotic world situation, he chose to disregard social and political issues in his criticism and retreated into art's autonomous realm, dealing exclusively with its aesthetic aspects. In a major article of 1955 surveying the new American painting, his only mention of World War II was, "What turned out to be another advantage was this country's [the United States] distance from the war and as immediately important as anything else, the presence in it during the war years of European artists like Mondrian, Masson, Léger, Chagall, Ernst, and Lipchitz, along with a number of European critics, dealers, and collectors."[12] All of this was true but relatively inconsequential in the face of a global war.

Greenberg maintained that feeling was everything in art, but he did not specify how it was manifest. Instead, he developed the hypothesis that art that aspired to be Modernist or avant-garde had to entrench itself within its own sphere rigorously, or as he put it, self-critically. He claimed that the "unique and proper area of competence in each art coincided with all that was unique in the nature of its medium. Thus would each art be rendered pure." It followed that to be Modernist, each of the arts had to purge "any and every effect that might be conceivably borrowed from or by the medium of any other art."[13] Painting, for example, was defined primarily by its flatness; hence, it had to be purified of all illusionistic and sculptural effects. Subject matter, which—for Greenberg—belonged in the province of literature, also had to be eliminated. Consequently, painting was required to "confine itself to the disposition pure and simple of color and line, and not intrigue us by associations with things we can experience more authentically elsewhere."[14]

Greenberg also claimed that each avant-garde style flourished for a time, and then became exhausted, leaving new formal problems to be confronted and solved by the succeeding avant-garde. He treated art history as evolutionary, one style leading to another as a matter of course. Different

though the new styles were from their antecedents, they nonetheless preserved and continued tradition. Greenberg wrote that the Abstract Expressionists dismantled tradition not "for sheer revolutionary effect, but in order to maintain the level and vitality of art under the steadily changing circumstances of the last hundred years—and that the dismantling has its own continuity and tradition." In short, the vanguard artists were "in pursuit of qualities analogous to those they admire in the art of the past."[15] As a consequence, they looked to the past for inspiration and guidance. Because of this, formalist art criticism tended to be history-minded.

In 1947, at the onset of the cold war, as if recoiling from disastrous world events, Greenberg called for Modernist artists to develop "a bland, large, balanced, Apollonian art ... in which an intense detachment informs all. Only such an art, resting on rationality ... can adequately answer contemporary life, found our sensibilities, and, by continuing and vicariously relieving them, remunerate us for those particular and necessary frustrations that ensue from living in the present moment in the history of western civilization."[16]

So committed was Greenberg to a rational and hedonistic art that in 1947 he criticized Pollock's painting, even though he admired it above all other Abstract Expressionist work, for its "Gothic-ness ... paranoia and resentment" and lack of breadth.[17]

On the whole, the Abstract Expressionists had little sympathy for Greenberg's formalist perspective. Their overriding interest was in the content of painting. In 1943, Gottlieb and Rothko wrote a letter to the *New York Times,* in which they stated, "It is a widely accepted notion among painters that it does not matter what one paints so long as it is well painted.... This is the essence of academicism.... There is no such thing as good painting about nothing."[18] Or, as Motherwell wrote, "Nothing could be more erroneous than the notion that modern art, in its abstraction, represents some kind of 'formalism.' [The] originality of forms in modern art is owing to its 'contentism'— from its emphasis on experience. [In] its intensity and immediacy, [it] is 'abstract' only in the sense that it is stripped bare of anything which might dilute its immediacy."[19] It is significant that when Rothko, Motherwell, Baziotes, and David Hare founded a school in 1949, they named it, at Newman's suggestion, the "Subjects of the Artist," implying that their concern was with meaning, not with the mechanics of painting or solving formal problems.

The Abstract Expressionists also rejected Greenberg's conception of Modernist art history as a seamless progression. As the painters viewed it, lost in all of Greenberg's begat-begat-begats was the rupture with tradition that their art represented. They believed that they were not following predestined developments but were taking risks in their art. With the exception of Hofmann, they also disavowed Greenberg's demand that art should be pleasurable and rational or Apollonian, and that

anxiety, alienation, and malaise should be suppressed. Instead, the leading Abstract Expressionists confronted the dreadful and tragic aspects of their experience and sought to express them.

Just as Greenberg's idea of art and its development was formalist, so was his conception of art criticism's function. He asserted that art writing should confine itself to analyzing the formal components of art and detailing their art-historical references. Greenberg claimed that nonformalist interpretations are too indeterminate to be dealt with in criticism. I disagree, of course, and maintain that art criticism can consider, indeed must consider, the emotional, as well as the moral, social, and psychological aspects of painting—if they can be identified in the work of art and hence be made communicable to others. If art criticism refuses to deal with the extra-aesthetic content of art—or at least of Abstract Expressionism—its expressive powers, whether tragic or lyrical, ironic or comedic—it misses the point. Above all, I reject Greenberg's assertion that "all paintings of Quality ask to be looked at rather than read."[20]

To be sure, I am aware that the quest to make sense of painting has pitfalls. As David Sylvester, taking his cue from Greenberg, is alleged to have said, "If one looks at anything with the intention of trying to discover what it means, one ends up no longer looking at the thing itself."[21] But I would ask: Why give anything more than a glance if it does not mean anything, and if it does, why not try to make sense of it—or its varied meanings? Because art, if it is of any consequence, does have multiple layers of significance. It strikes me as precious to assert that you cannot engage in a search for content while responding to aesthetic qualities. Surely one can use one's head while one looks, or as Robert Storr put it, one can "Think with the Senses [and] Feel with the Mind."[22] Yet, in the end, as A. N. Whitehead remarked "We experience more than we can analyze."

"Anything that has to do with an action"

Harold Rosenberg emerged as a major advocate of Abstract Expressionism a half decade after Clement Greenberg, but he soon rivaled him in reputation. In contrast to Greenberg's refusal to consider the hot and cold wars of the forties, Rosenberg, as we have seen earlier, confronted what he termed a "crisis," which he claimed had overwhelmed culture, made existing artistic styles irrelevant, and shaped the work of the contemporary avant-garde. (Like Rosenberg, I lived through the 1940s. My own experience at the time made me sympathetic to his point of view, an attitude I retain to this day.)

In his seminal essay, "The American Action Painters" (1952), Rosenberg argued that, confronted with the ongoing global situation, artists he labeled Action painters were relying on the improvisational process of painting and were striving to express their subjective experiences, which were shaped by social pressures. Rosenberg maintained that the anxious and tragic mood of the time was

filtering through Action Painting, whose raw marks were everywhere visible in the work. He wrote, "At a certain moment the canvas began to appear to one American painter after another as an arena in which to act—rather than as a space in which to reproduce, re-design, analyze or 'express' an object, actual or imagined. What was to go on the canvas was not a picture but an event…. The big moment came when it was decided to paint … just to PAINT."[23]

In a kind of Existentialist scenario, the Action painter began a picture with nothingness. Then, in an unpremeditated dialogue with the canvas, he painted—the movement of the brush dictated by what Vasily Kandinsky termed "inner necessity" until an authentic image was encountered. When no other stroke was required, the picture was completed. Working with no final image in mind and confronted with innumerable options in painting, choosing *felt* gestures was fraught with anxiety. Action painters were tormented by perpetual doubt. Indeed, they made this a virtue.[24] In sum, Rosenberg conceived of Action Painting as an urgent existential struggle for self-definition in pursuit of self-transformation.

Rosenberg insisted that "nothing get in the way of the act of painting…. What matters always is the revelation contained in the act."[25] In emphasizing single-mindedly the unpremeditated process of painting as the mainspring of Action Painting, Rosenberg maintained that the artists had jettisoned tradition. As he saw it, tradition asserted that an artist's important thinking had been done in advance of his own painting. That is, artists who looked primarily to tradition set out to work in established styles whose attributes were known and defined.[26] Their aim was to fabricate images rather than to *encounter* them in the process of painting.

Because of the rejection of known styles, Action Painting marked an unprecedented break with art that had come before. The artists, however, would not go as far as Rosenberg did. They agreed with him that Action Painting was a radical departure in the history of art and had deflected art in new directions, but they insisted that it had antecedents in modern art and therefore had a traditional aspect. As Robert Goldwater observed, the artists "were the very conscious heirs of a century of artistic change," tending to single out artists such as van Gogh and Soutine, who were angst ridden and alienated in their own time.[27]

Rosenberg claimed that the Action painters dispensed not only with references to past art but with ideas of "form, color, composition, drawing," which distorted the direct experience of painting. Indeed, he focused so unconditionally on improvisational painting as an event that he turned a blind eye to the completed work of art. The artists agreed with Rosenberg that painting should be more than mere picture making, that they should avoid fixed and habitual patterns, standards, and ideas, and that they should continually venture into the unknown.[28] Like Rosenberg, they valued existential struggle and reviled artistic performance. Painting meant more to them than formal manipulation;

its purpose was emotional discovery and the forging of artistic identity, which involved liberating themselves of received aesthetic ideas. Nevertheless, the artists maintained that it was impossible to ignore formal values, or to begin a canvas with "nothingness," or to shut out knowledge and memories of past and existing art, particularly the artist's own.

In short, the artists asserted that Rosenberg had carried the idea of Action Painting to an untenable extreme and had misstated how they actually worked.

As for the role of art criticism, according to Rosenberg, it needed to deal with "anything that has to do with action—psychology, history, mythology, hero worship." And he concluded with a jab at Greenberg: "Anything but art criticism."[29] As an art critic putting down art criticism, Rosenberg was probably being ironic. If not, his notion that art critics should, even if they could, suppress knowledge of art critical and historical discourse was misguided.

"A wide-awake existentialism"

Rosenberg's conception of Action Painting was buttressed by Existentialism, which was the philosophy that most engaged the Abstract Expressionists and their critics in the late 1940s and 1950s. A collaborator of Rosenberg on *Possibilities 1,* Motherwell recalled, "[We] often talked about Kierkegaard in whom Harold was then immersed," and which resulted in "an Existentialist attitude and an intense emphasis on individualism."[30] The thinking of Jean-Paul Sartre, Albert Camus, and Maurice Merleau-Ponty had been introduced in the United States in 1946 by articles by Sartre, William Barrett, Hannah Arendt, and Simone de Beauvoir in *Partisan Review* and, a year later, by articles and news stories in the *New York Times.* In 1947, Barrett's *What Is Existentialism* and Camus's *The Stranger* were published, and Sartre's plays *No Exit* and *The Flies* were staged in New York.

Barrett was the leading American advocate of Existentialism. A friend of many avant-garde artists, he was invited to lecture at The Club. He wrote that central to Existentialism was the idea that life was absurd because individuals were doomed to inevitable death. Consequently, the human condition was fraught with "alienation and estrangement; a sense of the basic fragility and contingency of human life; the impotence of reason confronted with the depths of existence; the threat of Nothingness, and the solitary and unsheltered condition of the individual before this threat."[31] No wonder that Existentialism, like the new American painting, was spawned by World War II. However, in the face of the meaninglessness of existence, individuals were compelled to find meaning in their own lives by making their own "selves." Moreover, they would do so with the good of humankind in mind, this adding a social and moral dimension to Existentialism. In short, Existentialism stressed the struggle of individuals to realize themselves with utter honesty, which is what the artists believed they were doing in their painting.

Existentialist angst and alienation supplanted Marxist class struggle and Freudian psychology as the relevant issues for artists in the late 1940s and 1950s, and Existentialist terminology threaded through their conversations and statements, and through the criticism of art writers. The political activist's soapbox and the analyst's couch were passé. I once asked de Kooning about Existentialism's influence. He replied, "It was in the air. Without knowing too much about it, we were in touch with the mood. I read the books, but if I hadn't I would probably be the same kind of painter. I live in my world."[32] Elsewhere he said, "There may be no answer in the end…. You keep searching, you want to live, so you keep painting it, but in the end you die and that's a sort of failure. Existentialism—I agree with it very much."[33] Abstract Expressionist painter James Brooks concurred: "I'm sure Pollock wasn't directly influenced by the writings of Sartre and various other existentialists, but he felt the same need very strongly at the time. And many other people did also."[34]

In a talk before an audience of avant-garde artists at The Club, Nicolas Calas, a champion of Surrealism, whose rhetoric was rooted in psychoanalysis, said that Surrealism died because dreams died. "We now live in a world of anxiety and insomnia. That requires a wide-awake Existentialism."[35] Even Greenberg recognized the significance of Existentialism, although he chose not to introduce its concepts or attitude into his art criticism: "What we have to do with here is an historical mood that has simply seized upon Existentialism to formulate and justify itself, but which had been gathering strength long before most of the people concerned had ever read Heidegger or Kierkegaard…. Whatever the affectations and philosophical sketchiness of Existentialism, it is esthetically appropriate to our age…. What we have to do with here, I repeat, is not so much a philosophy as a mood."[36]

A number of Existentialist premises were anticipated by the Pragmatism of John Dewey and William James, which had been disseminated not only in scholarly journals but in popular newspapers and magazines. Dewey's philosophy was widely known and highly regarded in the 1930s.[37] Motherwell called his *Art and Experience* "one of my early bibles." He was impressed by Dewey's belief that it was only "in acting—confronted with obstacles, compelled to make choices, and concerned to give form to experience—is man's being realized and discovered."[38]

Dewey's ideas anticipated Rosenberg's thinking of art as an intensified slice of life or "event" and Greenberg's concept of art as an "autonomous object." For Dewey, these contrasting concepts existed in a dialectical tension, which he tried to bridge without success.[39] Rosenberg and Greenberg, for their part, did not even try.

Art critics at war

Disagreeing as they did, Greenberg and Rosenberg waged an ongoing critical war against each other, an unrelenting verbal combat that continued into the 1960s and engaged the art world. Rosenberg attacked Greenberg for refusing to acknowledge avant-garde art as a disruptive force:

> To forget the crisis, individual, social, esthetic, that brought Action Painting into being, or to bury it out of sight … is to distort fantastically the reality of postwar American art. This distortion is being practiced daily by all who have an interest in "normalizing" vanguard art, so that they may enjoy its fruits in comfort.… But the net effect of deleting from art the artist's situation, his conclusions about it, and his enactment of it in his work is to substitute for the crisis-dynamics of contemporary painting and sculpture an arid professionalism.… The history of radical confrontation … is soaked up in paeans of technical variations on pre-Depression schools and masters.… In turn, society is deprived of the self-awareness made possible by … imaginative discontent.[40]

Greenberg rebutted by attacking Rosenberg's preoccupation with extra-aesthetic content and, more specifically, with the artist's action rather than the finished work of art. Greenberg claimed that in refusing to deal with formal values and the role of tradition—indeed, in rejecting them—Rosenberg had put Abstract Expressionism outside art's realm and opened it to attack by its enemies as non-art and even anti-art. Moreover, in an article titled "How Art Writing Earns Its Bad Name" (1962), Greenberg assailed Rosenberg's criticism for its "perversions and distortions of discourse," among them "pseudo-description, pseudo-narrative, pseudo-exposition, pseudo-history, pseudo-philosophy, and worst of all—pseudo-poetry." And consequently, what was even worse in Greenberg's eye, Rosenberg had made Abstract Expressionism look silly.[41]

Rosenberg countered Greenberg's attack by asserting,

> Formal criticism has consistently buried the emotional, moral, social and metaphysical content of modern art under blueprints of "achievements" in handling line, color, and form. Perhaps advancing Gauguin's idea of color or Cézanne's means of construction was what Picasso was "about" in painting "Demoiselles." I doubt, though, that anyone but an art historian would find it "stirring" on that account. "What forces our interest," Picasso has said, "is Cézanne's anxiety"—that's Cézanne's lesson; the torments of van Gogh—that is the actual drama of the man. The rest is sham.[42]

Who won the art critic's war? Rosenberg prevailed in the 1950s, Greenberg in the 1960s. During the fifties, the heyday of Action or Gesture Painting, Rosenberg's ideas appeared more relevant to the art world than Greenberg's. His criticism seemed to inform and to be informed by the leading avant-garde tendency of the decade: the work of de Kooning, Kline, and Guston. Rosenberg would reject new tendencies that did not continue Abstract Expressionism—notably hard-core Pop Art and

Minimalism—and his criticism became increasingly marginalized. Greenberg also renounced Pop Art and Minimalism but embraced stained Color-Field Abstraction and hence retained art-world interest. But, more important, his formalist approach appealed to younger art critics in the 1960s and would dominate art discourse during that decade.

Whose country? Whose culture?

Formalism triumphed over Existentialism because, as the 1950s progressed, the social situation in the United States was changing, and with it Abstract Expressionism and writing about it. World War II was receding into the past, and despite the continuing threat of nuclear devastation and the Korean War, the cold war was becoming less menacing. In the 1950s the mood of disquiet that had pervaded life during the 1940s dissipated. In turn, Abstract Expressionist painting became less angst ridden and more relaxed and lyrical and art criticism followed suit.

The United States may have been the foremost industrial society and the most powerful country in the world, but its citizens remained fearful and anxious about Communist moves toward world domination. As the threat of armed conflict waned, the cold war became a war of words on ideological, political, and cultural grounds between the United States and the Soviet Union as both nations sought to influence the thinking of Western Europe. Faced with a choice between democracy and totalitarianism, many American intellectuals and artists on the left changed their attitude toward the United States.

The approval of American foreign policy by leftist, hitherto dissident intellectuals prompted many to call for a rapprochement with middle-class America. This was the theme for instance, of the 1952 symposium "Our Country and Our Culture," discussed in the last chapter. It was in this context that Greenberg and Rosenberg noted the American-ness of Abstract Expressionism. Greenberg did so in a major essay revealingly titled "'American-Type' Painting," published in 1955. But two years earlier, he was already defining Abstract Expressionism as American: "In Paris they finish and unify the abstract picture in a way that makes it more agreeable to standard taste. [The Abstract Expressionist] vision is tamed in Paris—not, as the French themselves may think, disciplined. The American version is characterized … by a fresher, opener, more immediate surface. [It is] harder to take. Standard taste is offended…. Do I mean that the new American abstract painting is superior on the whole to the French? I do."[44]

In 1954, Rosenberg began to characterize Action Painting as American. In an essay titled "Parable of American Painting," he quoted from J. Hector St. John de Crèvecoeur's "Letters from an American Farmer" of 1782, "The American is a new man who acts on new principles: he must therefore entertain new ideas and form new opinions." Rosenberg pointed out that, despite de Crèvecoeur's assertion,

American art had in the past been dominated by "the British Look of Colonial portraiture, through the Dusseldorf Look, the Neo-Classic Look, down to the Last-Word Look of abstract art today." However, Abstract Expressionists, whose starting points were their own experiences, had "won ascendency in American painting for the first time during World War II."[45]

Rosenberg's and Greenberg's embrace of American values was not unqualified. Both criticized the increasing conformism in the United States, and in particular the burgeoning consumer society and the low-brow and middle-brow kitsch it spawned. Mass culture was bogus, intent only on augmenting profits and indifferent to authentic human and aesthetic values. What was worse, it was threatening to swamp high culture. Greenberg and Rosenberg both regarded Abstract Expressionism as uncontaminated by philistine kitsch or pseudo-art and hence a refuge of genuine art—but for different reasons. Rosenberg called for artists to be true to themselves and create authentic art. Greenberg wanted them to entrench themselves in abstraction on behalf of art-for-art's-sake.

"Angst is dead"[46]

The easing of the crisis mentality in the 1950s had another effect. Most of the older Gesture painters and, even more, their followers, among them Helen Frankenthaler, Joan Mitchell, Grace Hartigan, Alfred Leslie, and Michael Goldberg, felt increasingly free to paint pictures that were lyrical and that referred to American scene, nature, and art history. These painters achieved growing prominence in part because their work was featured in *Art News*, the leading art publication, which had become the New York School's "family" magazine.

As references to angst in art writing lost credibility, other justifications for Gesture Painting were formulated, notably in the essays of Meyer Schapiro and Robert Goldwater, both of them distinguished art historians. With Rosenberg's idea of Action Painting in mind, they now changed its emphasis by pointing to the artists' pleasure in the handling of the painting medium. Schapiro maintained that gestural painting, more than any other contemporary style, stressed spontaneity rather than angst. Goldwater also detected a different spirit, writing, "With certain exceptions (of whom de Kooning is the most obvious) this is a lyric, not an epic art…. Judged by their finished works, … here are artists who like the materials of their art: the texture of paint and the sweep of the brush, the contrast of color and its nuance, the plain fact of the harmonious concatenation of so much of the art's underlying physical basis to be enjoyed as such." Goldwater went on to say that New York painting is generally distinguished by "robustiousness." It features "the dripping paint can, the loaded brush, or the slashing palette knife" but "remains an art of harmonies as well as of contrasts. The over-all effects may be large and strong, but the details are subtle and soft…. It is an art which is as often delicate as it is powerful and indeed the best work is both at once."[47]

Unlike Rosenberg and Greenberg, younger art critics, such as myself, Dore Ashton, Frank O'Hara, James Schuyler, and Robert Rosenblum, avoided doctrinaire formalist or existentialist interpretations. Our criticism responded to the poetic and painterly qualities in fifties Abstract Expressionism and became more subjective and personal.

The influence of John Cage

In the middle 1950s, a number of angst-free tendencies that rerouted Abstract Expressionism or rejected it began to emerge. As new avant-garde styles gained prominence, art critical approaches to Field and Gesture Painting changed. The first of these new tendencies to interest the art world was the urban realism of Robert Rauschenberg and Jasper Johns. Rauschenberg attached junk, mostly found in New York streets, onto his de Kooning-esque combine-paintings, as he called them. In the context of objects, paint itself became a kind of object. Consequently, while extending Gesture Painting's concern with the American environment, he turned the inward-looking outward onto the real world.

Rauschenberg's attitude to Gesture Painting was at once approving and iconoclastic. In 1953, he tried to rub out Abstract Expressionism by asking de Kooning, the painter he most admired, for a drawing and telling him that he meant to erase it. De Kooning gave him one and Rauschenberg rubbed out the sketch, figuratively wiping the slate clean of de Kooning's Gesture Painting and reducing it to the bare surface on which life—by casting shadows, for example—presumably could act.

In 1957, Johns began to exhibit pictures of commonplace objects or signs—flags, targets, numerals, letters—rendered in free brushwork resembling that of Gesture Painting. In actuality, Johns' brushwork was not as impulsive as it looked. It was deliberately "crafted" in a dispassionate manner. His attitude to picture making was related to that of Rauschenberg—notably, two pictures the latter made in 1957. The first, titled *Factum 1,* was a Gesture Painting that included collage components. The second, *Factum 2,* was ostensibly a copy of *Factum 1*. These works by Johns and Rauschenberg subverted Gesture Painting's Existentialist demand that an authentic painting could not be fabricated but had to be found or encountered in the anxious act of painting.

Rauschenberg's and Johns' works were informed by the thinking of John Cage. The purpose of art, as Cage viewed it, was to open up one's eyes to just seeing what there was to see, and one's ears to just attending to sounds.[48] He rejected any hierarchy of sounds in music or of materials, forms and colors in the visual arts. Each element, as it occurred, was to exist only for itself, allowed to come into its own rather than being exploited to express emotions or formal ideas. Consequently, any sound or material, by itself or in any combination, whether intended or not, is art. Noise is music and so is silence, which Cage denied could even exist, because in nature sound is always to be found.

In short, he maintained that art should avoid negative attitudes and make people mindful of their surroundings and induce them to enjoy everyday life. Hence, Cage rejected the Abstract Expressionist demand that the artist's idiosyncratic experience be the primary source of art.

Cage is recognized as a composer of avant-garde music but not as an art critic. Nevertheless, he was arguably the single most influential art theoretician of the second half of the twentieth century. His aesthetic was in direct opposition to both Rosenberg's Existentialism and Greenberg's art-for-art's sake rhetoric and would eclipse both in its influence on the art of the 1950s and 1960s, on the one hand, and, on the other, the subsequent interpretation of Abstract Expressionism.

The rejection of hot painting

Just as Rauschenberg and Johns suppressed angst in their works, so did Morris Louis and Kenneth Noland in their stained Color-Field abstractions, more so than the two urban realists, because they eliminated the artist's hand. Indeed, Louis and Noland rejected all signs of the brushiness associated with the work of de Kooning, Kline, and Guston. Adopting Pollock's technique, Louis and Noland soaked thin paint onto the surface of their pictures. While enhancing the opticality of color, staining revealed the weave of the canvas. The canvas was treated as a field, relating it to Newman's allover abstractions.

Greenberg championed stained Color-Field abstraction. He had favored Pollock's and Newman's painting over de Kooning's, which he put down as passé for being too bound to Cubism, too painterly, too illusionistic, and too suggestive of the human figure. He acclaimed Louis and Noland as the worthy successors of Pollock and Newman. As he viewed it, they had made the necessary next move in Modernist painting and were also the best painters of their generation.

In their rejection of brushiness, Louis and Noland were related to other artists whose work would typify the art of the 1960s, among them the Hard-Edge painters Ellsworth Kelly and Al Held; the Minimalist Frank Stella; the Pop artists Andy Warhol, Roy Lichtenstein, James Rosenquist, and Tom Wesselmann; the New Perceptual Realists Alex Katz and Philip Pearlstein; and the Photo-Realists Malcolm Morley, Richard Estes, and Chuck Close. They all rejected visible indications of the creative process in the finished work as academic and dated. Moreover, they mistrusted claims made for the significance of subjective improvisation as the evidence of the artist's authenticity. In sum, the hot unfinished look of Gesture Painting gave way to finished surfacing that was cool, impassive, and distanced.

Greenberg's progeny

As avant-garde painting in the late 1950s and 1960s became less subjective and thus appeared to become more objective, Greenberg's seemingly factual analysis seemed more in keeping with the new art than Rosenberg's existential approach. In 1961, Greenberg's freshly revised collected essays, published as *Art and Culture,* appeared, and they attracted a new generation of art writers, including Walter Darby Bannard, E. A. Carmean, Michael Fried, Rosalind Krauss, Barbara Rose, William Rubin, and Karen Wilkin, who soon dominated art criticism and the history of modern art. Graduates of elite universities—Harvard, Princeton, and Columbia—the young critics had been schooled in art history and formal analysis. They found Greenberg's appeal to history and science—the twentieth century's two most powerful myths—compelling.[49] Greenberg's formal analysis struck them as empirical, and, if not exactly scientific or objective, at least visually verifiable, compared with the subjective criticism of the 1950s. The young formalists academicized art criticism and Modernist art history by analyzing art-historical precedents and formal minutiae at great length, bolstering their analyses and opinions with weighty footnotes (citing mostly Greenberg and themselves), and favoring dense language. Impressionistic and poetic art writing was scorned.

Following Greenberg's dicta, his young adherents endorsed the stained Color-Field painters and elaborated on his notion that they were Pollock's and Newman's successors. The formalist critics recognized that stained Color-Field painting had turned away from angst, and because it had, they entertained the idea that it was decorative, laudably so, even though decoration had been anathema to Pollock and Newman and their colleagues.[50] Thus, their view of Abstract Expressionism was contrary to that of its innovators.

Greenberg disliked Stella's Minimalist abstraction, but his young followers were attracted to it and to Stella's ideas, which, although they were influenced by Greenberg, were even more extremely formalist. Stella purged all extra-aesthetic references from his painting. He also replaced direct improvisation with preconception. As Bannard wrote, "Abstract Expressionism was repudiated point by point: painting within the drawing replaced drawing with paint; overt regularity replaced apparent randomness; symmetry replaced asymmetrical balancing; flat, depersonalized brushing or open, stained color replaced the smudge, smear and spatter.... The entire visible esthetic of Abstract Expressionism was brutally revised."[51] Stella also challenged every claim that Gesture Painting had extra-aesthetic content. Rejecting all subjective, psychological, and social interpretations, he said, "My painting is based on the fact that only what can be seen there is there.... What you see is what you see."[52] Stella's painting provided the basis of Minimal sculpture, which would command art-world attention in the 1960s and early 1970s.

Philip Leider, the editor of *Artforum,* summed up the change that occurred in avant-garde art at the end of the 1950s: "It would seem surprising if, after a movement as earth-shaking as abstract expressionism, some ideas would not seem to take the form of a reaction. Thus, a hatred of the superfluous, a drive toward compression, a precision of execution … an impeccability of surface, and, still in reaction, a new distance between artist and work of art [achieved], above all, by the precise, enclosed nature of the work, [a] quality of distance, coldness, austerity." Leider then said the new artists felt "that anything less than the most compressed statement is fat, sloppy and boring."[53] So did many young art critics who published in *Artforum,* which was the primary journal of formalist critics and which, because it featured artists who came to prominence in the 1960s, replaced *Art News* as the most relevant art periodical.

Newman tended to be downgraded by critics (with the exception of Greenberg), of his own generation, who preferred Pollock, de Kooning, Kline, and Guston. However, in the late 1960s, both formalist and Minimalist critics elevated Newman's status to that of Pollock. For instance, William Rubin, Director of Painting and Sculpture at the Museum of Modern Art and a Greenbergian, gave pride of place to outsize works by the two artists. Both formalists and Minimalist critics alike were taken with Pollock's and Newman's field organization. However, they differed among themselves in other areas. Formalists focused on Pollock's drip technique as the source of staining, while Minimalists admired it for its emphasis on the sheer materiality of the medium. Minimalist writers hailed Newman's canvases for their spare compositions and their seemingly impersonal unmodulated surfaces. In elevating Newman's painting, formalist and Minimalist art writers altered the pantheon of Abstract Expressionism and consequently its history.

In sum, the young devotees of Greenberg analyzed Abstract Expressionism in formalist and art historical terms that had been rejected by the Abstract Expressionists; they interpreted the work with disregard for the artists' own articulation of their intentions.

All the great modern things

The Pop Art of Andy Warhol, Roy Lichtenstein, James Rosenquist, and Tom Wesselmann, which emerged in 1962, continued Abstract Expressionist engagement with the American scene but stood opposed to its rejection of mass culture, its manner of painting, and its rationale. As Warhol said, "The Pop artists did images that anybody walking down Broadway could understand in a split second—comics, picnic tables, men's trousers, celebrities, shower curtains, refrigerators, Coke bottles—all the great modern things that the Abstract Expressionists tried so hard not to notice at all."[54] Not only did the Pop artists appropriate their subjects from vernacular culture but, they distinguished themselves from the Abstract Expressionists by using mechanistic techniques borrowed from commercial art. Lichtenstein poked fun at the Gesture painters' reliance on the act of painting by

shaping a brush stroke from stenciled dots. Thus, like Rauschenberg and Johns, the Pop artists and their critics called into question the premises of Abstract Expressionism and scoffed at its seriousness.

"Where animals would die"

Not only did avant-garde art and art criticism change at the end of the 1950s but so did the art world. I recall the shock that I and critics and historians of the Abstract Expressionist generation felt when we heard of the sale in 1957 of Pollock's *Autumn Rhythm* to the Metropolitan Museum of Art for the then unthinkable price of $30,000. Nor could my peers have imagined the subsequent development of an ever-growing art market, and the enormous increase in the number of commercial galleries and auctions, as well as sales of art at higher and higher prices. Leading Abstract Expressionists were overtaken by affluence. They made money—loads of it. Artists and art-world professionals became "men of the world," as Allan Kaprow characterized them, many of them enormously celebrated and rich.[55] There emerged a new, affluent art world, and to many young critics who flourished in it, it seemed it had been always thus. It had not.

The Abstract Expressionists in the 1940s, some three dozen in all, barely survived on the fringes of society. As Kline quipped, they "lived where animals would die." Of necessity, they took vows of poverty. In a 1950 article in *The Nation,* the poet, painter, and critic Weldon Kees wrote about how precarious life was for the Abstract Expressionists: "From an economic standpoint the activities of our advanced painters must be regarded as either heroic, mad, or compulsive; they have only an aesthetic justification.… One is continually astounded that art persists at all in the face of so much indifference, failure, and isolation." Kees then noted that van Gogh could write, "'Now it is getting grimmer, colder, emptier, and duller around me,' while insisting that 'surely there will come a change for the better.'"[57] Van Gogh had hope, but Kees was convinced that it was the fate of advanced American artists to have none—and he was not alone in this belief. Shortly before Kees wrote this article, an essay by Antonin Artaud titled "Van Gogh, The Man Suicided by Society" was published in the March 1949 issue of *Tiger's Eye,* a magazine that featured the painting and statements of the avant-garde artists, an indication that van Gogh's art and wretched life and death by suicide was very much on their minds at the time.[58]

I myself think back on the poverty, hardships, and frustrations that the artists I knew had to suffer in the 1940s and most of the 1950s. At the time it was accepted, as Greenberg claimed, that alienation was "the condition under which the true reality of our age is experienced. And the experience of the true reality of our age is indispensable to any ambitious art."[59] On this point Rosenberg agreed with his nemesis but he saw the idea of alienation, so paramount in the thinking of the Abstract Expressionists, no longer engaged younger critics. As he wrote, "To mention anxiety is to

arouse suspicion of nostalgia or of a vested interest in the past, if not a reactionary reversion to the middle-class notion of genius suffering in a garret."[60]

Not only had generational attitudes changed drastically, but as Rosenberg observed in 1966,

> The entire social basis of art is being transformed.... Instead of being, as it used to be, an activity of rebellion, despair or self-indulgence on the fringe of society, art is normalized as a professional activity within society.... No longer does the American artist tend to be a first- or second-generation outsider. [Today, he] has been through a university art department and surveyed the treasures of art through the ages and its majestic status.... Instead of resigning himself to a life of bohemian disorder and frustration, he may now look forward to a career in which the possibilities are limitless. In short, painting is no longer a haven for self-defeating contemplatives, but a glamorous arena in which performers of talent may rival the celebrity of senators or TV stars.[61]

Rosenberg may have overstated the change in the art world, but he was not far off.

The new perspectives on Abstract Expressionism and its history are explicit in Michael Leja's study of 1993. He wrote, "Abstract Expressionism comes to seem alien to viewers and commentators. [Its] premises are no longer tenable. To be creditable, new historians would have to exhibit a much more profound realization of the art's untraversable distance from us and of the inability of its categories—of self, spirit, and authenticity, for example—to compel empathetic identification."[62] Kim Levin, another younger art writer, concurred. In 1974, she wrote that "suffering is no longer fashionable. [The] soul-bearing emotionalism, along with the belief in inspiration and passion and spontaneity, is … alien today."[63]

Contributing to Leja's and Levin's alienation from Abstract Expressionism were most certainly the self-aggrandizing statements made by a few Abstract Expressionists about their intentions and achievements. These assertions struck young scholars as pretentious and no longer believable (not that they had been when first made). Clyfford Still, for example, had said, "I held it imperative to evolve an instrument of thought which would aid in cutting through all cultural opiates, past and present, so that a direct, immediate, and truly free vision could be achieved, and an idea be revealed with clarity.... Therefore, let no man under-value the implications of this work or its power for life; or for death, if it is misused."[64]

The art critic Peter Schjeldahl recognized that Abstract Expressionist rhetoric was often off putting to later historians, and that this made them suspicious of all statements of the artists' intentions. He called for young writers to be empathetic. With respect to Rothko's claim that his art aspired to be tragic and sublime, he wrote in 1979 that "one can experience the sensation of belief, of 'confidence in the truth or existence of something not immediately susceptible to rigorous proof.'" This

was "a major bet of Rothko's as of much other modern art. It is not, one must add, a feature of much sophisticated art today." Schjeldahl went on to say that "in our increasingly skeptical age, the word 'tragic,' a touchstone for Rothko and his earlier critics, has been practically abolished, except as a synonym for lamentable." Schjeldahl concluded, "It would be more than a shame, however, to let our understandable present cynicism be made retroactive, denigrating great work created at the last high tide of artistic faith, roughly the decade around 1950. It's not piety I'm recommending, just a decent respect for values that, though perhaps we can't share them, are responsible for an extraordinary legacy. For it is the pressure of the values that creates the intensity of the work, and to assume otherwise is to have no comprehension of how art actually happens."[65] As Schjeldahl saw it, Abstract Expressionist painting could still strike a more recently sympathetic viewer as "transcendent." Sadly, however, as art historian John Davis remarked, the "fundamental belief in the power of art to transcend, on occasion, the limitations inherent in its production [is] an affirmative statement in somewhat short supply these days."[66] And this attitude has shaped the interpretation of Abstract Expressionism.

Instead of dealing with transcendence, much of the art history of younger scholars is shot through with irony. A remark by Robert Hughes is a case in point. Clyfford Still, in all seriousness , said, "I made it clear that a single stroke of paint, backed by work and a mind that understood its potency and implications, could restore to man the freedom lost in twenty centuries of apology and devices for subjugation."[67] To which Robert Hughes quipped, "Some brushstroke."[68] Ironists do not comprise a receptive audience for Abstract Expressionist painting and its fervent rhetoric. Indeed, when irony is fashionable, high seriousness seems alien—even laughable.

To be sure, a number of younger scholars have exercised their historical imagination to recover what my generation felt, and have introduced fresh and relevant insights and approaches into the history of Abstract Expressionism. Nonetheless, as for myself, in reading the interpretations of younger scholars I often suffer pangs of estrangement. Their accounts of the mood and sensibility of the 1940s, and of artists I have known and events I have witnessed—or that had been recounted to me by artists who had—do not conform to my memories. This is exacerbated when younger art writers use the moral and political biases of their own time to evaluate Abstract Expressionism, and all too frequently to condemn its perceived shortcomings and vices. The past is not dealt with for what it was but is interpreted according to the prejudices of the later time. I also find questionable their often-made claim that distance from the events under consideration has made later analyses more objective than earlier interpretations. As I view it, historic distance merely makes the newer studies different, dependent on the differing needs, desires, and perceptions of the historians and their constituencies. I recognize that scholars of every stripe have the right to bring to art their own predilections and appetites. In any significant work of art there are always levels of meaning, and in

the end, there will invariably be something "more" or "other" that will escape any art critical, art historical, cultural, or historical interpretation that tries to pin it down, my own or anyone else's. As painter Al Held observed, "Attitudes about art keep changing and Pollock's paintings [for instance] seem to be able to absorb them," to which I would add, so do those of other Abstract Expressionists.[69] Nonetheless, I would like to examine what I consider several misleading biases that have influenced the analysis of Abstract Expressionism.

Vietnam and the new art history

In the late 1960s, the Vietnam War changed the course of the analysis of Abstract Expressionism. The interminable "bad" war cast a pall over the outlook of the art critics and historians who emerged at the time. This attitude was exacerbated by the assassinations of Robert Kennedy and Martin Luther King, the urban riots, student revolts, and the Watergate scandal. Consequently, most art writers no longer had the same image of the United States as that viewed by of my generation. Our war was the "good" World War II. For us, it was a noble cause in which America's armed forces—composed primarily of "civilian" soldiers who were drafted and served without question—defeated German Nazism, Italian fascism, and Japanese imperialism. However, much as we gloried in our victory, we were also anxiously aware of the precarious world situation.

The sensibility of scholars outraged by Vietnam was radically different from ours. To us, patriotism was habitual; to them, it was an illusory sham. They took to the streets to protest the war and went to great lengths to avoid serving in the armed forces, even ridiculing those who did. In the forties and fifties, we felt that Picasso's *Guernica* was a telling commentary on war and fascism. In 1967, Joseph Masheck dismissed the mural, asserting that it records "the kind of war where heroism and mercy, virtue and glory, are possibilities quite as actual as suffering and death." Vietnam changed this. Masheck went on to say that "we are also a different audience now, accustomed only to new-style wars.… Consequently, the Grand Manner treatment which [the disaster of war] receives in *Guernica* … is tiring; it is so profoundly un-cool."[70]

It is noteworthy that American historians were also divided by generation. In the 1940s and 1950s, the United States was generally presented by scholars as the greatest country in the world, invariably altruistic, and the epitome of democracy, freedom, and technological progress. In the 1960s and 1970s historians found a great deal to censure in America's past, little to commend. American history was a chronicle of ruthless exploitation of the weak and underprivileged. This attitude has led some scholars of the Vietnam era to look askance at Abstract Expressionism because of statements that it was so strongly identified as American.

As the Vietnam War intensified in the second half of the 1960s, the influence of Greenberg, Rosenberg, and Cage declined. Growing numbers of critics and historians began once more to deal with content, but now from the perspectives of feminism, Marxism, history (rather than art history), sociology, psychoanalysis, semiology, and linguistics. (Ironically, as Greenberg's influence waned, he assumed renewed importance as the esteemed target of the new art theorists.) These various methodologies were collectively subsumed under the label Postmodernism. To promote the new approaches, a group of dissident art writers founded the New Art Association at the height of the Vietnam War, in 1970. Its members adopted art historical alternatives to those of the traditional historians who controlled the College Art Association. Despite their differences, Postmodernists were agreed in scorning formalism. Instead, they analyzed the extra-aesthetic social and political background of art, and, especially, the role of the art world, notably museums, collectors, and the art market, in the production and consumption of art. That is, they investigated how the social order is represented and endorsed by art, by the institutions of art, and by art history itself.[71]

The new art historians tended to use art primarily to illustrate historical, sociopolitical, and art-theoretical propositions. Much of what they wrote had little if any relationship to the initial impulses that had brought the art into being. More often than not, these scholars overlooked both the expressiveness and the aesthetic quality of art. This failing was pointed out by Charles Harrison, a new historian. He wrote that "the most interesting and difficult thing about the best works of art is that they are so good, and that we don't know why or how (though we may know much else about them). [Unless] we can somehow acknowledge the great importance of this limit on our explanatory systems, we might as well give up. What would it be like? I suspect that it would be like becoming a social anthropologist."[72]

Neo-Marxism

To varying degrees, Rosenberg, Greenberg, and Schapiro had used aspects of Marxist dogma in their interpretation of avant-garde painting. Greenberg applied the notion of historical determinism to the history of Modernist art and concluded that Abstract Expressionism was Modernism's latest stage. Rosenberg applied the idea of praxis or action to Gesture Painting, focusing on the artist's creative process. Schapiro used the concept of unalienated labor to commend Abstract Expressionist painting as an antidote to mass culture and the growing conformity in American life.

Neo-Marxist art historians, among them T. J. Clark, Michael Leja, Serge Guilbaut, and Nancy Jachec, had little use for their elders' ideas and advocacy of Abstract Expressionism. Instead, they treated the work as the handmaiden of American capitalism, a notion that was utterly alien to the painters themselves and to their critics. Clark, for example, wrote that Pollock's poured paintings of 1947-1950 were created and have since been recognized, because their spontaneity was what "the

culture wants represented now, wants to make use of, because capitalism at a certain stage of its development needs a more convincing account of the bodily, the sensual, the 'free' in order to extend—perhaps to perfect—its colonization of everyday life."[73] It is not clear whether Clark meant that Pollock dripped pigment because of what Capitalism needed—that is, because he was in its grip or took dictation from it—or that what he painted could be used by Capitalism. Either way, Clark turned Pollock into an agent of an abstract but incongruously personalized entity named "Capitalism." Clark did not recognize Pollock as a real person in the art world and in American society who created pictures because of his complex, personal needs and desires, or that his pictures were responded to by real viewers for their own complex, personal reasons.

Serge Guilbaut was even more reductive than Clark in his interpretation of Abstract Expressionism, and far more negative. In his book *How New York Stole the Idea of Modern Art,* published in 1983, he accused the artists of producing pictures that were the aesthetic counterparts of American economic and military might at a time when the United States was the most powerful nation in the world and engaged in a cold war. Overlooking the poverty, alienation, and neglect of the artists by the art establishment, even the Museum of Modern Art, not to speak of the general public, he viewed the works as assertions of American artistic—and, by implication, political—global hegemony. He branded the avant-garde Americans triumphalists and cultural cold warriors. He maintained, moreover, that they achieved success not so much because of the expressive power of their art, but because they met "the ideological need of the powerful"—that is, the ruling Capitalist class.[74] (See Chapter 5 for a fuller discussion of Guilbaut's thesis.)

Ten years later, in *Reframing Abstract Expressionism: Subjectivity and Painting in the 1940s,* Michael Leja offered a subtler analysis than Guilbaut's. Describing as mistaken the two dominant views of Abstract Expressionism—a weapon of United States' cultural imperialism or as a sheer aesthetic achievement—he suggested that Abstract Expressionist paintings should be viewed not in terms of their reception but in terms of their production.[75] Leja rejected the idea that artists are mere pawns of political powers. Rather, they are agents who can make decisions, which, though shaped by existing ideologies, can also shape them.

Central to Leja's theory was the idea that "Modernity is defined by catastrophe." This led him to formulate what he termed the "Modern Man discourse," which focused on "primitive impulses and unconscious drives in man [that] functioned to [psychologize] the violence and brutality of modern experience." Reading Leja's book, I found much to agree with in his analysis, until he lapsed into neo-Marxism, claiming that the concern with individual psychology shifted "responsibility away from the political and economic orders and the nationalism, imperialism, and authoritarianism of those orders." He concluded that the function of the Modern Man discourse, with its emphasis on the primitive and the unconscious, was to rescue the dominant Capitalist ideology.[76] In his view, this was

the role played by Abstract Expressionism, which as "an art of tragedy or terror disguises the conditions of authoritarian domination, [and hence] is a tool of bourgeois ideology." Indeed, Abstract Expressionist painting "is a powerful factor … in legitimating prevailing power relations," and this contributed to its recognition and monetary success. By the same token, Leja maintained, the politically subversive transgressions of Philip Evergood and Ben Shahn caused their painting to be marginalized—this and not their overly obvious, outworn, and academic Social Realism.[77] In the end, sociopolitical issues were uppermost in Leja's interpretation.

That the Abstract Expressionists lived in a Capitalist society (as did their audience) is a given, but they did not have any political agenda, certainly not the preservation or advancement of the existing social order. On the whole, the artists mistrusted ideologies and did not seem particularly interested in specific political or social causes. It is noteworthy that discussion of politics was taboo at The Club. Having talked at length to all but four of the avant-garde painters—the exceptions were Gorky, Still, Pollock, and Tomlin—and to close friends of those I did not meet, I can attest that most were on the left politically but they rarely cared enough to talk about it or do much in the way of political activism.

Politics, however, did engage historians such as Guilbaut in his book on Abstract Expressionism and the cold war, and Nancy Jachec in her *The Philosophy and Politics of Abstract Expressionism* (2000). Guilbaut and Jachec assumed that politics directly influences art-making, which results in formulations like this by Jachec: "Thus, what appeared to be in stylistic terms a move toward complete abstraction and formal reduction was, *for the artists* involved, the development of an explicitly political art that redefined the role of the socialist agent as critical as opposed to party political, willfully alienated from mainstream society, and utopian in his or her outlook."[78] (my italics).

If the Abstract Expressionists had spent as much time reading *Partisan Review* and the writing of Adorno, Horkheimer, Schlesinger, MacDonald, or Merleau-Ponty, as Guilbaut and Jachec imply, they might have ended up as professors at the New School for Social Research, but they wouldn't have had much time to paint. In fact, only Motherwell, and to a lesser extent Reinhardt, followed (or seemed to follow) the convolutions of leftist and liberal politics.

The antiformalist humanists

Like the Neo-Marxists, other art historians of the 1980s and 1990s, among them Stephen Polcari, Michael Zakian, and David Craven, rejected a formalist approach. They advanced a humanist interpretation of the new American painting. However, unlike earlier humanists, such as Lincoln Kirstein, who had condemned Abstract Expressionism, they were sympathetic to it. *In Abstract Expressionism and the Modern Experience* (1991), Polcari rightly took the impact of World War II

and the cold war into account, although he did not view the artists' work as a tragic response to calamitous events. Instead, he presented it as an affirmation and regeneration of Western life. "'Overcoming nihilism,' to use Nietzsche's phrase, was the task the Abstract Expressionists generally set for themselves," Polcari wrote, and "Abstract Expressionism both diagnosed the inner crisis of its world and proposed to heal its manifestations in the mind, spirit, and behavior."[79] Zakian was even less inclined than Polcari to consider the dark mood of the forties. In a lengthy article titled "Barnett Newman and the Sublime" (1988), he focused on Newman's "humanism" and disregarded his preoccupation with terror.

Craven's *Abstract Expressionism as Cultural Critique: Dissent During the McCarthy Period* (1999) mixed humanism and neo-Marxism. He wrote,

> [The Abstract Expressionists] attempted to reintegrate humanity with nature, to reground art in more "spontaneous" human terms, and to recommence the construction of society along more equitable, disalienated lines, as part of their drive to create an "art of the Americas."

> Significantly, much of this work addresses such themes as elemental natural forces, social genesis, precapitalist artisanal traditions, and precepts of liberation theology, thus conveying the classic avant-garde desire for a clean cultural slate from which to start social development anew and in a different direction than that which produced the present.[81]

As in the case of Polcari and Zakian, Craven attributed intentions to the Abstract Expressionists that they did not claim to have.

Psychological self-portraiture

Abstract Expressionism has also been interpreted in psychological terms by a few critics, most notably Donald Kuspit and Francis O'Connor.[82] The artists themselves believed that their paintings revealed aspects of their personalities and temperaments, what Robert Storr called "a kind of psychological self-portraiture."[83] Thomas Hess who was close to so many Abstract Expressionists, observed that in that era, "It has been a rule for creative performance to be a phase in a rhythm of confusion, misery, letting go, even self-destruction—as the formula of Thomas Mann had it, of sickness, at once moral and physical. The lives of many, perhaps the majority, of the leading Action Painters have followed this disastrous rhythm from which creation is often inseparable."[84]

A team of psychoanalysts, using published material, analyzed fifteen leading Abstract Expressionist painters (as well as the sculptor David Smith) and concluded that more than half of the artists were neurotic and possibly psychotic.[85] However, the therapists must have or should have known that conclusions about the psychological states of the Abstract Expressionists were impossible to

draw because of the paucity of data about their inner lives. Even recent massive biographies of Pollock, de Kooning, and Gorky could not redress this lack.[86] In sum, psychological interpretations of Abstract Expressionist paintings have failed to convince. However, on the basis of their painting, it could be said that the artists were exemplifying the mental state of the time. As psychotherapist Rollo May wrote in his widely read *Man's Search for Himself* (1953), the 1940s and 1950s were "more anxiety-ridden than any period since the breakdown of the Middle Ages." The prophets, May went on to say, were Søren Kierkegaard, Friedrich Nietzsche, and Franz Kafka.[87]

No more heroes

One of the chief aims of Postmodernist theorists was to tear down Modernism. They attacked the lofty idea of the artist as a genius and hero, which had been accepted without question by the Abstract Expressionist generation, and castigated it as a pretentious myth, a Modernist invention, a form of intellectual imperialism, a fictitious ideological construct, and a manipulative illusion. A primary target of these critiques was the Abstract Expressionist painter.

Critical theorists denied that certain artists were so superior that their art, while rooted in its time and place, could be transcendent. A simple refutation of their claim is the very works of certain artists: Pollock's *Autumn Rhythm* and de Kooning's *Excavation* come to mind. What makes artists such as Pollock and de Kooning great is that they singlehandedly created unprecedented works of art that could not have been predicted in advance, that leap beyond existing artistic tendencies, and that would not have occurred without the painters' creative activity.

I consider Pollock, Still, de Kooning, Guston, Rothko, Kline, Reinhardt, and Newman to have been great artists, who heroically defied existing conventions and restraints and created painting of singular significance. At their most profound, they were the kinds of artists that Renato Poggioli characterized as "victim-heroes," who, "dominated by a sense of imminent catastrophe [strove] to transform the catastrophe into a miracle." They embraced "sacrifice and consecration [with] hyperbolic passion, a bow bent toward the impossible, a paradoxical and positive form of spiritual defeatism."[90]

"A macho, sexist game"

However, in the 1970s, this was not the view of feminists, who were particularly forceful in knocking down the artist-as-genius-and-hero concept, because that artist was generally presumed to be male. Feminists viewed claims to genius and heroism as male chauvinist attempts to divert attention from the achievements of women—that is, to dismiss their art as minor. Lynda Benglis put down Abstract Expressionism as a "heroic … macho, sexist game."[91] Benglis' charge was understandable.

Many Abstract Expressionists were sexist, and they frequently demeaned their female colleagues because of their gender; it was considered a compliment to tell a woman that she painted as well as a man. Although this was deplorable, it should be remembered that the cult of masculinity held sway in every aspect of American life during the post–World War II 1940s and 1950s. The machismo may have been even more intense in the art world, because male artists were reacting against the stereotype of the artist as a sissy, what David Craven termed "the stigma of effeminacy."[92]

The he-man stance of the Abstract Expressionists (much as it was shot through with anxiety) may have prompted them to enlarge their canvases and to shun decoration and elegance. It also led, if inadvertently, to the marginalization of the lyrical paintings of male first-generation Abstract Expressionists such as Hofmann, Tomlin, James Brooks, Esteban Vicente, and Jack Tworkov, even though they were not pigeon-holed as feminine. Not until well into the 1950s did they receive recognition along with leading second-generation women artists, such as Joan Mitchell, Grace Hartigan, and Helen Frankenthaler.

Put off by the absence of women as well as persons of color and homosexuals from the Abstract Expressionist canon, Ann Eden Gibson featured allegedly neglected artists in her book *Abstract Expressionism: Other Politics* (1997). She acknowledged that the Abstract Expressionists constituted a group, but asked why, in the words of Lee Krasner, "there was not room for a woman."[93] As Gibson viewed it, the answer was because of their gender, and in the case of African-Americans and homosexuals, because of their race or sexual orientation.

I am sympathetic to Gibson's attempt to expand the Abstract Expressionist canon, but I find her thesis flawed by the inclusion of too many artists who had little if any relationship to the painters now recognized as the first-generation Abstract Expressionists. In actuality, the latter chose themselves because of what they considered shared stylistic common denominators. They also established a hierarchy, with Pollock, Still, de Kooning, Rothko, and, later, Guston and Newman, preeminent. Other artists who were initially included with the Abstract Expressionists—for example, artists in the "The Irascibles" photograph Jimmy Ernst and Hedda Sterne (the only woman)—were later down graded because their work was too different from that of the self-designated Abstract Expressionists.

Gibson implied that any picture executed in the 1940s and 1950s that looks expressionist or painterly in any way or was merely executed at the time should be classified as Abstract Expressionist. This is simply off the mark. With some exceptions, the dozens of artists Gibson dealt with were unrelated to the innovators because of differences in their styles, attitudes, medium (she included sculpture and photography), ages, and dates of entry into the art world, not to mention originality and quality. Among the inappropriate artists are social realist Rose Piper, sculptors Louise Bourgeois

and Louise Nevelson, younger artist Nell Blaine, and geometric painters Alice Trumbull Mason, I. Rice Pereira, Charmion von Wiegand, and Leon Polk Smith. Gibson's desire to promote female, black, and homosexual artists is praiseworthy, but to piggyback these neglected others onto a group of first generation Abstract Expressionists is historically and conceptually questionable. Ironically, it also diminishes the painting of the self-designated Abstract Expressionists whose club she is anxious to expand because it treats it primarily in terms of its alleged "whiteness and heterosexual masculinity" and minimizes its other qualities.

In the end, we must not forget, as I have already observed, that Abstract Expressionism took place in another era. Art historians and critics who ignore this fact risk misunderstanding so much about this art, including why it has been able to transcend its now distant epoch.

1. Francis Henry Taylor, "Modern Art and the Dignity of Man," *Atlantic Monthly,* December 1948, pp. 30-31, 36.

2. James S. Plaut, "'Modern Art' and the American Public," A Statement by the Institute of Contemporary Art, formerly The Institute of Modern Art," leaflet (Boston: Institute of Contemporary Art, February 17, 1948), excerpt in *Modern Artists in America* (New York: Wittenborn, Schultz, 1951), p. 147.

3. "A Life Round Table on Modern Art," *Life,* October 11, 1948. The fifteen participants were Russell W. Davenport (moderator), Meyer Schapiro, Georges Duthuit, Aldous Huxley, Francis Henry Taylor, Sir Leigh Ashton, R. Kirk Askew, Raymond Mortimer, Alfred Frankfurter, Theodore Green, James Johnson Sweeney, Charles Sawyer, H. W. Janson, A. Hyatt Mayor, and James Thrall Soby.

4. "Revolt in Boston," *Life,* February 21, 1949, p. 84.

5. "Jackson Pollock: Is He the Greatest Living Painter in the United States?" *Life,* August 8, 1949, pp.42-45.

Bradford R. Collins, in "*Life* Magazine and the Abstract Expressionists 1948-1951: A Historiographic Study of a Late Bohemian Enterprise," *Art Bulletin,* June 1991, pp. 283-308. Collins tries to make a case for *Life* as "essentially supportive … on behalf of vanguard artists," but he is not convincing. He claims that the Abstract Expressionists desired public appreciation and monetary success. But Collins does not grasp that they were ambivalent about success and refused to compromise their art or pander to public tastes. Their greatest fear was "selling out." His focus is on the artists' desire for success rather than their idealism is a sign perhaps of his own regard for success, which seems to bias his interpretation. Collins belongs to a group of recent historians, who in the name of tough mindedness, aim to debunk Abstract Expressionism. He regards their statements about their commitment to their art as Bohemian and then asserts that they were not really Bohemians but used their claims that they were to advance their careerist ambitions. In the end, he accuses those of us who question his thesis as having a preconceived bias.

6. "Statement," *Reality,* I, Spring 1953, p. 1.

The attacks on Abstract Expressionism were like proverbial broken records. For example, Robert Brustein, a prestigious intellectual, in "The Cult of Unthink," *Horizon 1,* September 1958, pp. 44, 135, reviled Abstract Expressionism as an art of "self-indulgence." "[As] far as these painters are concerned, the outside world might just as well not exist.… Having abdicated the traditional responsibilities of the avant-garde … they seem determined to slough off all responsibility whatsoever."

In 1959, after Abstract Expressionism had become established, Cleve Gray, who later turned to an abstract expressionist in his own work, wrote an article, titled "Narcissus in Chaos: Contemporary American Art," in *American Scholar,* Autumn 1959, pp. 434, 437-439, in which he attacked the Abstract Expressionist for believing that asserting his or her own individual ego and unconscious is worthier than contemplating the visual world. In so doing, the individual artist "becomes idiotic [because] his experience is unrelated to a responsible conception of reality, the communal reality, and becomes entirely 'his own.…'" "The unhappy spectator stares at an unintelligible vacuum." However, at its best, the "work of the contemporary non-objective painter, such as Pollock, may be agreeably decorative, it is nothing more."

Again, in 1961, Edgar Levy, who had been an avant-garde painter in the 1930s, condemned abstract art in "Notes Toward A Program for Painting," *Columbia University Forum,* Spring 1961, pp. 5-6, as "nothing more than the production of decorations for the market. [They] are, despite slippery explanations, too simple-minded to warrant further serious attention." Levy went on to say that "this work is of course as empty of content as it looks." The attacks frequently focus on money, which tells us much about the new Humanist mentality. "The exaggerated high prices—six or seven thousand dollars—paid for these unpainted paintings entice artists to produce articles of commerce instead of works of art.… Such art has no passion and raises no embarrassing questions.… It lends itself passively to the routine of speculation, its worth exactly pegged on the newest quotation."

More recently, in a 1994 article titled "Against the Dehumanization of Art," in *New Criterion,* Mark Helprin provided a rabid rehash of the Humanist assault on modernist art. With nasty innuendoes, he lamented Modernism's rejection of "the potent common language that artists have used for thousands of years, the language that reaches across barriers of class, nationality, or belief, the language of natural and human

constants:… the universal existence of love and sorrow and courage and death and sacrifice, … the beauty of form, both human and natural."

Replacing this glorious art, in Helprin's opinion, was "the legacy of nihilism, which is the gift of the belief that the universe is devoid of purpose. [Modernism] has been and is the handmaiden of this century's matchless forces of destruction and alienation." He then suggested that Modernists were the "iron maiden[s]" of Franco, Mussolini, Hitler, and Stalin, and were somehow responsible in part for the evil these dictators perpetrated. Helprin concluded that the solution for art was "to paint the human form and to render light in its infinite and consequential beauty."

7. Sibyl Moholy-Nagy, "The Crisis in Abstraction," *Arts Magazine,* April 1959, pp. 22-24.

8. See John Canaday, *Embattled Critic: Views on Modern Art* (New York: Farrar, Scraus and Cudahy, 1962)

9. Clement Greenberg, "'American-Type' Painting," *Partisan Review,* Spring 1955, p. 181.

10. Clement Greenberg, "Modernist Painting," *Arts Yearbook,* 1961, p. 103.

11. Clement Greenberg, "Abstract Art," *Nation,* April 15, 1944, p. 451.

12. Greenberg, "'American-Type' Painting," p. 179.

13. Clement Greenberg, "Present Prospects of American Painting and Sculpture," *Horizon,* October 1947, p. 27.

14. Ibid., p. 26.

15. Adolph Gottlieb and Mark Rothko (in collaboration with Barnett Newman), "Letter to the Editor," *New York Times,* June 13, 1943, Sec. 2, p. 9.

16. Robert Motherwell, lecture at Fogg Museum, Harvard University, 1951, typescript in Motherwell archives, Greenwich, Connecticut, quoted in Robert S. Matson, "The Emperor of China," *Art International,* November-December 1982, p. 9.

 Philip Guston, in Philip Pavia, Irving Sandler, "The Philadelphia Panel," *It Is 5,* Spring 1960, p. 38, asserted the primacy of content: "There is something ridiculous and miserly in the myth [that] painting is autonomous, pure and for itself, therefore we habitually analyze its ingredients and define its limits. But painting is 'impure.' … We are image-makers and image-ridden."

17. Clement Greenberg, introduction, "Barnett Newman: First Retrospective Exhibition" (Bennington, Vt.: Bennington College, 1958), n.p.

18. A. A. Gill, "Sylvester, the Critic Who Kept Moving and Saw the Light," *Sunday Times,* June 24, 2001, News Review, p. 8.

 Greenberg believed that the first glance at a painting would reveal its aesthetic quality or lack of it. In artists' studios, he would have a painting brought to him while his back was turned so that he could turn on it and register his immediate reaction.

19. Robert Storr's theme for his show at the Venice Biennale, 2007.

20. Harold Rosenberg, "The American Action Painters," *Art News,* December 1952, pp. 22-23.

 Rosenberg anticipated his idea of Action Painting in a statement he made for the catalogue of a show at the Galerie Maeght in Paris in 1947, which was reprinted in *Possibilities* and in which he acclaimed painting that aimed "not to be a conscious philosophical or social ideal, but to what is basically an individual, sensual, psychic and intellectual effort to live in the present."

 Rosenberg's conception of "action" has other sources—for example, Kenneth Burke's *Grammar of Motives.* Robert Goldwater thought that Rosenberg's conception of "action" was influenced by the Marxist notion of praxis. Barnett Newman said that it may have derived from the remark, "Where's the action?" which refers to dice games or gambling. It is noteworthy that many Abstract Expressionists considered their art-making as a kind of gamble.

21. Guston affirmed Rosenberg's rhetoric, but with more urgency and angst, in Philip Guston, talk at Boston University, 1966, quoted in *Philip Guston* (New York: George Braziller, 1980), pp. 45-46:

> [You] felt as if you were driven into a corner against the wall with no place to stand, just the place you occupied, as if the act of painting itself was not making a picture, there are plenty of pictures in the world—why clutter up the world with pictures—it was as if you had to prove to yourself that truly the act of creation was still possible.... It felt to me as if you were on trial. I am speaking very subjectively. I felt as if I was talking to myself, having a dialectical monologue with myself to see if I could create.
>
> What do I mean by create? I mean … that complete losing of oneself in the work to such an extent that the work itself … felt as if a living organism was posited there on the canvas, on this surface. That's truly to me the act of creation.... I was forced and pushed into the kind of painting that I did. That is to say, the demands of the dialogue with myself—I give to it, I make some marks, it speaks to me, I speak to it, we have *terrible* arguments going on all night, weeks and weeks—do I really believe that? I make a mark, a few strokes. I argue with myself, not "do I like or not" but "is it true or not?" Is that what I mean, is that what I want?

22. Harold Rosenberg, "The American Action Painters," p. 23.

23. In rejecting the idea of the painter being bound to tradition, Rosenberg attacked T. S. Eliot, "with his famous formula of the supremacy of tradition over individual talent," as he remarked in Introduction to Marcel Raymond, *From Baudelaire to Surrealism* (New York: Wittenborn, 1949), p. xiv. Rosenberg also asserted that as a "poet and academician, word specialist and snob, [Eliot was] destructive [to] poetic and individual independence."

24. Robert Goldwater, "Reflections on the New York School," *Quadrum,* No. 8, 1960, p. 29.

25. Louis Finkelstein, in a conversation with the author, late 1950s, said, "When you paint a blue, the problem becomes: What is your attachment to it? You explore this attachment by adding a second color, a third, and so on, which modify the shape, weight, position, direction, light, tone, etc. of the blue, as well as raise questions about the colors added. In the end, you don't fix the forms; the forms fix you. The way you clarify your attachment to the pictorial elements can prompt emotional responses in the viewers."

26. Rosenberg, "The American Action Painters," p. 23.

27. Robert Motherwell, letter to Brandon Taylor, February 20, 1980, in Robert Saltonstall Mattison, *Robert Motherwell: The Formative Years* (Ann Arbor, Mich.: UMI Research Press, 1987), p. 162.

28. William Barrett, *Irrational Man* (New York: Anchor Books, 1958), p. 31. A concern with death is also found in the other writings read or discussed by the Abstract Expressionists such as Joseph Campbell's *The Hero with a Thousand Faces.*

29. Irving Sandler, "Conversations with de Kooning," *Art Journal,* Fall 1989, reprinted in Irving Sandler, *From Avant-Garde to Pluralism: An On-the-Spot History,* (Lenox Mass.: Hard Press Editions, 2006), p. 35.

30. Gladys Shafran Kashdin, interview with Willem de Kooning, May 6, 1965, in "Abstract Expressionism: An Analysis of the Movement Based Primarily upon Interviews with Seven Participating Artists," Ph.D. Dissertation, Florida State University, 1965, p. 173.

31. Kashdin, interview with James Brooks, March 8, 1965, ibid.

32. Nicolas Calas, panel discussion at The Club, late 1950s.

33. Clement Greenberg, "Art," *Nation,* July 13, 1946, p. 54.

34. The contemporary pragmatist Richard Rorty, in "The Invisible Philosopher," *New York Times,* Book Section, Sunday, 9 March 2003, p. 14, lists Dewey among the four most influential philosophers of the twentieth century, along with Martin Heidegger, Bertrand Russell, and Ludwig Wittgenstein (and of the four, Dewey had "the best moral character"). He was, moreover, "the conscience of his country."

35. Robert Saltonstall Mattison, *Robert Motherwell: The Formative Years* (Ann Arbor: UMI Research Press, 1987), p. 6.

Existentialism had an antecedent in John Dewey's pragmatism. For example, Barrett, in his widely read book, *Irrational Man,* p. 17, wrote:. "The image of man as an earthbound and timebound creature predominates Dewey's writings as it does the Existentialists up to a point. Beyond that he moves in a direction that is the very opposite of Existentialism.… Dewey places the human being very securely within the biological and social context, but he never gets past this context into that deeper center of the human person where fear and trembling start." Consequently, Dewey's humanist reliance on reason was out of keeping with the temper of the 1940s in a way that Existentialism was not.

36. See Casey Haskins, "Dewey's 'Art As Experience: The Tension between Aesthetics and Aestheticism,'" typescript of lecture delivered at a meeting of the American Society for Aesthetics, May 14, 1990.

37. Harold Rosenberg, "Action Painting: A Decade of Distortion," *Art News,* December 1962, p. 42.

38. Clement Greenberg, "How Art Criticism Earns Its Bad Name," *Second Coming,* March 1962, p. 71.

39. Harold Rosenberg, "The Art Galleries: The New as Value," *New Yorker,* September 7, 1963, p. 141.

40. Clement Greenberg, "Is the French Avant-Garde Overrated?" *Art Digest,* September 15, 1953, pp. 12, 27.

41. Harold Rosenberg, "Parable of American Painting," *Art News,* January 1954, pp. 61-62, 75.

42. Joseph Albers, letter to Harold Rosenberg, in Rosenberg, *Barnett Newman* (New York: Harry N. Abrams, 1978), p. 21.

43. Robert Goldwater, "Reflections on the New York School," *Quadrum 8,* 1960, pp. 33-34.

44. John Cage, *Silence: Lectures and Writings* (Cambridge, Mass.: MIT Press, 1967), p. 10.

45. I am indebted to Jacques Ellul, "Modern Myths," *Diogenes,* Fall 1958, p. 28, for this formulation.

46. Hofmann's painting was on the whole hedonistic, celebratory, and pleasurable. In the 1950s, this was held against him. The attitude changed in the following decade. For example, Frank Stella, arguably the most influential abstract artist of the early 1960s, in "The Artist of the Century," *American Heritage,* November 1999, pp. 14-17, wrote, "In this century Hans Hofmann has produced more successful color explosions on canvas than any other artist." Stella then called Hofmann "the Artist of the Century."

47. Walter Darby Bannard, "Present-Day Art and Ready-Made Styles," *Artforum,* December 1966, p. 30.

48. Bruce Glaser, interviewer, Lucy R. Lippard, ed., "Questions to Stella and Judd," *Art News,* September 1966, pp. 58-59.

49. "It would seem," Philip Leider, "The Cool School," *Artforum,* Summer 1964, p. 47.

50. Andy Warhol and Pat Hackett, *POPism,* (New York: Harcourt Brace Jovanovich, 1980), p. 3

51. Allan Kaprow, "Should the Artist Be a Man of the World?" *Art News,* October 1964.

52. Weldon Kees, "Art," *Nation,* January 7, 1950, pp. 19-20.

53. Antonin Artaud, "Van Gogh, The Man Suicided by Society," trans. Bernard Frechtman, *Tiger's Eye,* No. 7, March 1949, pp. 93-115. The essay was first published in French in 1947.

54. Clement Greenberg, "Art Chronicle: The Situation at the Moment," *Partisan Review,* January 1948, pp. 82-83.

55. Harold Rosenberg, "Toward an Unanxious Profession," in *The Anxious Object,* p. 14.

56. Harold Rosenberg, "A Guide for the Unperplexed," *Art News,* September 1966, p. 46.

57. Michael Leja, "Book Reviews: Abstract Expressionism: Sources and Surveys," *Art Journal,* after Summer 1991, pp. 101, 104.

58. Kim Levin, "Fifties Fallout: The Hydrogen Juke Box," *Arts Magazine,* April 1974, p. 29.

59. Clyfford Still, letter to Gordon Smith, in "Paintings by Clyfford Still" (Buffalo: Albright Art Gallery, 1959), n.p.

60. Peter Schjeldahl, "Rothko and Belief," *Art in America,* March-April 1979, p. 82.

61. John Davis, "The End of the American Century: Current Scholarship on the Art of the United States," *Art Bulletin,* September 2003, p. 565.

62. Clyfford Still, "An Open Letter to an Art Critic," *Artforum,* December 1963, reprinted in John P. O'Neill, ed., "Notes and Letters," *Clyfford Still* (New York: Metropolitan Museum of Art, 1979), p. 47.

63. Judith Flanders, "Newman Unzipped," *Times Literary Supplement,* London, October 11, 2002, p. 20.

64. Al Held, handwritten notes of conversation with the author, middle 1960s.

65. Joseph Masheck, "*Guernica* as Art History," *Art News,* December 1967, pp. 33-34.

66. A. L. Ries and Frances Borzello, "Introduction," *The New Art History* (London: Camden Press, 1986), p. 8.

67. Charles Harrison, "Taste and Tendency," *The New Art History* (London: Camden Press, 1986), p. 81.

68. T. J. Clark, "Jackson Pollock's Abstractions," in Serge Guilbaut, ed., *Reconstructing Modernism: Art in New York, Paris, and Montreal, 1945-1964* (Cambridge, Mass.: MIT Press, 1990), p. 180.

69. Serge Guilbaut, *How New York Stole the Idea of Modern Art: Abstract Expressionism, Freedom, and the Cold War* (Chicago: University of Chicago Press, 1983), p. 11.

70. Michael Leja, *Reframing Abstract Expressionism: Subjectivity and Painting in the 1940s* (New Haven, Conn.: Yale University Press, 1993), pp. 2, 4-5.

71. Leja, *Reframing Abstract Expressionism,* p. 16.

72. Leja, *Reframing Abstract Expressionism,* pp. 117-119.

73. Nancy Jachec, *The Philosophy and Politics of Abstract Expressionism: 1940-1960* (Cambridge: Cambridge University Press, 2000), p. 11.

74. Stephen Polcari, *Abstract Expressionism and the Modern Experience* (Cambridge, U.K.: Cambridge University Press, 1991) pp. 3, 40. Polcari also wrote on that "many Abstract Expressionists searched for a holistic view of the human historical continuum," and sought "to physically and spiritually heal their land in its time of illness and waste" (p. 52).

75. Michael Zakian, "Barnett Newman and the Sublime," *Arts Magazine,* February 1988, pp. 33-39.

76. David Craven, *Abstract Expressionism as Cultural Critique: Dissent During the McCarthy Period* (Cambridge, England: Cambridge University Press, 1999), p. 29. Craven tried to root Abstract Expressionist social and political attitudes in the painters' rhetoric, but he tended to focus on only two of them—Motherwell and Reinhardt—who are made to stand for all of their fellow artists. More often than not, he also generalized from a few phrases, at times taken out of context, that one or two of the artists might have used, ending up with the construction of full-blown politically correct positions that did not really interest the artists concerned, but obviously interested him. I hasten to add that although Craven's presentation is primarily Marxist exegesis, in other respects his book is valuable, because he offers penetrating insights that set right misstatements in the texts of Guilbaut and Jachec.

77. Psychologists and psychoanalysts have also analyzed the Abstract Expressionists. One example is the article by psychoanalysts Joseph J. Schildkraut, Alissa J. Hirshfeld, and Jane M. Murphy, "Mind and Mood in Modern Art, II: Depressive Disorder, Spirituality, and Early Deaths in the Abstract Expressionist Artists of the New York School," *American Journal of Psychiatry,* April 1994, pp. 482-489. The three analysts pointed to the expression of suffering and pain in Abstract Expressionist canvases but did not confront the issue of whether the artists' supposed psychological problems caused them to be sensitive about the social neuroses

of their time, or whether the social situation, aggravated by the painters' poverty and lack of recognition, gave rise to their alleged mental disorders. Or that one exacerbated the other. Schildkraut, Hirshfeld, and Murphy failed to recognize that in the very practice of their art the artists would escape in some measure from the ravages of depression and the sense of worthlessness. In the end, the findings of the psychoanalysts served to call into question the sanity of the artists and as a result to demean the work as deranged.

78. Robert Storr, *Philip Guston: The Late Works* (Melbourne: National Gallery of Victoria, 1984), p. 159.

79. Thomas B. Hess, "Pollock: The Art and the Myth," *Art News,* January 1964, p. 64.

80. Joseph J. Schildkraut, Alissa J. Hirshfeld, and Jane M. Murphy, pp. 482-489.

81. Francis O'Connor, "Two Methodologies for the Interpretation of Abstract Expressionism," *Art Journal,* Fall 1988, p. 222.

82. Rollo May, *Man's Search for Himself* (New York: Norton, 1953), pp. 34, 53-54. Quoted in Seitz, *Abstract Expressionist Painting in America* (Cambridge and London: Harvard University Press, 1983), p. 101.

83. Isaiah Berlin, "Chaim Weizman," pp. 32-33.

84. Renato Poggioli, *The Theory of the Avant-Garde* (Cambridge: Harvard University Press, 1968) pp. 66-67.

85. Robert Pincus-Witten, "Lynda Benglis: The Frozen Gesture" (1974), in *The New Sculpture 1965-1975: Between Geometry and Gesture* (New York: Whitney Museum of American Art, 1990), p. 310.

86. David Craven, *Abstract Expressionism as Cultural Critique,* p. 115.

87. Ann Eden Gibson, *Abstract Expressionism: Other Politics* (New Haven, Conn.: Yale University Press, 1997), p. ix. Lee Krasner should be included in the Abstract Expressionist canon. She is not because she kept out of the New York art scene for personal reasons; it would have threatened her marriage to Jackson Pollock. For instance, had she wanted she could have been included among the Irascibles in their photograph in *Life,* but she did not. Her first one-person show was in 1951 at the Betty Parsons Gallery.

CHAPTER 7
The Recognition of Abstract Expressionism

The breakthroughs of Pollock, Still, and de Kooning occurred in 1947, but they and other Abstract Expressionists did not achieve international recognition until 1958. Prior to World War II, Modernist artists in New York had acknowledged Paris as the center of advanced art. When the Germans occupied France during the war, Rosenberg wrote, in 1940, an article titled "On The Fall of Paris," lamenting that "the laboratory of the twentieth century had been shut down … the Holy Place of our time. The only one."[1]

In the wake of the war, significant numbers of School of Paris artists escaped to New York. With New York now the hub of world art, there were calls for an independent, global-minded American art. As Newman wrote at the beginning of 1943, Modernist artists in New York aspired to "reflect the new America that is taking place today and the kind of America that will, it is hoped, become the cultural center of the world."[2] But these calls were premature.

When the war ended, most American Modernist artists and critics took it for granted that Paris would resume its former position of artistic hegemony. In 1946, Greenberg wrote, "The School of Paris remains still the creative fountainhead of modern art, and its every move is decisive for advanced artists everywhere else."[3] Within months of his statement, New York museums and galleries exhibited war-time French painting and sculpture in considerable quantities, and Greenberg changed his mind. In a review of "School of Paris, 1939 to 1946," the first large-scale show of recent French art, held at the Whitney Museum, he wrote that he was shocked by the poor quality of the art generally. He added, "When one sees … how much the level of American art has risen in the last five years … then the conclusion forces itself, much to our own surprise, that the main premises of Western art have at last migrated to the United States."[4] The New York avant-garde, with the exception of Hofmann, shared Greenberg's opinion and increasingly resented French claims to artistic superiority.

By 1946, Baziotes, Gorky, Gottlieb, Hofmann, Motherwell, Pollock, Rothko, and Still had impressive one-person shows at the galleries of Peggy Guggenheim, Betty Parsons, and Samuel Kootz. These exhibitions revealed to the artists the significance and quality of what they had created and generated a sense of collective excitement that encouraged them to shed their inferiority complex; they became self-assertive, and conscious of themselves as a group sharing certain artistic ideas and values. At the same time, critics such as Greenberg, Rosenberg, and Manny Farber directed public attention to the new American painting and proclaimed that it was more vital, radical, and original than any being produced elsewhere. They would also organize to combat their esthetic "enemies" and vie for recognition.

From 1948 to 1952, the Abstract Expressionists began to achieve growing art-world approval in New York, a process that can be traced year by year. In 1948, Modernist artists organized a protest meeting at the Museum of Modern Art at which they spoke out against hidebound art critics and Boston's Institute of Contemporary Art repudiation of modern art. Moreover, in 1948, the Subjects of the Artist School, founded by Baziotes, David Hare, Motherwell, and Rothko (joined somewhat later by Newman), presented a series of Friday evening lectures by advanced artists. The school closed after one semester, but the programs were continued by a group of New York University professors who rented the school's space and renamed it Studio 35. Among the artists who delivered talks were Rothko, Newman, de Kooning (whose paper was read by Motherwell), Gottlieb, and Reinhardt. There was also a panel discussion, "What Has Happened in American Painting in the Last Two Years?" whose participants were Baziotes, de Kooning, Motherwell, Reinhardt, and Harry Holtzman. Inadvertently, the forum signaled the Abstract Expressionists' new sense of community and was a vehicle for the presentation of their views and promotion of their work in the art world. Moreover, 1948 saw the publication of the little magazine *Possibilities,* which featured avant-garde art. Despite its relevance, only one issue appeared, indicating that such publishing ventures were premature. Clement Greenberg in *The Nation* also called attention to avant-garde art. Moreover, in 1949, a new publication, *Tiger's Eye,* featured avant-garde artists.

In 1949, the Abstract Expressionists' growing sense of the worth of their painting and an accompanying anger at its neglect emboldened them to organize a club, which came to be called simply The Club.[6] They did so because they wanted a comfortable space where they could talk and have coffee. But there were other compelling, though not always conscious, reasons to meet: the need to discuss new aesthetic issues, and the need for mutual support. In the face of hostility, indifference, and ignorance on the part of the public and mainstream art world, vanguard artists created their own art world, composed mostly of other artists. They had long traded studio visits and discussed one another's work with great frankness. The Club was a semipublic outgrowth of these private studio visits.

Also in 1949, the growing art-world attention paid to the Abstract Expressionists prompted Harold Rosenberg and Samuel Kootz to feature them in an exhibition titled "Intrasubjectives" in the latter's gallery. It was the first attempt to group these avant-garde artists together.

In 1950, the growing self-confidence of the Abstract Expressionists was recognized by *New York Times* critic Stuart Preston, who predicted a confrontation between advanced and conservative artists in military terms, "One sure thing about the new art season is that the nonfigurative forces will be stronger. They have regrouped; their commanders are older and more seasoned."

Preston was right. In 1950, Studio 35 presented a three-day closed roundtable. The proceedings were stenographically recorded and published in *Modern Artists in America* (1951). A recurring topic of discussion was whether the participants constituted a community. At the close of the sessions, Gottlieb proposed that a public letter be sent to the president of the Metropolitan Museum denouncing a major show, titled "American Painting Today, 1950," for being hostile to modern art. Drafted by him in consultation with Newman, Motherwell, and Reinhardt, the letter decried the conservatism of the five regional juries, the national jury, and the jury of awards. It stated that the "choice of jurors … does not warrant any hope that a just proportion of advanced art will be included." Consequently, the signatories vowed to boycott this "monster" show. The letter was signed by eighteen painters and supported by ten sculptors, an indication of a new stage of their collective consciousness.[8]

The *New York Times* reported the protest on its front page under the headline "18 Painters Boycott Metropolitan: Charge 'Hostility to Advanced Art.'" The *New York Herald Tribune* then published an editorial titled "The Irascible Eighteen" (providing the artists with a label). *Art News* and *Art Digest* also covered the ensuing controversy, as did *The Nation, Time, Life,* and other publications. The article in *Time* was accompanied by reproductions of paintings by Baziotes, Reinhardt, and Hofmann. In 1951, *Life* printed a group portrait of dissident painters, a photograph that has been reproduced so often and disseminated so widely that it has become the iconic image of the artists who achieved the triumph of American painting.

The portrait in *Life* was the most telling sign that Abstract Expressionism had become sufficiently well known to warrant mass media acknowledgment. Most reviews of the Metropolitan show noted the Irascibles' absence and recapitulated the reasons for it. Moreover, the protest, as *Life* stated, "did appear to have needled the Metropolitan juries into turning more than half the show into a free-for-all of modern art." Moreover, in 1950, *Art News,* whose managing editor was Thomas Hess, began to print articles on the avant-garde artists, and in the following year, his *Abstract Painting,* the first book to feature Abstract Expressionism, was published.

In 1951, the members of The Club organized a major group show titled "9th Street Show." The sixty-one artists listed on the announcement read like a Who's Who of the New York School. Leo

Castelli, who helped underwrite the show, recalled, "The participating artists were elated. It proved that their art was new and important—and better than what was being made in Paris." Encouraged by the success of their show, the participating artists decided to organize further group exhibitions that they themselves would select. The Stable Gallery offered its space, and the "Stable Annuals," as they came to be known, were mounted from 1953 to 1957. Motherwell and Reinhardt recognized the new public status of the avant-garde in *Modern Artists in America* (1951), "From East to West numerous galleries and museums, colleges and art schools, private and regional demonstrations display their mounting interest in original plastic efforts."[9]

In 1951, the Museum of Modern Art mounted "Abstract Painting and Sculpture in America," which included twelve of the Irascibles, and in 1952, "Fifteen Americans," one of a series of prestigious group shows curated by Dorothy Miller, which included Baziotes, Pollock, Rothko, Still, and Bradley Walker Tomlin, conferring on them the museum's stamp of approval. However, it was not until 1958 when the Museum of Modern Art organized a major survey of "New American Painting" that traveled to eight European countries before returning to be shown in New York, that the museum, the Establishment bastion of modern art, wholeheartedly endorsed Abstract Expressionism. Because the new American painting was the most innovative in the world, it received slow but growing attention abroad on the part of leading European artists, art critics, museum directors, curators, dealers, collectors, and other establishment figures. In short, by the end of the 1950s, New York was recognized as the center of the avant-garde world. As Jeremy Lewison wrote, "In the decade and a half since the war, America had been transformed from a target of ridicule to a role model."[10]

In 1960, Robert Goldwater announced the demise of Abstract Expressionism as a vanguard tendency. "It has had time to change and develop, to evolve and alter and expand, to spread and succeed, to attract followers and nourish imitators. It has lived a history, germinated a mythology and produced a hagiology; it has descended to a second, and now a third artistic generation."[11]

Abstract Expressionism was not widely accepted by the American public until well after the art world accepted its importance. It was simply too abstract, subjective, and unconventional. However, over time it did gain approval, the final confirmation of which was the Pollock retrospective at the Museum of Modern Art at the cusp of the millennium in 1999. In their press release of February 12, 1999, the museum reported that total attendance was 329,330—a figure substantiated by the frequent lines that stretched from the museum to Fifth Avenue, at times extending to 54th Street. Total retail sales for Pollock-related merchandise were $2 million, including 20,000 CDs of period jazz, and 1200 scarves. *Lucifer* was the best-selling poster; the 4700 sold grossed $70,000. Forty-five percent of the visitors were from out of town, and fifty-six percent of these came primarily to see the Pollock show.

If there were any doubts about the public reception of Abstract Expressionism, the Pollock retrospective laid them to rest and may be considered proof that now in the twenty-first century, more than fifty years after its inception, Abstract Expressionist painting at its best continues to resonate deep in the human psyche and transcend its time and place.

1. Harold Rosenberg, "On the Fall of Paris," *Partisan Review,* November-December 1940, pp. 440-441.

2. Barnett Newman, "Introduction," *Modern American Artists,* exhibition catalogue, Riverside Museum, 1943, n.p.

3. Clement Greenberg, "Art," *The Nation,* June 29, 1946, p. 792.

4. Clement Greenberg, "Art Chronicle: The Decline of Cubism," *Partisan Review,* March 1948, p. 369.

5. The new American painters downgraded artists whose painting looked too French—that is, beautifully made—including Hans Hofmann. Guilbaut made this point and he was right.

6. The artists who founded The Club included George Cavallon, Peter Grippe, Franz Kline, Willem de Kooning, Ibram Lassaw, Landes Lewitin, Conrad Marca-Relli, Phillip Pavia, Milton Resnick, Ad Reinhardt, James Rosati, Ludwig Sander, Joop Sanders, and Jack Tworkov (and the dealer Charles Egan). Elaine de Kooning and Mercedes Matter also attended but were not considered charter members because they were women; such was the masculine ethos at the time. The founding members rented a loft at 39 East 8th Street and fixed it up.

7. Stuart Preston, "Among the Early Show," *New York Times,* September 17, 1950, Sec. 2. p. 9.

8. "Choice of Jurors": The letter was reprinted in Weldon Kees, "Art," *The Nation,* June 3, 1950, p. 557.

 The Irascible 18 were William Baziotes, James Brooks, Fritz Bultman, Jimmie Ernst, Adolph Gottlieb, Hans Hofmann, Weldon Kees, Willem de Kooning, Robert Motherwell, Barnett Newman, Jackson Pollock, Richard Pousette-Dart, Ad Reinhardt, Mark Rothko, Theodoros Stamos, Hedda Sterne, Clyfford Still, and Bradley Walker Tomlin.

9. Bernard Karpel, Robert Motherwell, and Ad Reinhardt, "A Statement," 1951, *Modern Artists in America* (New York: Wittenborn Schultz, 1951), p. 6.

10. Jeremy Lewison, "Jackson Pollock and the Americanization of Europe," in Kirk Varnedoe and Pepe Karmel, eds., *Jackson Pollock: New Approaches* (New York: Harry N. Abrams, 1999), p. 214.

11. Robert Goldwater, "Reflections on the New York School," *Quadrum 8,* 1960, p. 18.

The author and publishers are grateful to the institutions and foundations for the use of these works of art and the permission to reproduce them in this book. Sources and information not included in the captions are listed here.

Page 28
Jackson Pollock (1912-1956) © ARS, NY. *Full Fathom Five,* 1947. Oil on canvas with nails, tacks, buttons, key, coins, cigarettes, matches, etc. 50 7/8 x 30 1/8". Gift of Peggy Guggenheim. (186.1952)
The Museum of Modern Art, New York, NY U.S.A.
Digital Image © The Museum of Modern Art/Licensed by SCALA / Art Resource, NY
© 2008 The Pollock-Krasner Foundation / Artists Rights Society (ARS), New York

Page 51
Josef Albers
b and p
1937
Oil on masonite, 23 7/8 x 23 3/4 inches (60.6 x 60.2 cm).
Solomon R. Guggenheim Museum, New York
Estate of Karl Nierendorf, By purchase
48.1172.264.
© 2008 The Josef and Anni Albers Foundation / Artists Rights Society (ARS), New York

Burgoyne Diller, 1906-1965
First Theme, 1938
Oil on canvas, Overall: 30 1/16 x 30 1/16 in. (76.4 x 76.4cm)
Whitney Museum of American Art, New York;
Purchase, with funds from Emily Fisher Landau 85.44
© Estate of Burgoyne Diller/Licensed by VAGA, New York, NY

Page 57
Arshile Gorky, *Organization,* Ailsa Mellon Bruce Fund, Image courtesy of the Board of Trustees, National Gallery of Art, Washington, 1933-1936, oil on canvas, 1.270 x 1.520 (50 x 59 13/16); framed; 1.346 x 1.600 x .070 (53 x 63 x 2 3/4)
© 2008 Artists Rights Society (ARS), New York

Page 75
Arshile Gorky 1904-1948
The Betrothal, II, 1947
Oil on canvas, Overall: 50 3/4 x 38 in. (128.9 x 96.5cm)
Framed: 51 3/16 x 39 x 1 15/16 in. (130 x 99.1 x 4.9cm)
Whitney Museum of American Art, New York;
Purchase 50.3
© 2008 Artists Rights Society (ARS), New York

Page 79 and Cover
Willem de Kooning
Pink Angels, 1945
oil and charcoal on canvas
52 x 40 in.
Frederick R Weisman Art Foundation, Los Angeles.
© 2008 The Willem de Kooning Foundation / Artists Rights Society (ARS), New York

Page 86
Jackson Pollock (1912-1956) *Male and Female,* 1942-43. Oil on canvas, 6 feet 1 1/4 inches x 4 feet 15/16 inches (186.1 x 124.3 cm). Gift of Mr. and Mrs. H. Gates Lloyd, 1974. (1974-232-1)
Philadelphia Museum of Art, Philadelphia, Pennsylvania, U.S.A.
Photo credit: The Philadelphia Museum of Art / Art Resource, NY
© 2008 The Pollock-Krasner Foundation / Artists Rights Society (ARS), New York

Page 89
Mark Rothko, *The Omen of the Eagle,* Gift of The Mark Rothko Foundation, Inc., Image courtesy of the Board of Trustees, National Gallery of Art, Washington, 1942, oil and graphite on canvas, .654 x .451 (25 3/4 x 17 3/4); framed: .716 x .557 x .056 (28 3/16 x 21 15/16 x 2 3/16)
© 2008 Kate Rothko Prizel & Christopher Rothko / Artists Rights Society (ARS), New York

Page 90
William Baziotes (1912-1963) © Copyright Estate of the Artist. *Dwarf,* 1947. Oil on canvas, 42 x 36 1/8". A. Conger Goodyear Fund. (229.1947)
The Museum of Modern Art, New York, NY, U.S.A.
Digital Image © The Museum of Modern Art/ Licensed by SCALA / Art Resource, NY

Page 94
Adolph Gottlieb *Pictograph,* 1942, oil on canvas, 48 x 36"
Art © Adolph and Esther Gottlieb Foundation/Licensed by VAGA NY, NY

Page 118
Clyfford Still (1904-1980) *Untitled,* 1945, oil on canvas, 42 3/8 x 33 5/8 in. (107.63 x 85.41 cm). PH-141. Whitney Museum of American Art, New York; Gift of Mr. and Mrs. B. H. Friedman 69.3
© The Clyfford Still Estate

Page 120
Barnett Newman (1905-1970) © ARS, NY. *Abraham,* 1949. Oil on canvas, 6' 10 3/4" x 34 1/2". Philip Johnson Fund. (651.1959)
The Museum of Modern Art, New York, NY, U.S.A.
Digital Image © The Museum of Modern Art/ Licensed by SCALA / Art Resource, NY
© 2008 The Barnett Newman Foundation, New York / Artists Rights Society (ARS), New York

Page 123
Jackson Pollock, *Number 8, 1949,* 1949, oil, enamel and aluminum paint on canvas, 34 1//8 x 71 1/4 inches. Collection Neuberger Museum of Art
Purchase College, State University of New York
Gift of Roy R. Neuberger.
Photo credit: Jim Frank
© 2008 The Pollock-Krasner Foundation / Artists Rights Society (ARS), New York

Robert Motherwell *Elegy to the Spanish Republic No.34*
1953-54, oil on canvas
Overall 80 x 100" (203.2 x 254 cm.)
Albright-Knox Art Gallery, Buffalo, New York
Gift of Seymour H. Knox, Jr., 1957
Art © Dedalus Foundation, Inc. / Licensed by VAGA, New York, NY

Page 127
Clyfford Still (1904-1980) *Untitled,* Gift of Marcia S. Weisman, in Honor of the 50th Anniversary of the National Gallery of Art, Image courtesy of the Board of Trustees, National Gallery of Art, Washington, 1951, oil on canvas, 2.743 x 2.349 (108 x 92 1/2); framed: 2.807 x 2.362 x .044 (110 1/2 x 93 x 1 3/4)
© The Clyfford Still Estate

Page 133
Mark Rothko, *Old Gold over White,* 1956, oil on canvas, 68 x 46 inches. Collection Neuberger Museum of Art, Purchase College, State University of New York
Gift of Roy R. Neuberger.
Photo credit: Jim Frank
© 2008 Kate Rothko Prizel & Christopher Rothko / Artists Rights Society (ARS), New York

Page 136
Barnett Newman (1905-1970) © ARS, NY. *Vir Heroicus Sublimis,* 1950-51. Oil on canvas, 7 feet 11 3/8" x 17 feet 9 1/4".
Gift of Mr. and Mrs. Ben Heller. (240.1969)
The Museum of Modern Art, New York, NY, U.S.A.
Digital Image © The Museum of Modern Art / Licensed by SCALA/ Art Resource, NY
© 2008 The Barnett Newman Foundation, New York / Artists Rights Society (ARS), New York

Page 155
Willem de Kooning, American, born Netherlands, 1904-1997. *Excavation,* 1950, Oil on canvas, 205.7 x 254.6 cm (81 x 100 1/4 in.), unframed, Mr. and Mrs. Frank G. Logan Purchase Prize Fund; restricted gifts of Edgar J. Kaufmann, Jr., and Mr. and Mrs. Noah Goldowsky, Jr., 1952.1 The Art Institute of Chicago.
Photography © The Art Institute of Chicago
© 2008 The Willem de Kooning Foundation / Artists Rights Society (ARS), New York

Page 158
Willem de Kooning, *Marilyn Monroe,* 1954, oil on canvas, 50 x 30 inches. Collection Neuberger Museum of Art
Purchase College, State University of New York
Gift of Roy R. Neuberger.
Photo credit: Jim Frank
© 2008 The Willem de Kooning Foundation / Artists Rights Society (ARS), New York

Page 161
Franz Kline (1910-1962), *The Bridge,* ca. 1955. Oil on canvas. Frame: 82"x 54-1/2".
Munson-Williams-Proctor Arts Institute, Utica, NY, U.S.A.
Photo credit: Munson-Williams-Proctor Arts Institute / Art Resource, NY
© 2008 The Franz Kline Estate / Artists Rights Society (ARS), New York

Philip GUSTON (1913-1980)
White Painting, 1951
oil on canvas
57-7/8 x 61-7/8
San Francisco Museum of Modern Art, T. B. Walker Foundation Fund
Reprinted with permission from the Estate of Philip Guston

Page 163
Bradley Walker Tomlin 1899-1953
Number 12 - 1949, 1949
Oil on canvas,
32 x 31 in. (81.28 x 78.74 cm)
Frame 33 1/2 x 32 3/8 in.
Whitney Museum of American Art, New York
Gift of Abby and B. H. Friedman in honor of John I. H. Baur 86.53

Page 165
Hans Hofmann © The Berkeley Art Museum.
The Third Hand
1947
oil on canvas
60-1/8 x 40 inches
University of California, Berkeley Art Museum and Pacific Film Archive
Gift of Hans Hofmann.
Photographed for the UC Berkeley Art Museum by Benjamin Blackwell